FLORILEGIUM

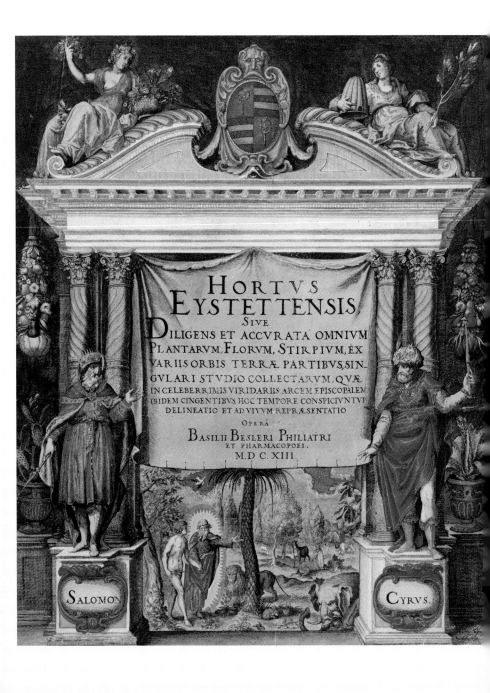

HORTVS EYSTETTENSIS,

SIVE

DILIGENS ET ACCVRATA OMNIVM
PLANTARVM, FLORVM, STIRPIVM, EX
VARIIS ORBIS TERRÆ PARTIBVS, SIN-
GVLARI STVDIO COLLECTARVM, QVÆ
IN CELEBERRIMIS VIRIDARIIS ARCEM EPISCOPALEM
IBIDEM CINGENTIBVS HOC TEMPORE CONSPICIVNTVR
DELINEATIO ET AD VIVVM REPRÆSENTATIO

OPERÂ

BASILII BESLERI PHILIATRI
ET PHARMACOPOEI.

M.D.C.XIII.

SALOMON

CYRVS.

BASILIUS BESLER

Werner Dressendörfer
Klaus Walter Littger

FLORILEGIUM

The Book of Plants – The Complete Plates

TASCHEN

Bibliotheca Universalis

In Icona affabrè effictam clariss. Pharmacopœi
NORIMB. DN. BASILI BESLERI.

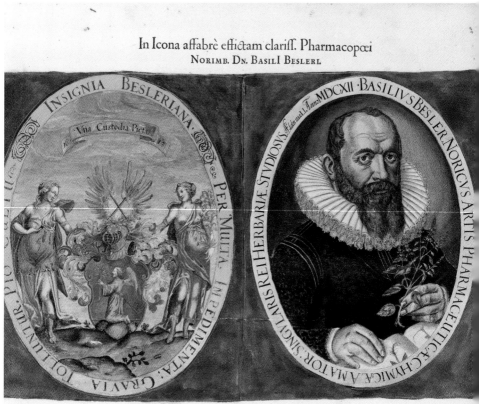

ESLERUM glyptes BASILEION imagine pulcrâ,
 Quisquis es, ô Hospes, reddidit, ecce, tibi.
Nempe viri vultus dedit heic, atq; ora tueri:
 Cernere vis mentis dona sagacis? age,
HERBARUM magnum hoc PLANTARUMq; Amphitheatron.
 Inspice, quas dotes AREATINUS habet.
Divitiasq; HORTUS: Paradeison dixeris ipsum:
 Condidit immortale hoc BASILEIUS OPUS.

GEORG. REMUS, P. AJC^{us}

FOREWORD

Werner Dressendörfer
Klaus Walter Littger

This new edition of the three-volume Eichstätt copy of the *Hortus Eystettensis* of 1613 reproduces the plates in colour, and differs markedly from its two predecessors on several counts. The new version clears up some uncertainties from the earlier editions.

One difference from the 1964 black-and-white impression, which was the only one to publish the complete text of the final edition of 1750, as well as the index, is that in the present volume the seven plates illustrating winter-blooming plants appear at the end instead of at the beginning of the sequence, which is the case with most other known versions.

The most important difference between the new version and the second edition (coloured reproductions of the plates based on the copy in the Musée National d'Histoire Naturelle in Paris) is that a completely different colouring process is used. The Paris edition, the only one of its kind, was so highly coloured that the graphic details of the print had almost disappeared completely under the colour coating. But although this artwork was certainly finely executed (and expensive), it produces an optical impression which was undoubtedly not what the compilers of the work would have wished. Instead, the *Hortus Eystettensis*, like other illustrated books of its time, was intended to be varnished, so that, for example, the cross-hatching (which had not been possible before copper engraving was developed), which gave the plants a three-dimensional appearance, and all the other graphic details, could be shown to their full advantage. The present volume does justice to this fine detail.

In addition to this, corrections have been made in four places where the sequence of plates was out of order in the Paris edition: plates 7 and 8 were transposed, as were plates 92 and 131, plates 157 and 158, and plates 322 and 323, thus restoring the original sequence followed by the text. Since the plates themselves are not numbered, but can be linked up in sequence only by reference to the associated description and their identification as "ordo" or "folio", such correct placing is of great significance. For this reason, an obvious sequencing error with regard to the illustrations of tulips in the Eichstätt copy has also been eliminated at the same time: plates 67–73 were arranged in the wrong order (67, 69, 71, 70, 73, 68, 72) through an error by the bookbinder. The present version is therefore the most accurate, the page order of which

corresponds to the original ideas of the compilers and the client, and should provide a standardised reference base for easy identification of the plates for research purposes. For this reason, in addition to consecutive numbering for easier identification, the plates also carry the old "ordo" descriptions. The plants are identified by giving them their common English names, together with the internationally accepted scientific term in Latin. In accordance with the rules of binary nomenclature, this is made up of the generic name and the species name. In many cases, the species could no longer be unambiguously identified, so that here the generalised "spec." replaces the species description. To make the present edition easier to read, the inclusion of the author's name (which, in abbreviated form, identified the scientist who first described the plant scientifically, in accordance with specific rules) has been dispensed with, especially as this does not lead to any lack of clarity. As far as possible, the nomenclature follows Zander (15th edition, 1994).

THE GARDEN AT EICHSTÄTT

The history of the garden and the book
Klaus Walter Littger

1. THE WILLIBALDSBURG CASTLE AND ITS GARDEN

Approaching Eichstätt by the main road from the north, you are greeted by a fascinating view across the Altmühl valley. On the other side, at the same level on the Frauenberg hill towering high above the Altmühl, rises the Gemmingen building of the Willibaldsburg castle, still an imposing edifice despite the ravages of the 19th century. In the valley to the east lies the old cathedral city, while to the west is the former seat of the Augustinian canonical order of Rebdorf.

The Willibaldsburg castle was founded in the middle of the 14th century as the residence of the prince bishops of the Eichstätt bishopric. In later years it was repeatedly extended and fortified, with major works being carried out for 200 years after it was founded, involving the alteration of old buildings and construction of new ones. These works continued into the first 30 years of the 17th century. Like many other places in Germany, the residence in Eichstätt was made into a stately but well-fortified castle. From 1569, Prince Bishop Martin von Schaumberg (1560–1590) completely changed the front of the eastern side of the castle on the

Frauenberg and built up an extensive, three-winged structure from the old curtain wall that was closed to the outside world. This was a prestigious residential building, although the basements did continue to house weaponry.

After the short rule of Kaspar von Seckendorff (1590–1595), Prince Bishop Johann Konrad von Gemmingen (1593/95–1612) devoted his energies to renovating the old central building of the castle on the western spur of the hill. In 1609, he began work on building a magnificent Renaissance castle, using plans drawn up by the Augsburg architect Elias Holl (1573–1646). A drawing has been preserved dated 1611, in other words from the time of the rebuilding works, which shows the "Gemmingen building" in an advanced stage of construction, probably far beyond the stage it was really at, flanked by the two towers. The draughtsman, the Augsburg aristocrat and art dealer Philipp Hainhofer (1578–1647), commented at the time: "Your Highness wishes to turn the entire palace round, and to have it built from blocks of rock on top of the cliff. It is intended to roof over one side even by this summer and to cover it all in copper. All together it will cost over 100,000 florins."[1] The "side"

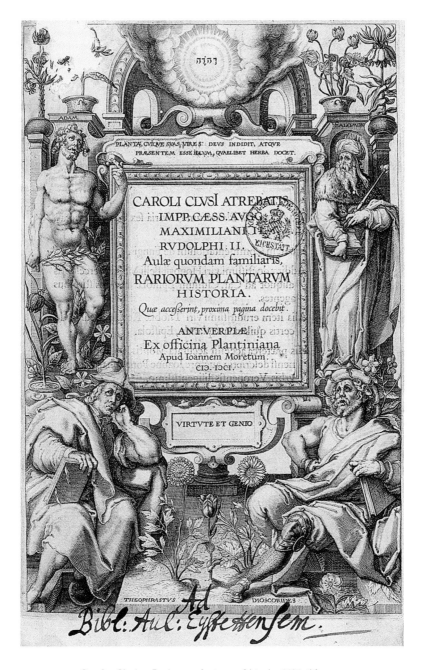

Carolus Clusius, Rariorum plantarum historia, 1601, title page

which was to be completed in the very same year is the south wing, towering high above the mountain crags, barely visible on the plate. However, Gemmingen died at the end of 1612, without completing the building. The chapter of Eichstätt cathedral transferred the task to his successor, Johann Christoph von Westerstetten (1612–1635/37). Wolfgang Kilian's (1581–1662) large copperplate engraving, dated 1628, shows the result: an imposing, fortified castle, "the perfect picture of one of the most beautiful princely residences in Germany at that time, as well as being an important fortress".[2] With its numerous large windows, the castle is open to the outside world, but it is closed to anyone looking at the picture. Nowhere, apart from a bare forecourt, is it possible to gain a glimpse of the inside, not even the moat. Within 50 years, the Willibaldsburg was fundamentally changed again, from a late medieval castle to a well-fortified stately building of the Counter-Reformation (Schaumberg), then to a stately "summer palace" of the late-Renaissance period (Gemmingen) and subsequently into a magnificent fortified building (Westerstetten). Apart from a shrubbery by the old summerhouse below the front of the tower, Kilian's engraving shows no trace of the gardens for which Eichstätt castle was famous at the beginning of the 17th century and which continued to flourish around 1628, as is clear from Hainhofer's drawing.

Prince Bishop Schaumberg had already had splendid gardens laid out. A contemporary source states that he had "run walls around the castle and the gardens, also renovated the fountains and water-works and put them to better use in various places in the castle, and had made all the preparations, borders, steps, pathways and turns this necessitated".[3] In his funeral oration for the Prince Bishop, suffragan bishop Lorentz Eiszeph praised him for having "built the new gardens, summerhouses and summer palaces so splendidly".[4] In an obituary, the professor and poet laureate of Ingolstadt University, Philipp Menzel, praised the deceased for the castle buildings and for the irrigation systems in the gardens, which were fragrant with exotic flowers ("peregrinis halantes floribus hortos").[5]

Prince Bishop Gemmingen immediately started work on developing the gardens further. Schaumberg had already filled in the broad moat spanned by a bridge between forecastle and outworks with vault constructions and had created a level area for the new castle building. Gemmingen set about altering the rocky rounded mountaintop with renewed vigour. In his dedication to Prince Bishop Gemmingen in the foreword to the *Hortus Eystettensis*,[6] Besler praises the fact that the soil around the castle had been improved and cultivated for many years with good earth from the valley, which combined with the splendid development of the castle to produce a wonderful overall picture. A summary of numerous expenses for the gardens, namely for the rear castle garden, as well as for the adaptation and furnishing of a round tower as a garden pavilion, has survived, dating from as early as 1599, ten years before work started on the further development of the castle. In 1611, Hainhofer reports direct from the construction site that he "went into eight gardens around the

Philipp Hainhofer
The Willibaldsburg, view from the north, c. 1611
Watercolour over pen
Wolfenbüttel, Herzog-August-Bibliothek, Cod. Guelf. 23.3.Aug. 2°, fol. 13v–14r.

castle, which is situated on rock ... all of which are arranged differently with flowerbeds, flowers, especially beautiful roses, lilies, tulips, ... some of which are embellished with painted rooms and summerhouses, including in one room a round ebony table, the leaf and foot of which are inlaid with silver engraved flowers and insects". He continues: "The gardens are all going to be turned round as well and levelled with each other around the castle."[7] In the quarry below the castle, Gemmingen arranged for stones to be cut and brought up, in order to re-landscape the inhospitable, rocky terrain and thus to create the "eight gardens around the castle", or, as the Prince Bishop himself wrote to Duke Wilhelm V of Bavaria, to create a spacious, integrated garden from his "narrow little garden".[8] At the time of Hainhofer's visit, these gardens actually extended within the ramparts, around the castle and over the inner courtyards. Many of the plants in the Hortus that were exotic at the time are now naturalised. Even at that time, more than half were naturalised in Germany; up to a third came from the Mediterranean region,

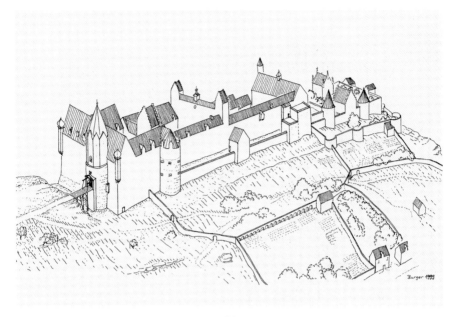

Daniel Burger
The Willibaldsburg, view from the north-east, c. 1600
Drawing of reconstruction, 1999

around ten per cent from Asia, mainly from the Middle East and east India, and at least five from America, with only a few plants coming from Africa. Besler had obtained some of the exotic plants mainly from his advisers Joachim Camerarius and Carolus Clusius, while some, as the Prince Bishop tells Hainhofer, had been supplied by traders from the major commercial towns of the Low Countries.

On the belvedere ("Altane") in front of the Prince Bishop's room stood ordered rows of glass bowls and wooden troughs with plants, which the Bishop looked out onto through large, clear windows. Here too there were also six large blocks of wood that held small desiccated trees. The Bishop explains to his visitor that in winter they act as an aviary in front of his room, for when he scatters bird food, "the birds come in flocks, often more than 200 at a time, looking for food, singing together", and he lets them fly away. However, if he tried to catch them, then he would drive them away "and his pleasure would be gone for ever". Hainhofer also recorded that a water pipe led through the royal chamber to irrigate the garden, so that running water could be heard in the room. The garden itself was irrigated by means of "little wooden pillars with pipes, which conduct the water to a brook and the entire garden".[9] In the two storeys beneath the belvedere, there were treasure vaults, entry to which was gained from the antechamber of the Prince's room by a spiral

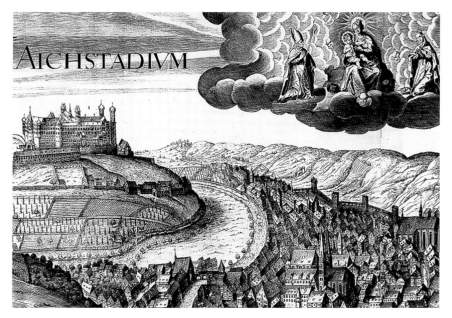

Wolfgang Kilian
The Willibaldsburg, view from the north-west, 1628
Copperplate (detail), Erlangen, University Library, GS(6)3.1.60

staircase. The stairs led further down to the hare pit and over the bridge into the outer ward, which was laid out as a garden. The spiral staircase, known as the "botanical staircase", is fitted with wooden panelling, some of which still remains, which is painted with flowers, such as are shown in the lavishly illustrated de luxe edition of the *Hortus Eystettensis*. The projecting section of the belvedere with its treasure vaults and staircase appears to have been constructed only a few years before Elias Holl's so-called Gemmingen building, but still actually during Gemmingen's lifetime. The painting of the stairs was thus undoubtedly connected with the development of the garden and the drawing of the plants for the *Hortus Eystettensis*. This makes it possible to see Gemmingen's overall plan. The sumptuously furnished castle, the treasure vaults with their lavish plant decorations and plant-bedecked figures, as described extensively by Hainhofer, together with the gardens produce an integrated summer palace and garden, such as had developed in Italy since the 16th century, but which was still unknown in Germany at that time. It would be pleasant "to look out of the window onto many well-cultivated and maintained fields". But it would be even more beautiful and beneficial "to look out onto lovely gardens of well-balanced proportions, attractive and handsome arbours and, if possible, onto small displays and delectable borders of lavender, rosemary,

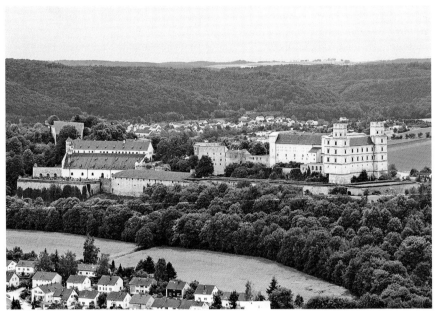

The Willibaldsburg, view from the north

box and the like; to hear the enchanting music of an infinite number of pretty little birds". So writes Charles Estiennes in his *Praedium Rusticum*[10] as early as the middle of the 16th century. Prince Bishop Gemmingen created this pleasure for himself in and around the Willibaldsburg castle as well as by means of the structure itself. He looked out through the large windows of his room over the roof garden of the belvedere and the well-proportioned walled gardens, as described by Besler, which he had built himself, with fountains, pavilions and statues in between plants, and then further out over the Altmühl river, the villages, the meadows and the well-cultivated fields in the valley. Significantly, Hainhofer actually talks of the river Altmühl as a stretch of water "which has been conducted right around the hill of the castle": he was even of the opinion that the river itself had been artificially diverted. According to Hainhofer, the Prince Bishop also kept animals. There were four pheasant gardens for different-coloured types of pheasant, each with its own garden, a hare pit and some birds, most notably a nightingale. There do not seem to have been any of the otherwise customary aviaries: the birds were to be allowed to fly in and out quite freely. A great variety of fish splashed around in the Altmühl. In addition to these living treasures, there were fossils, found in the Jura Mountains through which the Altmühl flows, "fish, leaves, birds, flowers and many strange things, which Nature makes visible there".[11] Around 1600, summer pal-

aces and pleasure gardens could be found in other German cities, in Linz, Munich andStuttgart, for example, but as a rule these were next to the actual royal residence. Thus the "Rosengart" (rose garden) attached to the Residenz in Munich was enclosed by a three-winged building with a belvedere around its roof. People could look out from the belvedere into the large palace gardens, but not beyond. They remained in the "hortus conclusus", a garden shut off from the outside world. It was not yet common for different elements of the landscape to be linked, as in the view from the Willibaldsburg belvedere, a style that must have further increased the elegiac atmosphere typical of a Renaissance garden. The Prince Bishop of Eichstätt, however, who by all accounts suffered from gout and other complaints, did not seek relaxation in a hermetically sealed garden, but, as Hainhofer reports, "had himself carried into the green fields"[12] to get some fresh air. Having experienced something of the beauty of the world on extensive travels through Europe during his youth, he was now inclined to compare his existence with the sufferings of Job.[13] But unlike the latter, according to Hainhofer, Gemmingen did not complain and withdraw from life, but continued to be receptive to anything of beauty, collected it and enjoyed doing so: "this bishop's greatest recreation lies in flowers, birds, gold and precious stones".[14]

This treasure vault in the narrower sense, the botanical staircase, and the whole castle structure – still undergoing reconstruction – with its surrounding gardens and view over the landscape together formed the unique treasure vault of this Prince Bishop of Eichstätt. It also included the magnificent illustrated florilegium of his pleasure garden. Having possibly initially entrusted the garden design to Joachim Camerarius the Younger (1534–1598), he subsequently handed this over to the Nuremberg apothecary Basilius Besler (1561–1629), as the latter emphasises in his dedication (p. III). In 1606/07 he was also commissioned to produce the copperplate engravings. However, as with the construction of the castle and many other projects, it was not to be completed within Gemmingen's lifetime.

2. THE BOOK

The oft-quoted authorities Philipp Hainhofer and Basilius Besler give the most detailed information on the development of the *Hortus Eystettensis*. Hainhofer quotes from a letter from Prince Bishop Gemmingen to Duke Wilhelm V of Bavaria stating that he had, "with regard to flowers and garden plants", [for some time] "had flowers and garden plants copied" [from his garden] "which just now I do not have to hand, but have sent them to Nuremberg, to be engraved in copper, and perhaps might like to have printed subsequently". He tells Hainhofer the same: the drawings were in Nuremberg, where "I have asked an apothecary, who is helping me establish my garden and propagate plants, and who wants to engrave it in copper, print it, dedicate it to me and thereby find fame and fortune." In his report, Hainhofer continues "that the apothecary, Beseler, is very busy in Nuremberg working on the book, since Your Highness is sending weekly one or two boxes of fresh flowers to be copied" [and that the] "book

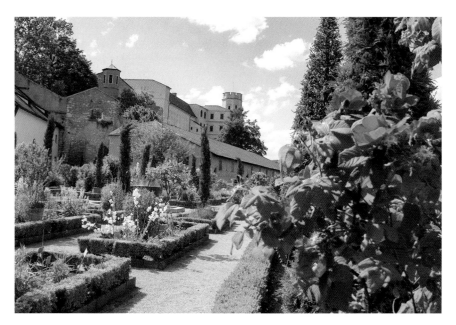

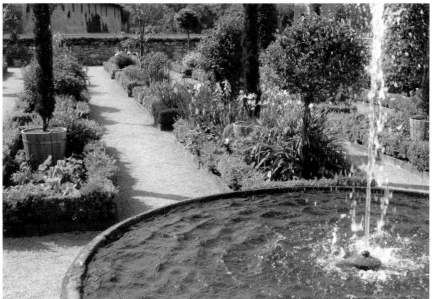

The Bastion Garden

will cost a good 3,000 fl".[15] The Nuremberg apothecary Besler went into great detail about his method in the book's Latin dedication to the PrinceBishop and in the Foreword to the Reader. He describes how he obtained the required botanical knowledge through lectures and discussions with renowned botanists and had established a little garden of his own in Nuremberg, "not only to pursue plant studies more intensively and to please my patron, but also so that as is necessary the respective plants could be taken as fresh as possible for the purpose" [of drawing].[16] The plants sent from Eichstätt once or twice a week were not always in a sufficiently fresh condition when they arrived. Also, having a garden of his own meant that Besler could keep the troublesome transportation of plants under control.

In the Foreword to the Reader, Besler writes that for the most part the plants came directly from the Eichstätt garden, but that some also came from the Prince Bishop's estate, and the Eichstätt diocese, which stretched as far as south Nuremberg. He writes that he took the hawk's-beard (plate 256, I) with him on the way to Augsburg. As for the rest, he simply omitted more than 40 indigenous plants and herbs from the Prince Bishop's garden in favour of rarer and more choice ones, thereby following the example of Leonhard Fuchs (1501–1566) and Jakob Theodor Tabernaemontanus (1522–1590), who set aesthetic considerations above botanical ones. According to his writings, he was not commissioned to make engravings of every single plant.

Following the example of Camerarius, the work is divided into four seasons and orders, which were numbered leaf by leaf.

Besler was primarily concerned with depicting the plants, at any rate the choice ones, "flores & plantae istae principes", in full bloom. Small plants and those that grew in the wild are added "virtually as servants and lackeys" and as decoration to fill up the plates. Each plate is therefore conceived as a work of art. Even subsequent colouring was taken into account in the initial planning, as can be seen by comparison with editions that were not coloured. The smaller plants included in the plates always match the large ones in terms of colour.

In fact, colour is often the most important compositional element, as can be seen in plate 274, which illustrates bear's breeches in combination with two forget-me-nots: plants that are totally different in appearance but that match each other exactly in terms of colour. Accordingly, the preliminary drawings for the copperplates, which are held at the university library, include adequate, if rather rudimentary, indications of colouring.

Researchers have long agreed that the *Hortus Eystettensis* is of limited scientific value. It is true that the illustrations are exact, but they do not distinguish the essential from the inessential in botanical terms, a distinction already introduced by Konrad Gesner (1516–1565). But that was not Besler's intention. He primarily wanted to produce a magnificent set of plates, a florilegium, as true to nature as possible, as he stresses repeatedly. The plants were to be depicted in all their beauty, and life-size. This is why he often shows the same species of plant in various stages of development, and in different forms, often just with different variations in colour. For example, the large Eichstätt yellow

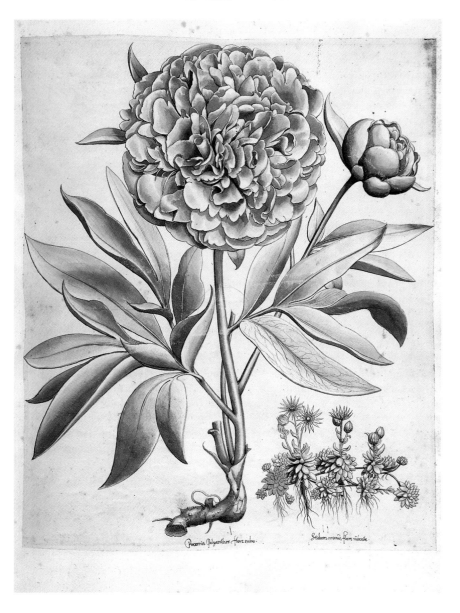

Paeonia polyanthos flore rubro, Common peony,
preliminary drawing, Erlangen, University Library,
E 356, MS 2370, Bl. 113

viola (plate 169, I) is really nothing other than a virus-infected wallflower. Although the illustration of the Turk's cap lily (plates 181 and 182) is spread over two pages to reproduce it life-size, in many other cases part of the plant stem is cut off and tubers, bulbs or roots are shown either immediately below or alongside the top growth of the plant. In contrast, the Indian fig (plate 359) is considerably reduced (but with a scale in feet at the bottom left corner of the page), while only individual branches are shown for other trees and shrubs.

Even early on, the book was criticised for the descriptions of the plants and their nomenclature, which, despite, copious literary references, were not thought to meet the standard of the time. Besler himself agrees with this criticism. In fact, Besler, a devotee of Paracelsus, had no interest whatsoever in the scientific classification system, which was in any case only beginning to emerge at that time;[17] his own criticism of "outdated" referencing is misplaced for the simple reason that the works cited in the *Hortus Eystettensis* were the most recent at that time, having only just been published. He wanted to use a symbolic taxonomy, as it were, to show the plants as reflections of creation in their original, and at the same time eschatological, beauty. Hainhofer talks, for example, of "about five hundred" different-coloured tulips in the Eichstätt Garden;[18] fifty were in fact reproduced in the plates. However, plate 78 shows the same tulip twice, in one case open and the other closed. So there are forty-nine different tulips. The number is well known in the Bible as a symbol of infinity (7 × 7). At the same time, the

apparent rounding up to fifty evokes the number of years in a jubilee according to the Old Testament. Reference is thus made to everlasting redemption and the state of salvation at the end of days. A few decades later, Paul Gerhardt (1607–1676) wrote in the text of his hymn "Geh aus, mein Herz, und suche Freud" ("Go Forth, My Heart, and Seek Delight"):

The trees stand thick and dark with leaves,
And earth o'er all here dust now weaves
A robe of living green;
Nor silks of Solomon compare
With glories that the tulips wear,
Or lilies' spotless sheen.

The first plate depicting plants in the *Hortus Eystettensis* establishes the symbolic design of the work in a different way: it shows a box tree and two lilacs; the box tree as the symbol of eternal life, and the lilac representing first young love. By way of contrast, the final plant of the year depicted, a purple crocus, symbolises "permanence through change" and "hope for return", yet also the rapid fading of beauty and happiness,[19] picking up on the symbolism of the first plate at the end of the book. With its total of 366 plates, divided into four seasons, the *Hortus Eystettensis* collectively represents a complete year.

Besler is also accused of having consulted expert assistants, such as Ludwig Jungermann (1572–1653), who was later to become professor of botany at Altdorf, on writing the text, without acknowledging them in the forewords to the *Hortus Eystettensis*. But Besler, like the widely praised Camerarius, mentions none of the

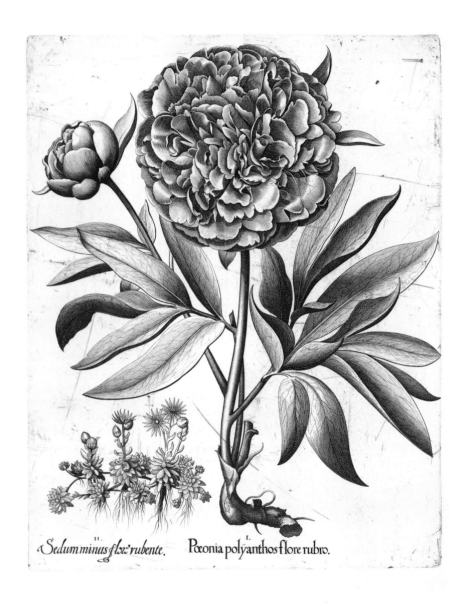

Paeonia polyanthos flore rubro, Common peony,
copperplate, print made in 1998,
Albertina Graphic Collection, Vienna

many people who collaborated on the book, whether they were the draughtsmen who drew the plants from nature or who prepared the drawings for the copperplate engravings, or the copperplate engravers or the illustrators, nor does he once mention the printer(s), so that it is still not clear even today where the *Hortus* was actually printed. However, all those involved are praised en bloc in the Hortus charter of the Nuremberg Collegium Medicum, to which Besler belonged. The only people whom Besler thanks in the forewords are his two famous advisers, Joachim Camerarius the Younger and Carolus Clusius (1526–1609), sometime botanist to the imperial court and subsequently professor at Leiden, both of whom had died by the time the book was printed, and, of course, Prince Bishop Johann Konrad, who had planned and planted much of the Eichstätt garden himself. And so, just as the garden was the Bishop's work, so the overall planning and organisation of the book was "Opera Basilii Besleri", as stated on the title page (see p. 2). Besler also immortalised himself on the four similar interim title pages with his coat of arms and the tools of his trade. Presumably, he had even intended to insert his portrait and coat of arms alternately into the cartouche of the interim title pages, into which the names of the respective seasons have now been very clumsily engraved. At any rate, the attached replicas of the portrait and coat of arms, which seem rather arbitrary and unsuited in format to the end of the titles and forewords, are a perfect fit for the empty spaces of the cartouche ovals.[20] This must have been rejected, however, by the Prince Bishop, who allowed his own image and coat of arms to be represented only on the title copperplate; Besler probably then engraved the title of his *Hortus* special edition directly into the empty cartouche space in 1627. Thereafter, the plate could no longer be used, and is now lost for ever.

People in Eichstätt subsequently seem to have regarded Besler's conduct as presumptuous and impertinent. They certainly had no idea of the work entailed in producing this monumental book. It would have been possible only in a city like Nuremberg, with its early industrial economic life, where several trades did the groundwork for a single maker ("publisher") and where, 120 years earlier, in the early days of book printing, Hartmann Schedel had carried out a comparable project with the *Weltchronik*.

Since plants with different flowering times are frequently combined on the plates, it can be presumed that the plants were first drawn from nature and the composition of what are known as the preliminary drawings for the engravers was decided upon only afterwards. Nicolas Barker believes he can identify Sebastian Schedel (1570–1628) as one of the draughtsmen who drew from nature.[21] Schedel belonged to an important Nuremberg family. However, as was customary at the time, Besler also made assiduous use of the existing florilegia, especially that of Camerarius.

To date, Daniel Hertzog from Augsburg and Georg Gärtner (†1654) from Nuremberg are known by name as artists who made the preliminary drawings, while the following are known to have been among the copperplate engravers: Wolfgang Kilian also known as Dominicus (1560–1615) and

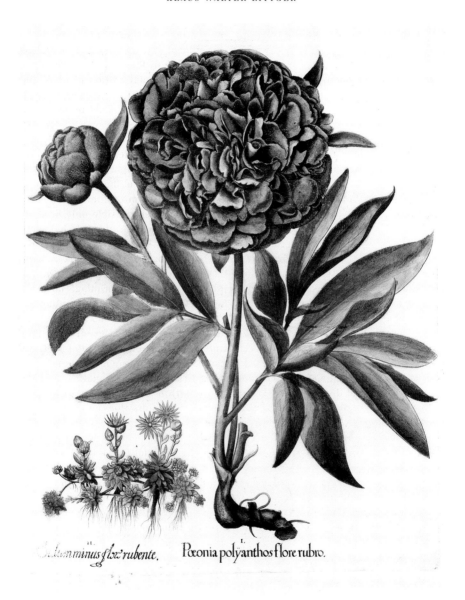

Cælum minus flore rubente. *Pæonia polyanthos flore rubro.*

*Paeonia polyanthos flore rubro, Common peony,
copperplate, original hand-coloured, 1636, cf. plate 101*

Basilius Besler
Hortus Eystettensis, text and illustration pages from Vol. 3, plate 283,
University Library of Eichstätt-Ingolstadt
Hortus Eystettensis, text and illustration pages from Vol. 3, plate 290,
University Library of Eichstätt-Ingolstadt

Raphael Custos (c. 1591–1664), both from Augsburg, and Friedrich (c. 1580–1660) and Levin van Hulsen (c. 1550–1606), both resident in Nuremberg and the general area of Franconia, Peter Isselburg (c. 1580–1630/31), Dietrich Krüger (c. 1575–1624), Hieronymus Lederer (†1615), Johann Leypoldt, Servatius Raeven, G. Remus, Heinrich Ulrich (†1621) and Georg Gärtner, already mentioned as a draughtsman. Some of these names appear again as plate illuminators, together with Georg Mack the Younger († post 1622) and family from Nuremberg, and later Magdalena Fürstin (1652–1717) and Hans Thomas Fischer.

As tests in Vienna's Albertina Graphic Collection demontrated, to obtain a good print of a plate, from setting up the copperplate, applying the colours and making various test prints through to achieving the successful final proof, requires a full day's work even today. Working on the basis of a similar amount of time being required around 1612/13, it would take about one and a quarter years for over 370 individual plates. Of course, multiple prints from a copperplate are quicker. But even these would produce barely more than about ten prints per day, taking into consideration all the preparation work required for the plate and paper. The plates were prepared and printed in several workshops in various locations, of which Augsburg and Nuremberg are known for certain. This would reduce the overall amount of time required accordingly. But dividing up the work between the various workshops and towns required difficult planning. This was Besler's task, as was the organisation of all the other work, from obtaining the plants from Eichstätt or from his own gar-

den in Nuremberg and preparing them for copying, through to the engraving and printing and subsequent colouring work. It was clearly very advantageous for him for the drawing, engraving, printing and colouring all to be carried out in Nuremberg by the same craftsmen, so that no further craftsmen's guilds had to be called in.

The book printers, however, were a guild of craftsmen in their own right. They had to be engaged and taken into account separately. The question of where the *Hortus* text was printed has met with various answers. The most convincing is Barker's theory that several printers were involved.[22]

A consequence of the huge format of the *Hortus Eystettensis* (royal folio = 57 × 46 cm) was that the text pages also had to be printed singly. Two editions were produced. In the plain one, the copperplate engraving was printed on the recto of a leaf, with the text for the following plate being printed on the reverse side. In the de luxe version, the reverse sides of the plates were left blank and a text page, printed on both sides, was inserted between every two illustrated pages. The plates are assigned to the appropriate accompanying text page, so that the text accompanying a verso plate is on the right while the text to the following plate is on the left.

The double-sided printed edition was intended for the book trade, while the de luxe version, all copies of which were to be coloured, was intended for the requirements of the Prince Bishop. Unlike the de luxe version, in the case of the standard edition rejects were anticipated in the second printing stage, regardless of whether

the copperplate engraving or the text was printed first. Adding text pages to the plates thus involved a considerable extra organisational and financial burden for the makers. It is clear that Besler became involved with this only at the insistence of the Prince Bishop and other people, the experts he refers to in his Foreword to the Reader.

There is another problem. Apart from what is known as the signature (section number) on the bottom of the text pages, there are no page or leaf numbers. The text sides show the *ordo* (within the season) and the appropriate folio number, so that text and illustration can be correctly compiled only by using the index. The book was not sold bound or as a book block, but as loose leaves, comprising a title page, a further ten pages with dedication, foreword etc., four interim title pages, and a multi-page index to the individual seasons together with 367 or 551 leaves of plates and text. The bookbinder, who usually received clear sections, thus had to collate the pages in the correct order first into sheets (of two pages each) and then into fascicles (four sheets laid in order one on top of the other). This was an extremely laborious task. It is no wonder that mistakes were frequent. There are complaints in the correspondence with Hainhofer, who had obtained copies for several princes. On 6th April 1617, he writes to Duke August the Younger of Brunswick (Braunschweig-Lüneberg): "I have had the flower book bound, and as it has once again proved to have defects … although even 100 fumbling bookbinders could not collate this book if they had not seen a complete copy of it".[25] Besler must rapidly have come to hear of these com-

plaints with alarming frequency. Understandably, he still tried to realise his wish to produce an edition with no text. Prince Bishop Gemmingen died on 7th November 1612, a good six months before the work was published. On 23rd August 1613, Besler dedicated an edition without text to his successor, Prince Bishop Johann Christoph von Westerstetten, stating that the other version was too expensive for the buyers. He said people were also querying the usefulness of the obsolete literature it quoted, especially since the plants it showed were reduced in scale, whereas here they were for the first time shown life-size. With this dedication, Besler managed to involve his dead patron's successor in the project to publish a new edition. According to later records, by the time of his death Gemmingen had contributed 7,500 florins. The total cost is estimated at 17,920 florins. Thus Westerstetten must have donated a good 10,000 florins more. In return, an edition without text was dedicated to him for the obvious reason that he was definitely not so well versed in botany as his predecessor.

In 1613, three different editions were therefore published, two with accompanying texts to the plates and one without text. According to Barker, the more impressive version with text was produced only after the standard version, in any case after October 1613.[24] The edition without text must likewise have appeared in 1613, perhaps even just before the de luxe version. Any attempt to differentiate between different impressions is therefore futile. It is better to say that all three editions together must have produced 300 copies, the figure recorded at the time. It is better to speak of one impression in

Basilius Besler
Hortus Eystettensis, *3 volumes, Nuremberg 1613*

This Hortus Eystettensis edition was published in the Royal folio format, measuring 57 x 46 cm. The volumes contain 584 pages, 373 of which are illustrations. The first volume of the Eichstätt copy covers Spring (Plates 1–134), the second deals with Summer (Plates 135–261), and the third covers late Summer, Autumn and Winter (Plates 262–367). Three hundred copies were made for the first impression; the price of the monochrome edition was 35 or 48 florins, while the coloured edition was 500 florins, roughly equivalent to the cost of a small house.

three different editions, in the same way, for example, as practically 200 years later Göschen issued a complete edition of the works of Christoph Martin Wieland in four versions at the same time. At any rate, in the 1640 reprint, the three editions were described as being a first impression. The monochrome edition cost 35 florins, 48 if bound (the costs of binding could hardly have amounted to 13 florins), while the coloured edition cost 500 florins, roughly the same as a small house in Nuremberg or Munich.[25] There are references in the literature to a 1627 edition. However, this is possibly just a florilegium with a series of selected pages (possibly surplus, which varied from copy to copy) of the *Hortus*, a few copies of which were compiled for Besler's colleagues who had helped him, among other things, with the *Hortus Eystettensis*. As already mentioned, for the title page Besler used the interim title plate of the 1613 editions which is missing in the later volumes. Today, a further two copies of different sizes are known, one in the Hessische Universitäts- und Landesbibliothek in Darmstadt, with 96 plates, and the other, with 23 plates, which was auctioned at Christie's in London in 2001.

The next reprint appeared during the Thirty Years War under Prince Bishop Marquard II Schenk von Castell (1636–1685). While the garden itself suffered

from neglect and with the financial resources of the diocese being required for the renovation of the royal palace, destroyed in 1633, a new edition was bravely published in the hope that the de luxe version, which had by this time become well known throughout Germany, would sell well in France, the Low Countries and England. Thus the foreword to this edition reads:

This Garden of Eichstätt,
Created in the Golden Age,
In brazen letters displayed,
Renovated in the Iron Years.[26]

This edition has no text, as, according to the foreword, experts considered it to be quite inaccurate or at best superficial – which was Besler's own argument for the edition without text! The order is retained, except that the winter plants are assigned to autumn, so that there are now only three sections.

This new edition, published "in the Iron Years", shortly after the royal seat and bishopric of Eichstätt had been completely destroyed during the Thirty Years War, was intended as a reminder of the "Golden Age" before the war. In those highly charged times, Prince Bishop Gemmingen managed to preserve the weak prince bishopric unscathed through his prudent policies, and even restored it to renewed splendour in various ways, for example through the famous garden. The strict re-Catholicisation policy of his successor, however, subsequently led to its destruction. His successor, Marquard II, is heralded in the dedication as the great bearer of hope for regeneration. In this way the *Hortus* became the emblem for

the desired restoration of the "Golden Age of Eichstätt". As the reconstruction work progressed, this role diminished, and became superfluous by the time of the jubilee to celebrate 1,000 years of the prince bishopric in 1745, when the "most solemn new glory"[27] was celebrated with reference to the bishopric's founder, Willibald.

Prince Bishop Johann Anton I Knebel von Katzenelnbogen (1705–1725), who also wanted to renovate the garden, which had run wild, planned an anniversary edition in 1713. It was to have been extended by a few plates prepared from preliminary drawings by the Ingolstadt professor of medicine and botany, Johann Michael Hertel (c. 1650–1740). Various difficulties must have arisen, however, with the result that the project came to a halt shortly before completion. It was not until 1746 that the project was completed by the Prince Bishop's personal physician, Johann Georg Starckmann (1701–1780), with the support of the Nuremberg doctor Christoph Jacob Trew (1695–1769). The texts were reset with a few alterations, although the title page prepared for the 1713 edition remained unchanged, which is why this edition shows the year of publication as being 1713. It was printed at the Strauss court bookbinders in Eichstätt. Apart from a few advance copies actually issued in 1713, this edition was published around or shortly after 1750. It is not known how many copies were printed or how much they cost. At any rate, fifty years later, numerous copies were still available, which people tried to sell with little success. Thus on Wednesday, 25th April 1803, a sales promotion was announced in the Eichstätt newspaper,

although it was called off again soon after on 29ᵗʰ June 1803.

By the time of Linnaeus' new plant classification system, the classification of the *Hortus Eystettensis* had become hopelessly outdated in botanical terms. The Eichstätt doctor Franz Seraph Widmann (1765–1848) therefore brought out a concordance with the Linnaean system in Nuremberg in 1805, which appeared in Eichstätt in a French translation with a dedication to Empress Josephine in 1806. It was sold with the *Hortus* of 1750. It did not do well. The population was hard up after paying endless contributions to the war. In the year 1817, 86 publisher's copies of the *Hortus Eystettensis* remained unsold.

For a long time the copperplates of the *Hortus* were thought to have been lost. They were said to have been melted down after 1820 in the Munich mint. In 1994 it became known that 329 original plates, including the title copperplate, had been discovered during the reorganisation of the storage of artefacts in Vienna's Albertina Graphic Collection. The whereabouts of the other plates is not known. It is unclear how the plates got to Vienna. It seems that they came to Salzburg, and later to Vienna, in 1803 when the Deputation of the German Estates decided to compensate German sovereign princes for the losses of territories ceded to France, thereby awarding Eichstätt, which had now lost its ecclesiastical status, to Archduke Ferdinand of Salzburg-Toscana. At the end of 1802, when Bavaria first wanted to include Eichstätt, the plates had been removed to Bavarian Neuburg/Donau, as Interims-Hofmarschall Ignaz Frhr von Zweyer reported to the Salzburg govern-

ment in Eichstätt on 3ʳᵈ March 1803. The archducal government probably asked for them to be returned, not to Eichstätt, but, because of their size (approx. 49 × 40 cm) and their considerable weight (about 4 kg), straight to Salzburg via the Danube, Inn and Salzach rivers or direct to Vienna. A small section of the former gardens has been restored based on the *Hortus Eystettensis* and opened to the public as a "bastion garden" at the Willibaldsburg castle.

3. PORTRAYAL OF PARADISE

The title copperplate outlines the agenda of the *Hortus* of 1613. In the foreword to the *New vollkommen Kräuter-Buchs* by Jakob Theodor Tabernaemontanus, edited by Caspar and Hieronymus Bauhin and published in 1664, it is stated that the "herbs" and "plants of the earth" are solely for human use, "initially admittedly partly and particularly for food, partly for pleasure, but subsequently, after the Fall of Man, also for clothing and medicine". The Nuremberg botanist Joachim Camerarius, whom Besler regarded as an authority, expressed it quite differently in his foreword to Pier Andrea Matthioli's *Kreutterbuch*, which he had translated and edited, several editions of which were published after 1586. According to him, when man contemplates the grasses, herbs and trees of the third stage of the Creation, he will be forced to praise God. Carolus Clusius, whom Besler had originally recommended to the Eichstätt Prince Bishop as editor of the *Hortus Eystettensis*, expressed it even more clearly in 1601 on the title page of his florilegium *Rariorum plantarum historia*. It shows an epigraph, with the title in the

Offentliche Bekanntmachung.

Wenn jeder Unterthan der Pächter seines eignen Zehends werden, und solchen in Art eines Sackzehends in einer jährl. bestimmten Getraideabgabe entrichten darf, so fallen alle Unannehmlichkeiten, welche mit der bisherigen Zehenderhebungsart verbunden waren, weg, es kömt kein fremder Zehendpächter mehr in die Felder des Landsmannes, und dieser führt ohne besondere Kosten die zehnte Garbe mit den 9 übrigen ein.

Eichstätt den 6ten April 1803.

Man hat deswegen sämmtl. Aemter zu einem Versuche eingeladen, wie hoch sich jeder dahero zehendbare Unterthan für seinen Theil einlassen wolle, und das Kastenamt Mörnsheim hat bereits bey Sondershol, Lichtenberg und Schönau diese Umänderung der Zehenden in eine auf jeden einzelnen Unterthan ausgeschlagene jährl. bestimmte Abgabe zur Zufriedenheit der Zehendherrschaft, und Zehendpflichtigen gut eingeleitet, gleichwie nun diesem Amte die Zufriedenheit, und das Wohlgefallen des Hof- und Kammerraths-Dikasteriums darüber zu erkennen gegeben worden ist, so wird dieses auch zur mehrern Ermunterung, und Nachahmung öffentl. bekannt gemacht.

Großherzoglich - Toskanisch - Eichstättisch - provisorischer Hof - und Kammerrath.

Vorsitzender Rath, Kapfermppria.

Wildt.

Anzeige.

Von einer Großherzoglich - Toskanisch gnädigst - angeordneten Hofkommißion ist beschlossen worden, daß die noch vorhandenen Exemplarien des bekannten Botanischen Werkes unter dem Titel: Hortus Eystettensis, sive diligens & accurata omnium Plantarum, Florum, Stirpium ex variis orbis terrae partibus singulari studio collectarum, quae in celeberrimis Viridariis arcem episcopalem ibidem cingentibus olim conspiciebantur, delineatio, & ad vivum repraesentatio 1713. um einen ganz leidentlichen Preis, nämlich das Exemplar zu 2 Laubthaler verkauft, und dadurch gemeinnützlicher gemacht werden sollen.

Es besteht dieses Werk aus ohngefähr 365 Kupfertafeln, wobey auf der andern Seite jeder Tafel der Text und Erklärung der gegenüber befindlichen Pflanze, Blume, oder Strauches angebracht, und am Ende jeder Abtheilung ein doppeltes Register, nämlich der lateinisch - und deutschen Benennung, angehängt ist. Die Ku-

pfer sind sehr schön gestochen, auf groß Regalpapier in Folio gedruckt, und gut erhalten.

Es wird dieses daher mit dem Anhange bekannt gemacht, daß, wer ein - oder mehrere Exemplarien dieses vortreflichen und seltenen Werkes zu erkaufen gedenket, sich deshalb an Unterzeichneten zu wenden, und dasselbe von ihm gegen gleich baare Bezahlung in Empfang nehmen möge.

Eichstätt den 25ten April 1803.

Joseph Jung,
Großherzogl. Toskanischer Rath und Archivar.

Verruf.

Nachdem sich bey dem dießamtlichen Unterthan, Michael Pfaller zu Emsing, eine das Vermögen übersteigende Schuldensumme veroffenbarte, und von der Großherzoglich - Toskanisch - zur Besitznahme des hiesigen Domkapitels gnädigst angeordneten Subdelegationskommißion am 15ten dieses beschlossen wurde, gegen diesen Pfaller in via Subhastationis & concursus zu verfahren; so wird dessen aus Haus, Stadel, Garten, und 5 kleinen Aeckern bestehend, und in dem Mayerhof zu besagtem Emsing lehnbares Söldengütlein, wobey sich ohngefähr 6 Jauchert eigener Aecker, und 1/2 Tagwerk derley Wiesen in verschiedenen Lagen befinden, dergestalten öffentlich feilgebothen, daß sich die Kaufslustigen in nachstehenden 3 Terminen, als Dienstag, den 3ten, Dienstag, den 17ten, und Dienstag, den 31ten des eingehenden Maymonats, bey dem hiesig Domkapitl. Richteramte einfinden, ihre Anbothe ad Protocollum abgeben, und den Kaufsabschluß gewärtigen sollen.

Zugleich werden auch alle diejenige, welche an Eingangs gedachtem Michael Pfaller eine rechtliche Forderung zu machen haben, zu dem Ende hiemit vorgeladen, daß sie an einem der besagten Täge hierorts ebenfalls erscheinen, und ihre Forderungen um so mehr liquidiren sollen, als sie nach Verfluß dieser Termine nicht mehr gehört, sondern gänzlich ausgeschlossen würden.

Eichstätt den 18ten April 1803.

Großherzoglich - Toskanisch - provisorisches Richteramt allda.

Veruf.

Auf erfolgtes Absterben Anton Bauers, gewesten Köblers zu Pemsfeld, werden alle diejenigen, welche aus dessen Rücklassenschaft noch einige Forderung zu machen haben, andurch auf-

Notice of sale, dated 25 April 1803, for the 1750
edition of the Hortus Eystettensis, *Gnädigst-Privilegirtes Großherzoglich-Toskanisches*
Eichstätter-Intelligenz-Blatt, *1803, No. XVII, p. 2*

middle, the motto "virtute et ingenio" underneath, and the sentence "plantae cuique suas vires deus indidit, atque praesentem esse illum, quaelibet herba docet" above, "God gave to each plant its strength and each plant proves that He is present." To the left and right stand the Old Testament figures of Adam and Solomon, while below sit the Classical botanists Theophrastus and Dioscorides. The scene is crowned by the divine pillar of fire and cloud from the Old Testament with God's name in Hebrew.

These are reversed in the title copperplate of the *Hortus Eystettensis*. A portico, a temple porch, dominates the picture. It is flanked by twisting double pillars whose design was inspired by the pillars in the Temple of Solomon. As in Gothic and Renaissance churches, a cloth is stretched between them, on which the title of the book is displayed. Below, the view opens out into paradise, into which God is leading Man, so that he, as their master, may give the animals names and cultivate the Garden of Eden. Solomon and Cyrus are positioned to the side of the columns. King Solomon could speak just as knowledgeably about the cedars of Lebanon as he could about the hyssop, which grows as a weed on the walls (1 Kings 4.33). Cyrus, the powerful king of Persia, was also amazingly well versed in horticulture, and had himself laid out a famous garden and planted trees, as Cicero writes in *De senectute* (Chap. 17). Besler also refers to these passages in his dedication to the Prince Bishop.[28] On the far left, on pedestals as tall as the kings stands an Indian fig (*Opuntia ficus-indica*), to the right a century plant, both imported from America in the 16th century. Crowning them all is the coat of arms of the Eichstätt Prince Bishop Johann Konrad von Gemmingen.

On the left-hand side of the portal rests flower-bedecked Flora holding freshly picked flowers in her right hand and a wicker basket full of flowers in her left, a symbol of abundant wealth and prosperity. To the right sits Ceres holding an olive branch in her left hand and a beehive in her right. The olive branch is a symbol of the reconciliation between God and Man and God's promise after the Flood that the earth would once again bring forth life and would once again be fertile. The beehive symbolises an abundance of wealth and gifts, arising from the diligence and care of its inhabitants. The flower basket and the beehive are handmade, the flower basket for the enjoyment of blossoming flowers, the beehive so as to be able to make use of the flowers, through the bees. Bunches of fruit hang down from the feet of both goddesses.

The range of this title page is astonishing: the coat of arms is there to honour Prince Bishop Johann Konrad von Gemmingen, a reliable authority on garden cultivation who commissioned and was involved in the development of his famous garden, as the man of the piece. Space and time, the exotic plants and the Classical kings so well-versed in botany, even the Old Testament God himself with his Creation; all refer to the Bishop and his creation.[29] In 1713, either people no longer dared or else no longer understood, and the Gemmingen coat of arms was replaced with that of the Prince Bishopric of Eichstätt, with the coat of arms of the then Prince Bishop being shown much smaller

under the architrave. In the title, on the other hand, the Prince Bishop as Commissioner ("curis episcopi") assumes Besler's place as maker ("opera Besleri"). Incidentally, Besler ceased to be mentioned as early as the 1640 reprint. The tapestry with the book title between the pillars of Solomon is reminiscent of the curtain of the Temple, behind which the Ark of the Covenant was hidden. The *Hortus Eystettensis* curtain proclaims the plant book that illustrates the world of plants to the life, so that, as in the Eichstätt garden, botanical studies can be pursued using the illustrations, without incurring the great expense of the lengthy journeys that would otherwise be necessary.[30] The *Hortus* is grouped into four seasons. The dedication to Prince Bishop Gemmingen dates from spring 1612. It was probably intended to publish the book that year. The *Hortus Eystettensis* contains 366 plates with plant pictures, counting as one page plates 181–182, which make up one illustration. 366 plates correspond to the number of days in a leap year, the biblical year of grace. Like the garden, the book was meant to be a fitting representation of divine Creation.[31] Just as the Eichstätt garden, established with such great efforts on the instructions of the Eichstätt Prince Bishop, included flora and fauna from the surrounding area and from the early geological period, so the de luxe version of the *Hortus Eystettensis* encompasses time and space by external classification, through the number of plates and the selection of the illustrated plants. Both the garden and the book were a portrayal of paradise, shaped by Eichstätt yet universal.

1 Hainhofer, Philipp, "Die Reisen des Augsburgers Philipp Hainhofer nach Eichstädt, München und Regensburg in den Jahren 1611, 1612 und 1613", Christian Häutle (ed.), *Zeitschrift des Historischen Vereins für Schwaben und Neuburg* 8, 1881, p. 25.

2 Lochner v. Hüttenbach, Oskar, "Die Willibaldsburg bei Eichstätt", *Sammelblatt des Historischen Vereins Eichstätt* 27, 1912, p. 24.

3 Quoted by Burger, Daniel, "Von der Burg zum Schloß. Die Willibaldsburg im 16. Jahrhundert", *Sammelblatt des Historischen Vereins Eichstätt* 88/89, 1995/96, p. 40.

4 Eiszeph, Laurentius, "Leychpredig / Bey der Christlichen Begräbnuß / weyland deß hochwirdigen Fürsten und Herren / Herrn Martin von Schaumberg / Bischoffen zu Eystett [...]", Ingolstadt, 1590, p. 16.

5 Turner, Robert, "Oratio & epistola de vita & morte reverendissimi & illustrissimi Dn. Martini a Schaumberg, principis & episcopi Eystadiani, illa in funere 3. Non. Iul. An. 1590 Eystadii habita [...]. Subnexum est [...] Philippi Menzelii carmen de eadem re elegantissimum", Ingolstadt, 1580, p. 67.

6 Besler, *Hortus Eystettensis*, 1613, p. IV.

7 Hainhofer 1881, pp. 24f.

8 Ibid., p. 19.

9 Papebroch, Daniel, "Daniel Papebrochs Reisebericht über Nürnberg, Ellingen, Weißenburg und Eichstätt aus dem Jahre 1660", *Zeitschrift für bayerische Kirchengeschichte* 44, 1975, pp. 88–89.

10 Published 1554 in Latin, 1564 and 1583 in French; quoted in Cowell, Frank Richard, *Gartenkunst. Von der Antike bis zur Gegenwart*, Stuttgart/

Zurich, 1979, p. 164.

11 Hainhofer 1881, p. 26.

12 Ibid., p. 40.

13 Ibid., p. 32.

14 Ibid., p. 154.

15 Ibid., pp. 19 and 27f.

16 Besler, dedication and foreword to *Hortus Eystettensis*, pp. III, VII.

17 Müller-Jahncke, Wolf-Dieter, "Artis Pharmaceuticae Chymicae Amator. Apotheker Basilius Besler und der Paracelsismus in Nürnberg", *Geschichte der Pharmazie. Beilage der Deutschen Apotheker Zeitung (DAZ)* 61, 2009, pp. 35f.

18 Hainhofer 1881, p. 28.

19 Beuchert, Marianne, *Symbolik der Pflanzen. Von Akelei bis Zypresse. Mit 101 Aquarellen von Maria-Therese Tietmeyer*, Frankfurt a. M./Leipzig, 1995, p. 171.

20 Littger, Klaus Walter, "Die Titelblätter des 'Hortus Eystettensis' in der Tradition der Pflanzenbücher des 16. und frühen 17. Jahrhunderts", *Wiener Geschichtsblätter* 56, 2001, pp. 54f.

21 Barker, Nicolas, *Hortus Eystettensis. The Bishop's Garden and Besler's Magnificent Book*, London, 1995, pp. 29–35.

22 Barker, Nicolas, "Who printed the text of the *Hortus Eystettensis*?", *The German Book 1450–1750. Studies presented to David L. Paisey*, London, 1995, pp. 85–192.

23 Hainhofer, Philipp, *Der Briefwechsel Zwischen Philipp Hainhofer und Herzog August d. J. von Brunschweig-Lüneburg*, ed. Ronald Gobiet, Munich, 1984, p. 198, no. 304.

24 Barker, *Hortus*, p. 15.

25 Hainhofer 1984, pp. 39f., no. 26, p. 198, no. 304.

26 Besler, foreword to 1640 edition, p. VI.

27 See work published on the occasion of the millennial celebrations by Johann Andreas de la Haye, "Die in seinem tausend-jährigen Alter feyerlichist erneuerte Herrlichkeit der Eichstättischen Kirch: Bey jenem großen Jubel- u. Danck-Fest, welches wegen ... erreichten tausend Jahren von Errichtung d. Hochstiffts ... höchst-feyrlichist celebrirt worden ist", Ingolstadt, 1746.

28 Besler, dedication in foreword to *Hortus Eystettensis*, p. II.

29 Ibid., pp. II–IV.

30 Ibid., pp. IVf.

31 Littger, Klaus Walter, "Der 'Hortus Eystettensis' als Wunderkammer", *Hortus Wander Wunder Kammer*, Eichstätt, 2008, p. 12.

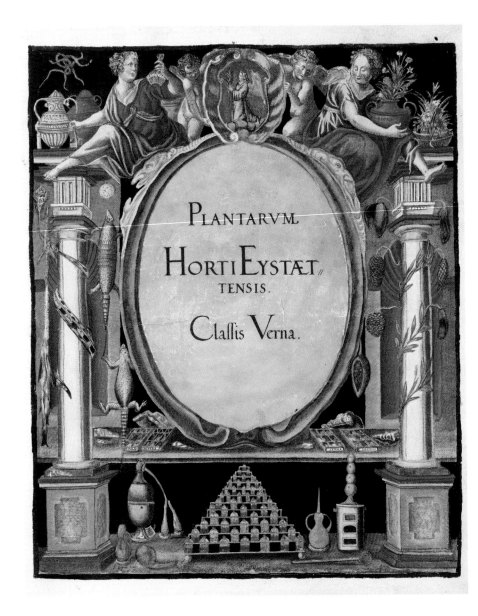

PLANTARVM

HORTI EYSTÆT,,

TENSIS.

Claſſis Verna.

SPRING

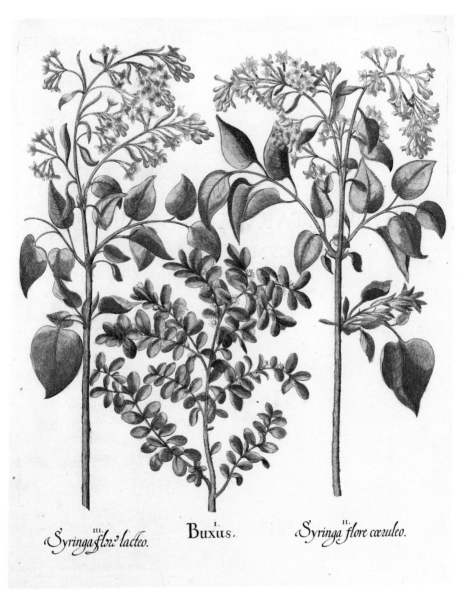

Syringa flor. lacteo. **Buxus.** *Syringa flore cœruleo.*

SYRINGA VULGARIS, II.–III. BUXUS SEMPERVIRENS
Common lilac *Common box*

Plate 1 35

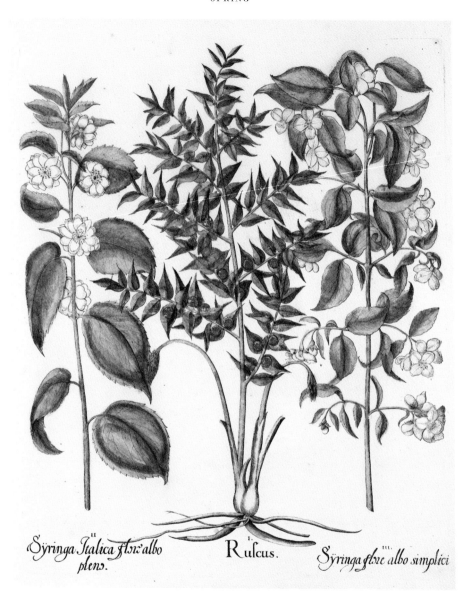

Syringa Italica flor: albo plens. *Ruscus.* *Syringa flor. albo simplici*

PHILADELPHUS CORONARIUS, II.–III.
Mock orange

RUSCUS ACULEATUS
*Butcher's broom,
Box holly, Jew's myrtle*

Plate 2

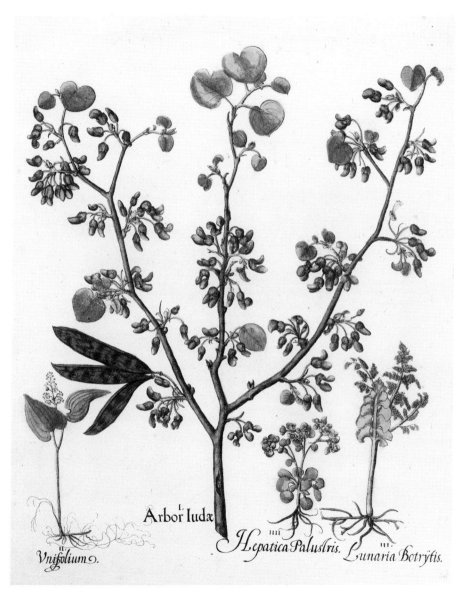

Arbor Iudæ.

Vnifolium.

Hepatica Palustris. Lunaria Botrytis.

MAIANTHEMUM BIFOLIUM	CERCIS SILIQUASTRUM	CHRYSOSPLENIUM OPPOSITIFOLIUM	BOTRYCHIUM LUNARIA
False lily of the vally	*Judas tree, Love tree*	*Golden saxifrage*	*Common moonwort*

Plate 3 37

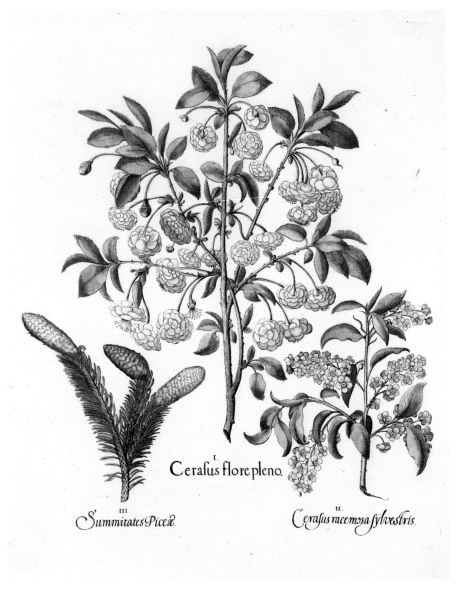

I.
Cerafus flore pleno.

III.
Summitates Piceæ.

II.
Cerafus racemosa sylvestris.

PICEA ABIES

Norway spruce, Christmas tree

PRUNUS SPEC., I. – II.

Cherry blossom

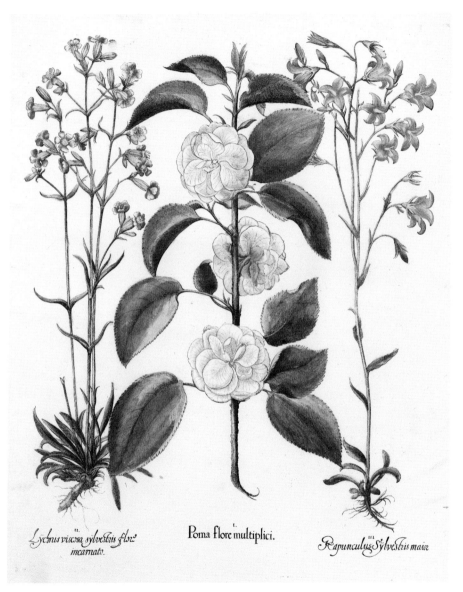

Lychnis viscosa sylvestris flor.
incarnato.

Poma flore multiplici.

Rapunculus Sylvestris maior

LYCHNIS VISCARIA
German catchfly

MALUS SPEC.
Double apple blossom

CAMPANULA PATULA
Bellflower

Plate 5

39

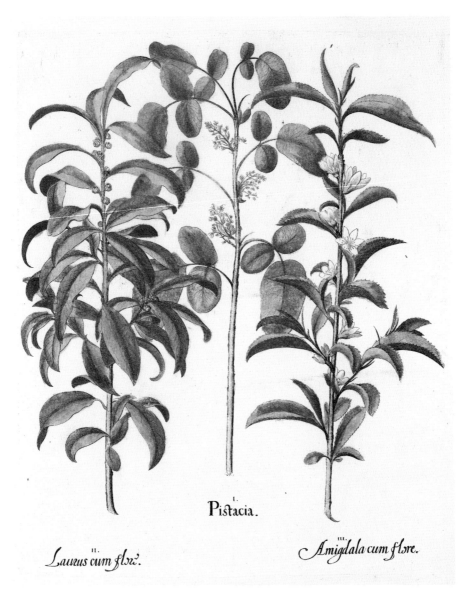

I.
Pistacia.

II.
Laurus cum flore.

III.
Amigdala cum flore.

LAURUS NOBILIS

True laurel, Bay laurel,
Sweet bay, Bay tree

PISTACIA VERA

Pistachio, Green
almond, Fustuq

PRUNUS DULCIS

Almond, Almond tree

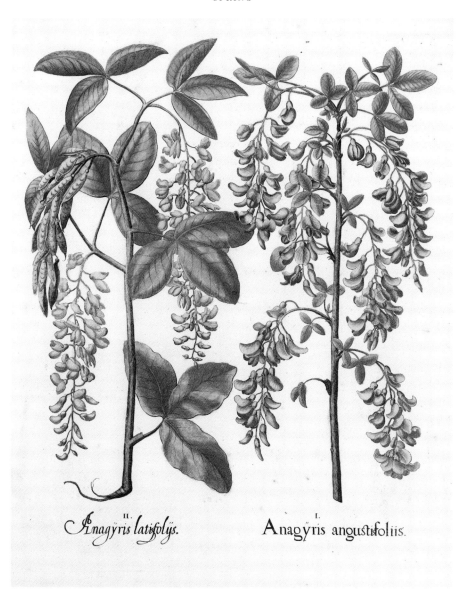

Anagÿris latifolÿs. II.

Anagÿris angustifoliis. I.

LABURNUM ALPINUM

Scotch laburnum,
Alpine golden chain

LABURNUM ANAGYROIDES

Common laburnum,
Golden chain

Plate 7 41

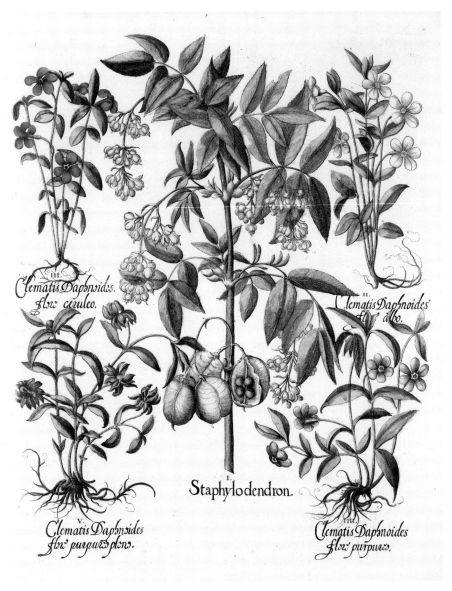

III.
Clematis Daphnides.
flor. cœruleo.

II.
Clematis Daphnoides
flor. albo.

I.
Staphylodendron.

V.
Clematis Daphnsides
flor. purpureo plens.

IIII.
Clematis Daphnoides
flor. purpureo.

VINCA MINOR, II.–V. STAPHYLEA PINNATA
Lesser periwinkle *Bladdernut*

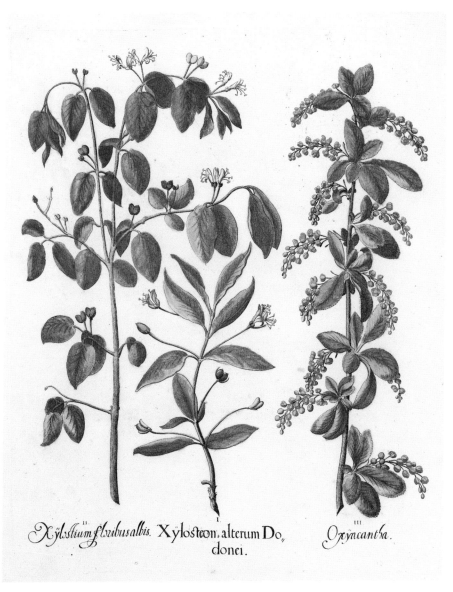

Xylostium fl.subusalbis. Xylosteon, alterum Do„
donei.

Oxyacantha.

LONICERA XYLOSTEUM
Fly honeysuckle

LONICERA ALPIGENA
Honeysuckle

BERBERIS VULGARIS
Common barberry

Plate 9

43

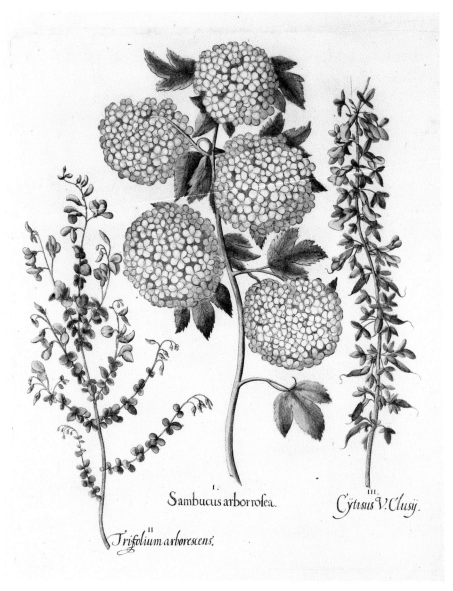

I.
Sambucus arbor rosea.

III.
Cytisus V. Clusij.

II.
Trifolium arborescens.

CYTISUS SESSILIFOLIUS
Broom

VIBURNUM OPULUS
*Snowball bush,
Guelder rose, European
cranberry bush*

CYTISUS CILIATUS
Broom

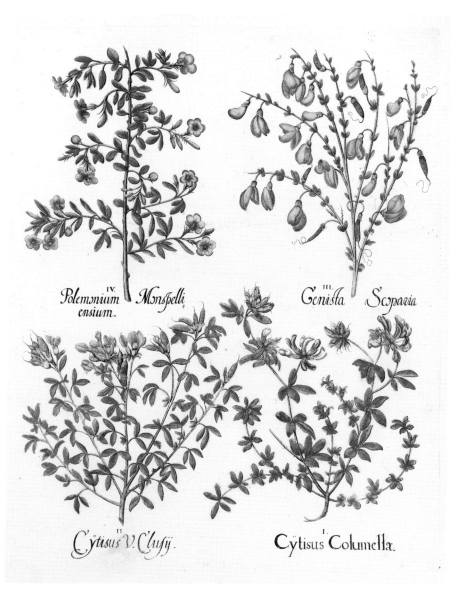

Polemonium IV. Monspelliensium.

Genista III. Scoparia

Cytisus V. Clusij.

Cytisus I. Columella.

JASMINUM FRUTICANS
Jasmine

CYTISUS SUPINUS
Prostrate broom

CYTISUS SCOPARIUS
*Common broom,
Scotch broom*

DORYCNIUM HIRSUTUM
Hairy canary clover

Plate 11

45

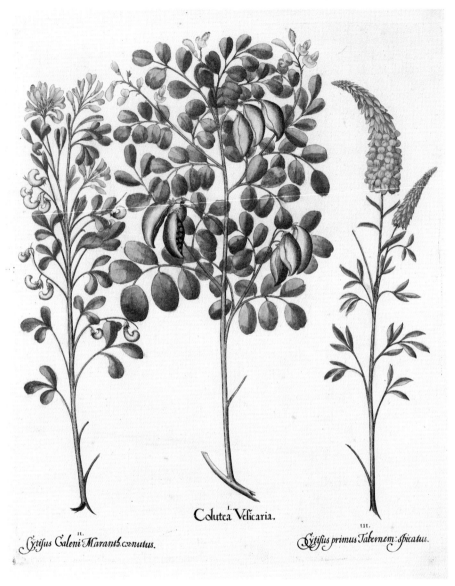

Colutea Veficaria.

Cytifus Galeni Marantb.cænutus.

Cytifus primus Tabernæm:fpicatus.

MEDICAGO ARBOREA
Moon trefoil

COLUTEA ARBORESCENS
Bladder senna

CYTISUS NIGRICANS
Black broom

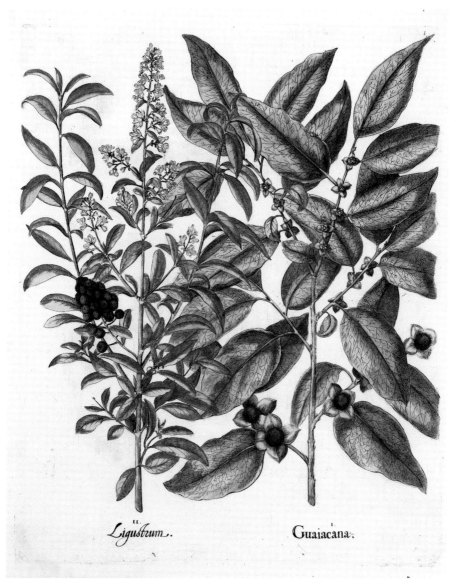

Ligustrum. II. *Guaiacana.* I.

LIGUSTRUM VULGARE DIOSPYROS LOTUS

Common privet *Date plum*

Plate 13 47

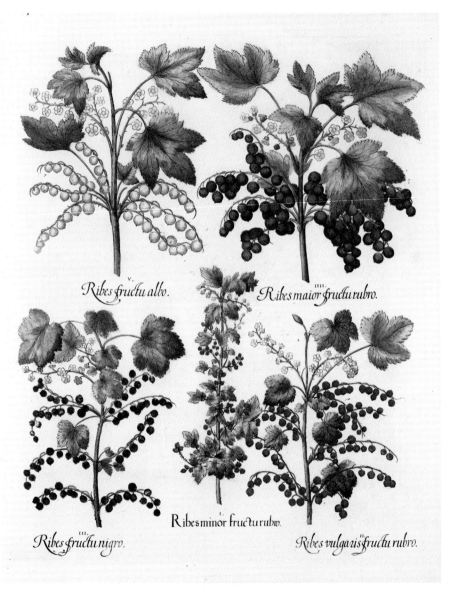

Ribes fructu albo.

Ribes maior fructu rubro.

Ribes minor fructu rubro.

Ribes fructu nigro.

Ribes vulgaris fructu rubro.

RIBES
NIGRUM

Black currant

RIBES
ALPINUM

*Alpine currant,
Mountain currant*

RIBES RUBRUM,
II., IV. – V.

Red currant

Plate 14

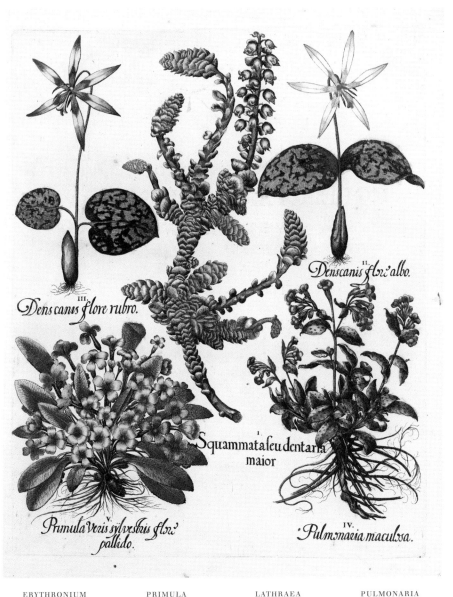

Denscanis flore albo.

Dens canis flore rubro.

Squammata seu dentaria maior

Primula Veris sylvestris flore pallido.

Pulmonaria maculosa.

ERYTHRONIUM DENS-CANIS, II.–III.	PRIMULA VULGARIS	LATHRAEA SQUAMARIA	PULMONARIA OFFICINALIS
European dog's tooth violet	*Primrose*	*Toothwort*	*Jerusalem cowslip, Soldiers and sailors, Spotted dog*

Plate 15 49

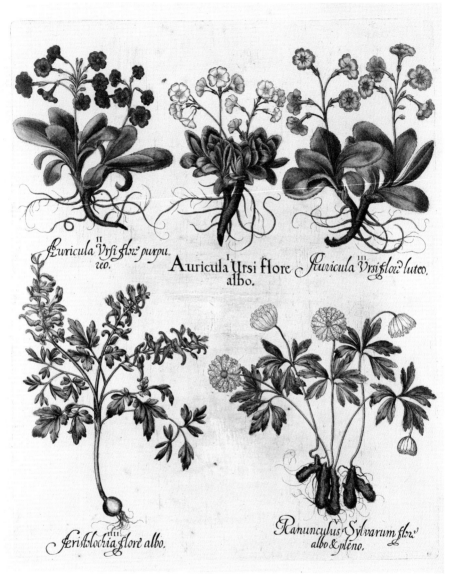

Auricula Ursi flore purpureo.

Auricula Ursi flore albo.

Auricula Ursi flore luteo.

Aristolochia flore albo.

Ranunculus Sylvarum flore albo & pleno.

CORYDALIS CAVA	PRIMULA AURICULA, I.–III.	ANEMONE NEMOROSA
Hollow-rooted corydalis	*Alpine auricula*	*Windflower, Wood anemone*

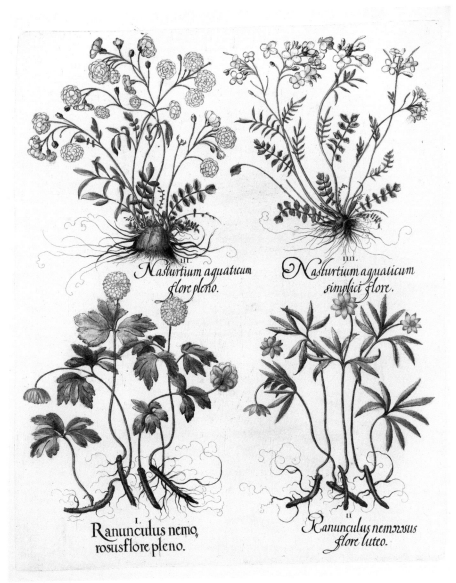

Nasturtium aquaticum flore pleno.

Nasturtium aquaticum simplici flore.

Ranunculus nemo, rosus flore pleno.

Ranunculus nemorosus flore luteo.

CARDAMINE PRATENSIS, III.—IV.

Cuckoo flower, Lady's smock,
Meadow cress

ANEMONE
SYLVESTRIS

Snowdrop windflower

ANEMONE
RANUNCULOIDES

Windflower

Plate 17 51

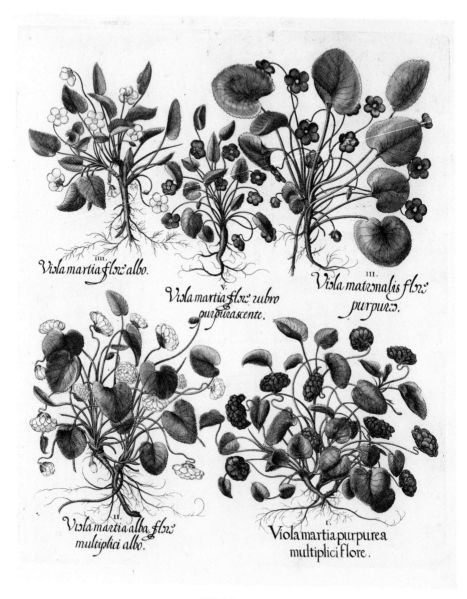

Viola martia flore albo.

Viola martia flore rubro purpurascente.

Viola matronalis flore purpureo.

Viola martia alba, flore multiplici albo.

Viola martia purpurea multiplici flore.

VIOLA ODORATA
English violet, Garden violet,
Sweet violet

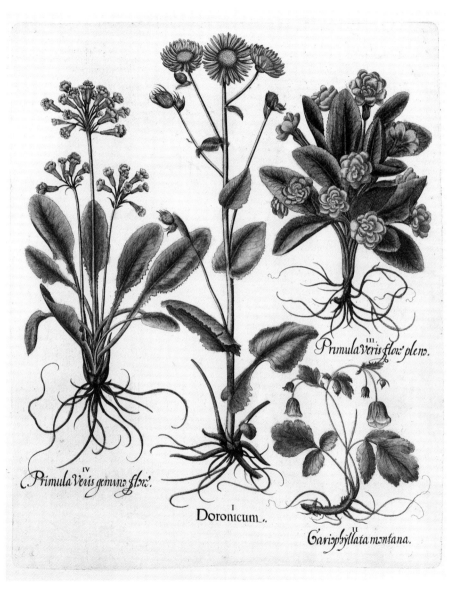

Primula Veris gemino flox.

IV

III

Primula Veris flor: plen.

I

Doronicum.

II

Cariophyllata montana.

PRIMULA SPEC., III.–IV.
Cowslip, Primrose

DORONICUM PARDALIANCHES
Great leopard's bane

GEUM RIVALE
Water avens, Indian chocolate,
Purple avens, Chocolate root

Plate 19 53

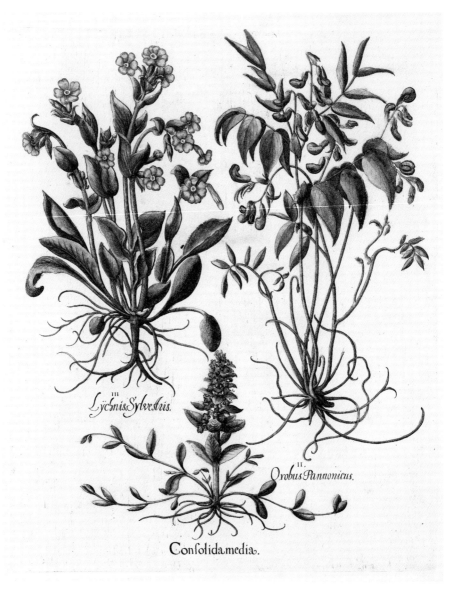

Lychnis Sylvestris.

Orobus Pannonicus.

Consolida media.

SILENE DIOICA	AJUGA REPTANS	LATHYRUS VERNUS
Red campion	*Creeping bugle*	*Spring vetch*

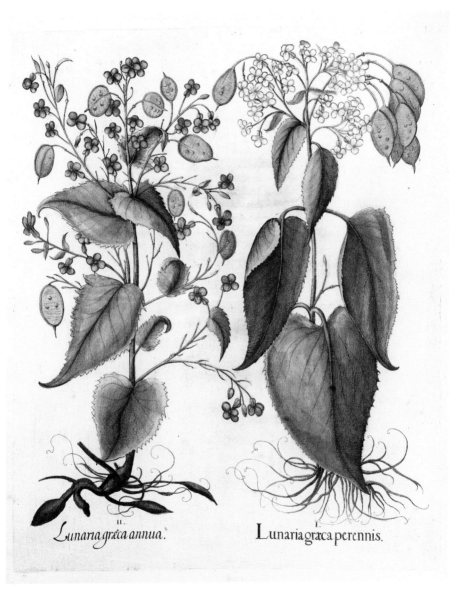

II.
Lunaria grǽca annua.

I.
Lunaria grǽca perennis.

LUNARIA ANNUA
Annual honesty, Silver dollar,
Penny flower, Satin flower

LUNARIA REDIVIVA
Perennial honesty, Silver dollar,
Penny flower, Satin flower

Plate 21 55

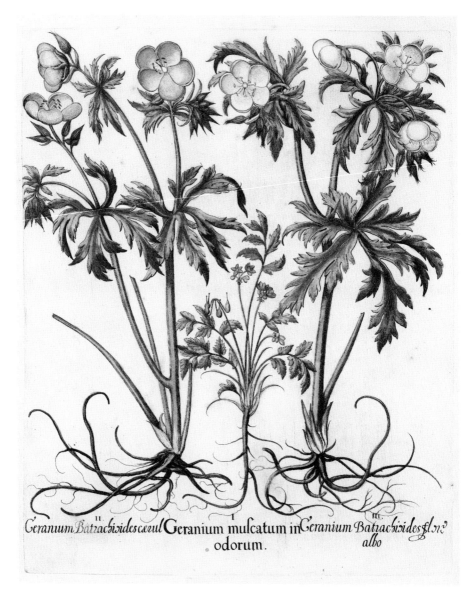

Geranium Batrachixides cærul *Geranium muſcatum in* *Geranium Batrachixides fl.ne*
odorum. *albo*

GERANIUM PRATENSE, II.–III. ERODIUM CICUTARIUM
Meadow cranesbill *Heron's bill, Storksbill*

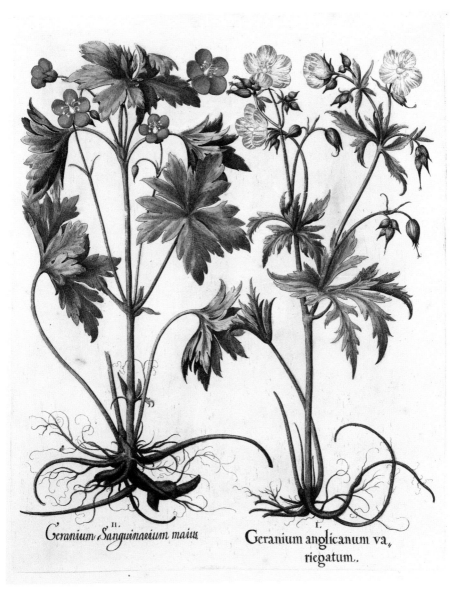

Geranium Sanguinarium maius

Geranium anglicanum variegatum.

GERANIUM PALUSTRE
Marsh cranesbill

GERANIUM RIVULARE
River cranesbill

Plate 23

57

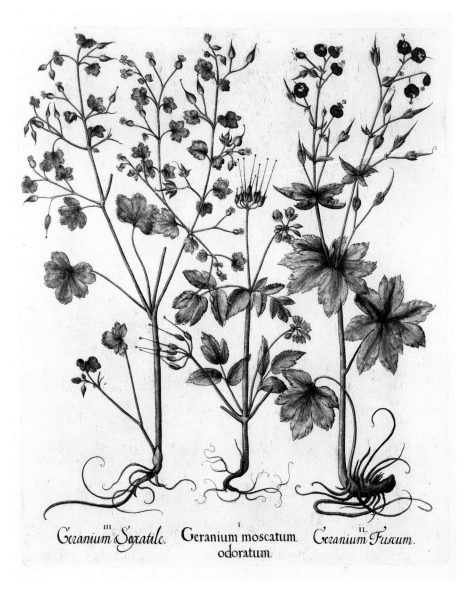

Geranium Saxatile.
III.

Geranium moscatum
odoratum
I.

Geranium Fuscum.
II.

GERANIUM LUCIDUM
Cranesbill

ERODIUM MOSCHATUM
*Heron's bill, White-stemmed
filaree, Musk clover*

GERANIUM PHAEUM
*Dusky cranesbill, Mourning
widow, Black widow*

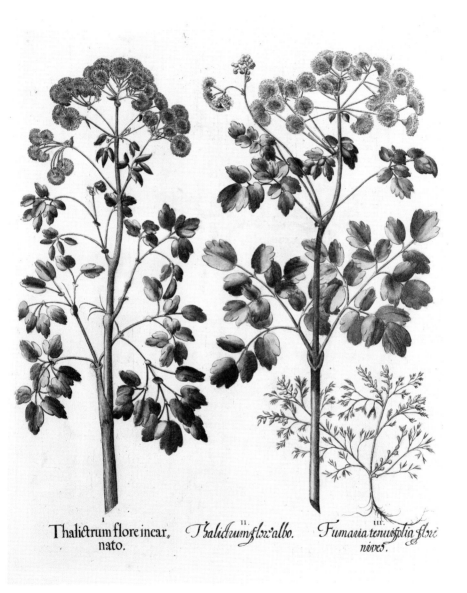

I
Thalictrum flore incar‚
nato.

II.
Thalictrum flore albo.

III.
Fumaria tenuifolia flore
niues.

THALICTRUM AQUILEGIFOLIUM
Meadow rue

THALICTRUM SPEC.
Meadow rue

FUMARIA PARVIFLORA
Hollowroot

Plate 25

59

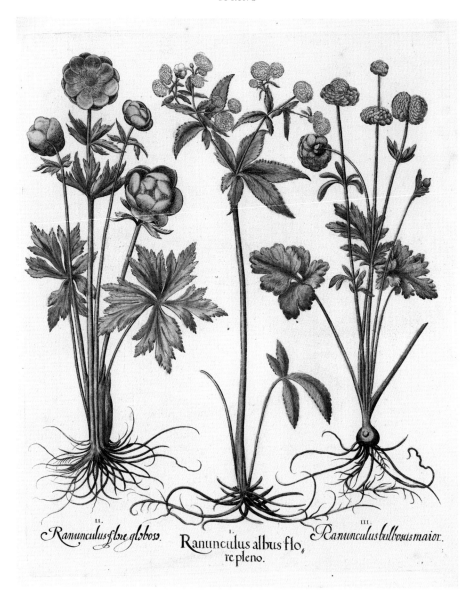

Ranunculus flore globoso.

Ranunculus albus flo, re pleno.

Ranunculus bulbosus maior.

TROLLIUS EUROPAEUS

European globe-flower

RANUNCULUS ACONITIFOLIUS

Bachelor's buttons, Fair maids of France, Fair maids of Kent

RANUNCULUS BULBOSUS

Bulbous buttercup, Crowfoot

Plate 26

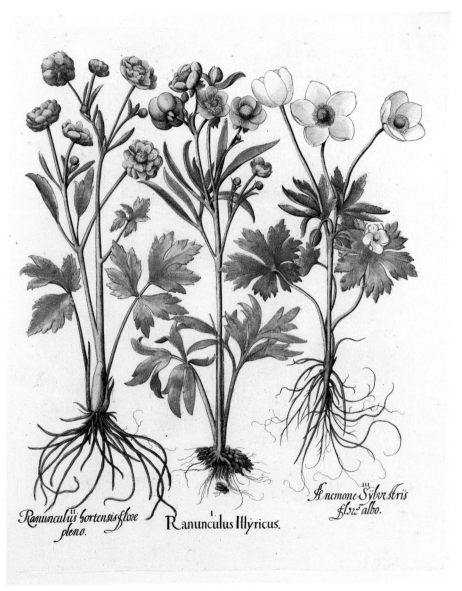

RANUNCULUS SPEC.

Double yellow buttercup,
Crowfoot

RANUNCULUS ILLYRICUS

Buttercup, Crowfoot

ANEMONE SYLVESTRIS

Snowdrop windflower

Plate 27 61

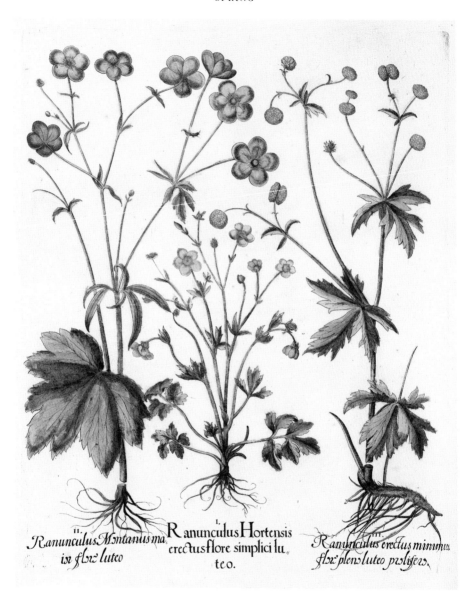

Ranunculus Montanus ma ir flx: luteo

Ranunculus Hortensis erectus flore simplici luteo.

Ranunculus erectus minimus flx: plens luteo prolifers.

RANUNCULUS MONTANUS

Mountain buttercup,
Crowfoot

RANUNCULUS REPENS

Creeping buttercup

RANUNCULUS ACRIS

Meadow buttercup

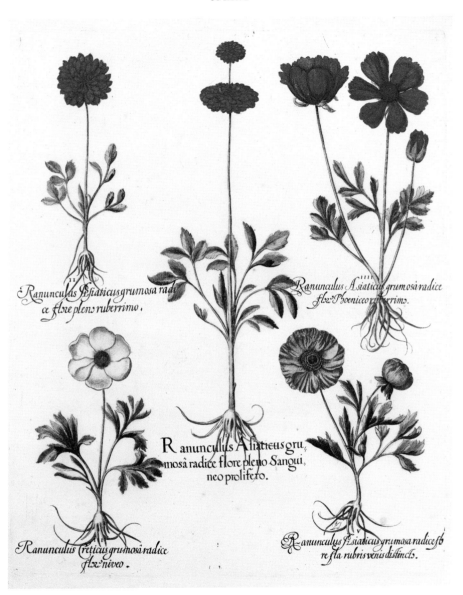

Ranunculus Asiaticus grumosa radice flore plens ruberrimo.

Ranunculus Asiaticus grumosà radice flx:Phoeniceo ruberrims.

Ranunculus Asiaticus grumosà radice flore pleno Sanguineo prolifero.

Ranunculus Creticus grumosà radice flx:niveo.

Ranunculus Asiaticus grumosa radice flore flã rubris venis distincts.

RANUNCULUS SPEC.
Asian buttercup, Crowfoot

Plate 29 63

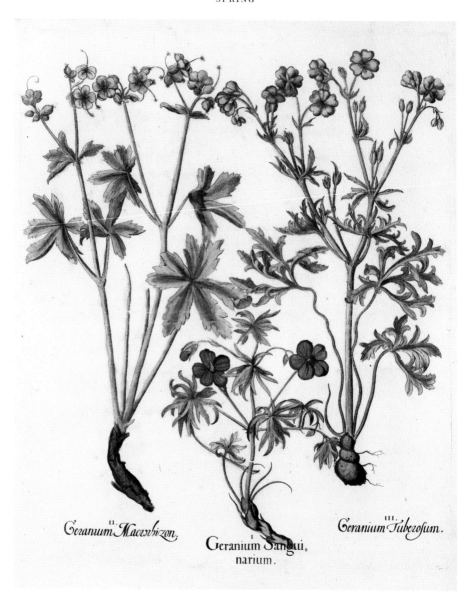

Geranium ". *Macrorhizon*,

Geranium ' *Sangui*,,
narium.

Geranium ". *Tuberosum*.

GERANIUM MACRORRHIZUM
Cranesbill

GERANIUM SANGUINEUM
Bloody cranesbill

GERANIUM TUBEROSUM
Cranesbill

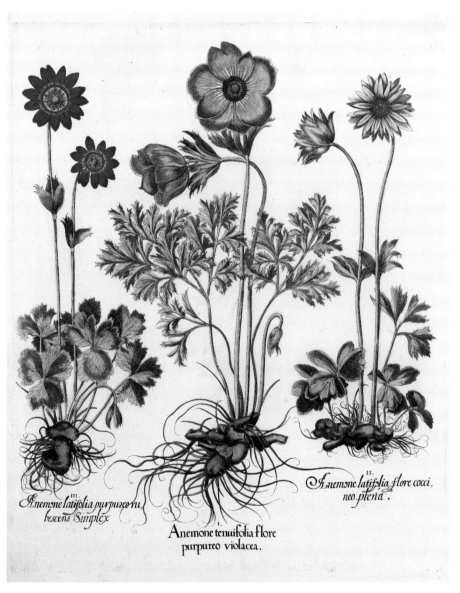

Anemone latifolia purpureo rubescens Simplex

Anemone latifolia flore cocci, neo.plena.

Anemone tenuifolia flore purpureo violacea.

ANEMONE HORTENSIS, II.–III. ANEMONE CORONARIA
Windflower *Windflower*

Plate 31 65

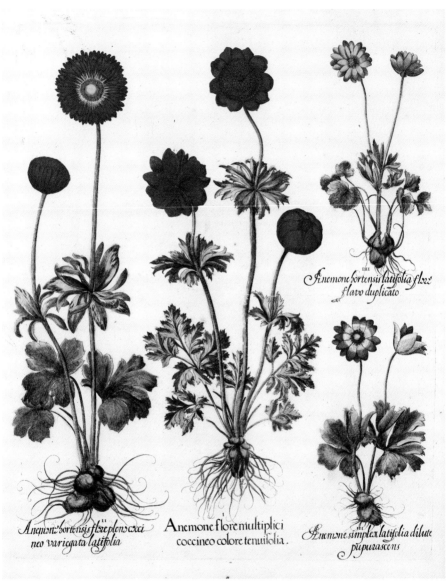

IIII Anemone hortensis latifolia flore flavo duplicato

Anemone hortensis flore pleno cocci neo variegata latifolia

Anemone flore multiplici coccineo colore tenuifolia.

Anemone simplex latifolia dilute pupurascens

ANEMONE SPEC., I.–II.	ANEMONE PALMATA	ANEMONE HORTENSIS
Windflower	*Windflower*	*Windflower*

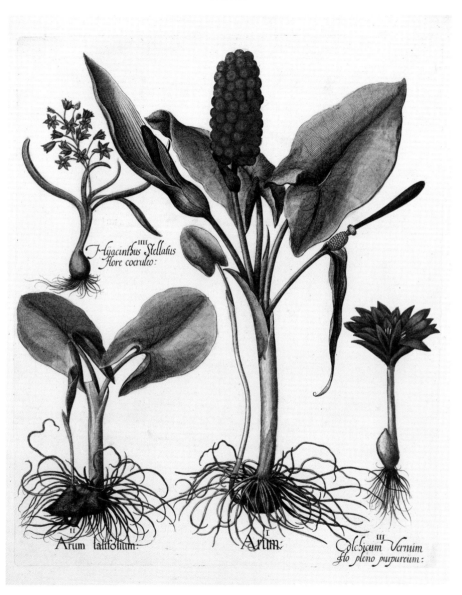

Hyacinthus Stellatus
Flore coeruleo:

Arum latifolium:

Arum:

Colchicum Vernum
flo pleno purpureum:

ARUM MACULATUM,
I. – II.

Lords-and-ladies, Cuckoo-pint,
Jack-in-the-pulpit

SCILLA
AMOENA

Squill

BULBOCODIUM
VERNUM

Spring meadow saffron

Plate 33 67

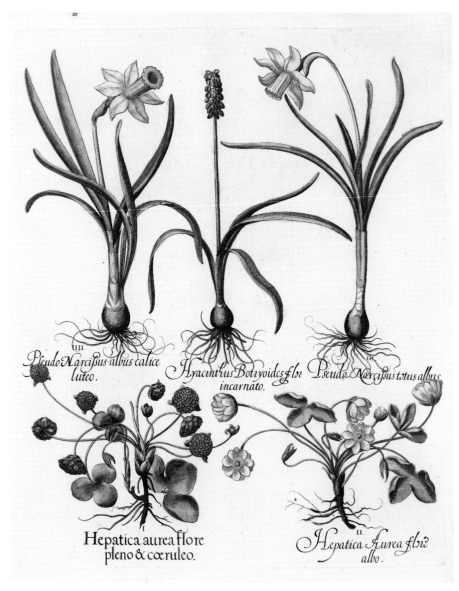

Pseudo Narcissus albus calice
luteo.

Hyacinthus Botryoides flre
incarnáto.

Pseudo Narcissus totus albus

Hepatica aurea flore
pleno & cœruleo.

Hepatica Aurea flre
albo.

NARCISSUS
PSEUDONARCISSUS, III. – IV.

*Lent lily, Wild daffodil,
Trumpet narcissus*

MUSCARI
BOTRYOIDES

Grape hyacinth

HEPATICA NOBILIS,
I. – II.

Blue anemone

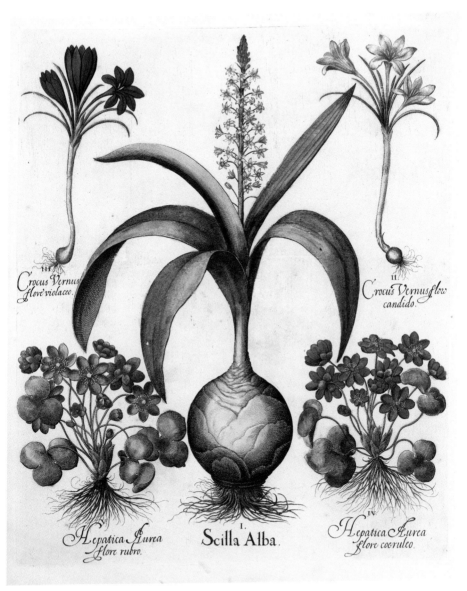

Crocus Vernus flore violaceo.

Crocus Vernus flore candido.

Hepatica Aurea flore rubro.

I.
Scilla Alba.

Hepatica Aurea flore cœruleo.

CROCUS VERNUS,
II.–III.

Crocus

URGINEA
MARITIMA

Sea onion, Squill

HEPATICA NOBILIS,
IV.–V.

Blue anemone

Plate 35

69

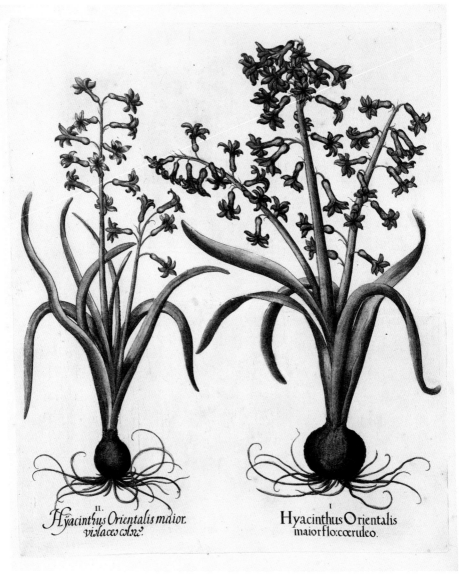

II.
Hyacinthus Orientalis maior.
violaces colne.

I
Hyacinthus Orientalis
maior flo: cœruleo.

HYACINTHUS
ORIENTALIS

Blue hyacinth

HYACINTHUS
ORIENTALIS

Sky blue hyacinth

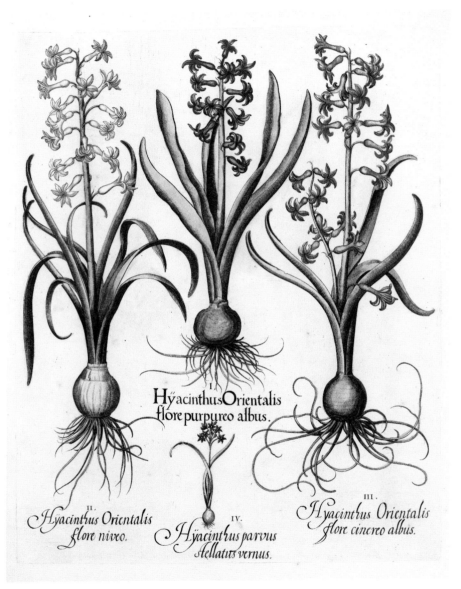

I.
Hyacinthus Orientalis
flore purpureo albus.

II.
Hyacinthus Orientalis
flore niveo.

IV.
Hyacinthus parvus
stellatus vernus.

III.
Hyacinthus Orientalis
flore cinereo albus.

HYACINTHUS
ORIENTALIS
White hyacinth

HYACINTHUS
ORIENTALIS
Mauve hyacinth

SCILLA
BIFOLIA
Twinleaf squill

HYACINTHUS
ORIENTALIS
Off-white hyacinth

Plate 37 71

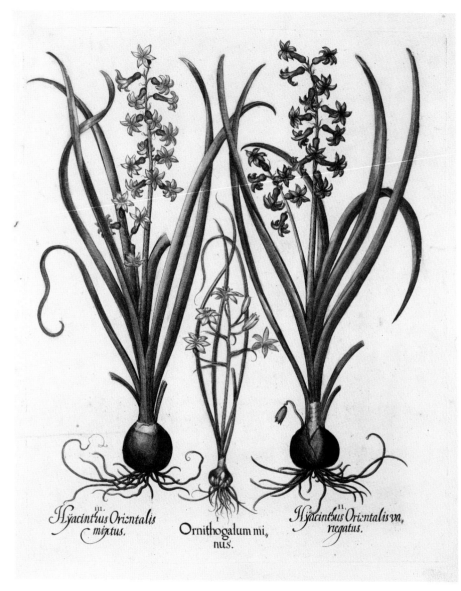

HYACINTHUS
ORIENTALIS

Milk-blue hyacinth

ORNITHOGALUM
UMBELLATUM

Star-of-Bethlehem

HYACINTHUS
ORIENTALIS

Dark red hyacinth

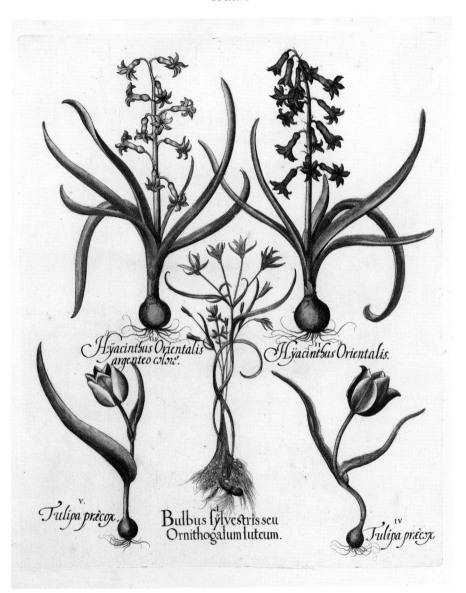

Hÿacinthus Orientalis argenteo colore.

Hÿacinthus Orientalis.

Tulipa præcox.

Bulbus sÿlvestris seu Ornithogalum luteum.

Tulipa præcox.

TULIPA SPEC.,
IV.–V.

Tulip

GAGEA
ARVENSIS

Yellow Star-of-Bethlehem

HYACINTHUS
ORIENTALIS, II.–III.

Common hyacinth

Plate 39 73

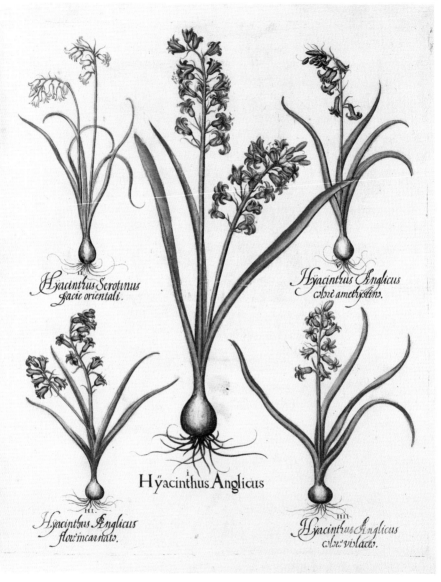

Hyacintlus Serotinus
facie orientali.

Hyacintlus Anglicus
colnè amethystino.

Hÿacinthus Anglicus

Hyacinthus Anglicus
flore incarnato.

Hyacinthus Anglicus
colore violacè.

HYACINTHOIDES HISPANICA	HYACINTHUS SPEC.	HYACINTHOIDES NON-SCRIPTA, III.–V.
Spanish bluebell	*Blue hyacinth*	*Bluebell*

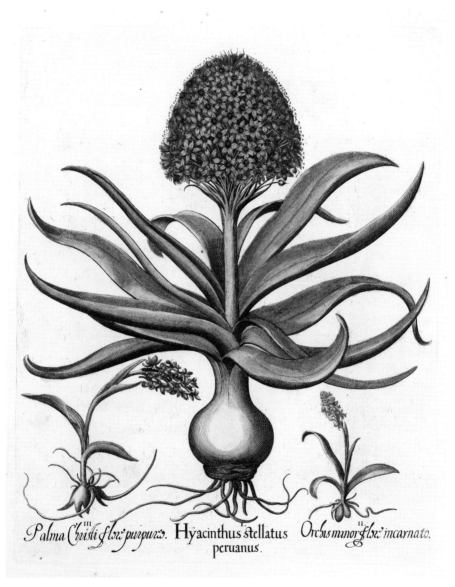

Palma Christi flɔːpurpurɔː. Hyacinthus stellatus peruanus. Orchis minor flɔːincarnato.

DACTYLORHIZA MAJALIS
Broad-leaved marsh orchid

SCILLA PERUVIANA
Squill of Peru

ORCHIS TRIDENTATA
Toothed orchid

Plate 41

75

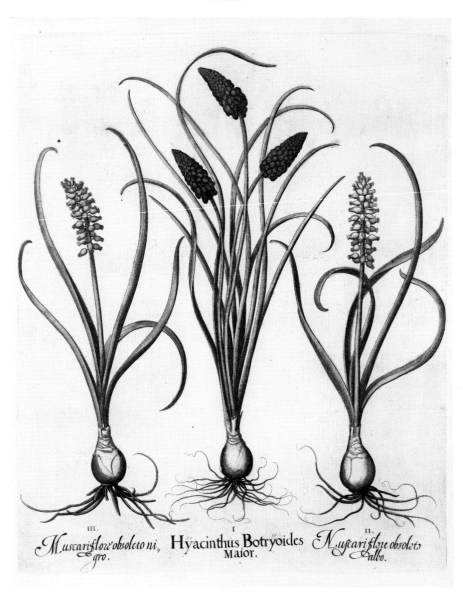

III.
Muscari flore obsoleto ni gro.

I.
Hÿacinthus Botrÿoides
Maior.

II.
Muscari flore obsoleto albo.

MUSCARI MOSCHATUM, II.–III. MUSCARI NEGLECTUM
Grape hyacinth *Common grape hyacinth*

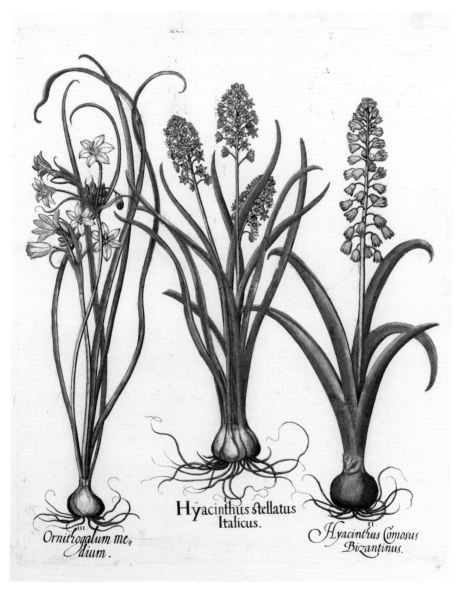

Ornithogalum me₄ dium.

Hyacinthus stellatus Italicus.

Hyacinthus Comosus Bizantinus.

ORNITHOGALUM UMBELLATUM
Star-of-Bethlehem

HYACINTHOIDES ITALICA
Italian hyacinth

BELLEVALIA ROMANA
Dark grey hyacinth

Plate 43

77

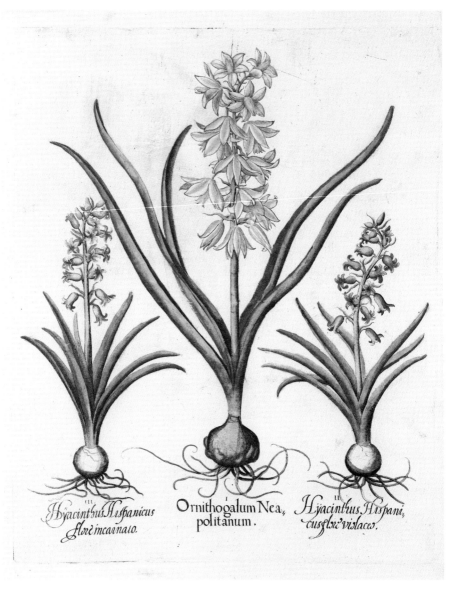

BRIMEURA AMETHYSTINA
Pink hyacinth

ORNITHOGALUM NUTANS
Star-of-Bethlehem

HYACINTHUS ORIENTALIS
Common hyacinth

Plate 44

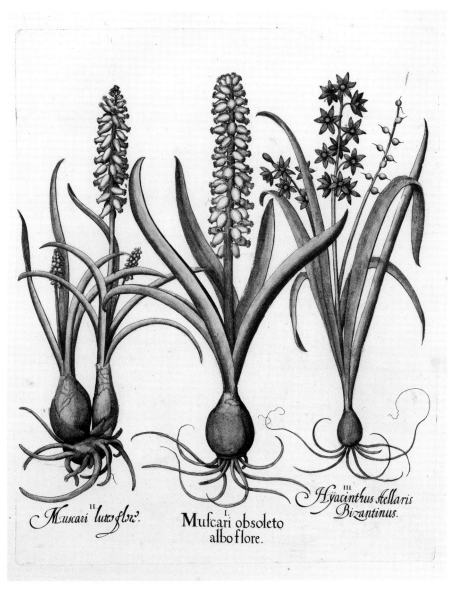

Muscari II *lutes flor.*

I.
Mufcari obsoleto
albo flore.

III
*Hyacinthus stellaris
Bizantinus.*

MUSCARI MOSCHATUM, I.–II. HYACINTHUS SPEC.

Grape hyacinth *Hyacinth*

Plate 45 79

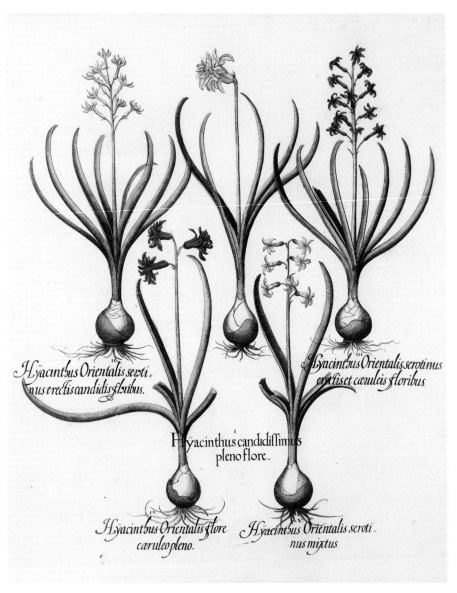

Hÿacinthus Orientalis serti
nus erectis candidis floribus.

Hÿacinthus Orientalis serotinus
erectis et cæruleis floribus

Hÿacinthus candidissimus
pleno flore.

Hÿacinthus Orientalis flore
cæruleo pleno.

Hÿacinthus Orientalis seroti
nus mixtus

HYACINTHUS ORIENTALIS	HYACINTHUS ORIENTALIS	HYACINTHUS ORIENTALIS	HYACINTHUS ORIENTALIS	HYACINTHUS ORIENTALIS
White hyacinth	*Double blue hyacinth*	*Double white hyacinth*	*Multi-coloured hyacinth*	*Blue hyacinth*

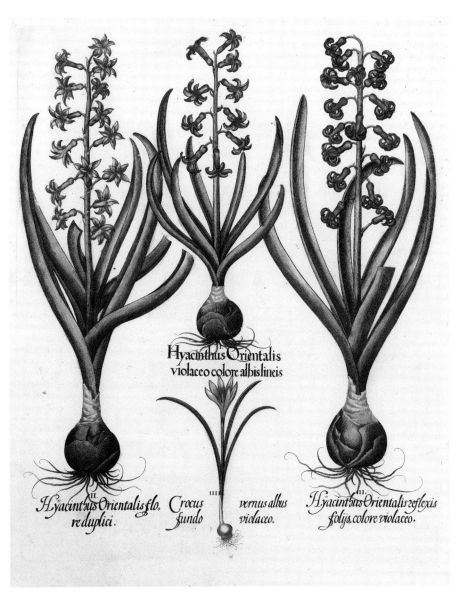

Hyacinthus Orientalis
violaceo colore albis lineis

H. Hyacinthus Orientalis flo-
re duplici.

Crocus
fundo

vernus albus
violaceo.

Hyacinthus Orientalis reflexis
folijs, colore violaceo.

HYACINTHUS ORIENTALIS	HYACINTHUS ORIENTALIS	CROCUS VERNUS	HYACINTHUS ORIENTALIS
Double hyacinth	*Violet-blue hyacinth with dark stripes*	*Crocus*	*Blue hyacinth*

Plate 47 81

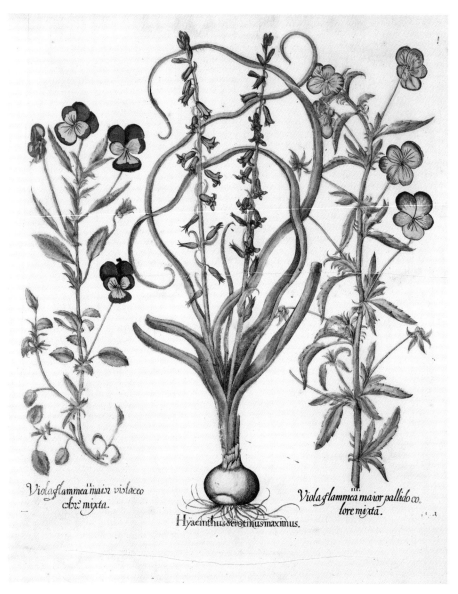

Violaflammea maior violaceo colxe mixta.

Hyacinthus serotinus maximus.

Viola flammea maior pallido colore mixta.

VIOLA SPEC.,
II. – III.

Violet, Pansy

DIPCADI
SEROTINUM

Light brown hyacinth

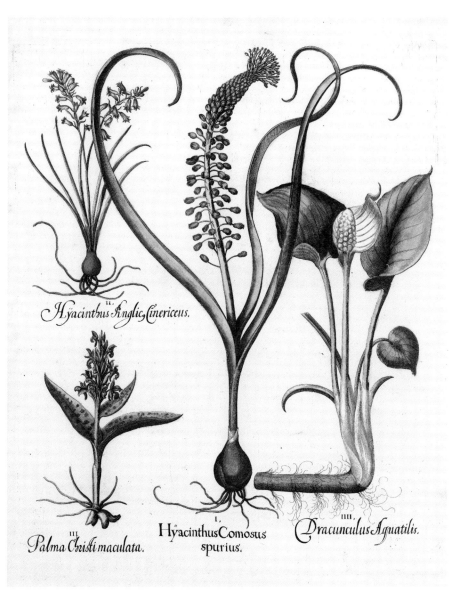

Hyacinthus Anglic. Cinericeus.

Palma Christi maculata.

Hyacinthus Comosus spurius.

Dracunculus Aquatilis.

HYACINTHOIDES NON-SCRIPTA	DACTYLORHIZA MACULATA	MUSCARI COMOSUM	CALLA PALUSTRIS
Bluebell	*Marsh orchid*	*Tassel grape hyacinth*	*Bog arum, Water arum, Wild calla, Water dragon*

Plate 49　　　　　85

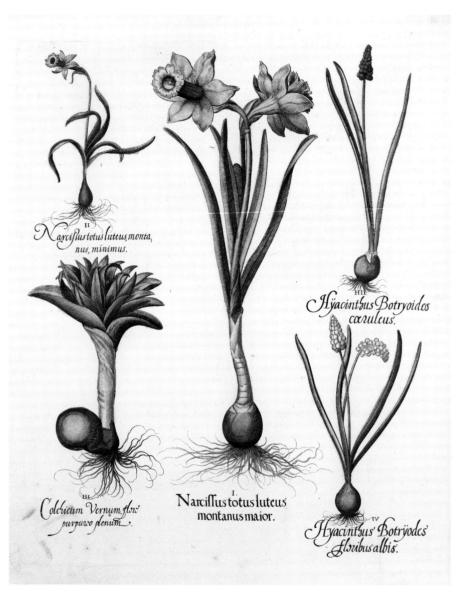

Narciſſus totus luteus monta‚
nus‚ minimus.

Hyacinthus Botryoides
cœruleus.

Colchicum Vernum, flore
purpureo plenum.

Narciſſus totus luteus
montanus maior.

Hyacinthus Botryodes
floribus albis.

NARCISSUS PSEUDONARCISSUS	BULBOCODIUM VERNUM	NARCISSUS PSEUDONARCISSUS	MUSCARI BOTRYOIDES, IV.–V.
Lent lily, Wild daffodil, Trumpet narcissus	*Spring meadow saffron*	*Lent lily, Wild daffodil, Trumpet narcissus*	*Grape hyacinth*

Plate 50

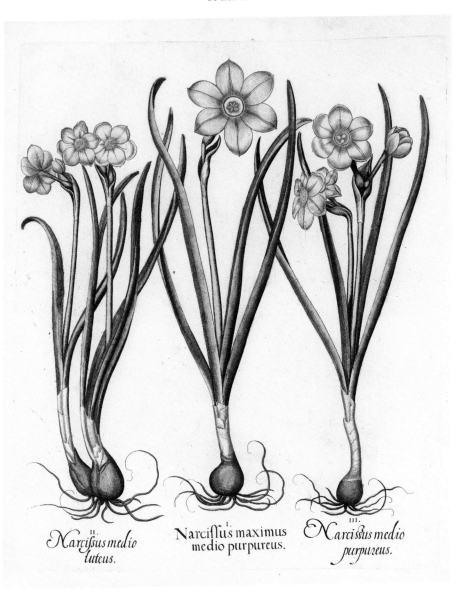

II.
Narcissus medio luteus.

I.
Narciſsus maximus medio purpureus.

III.
Narcissus medio purpureus.

NARCISSUS X
MEDIOLUTEUS, II. – III.

Primrose peerless

NARCISSUS
POETICUS

*Poet's narcissus,
Pheasant's eye narcissus*

Plate 51

85

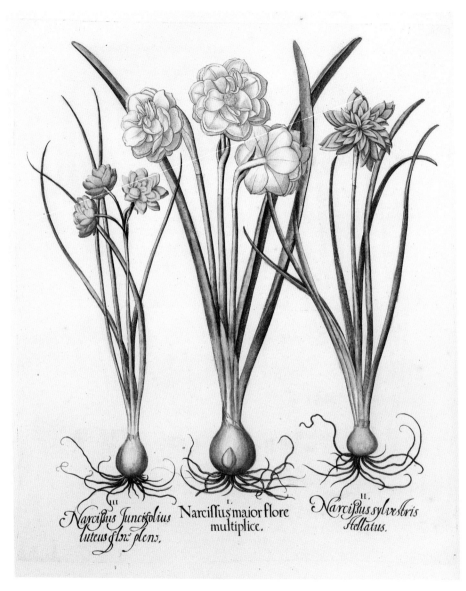

NARCISSUS SPEC.
Double daffodil

Plate 52

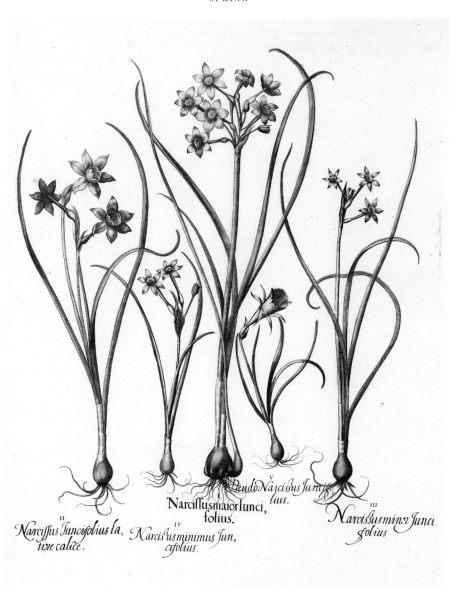

NARCISSUS
SPEC.

Daffodil

NARCISSUS
JONQUILLA, I., III.–IV.

Jonquil

NARCISSUS
BULBOCODIUM

*Hoop-petticoat daffodil,
Petticoat daffodil*

Plate 53 87

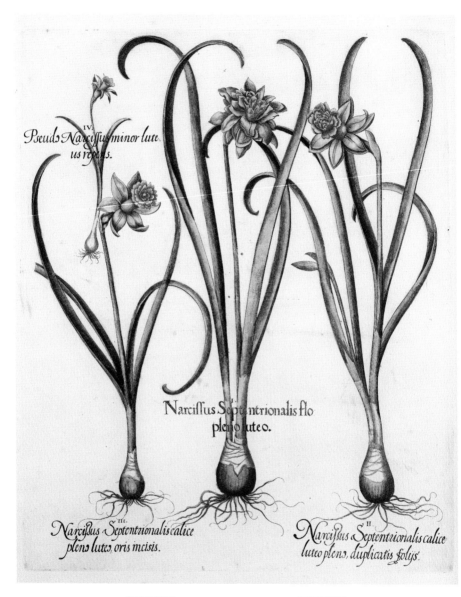

Pseudo Narcissus minor luteus repens.

Narcissus Septentrionalis flo pleno luteo.

Narcissus Septentrionalis calice pleno luteo, oris incisis.

Narcissus Septentrionalis calice luteo pleno, duplicatis folijs.

NARCISSUS
MINOR

Lent lily, Wild daffodil,
Trumpet narcissus

NARCISSUS
PSEUDONARCISSUS, I.–III.

Lent lily, Wild daffodil,
Trumpet narcissus

Plate 54

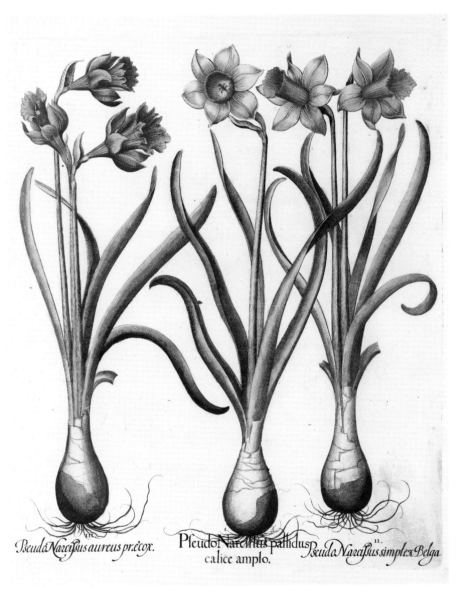

Pseudo Narcissus aureus præcox.

Pseudo Narcissus pallidus calice amplo.

Pseudo Narcissus simplex Belga.

NARCISSUS PSEUDONARCISSUS
*Lent lily, Wild daffodil,
Trumpet narcissus*

NARCISSUS X INCOMPARABILIS, I.–II.
Daffodil

Plate 55

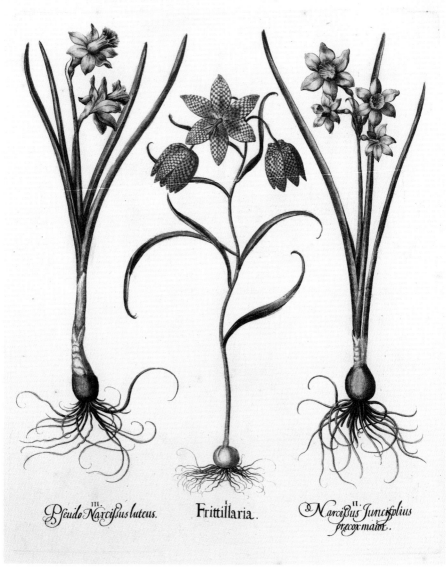

Pseudo Narcissus luteus. *Frittillaria.* *Narcissus Juncifolius præcox maior.*

NARCISSUS PSEUDONARCISSUS

*Lent lily, Wild daffodil,
Trumpet narcissus*

FRITILLARIA MELEAGRIS

*Snake's head fritillary,
Guinea-hen flower,
Chequered lily, Leper lily*

NARCISSUS JONQUILLA

Jonquil

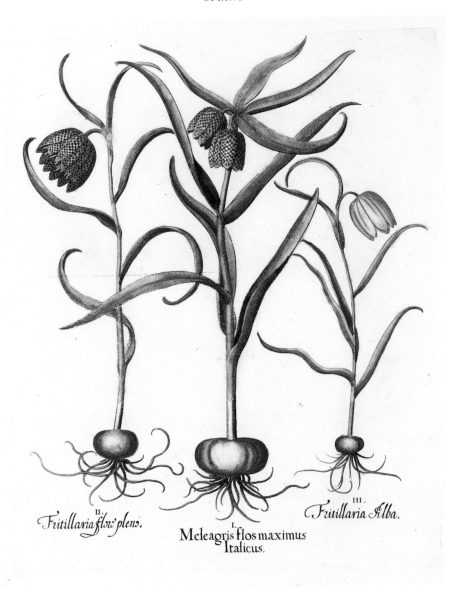

Fritillaria flor: plens.
II.

I.
Meleagris flos maximus
Italicus.

Fritillaria Alba.
III.

FRITILLARIA MELEAGRIS, II.–III.
*Snake's head fritillary, Guinea-hen
flower, Chequered lily, Leper lily*

FRITILLARIA ORIENTALIS
Fritillary

Plate 57

91

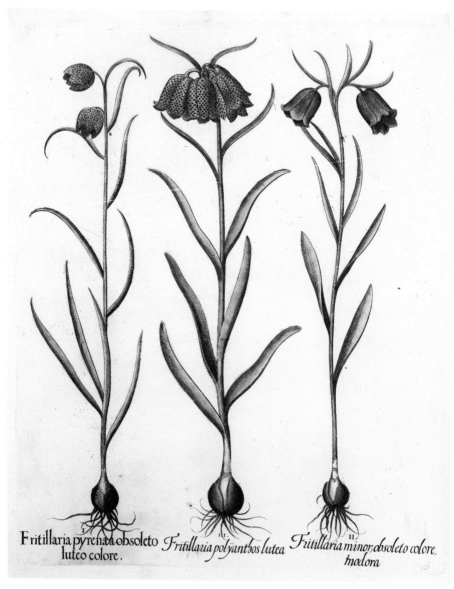

Fritillaria pyrenaica obsoleto luteo colore.

Fritillaria polyanthos lutea

Fritillaria minor, obsoleto colore. inodora

FRITILLARIA GRAECA
Fritillary

FRITILLARIA SPEC.
Fritillary

FRITILLARIA PYRENAICA
Two-coloured fritillary

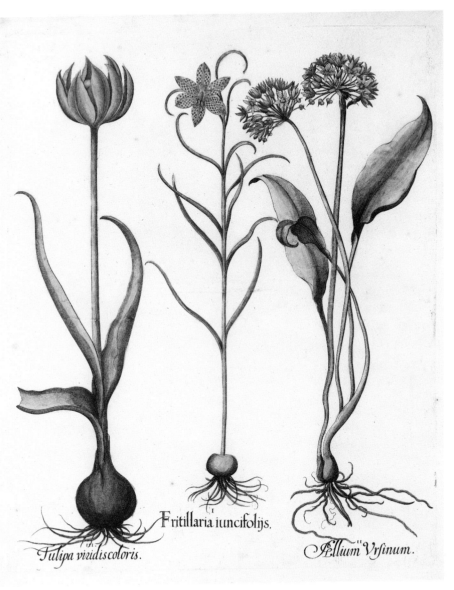

Fritillaria iuncifolijs.

Tulipa viridiscoloris.

Allium Vrsinum.

TULIPA SPEC.
Tulip with green flower

FRITILLARIA SPEC.
*Fritillary with
saucer-shaped flower*

ALLIUM URSINUM
*Wild garlic, Wood garlic,
Ramsons*

Plate 59 93

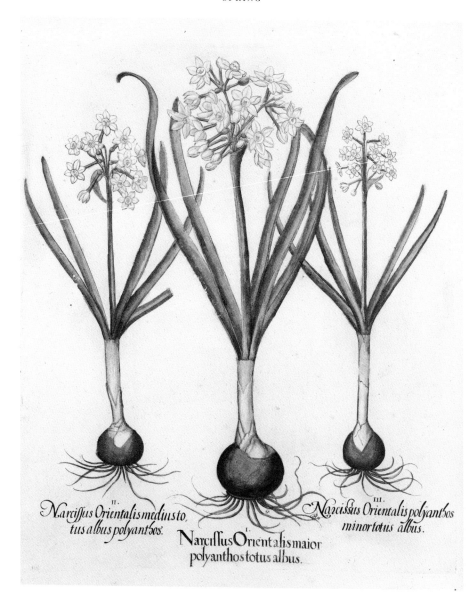

Narcissus Orientalis medius to-
tus albus polyanthos.

Narcissus Orientalis maior
polyanthos totus albus.

Narcissus Orientalis polyanthos
minor totus albus.

NARCISSUS PAPYRACEUS
White-blue narcissus

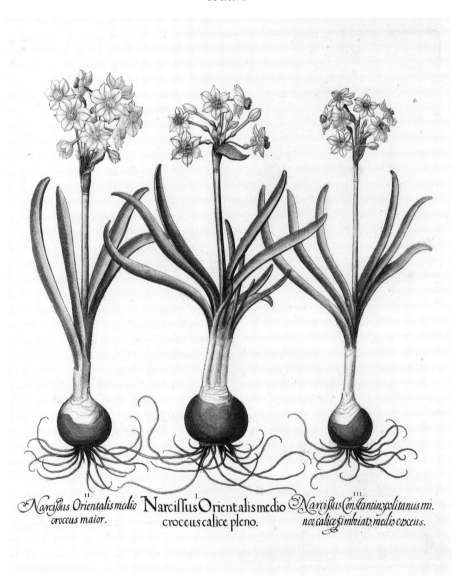

Narcissus Orientalis medio ^{II.}
croceus maior. *Narcissus Orientalis medio* ^{I.}
croceus calice pleno. *Narcissus Constantinopolitanus mi.* ^{III.}
nor, calice fimbriato, medio croceus.

NARCISSUS TAZETTA
Bunch-flowered narcissus, Polyanthus narcissus

Plate 61 95

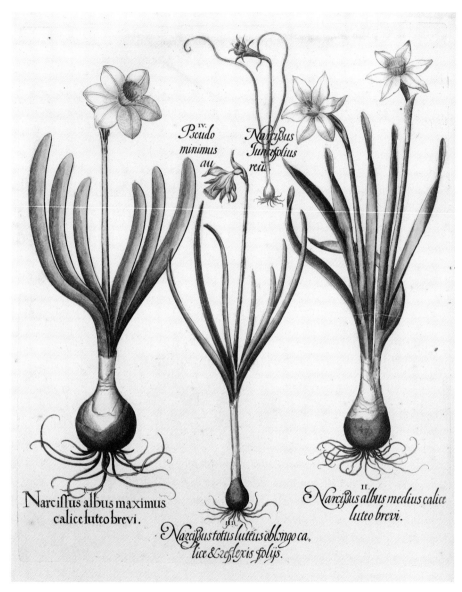

Pseudo minimus au

Narcissus Iuncifolius reüs

Narcissus albus maximus calice luteo brevi.

Narcissus totus luteus oblongo calice & reflexis folijs.

Narcissus albus medius calice luteo brevi.

NARCISSUS
POETICUS, I. – II.

*Poet's narcissus,
Pheasant's eye narcissus*

NARCISSUS
PSEUDONARCISSUS

*Lent lily, Wild daffodil,
Trumpet narcissus*

NARCISSUS
BULBOCODIUM

*Hoop-petticoat daffodil,
Petticoat daffodil*

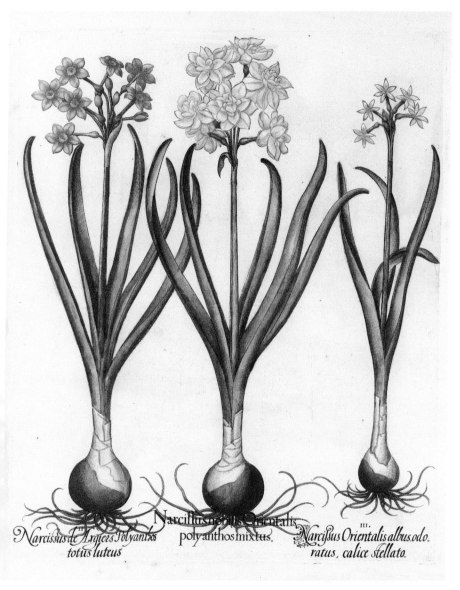

NARCISSUS AUREUS

Yellow daffodil

NARCISSUS TAZETTA

Bunch-flowered narcissus,
Polyanthus narcissus

NARCISSUS SPEC.

White-blue daffodil

Plate 63

97

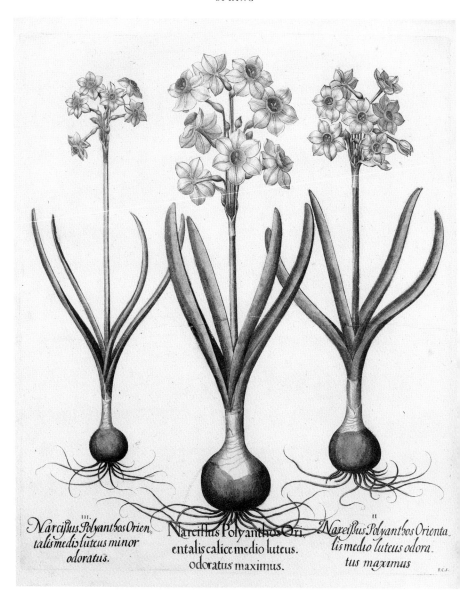

III.
*Narcissus Polyanthos Orien-
talis medis luteus minor
odoratus.*

*Narcissus Polyanthos Ori-
entalis calice medio luteus.
odoratus maximus.*

II
*Narcissus Polyanthos Orienta-
lis medio luteus odora-
tus maximus*

R.C.S.

NARCISSUS TAZETTA
Bunch-flowered narcissus, Polyanthus narcissus

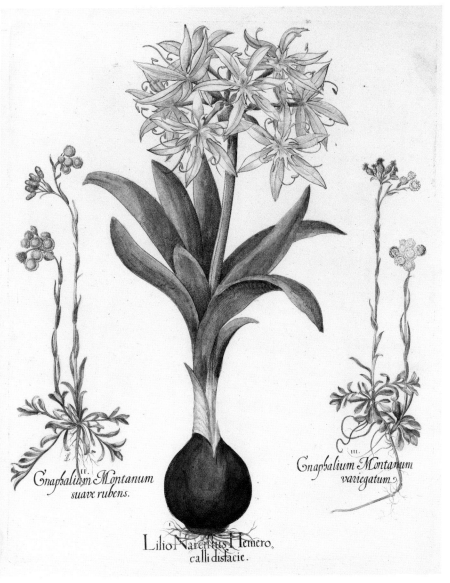

Gnaphalium Montanum suave rubens.

Gnaphalium Montanum variegatum

Lilio Narcissus Hemero calli disfacie.

ANTENNARIA DIOICA, II.–III.

Cat's ears, Pussy-toes

PANCRATIUM ILLYRICUM

Sea lily

Plate 65

99

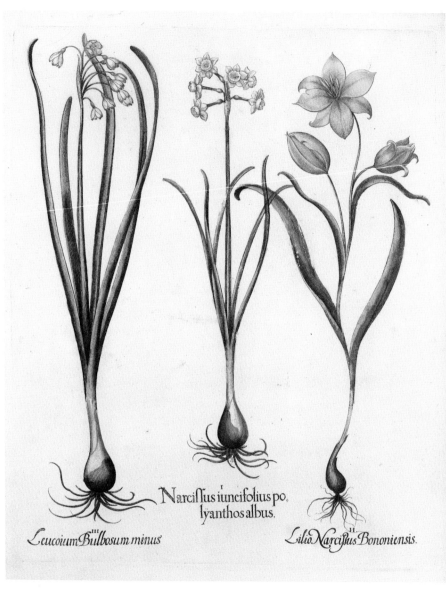

Narcissus iuncifolius po,
lyanthos albus.

Leucoium Bulbosum minus

Lilio. Narcissus Bononiensis.

LEUCOJUM AESTIVUM

*Summer snowflake,
Loddon lily*

NARCISSUS PAPYRACEUS

Paper-white narcissus

TULIPA SYLVESTRIS

Wild tulip

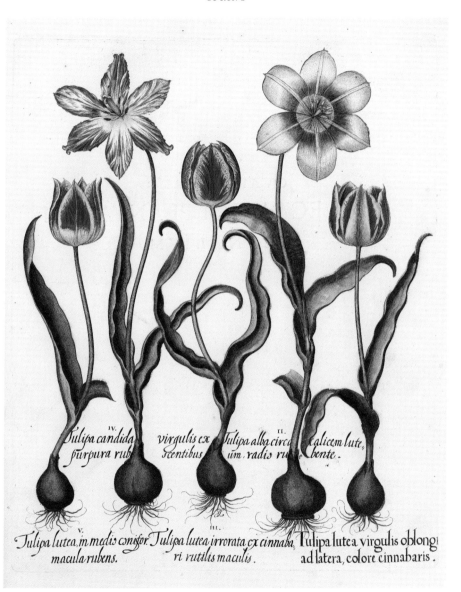

IV.
Tulipa candida
purpura rub

virgulis ex
scentibus

II.
Tulipa alba circa *calicem lute,*
um, radis ru *bente.*

V.
Tulipa lutea, in medis coniator.
macula rubens.

III.
Tulipa lutea irrorata ex cinnaba,
ri rutilis maculis.

Tulipa lutea virgulis oblongi
ad latera, colore cinnabaris.

TULIPA SPEC.	TULIPA SPEC.	TULIPA SPEC.	TULIPA SPEC.	TULIPA SPEC.
Golden yellow tulip with purple sheen	*Red and white striped tulip*	*Golden and brick red variegated tulip*	*White tulip, yellow and carmine inside*	*Yellow tulip, flamed red and green*

Plate 67

101

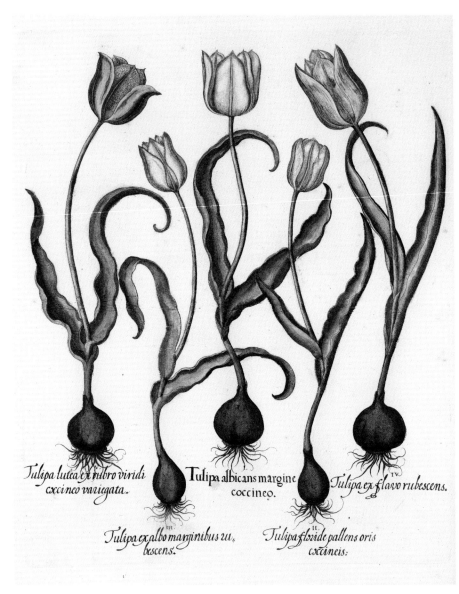

Tulipa lutea ex rubro viridi coccineo variegata.

Tulipa albicans margine coccineo.

Tulipa ex flavo rubescens.

Tulipa ex albo marginibus rubescens.

Tulipa floride pallens oris coccineis:

TULIPA SPEC.	TULIPA SPEC.	TULIPA SPEC.	TULIPA SPEC.	TULIPA SPEC.
Late, red tulip with green stripes	*Early, two-coloured tulip*	*Late, white, red-marginated tulip*	*Early, three-coloured tulip*	*Late, white-yellow, red-margined tulip*

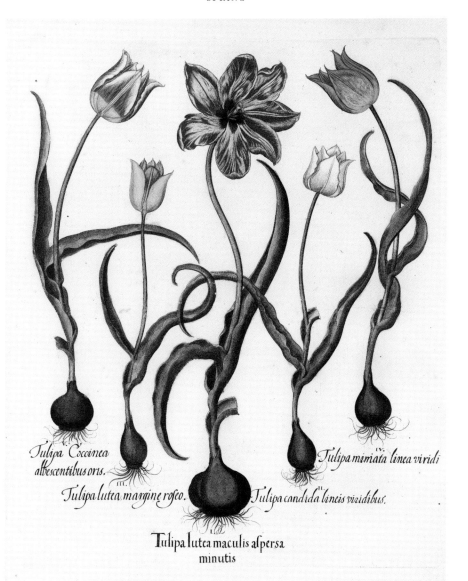

Tulipa Coccinea albescentibus oris.

Tulipa lutea margine roseo.

Tulipa miniata linea viridi

Tulipa candida lineis viridibus.

Tulipa lutea maculis aspersa minutis

TULIPA SPEC.

Late, white-margined carmine tulip

TULIPA SPEC.

Single, early red-margined yellow tulip

TULIPA SPEC.

Golden yellow tulip with carmine stripes

TULIPA SPEC.

Single, early, whitish tulip

TULIPA SPEC.

Early red tulip with golden base

Plate 69 103

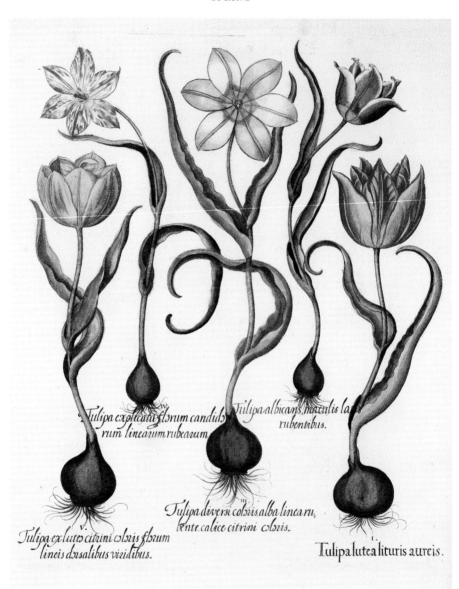

Tulipa explicata florum candids rum linearum rubearum.

Tulipa albicans, maculis la rubentibus.

Tulipa diversi colsris alba linea ru, vente calice citrini colsris.

Tulipa ex luteo citrini colsris florum lineis dorsalibus viridibus.

Tulipa lutea lituris aureis.

TULIPA SPEC.	TULIPA SPEC.	TULIPA SPEC.	TULIPA SPEC.	TULIPA SPEC.
Species tulip, slightly tinged green	*Tulip with purple and white striped petals*	*Silver-white tulip, yellow inside with a blue rim, and red-striped petals*	*Early, white-margined carmine tulip*	*Yellow flamed species tulip*

Plate 70

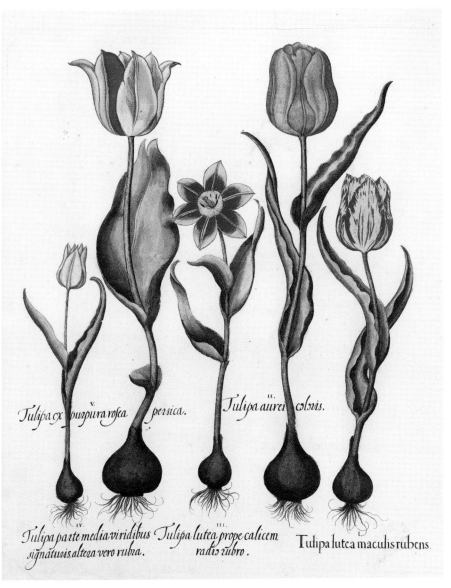

Tulipa ex purpura rosea persica.

Tulipa aurei colоris.

Tulipa parte media viridibus signaturis, altera vero rubra.

Tulipa lutea prope calicem radis rubro.

Tulipa lutea maculis rubens.

TULIPA SPEC.	TULIPA SPEC.	TULIPA SPEC.	TULIPA SPEC.	TULIPA SPEC.
Early, single, pale pink tulip	*Late, red tulip, bursting into flower*	*Early yellow tulip with brick red rim*	*Early yellow tulip with large orange-coloured flowers*	*Early, yellow and red flamed tulip*

Plate 71　　105

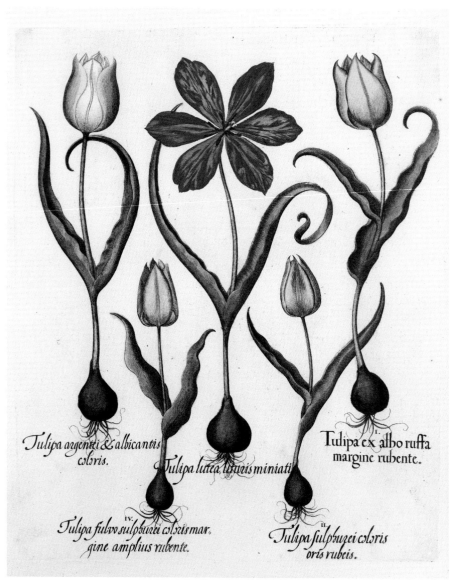

Tulipa argentei & albicantis coloris.

Tulipa lutea lituris miniati

Tulipa ex albo ruffa margine rubente.

Tulipa fulvo sulphurei coloris margine amplius rubente.

Tulipa sulphurei coloris oris rubeis.

TULIPA SPEC.

Early, single, silver-white tulip

TULIPA SPEC.

Single carmine-margined yellow tulip

TULIPA SPEC.

Single, red flamed tulip

TULIPA SPEC.

Single, yellow, slightly green-tinged tulip

TULIPA SPEC.

Single, yellow tulip

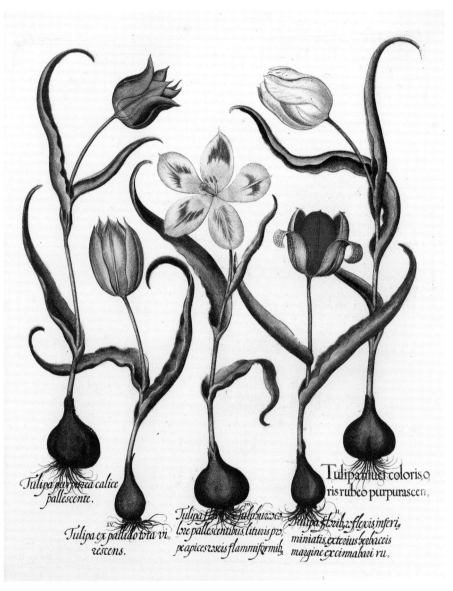

Tulipa purpurea calice pallescente.

Tulipa ex pallido tota virescens.

Tulipa flore ... tulip purpureo love pallescentibus lituris prope apices roseis flammiformib.

Tulipaniul coloris oris rubeo purpurascen.

Tulipa floribz flexis inferi, miniatis, exterius herbaceis margine ex cinnabari ru.

TULIPA SPEC.	TULIPA SPEC.	TULIPA SPEC.	TULIPA SPEC.	TULIPA SPEC.
Gesneriana hybrid with yellow base	*Species tulip, green*	*Yellow-flamed tulip*	*Early, carmine-red tulip with large yellow petals*	*Late, white, red-margined tulip, fringed*

Plate 73 107

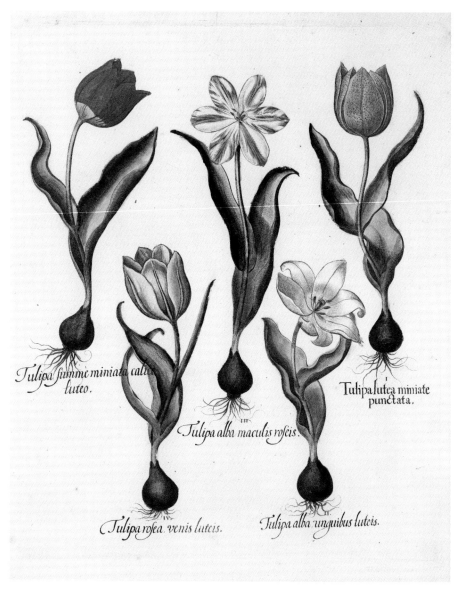

Tulipa summe miniata calice luteo.

Tulipa lutea miniate punctata.

Tulipa alba maculis roseis.

Tulipa rosea venis luteis.

Tulipa alba unguibus luteis.

TULIPA SPEC.

Gesneriana hybrid with yellow base

TULIPA SPEC.

Pink tulip, finely veined yellow

TULIPA SPEC.

Early, white tulip, purple striped

TULIPA SPEC.

Early, white tulip, yellow inside

TULIPA SPEC.

Early, yellow, purple flecked tulip

Plate 74

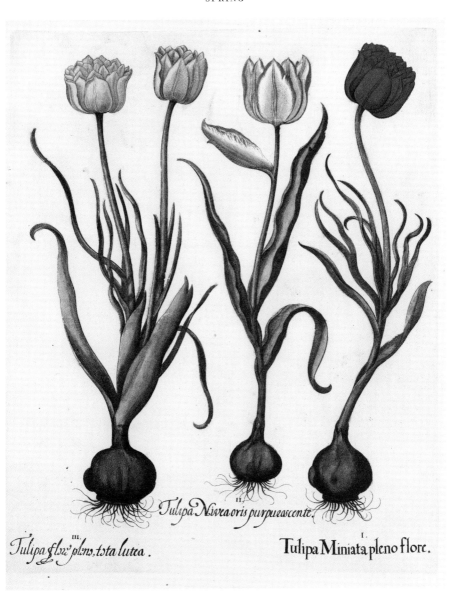

Tulipa Niveaoris purpueascente.

III.
Tulipa g flvz' plzno. tota lutea.

I.
Tulipa Miniata pleno flore.

TULIPA SPEC.
Double yellow tulip with two flowers

TULIPA SPEC.
Late, white red-margined, fringed tulip

TULIPA SPEC.
Late, double, purple-black tulip

Plate 75 109

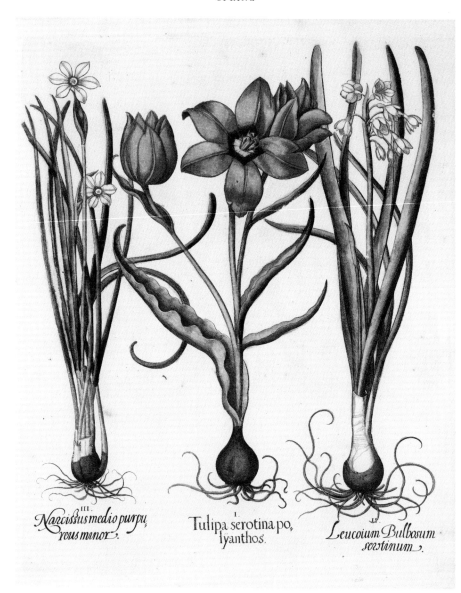

NARCISSUS SPEC.

Single white narcissus

TULIPA SPEC.

Late multi-flowered red tulip

LEUCOJUM AESTIVUM

Summer snowflake, Loddon lily

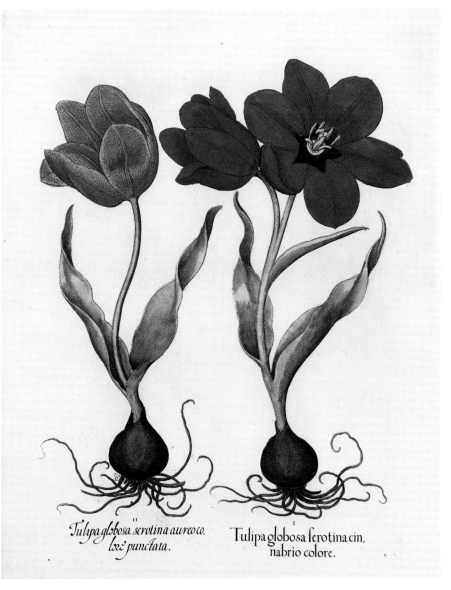

Tulipa globosa serotina aureo co. lxe punctata.

Tulipa globosa serotina cin. nabrio colore.

TULIPA SPEC.
Tulip with yellow-feathered petals

TULIPA SPEC.
Late tulip with large red flower

Plate 77

111

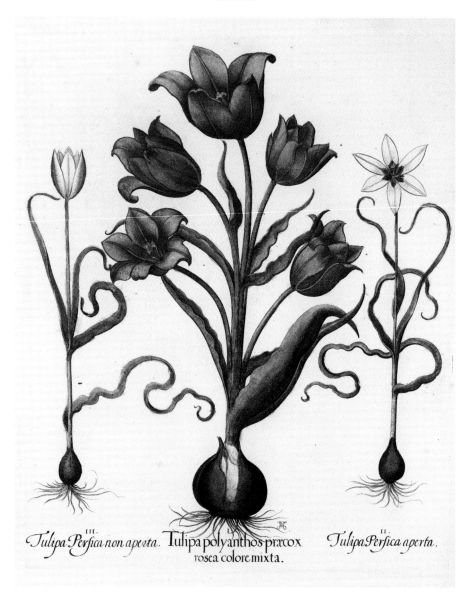

Tulipa Persica non aperta. **Tulipa polyanthos præcox rosea colore mixta.** *Tulipa Persica aperta.*

TULIPA SPEC.

White botanical tulip, flower closed

TULIPA SPEC.

Multi-flowered red tulip

TULIPA SPEC.

White botanical tulip, flower open

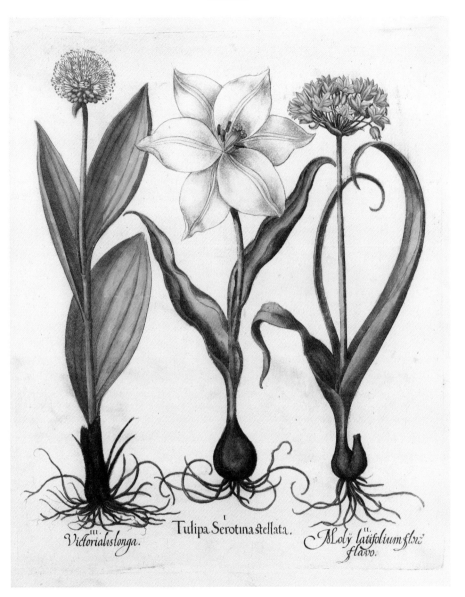

Victorialis longa.

Tulipa Serotina stellata.

Moly latifolium flore flavo.

ALLIUM VICTORIALIS

*Spotted ramson,
Serpent's garlic, Alpine leek*

TULIPA SPEC.

Late tulip with white flower

ALLIUM MOLY

*Golden garlic, Yellow onion,
Lily leek*

Plate 79 113

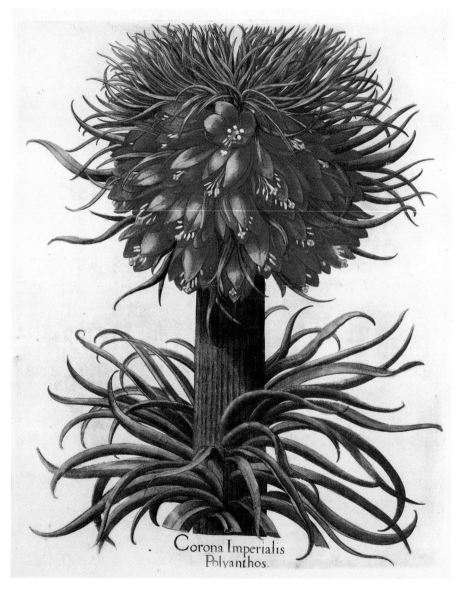

Corona Imperialis
Polyanthos.

FRITILLARIA IMPERIALIS
Multi-flowered crown imperial

Plate 80

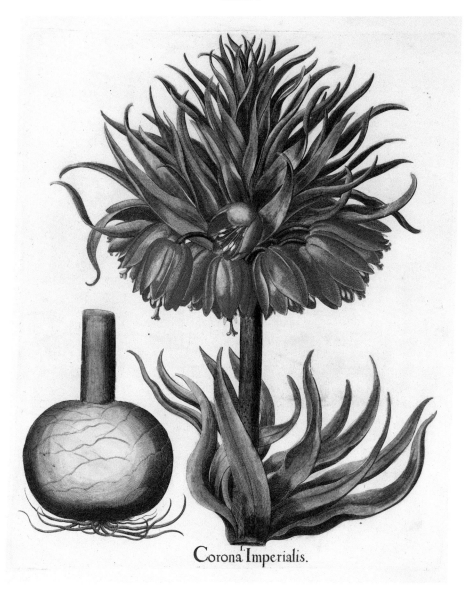

Corona Imperialis.

FRITILLARIA IMPERIALIS
Crown imperial with bulb

Plate 81 115

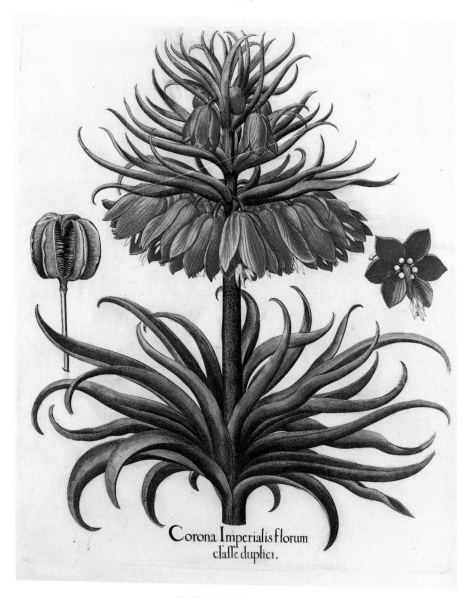

Corona Imperialis florum
claſſe duplici.

FRITILLARIA IMPERIALIS
Crown imperial with two crowns

Plate 82

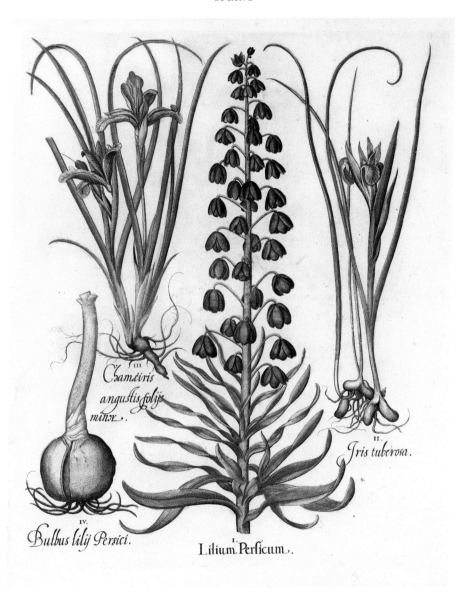

III.
Chamæiris
angustis folijs
minor.

II.
Iris tuberosa.

IV.
Bulbus lilij Persici.

I.
Lilium Persicum.

FRITILLARIA PERSICA, I., IV.
Fritillaria persica with bulb

IRIS GRAMINEA
Spuria iris

HERMODACTYLUS TUBEROSUS
Widow iris, Snake's head iris

Plate 83 117

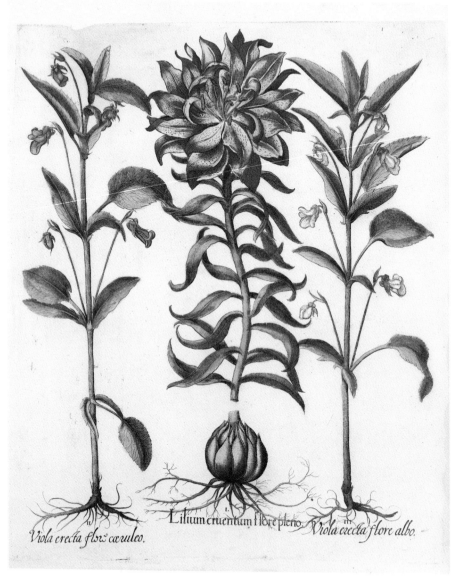

Viola erecta flor cœruleo.

Lilium cruentum flore pleno.

Viola erecta flore albo.

VIOLA ELATIOR, II.–III.
Violet

LILIUM BULBIFERUM
Fire lily

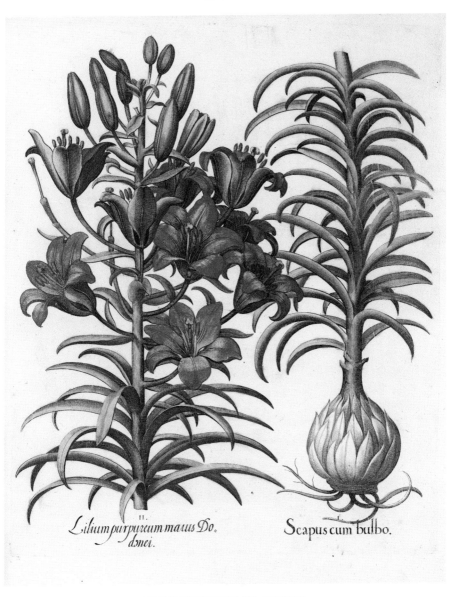

Lilium purpureum maius Do,
dnei.

Scapus cum bulbo.

LILIUM BULBIFERUM SSP. CROCEUM
Fire lily with bulb

Plate 85

119

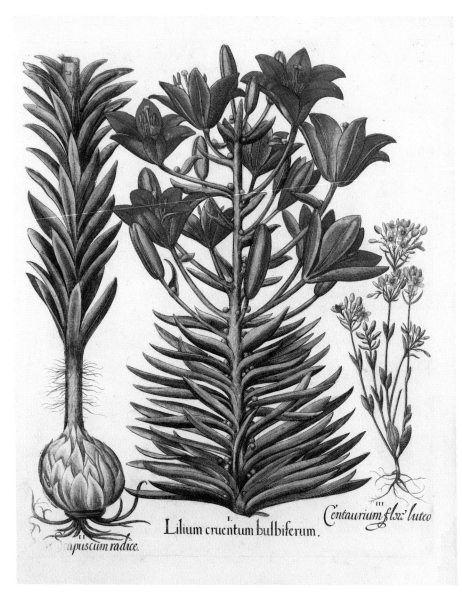

I. Lilium cruentum bulbiferum.

III. Centaurium flæ luteo

apuscum radice.

LILIUM BULBIFERUM SSP. BULBIFERUM	LILIUM BULBIFERUM SSP. BULBIFERUM	BLACKSTONIA SEROTINA
Bulbil-producing varietas with bulb	*Bulbil-producing varietas*	*Yellow-wort*

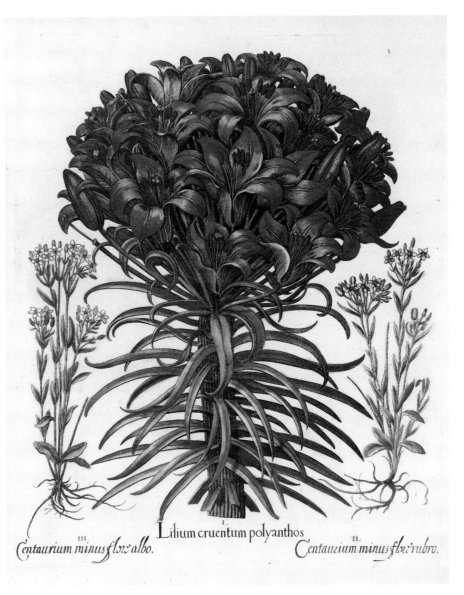

I.
Lilium cruentum polyanthos

III.
Centaurium minus flore albo.

II.
Centaurium minus flore rubro.

CENTAURIUM ERYTHRAEA,
II.–III.

Common centaury

LILIUM BULBIFERUM

Proliferation of fire lily

Plate 87 121

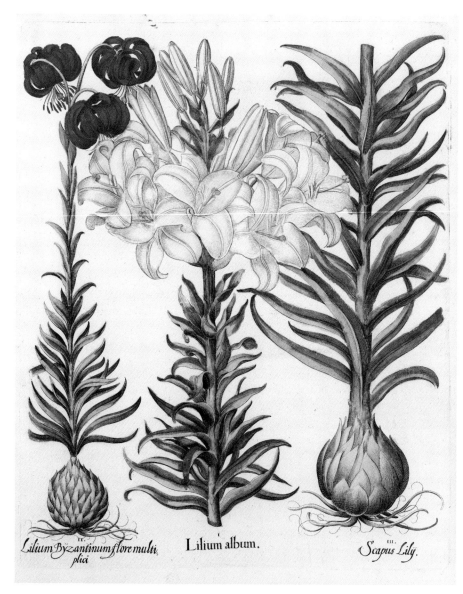

Lilium Byzantinum flore multi plici

Lilium album.

Scapus Lily.

LILIUM CHALCEDONICUM

Scarlet Turk's cap lily, Red martagon of Constantinople

LILIUM CANDIDUM, I., III.

Madonna lily, White lily

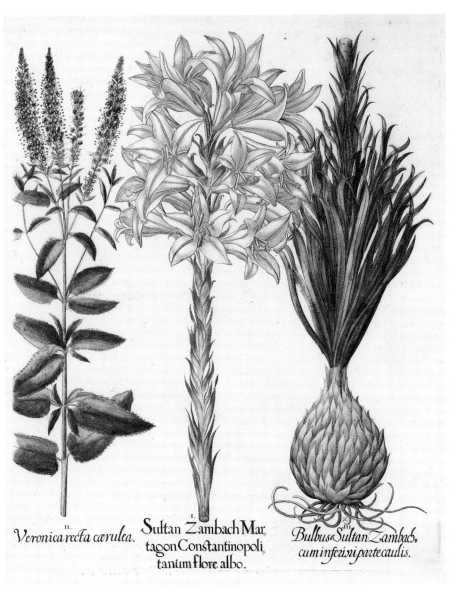

Veronica recta cærulea.

Sultan Zambach Mar-tagon Constantinopoli, tantum flore albo.

Bulbus Sultan Zambach, cum inferi,ni parte caulis.

VERONICA LONGIFOLIA
Speedwell, Bird's-eye

LILIUM CANDIDUM, I., III.
Madonna lily, White lily with bulb

Plate 89 123

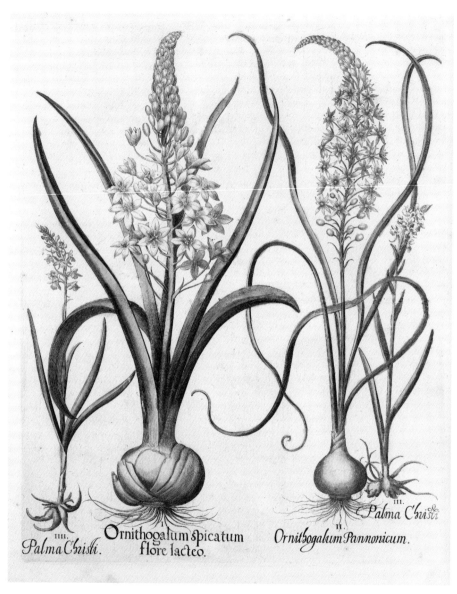

IIII.
Palma Christi.

I.
Ornithogalum spicatum
flore lacteo.

II.
Ornithogalum Pannonicum.

III.
Palma Christi.

GYMNADENIA
CONOPSEA, III.–IV.

Fragrant orchid

ORNITHOGALUM
PYRAMIDALE, I.–II.

Star-of-Bethlehem

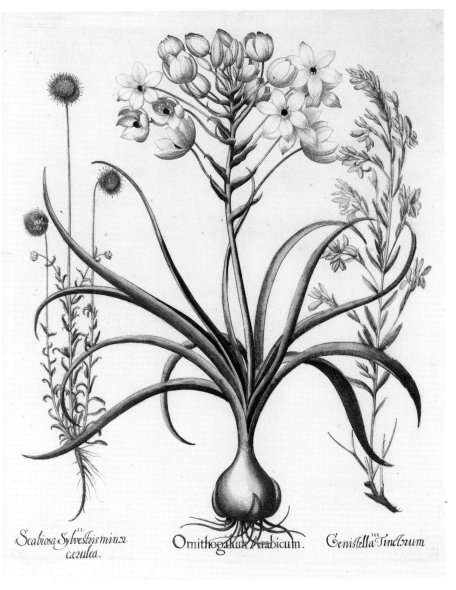

Scabiosa Sylvestris minx cærulea. *Ornithogalum Arabicum.* *Genistella Tinctorum*

JASIONE MONTANA ORNITHOGALUM ARABICUM GENISTA TINCTORIA
Sheep's bit *Star-of-Bethlehem* *Dyer's greenweed*

Plate 91 125

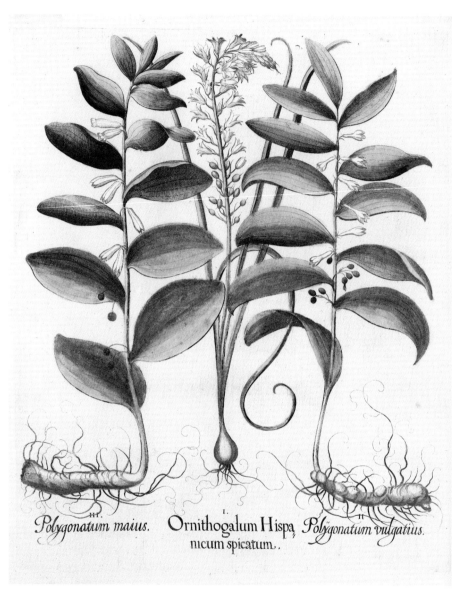

III. *Polygonatum maius.* I. Ornithogalum Hispa̧ nicum spicatum. II. *Polygonatum vulgatius.*

POLYGONATUM ODORATUM
Angled Solomon's seal

ORNITHOGALUM SPEC.
Star-of-Bethlehem

POLYGONATUM MULTIFLORUM
Solomon's seal

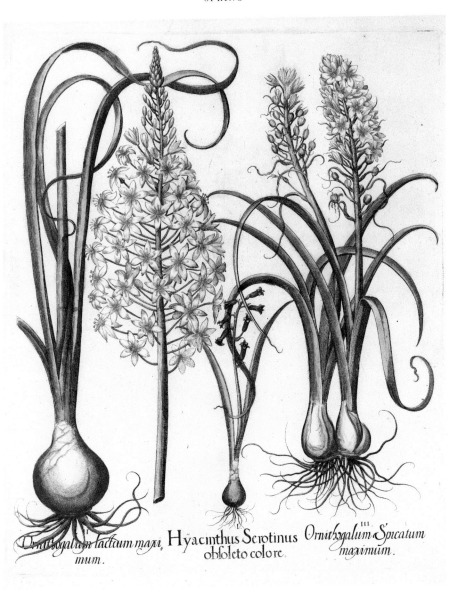

Ornithogalum lacteum maxi, Hyacinthus Serotinus *Ornithogalum Spicatum*
mum. obsoleto colore. maximum.

ORNITHOGALUM SPEC., II.–III. DIPCADI SEROTINUM
Star-of-Bethlehem *Light brown hyacinth*

Plate 93

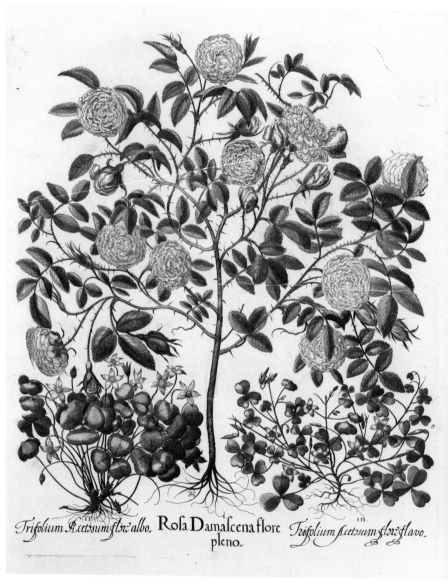

Trifolium Acetosum flore albo. **Rosa Damascena flore pleno.** *Trifolium acetosum flore flavo.*

OXALIS ACETOSELLA
*Wood sorrel, Cuckoo bread,
Alleluia*

ROSA SPEC.
White rose

OXALIS CORNICULATA
*Procumbent yellow sorrel,
Creeping oxalis*

Plate 94

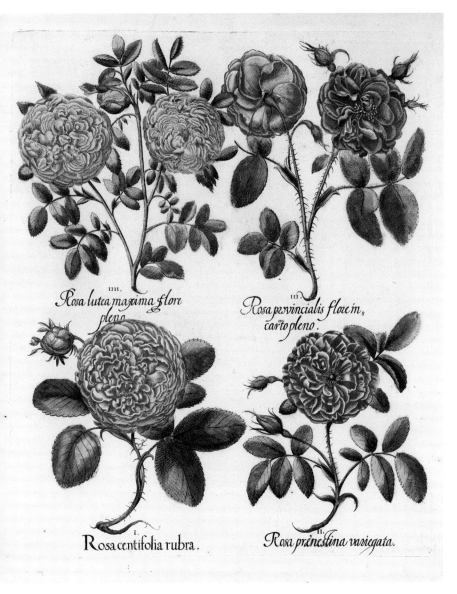

Rosa lutea maxima flore pleno

Rosa provincialis flore in carto pleno.

Rosa centifolia rubra.

Rosa prænestina variegata.

ROSA HEMISPHAERICA	ROSA CENTIFOLIA	ROSA GALLICA OFFICINALIS	ROSA GALLICA OFFICINALIS-VERSICOLOR
Sulphur rose	*Provence rose*	*Apothecary's rose, Red rose of Lancaster*	*Rosa mundi*

Plate 95

129

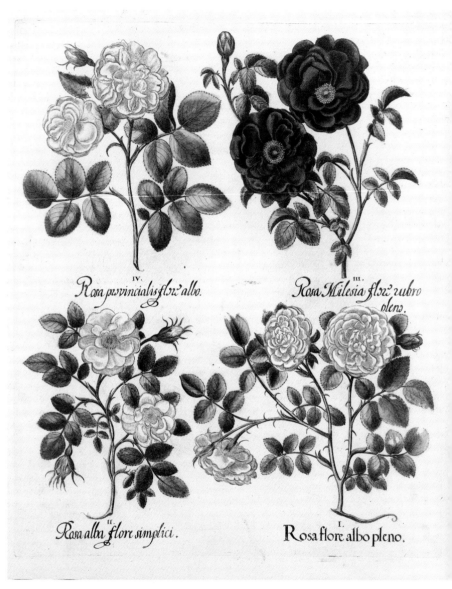

IV.
Rosa provincialis flore albo.

III.
Rosa Milesia flore rubro olens.

II.
Rosa alba flore simplici.

I.
Rosa flore albo pleno.

ROSA SPEC.	ROSA X ALBA	ROSA GALLICA	ROSA X ALBA
White rose	*Single white rose, Single white rose of York*	*Red rose, French rose*	*Double white rose, Double white rose of York*

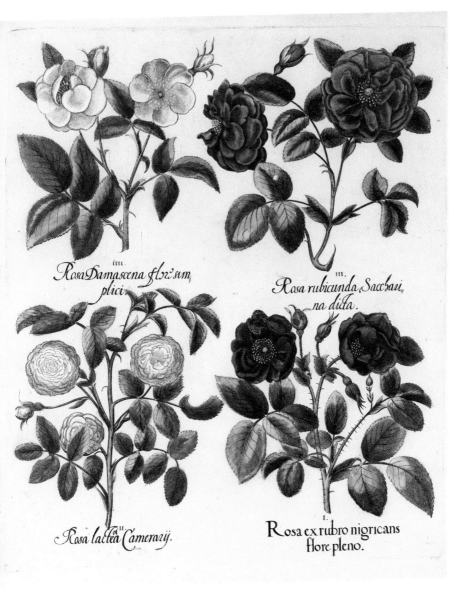

*Rosa Damascena flo.̃ sim,
plici.*

*Rosa rubicunda Sacchari,
na dicta.*

Rosa lactea Camerarij.

*Rosa ex rubro nigricans
flore pleno.*

ROSA SPEC.
*Single white rose,
Single white rose of
York*

ROSA SPEC.
*White wild rose with
semi-double flowers*

ROSA GALLICA
Red rose, French rose

ROSA TURBINATA
Dark red rose

Plate 97
131

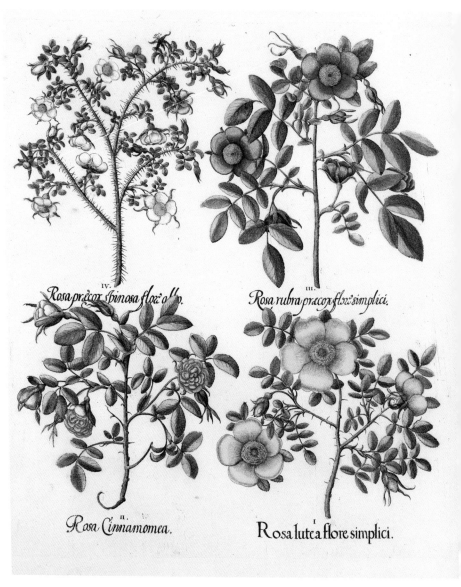

Rosa præcox spinosa flor̄ albo.

IV.

Rosa rubra præcox flor̄ simplici.

III.

Rosa Cinnamomea.

II.

Rosa lutea flore simplici.

I.

ROSA SPINOSISSIMA

Burnet rose,
Scotch rose

ROSA MAJALIS

Whitsuntide rose,
May rose

ROSA PENDULINA

Red Alpine rose

ROSA FOETIDA

Austrian yellow rose,
Austrian briar

Plate 98

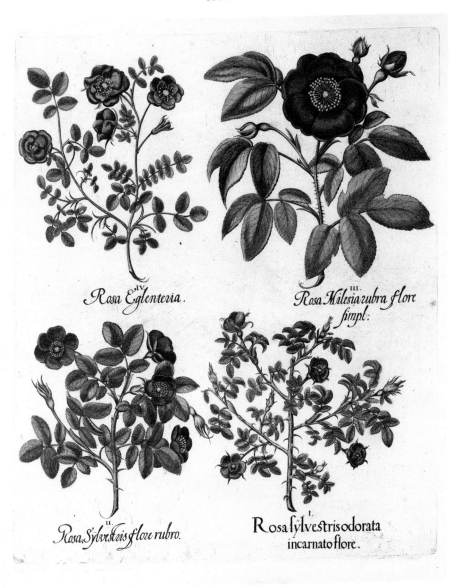

Rosa Eglenteria.

Rosa Milesia rubra flore simpl:

Rosa Sylvestris flore rubro.

Rosa sylvestris odorata incarnato flore.

ROSA RUBIGINOSA, I., IV.

Eglantine rose,
Sweet briar

ROSA CANINA

Dog rose, Common briar,
Dog briar

ROSA GALLICA

Red rose, French rose

Plate 99 135

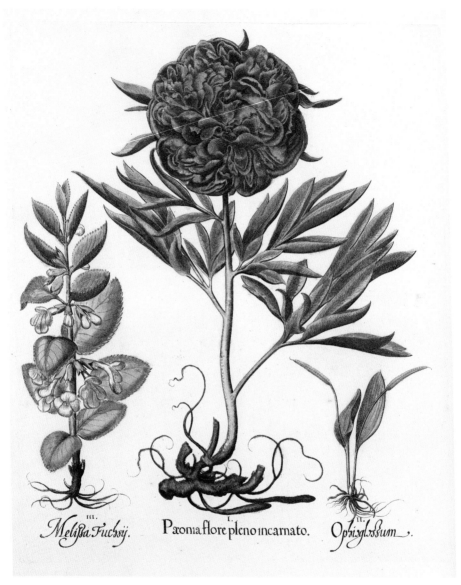

Melissa Fuchsij. *Pæoniaflore pleno incarnato.* *Ophioglossum.*

MELITTIS MELISSOPHYLLUM PAEONIA OFFICINALIS OPHIOGLOSSUM VULGATUM

Bastard balm *Double common peony* *Adder's tongue*

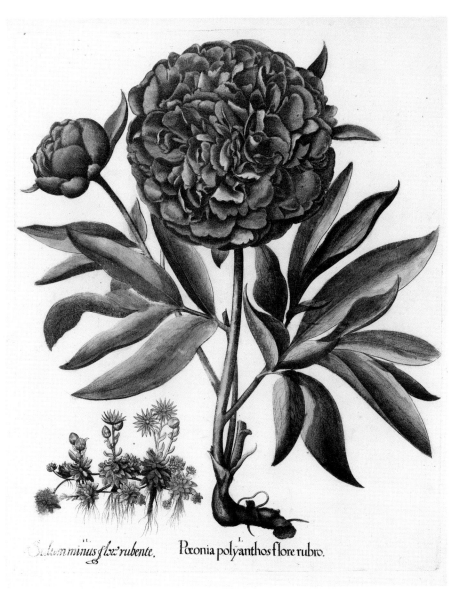

Sedum minus flor'rubente. *Pæonia polyanthos flore rubro.*

SEMPERVIVUM MONTANUM PAEONIA OFFICINALIS
Alpine houseleek *Double common peony*

Plate 101 135

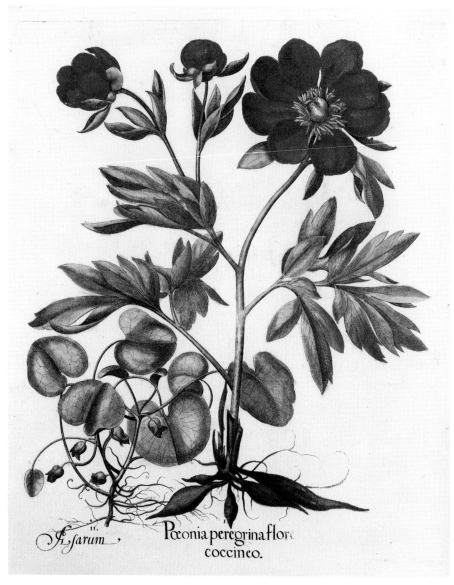

ASARUM EUROPAEUM
Asarabacca

PAEONIA OFFICINALIS
Single common peony

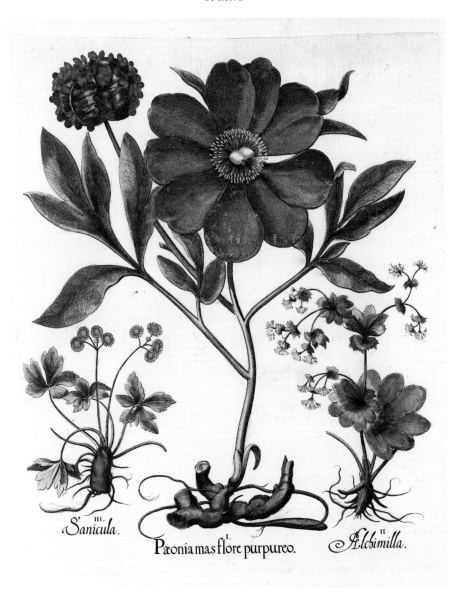

Sanicula. III.

Pæonia mas flore purpureo. I.

Alchimilla. II.

SANICULA EUROPAEA
Sanicle

PAEONIA MASCULA
Peony

ALCHEMILLA XANTOCHLORA
Lady's mantle

Plate 103 137

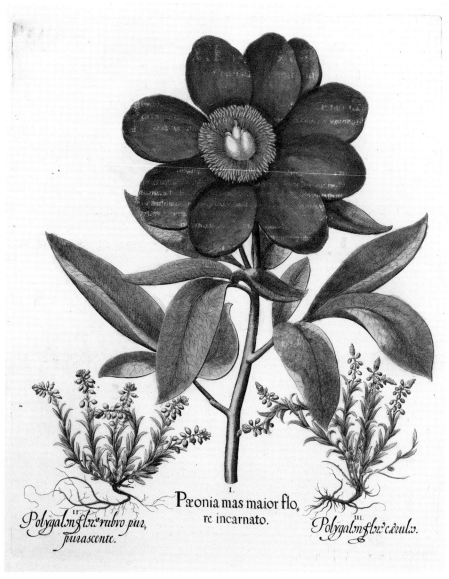

I.
Pæonia mas maior flo,
re incarnato.

II.
Polygalon flor: rubro pur,
purascente.

III.
Polygalon flor: cærul:.

POLYGALA VULGARIS
Gand flower, Milkwort

PAEONIA MASCULA
Peony

POLYGALA VULGARIS
Gand flower, Milkwort

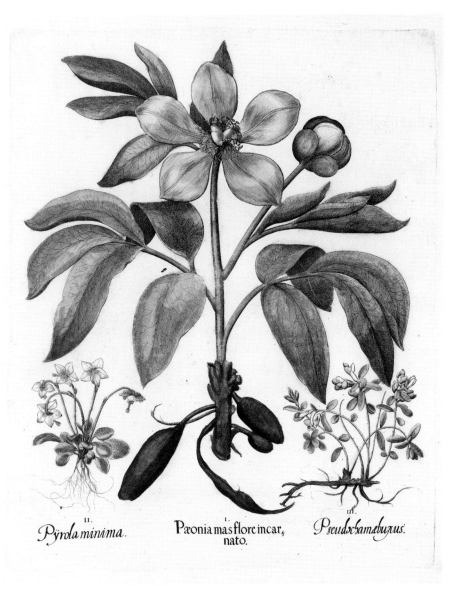

II.
Pyrola minima.

I.
*Pæonia mas flore incar,
nato.*

III.
Pseudochamæbuxus.

MONESES UNIFLORA

*Wood nymph, One-flowered
wintergreen*

PAEONIA MASCULA

Peony

POLYGALA CHAMAEBUXUS

Gand flower, Milkwort

Plate 105 139

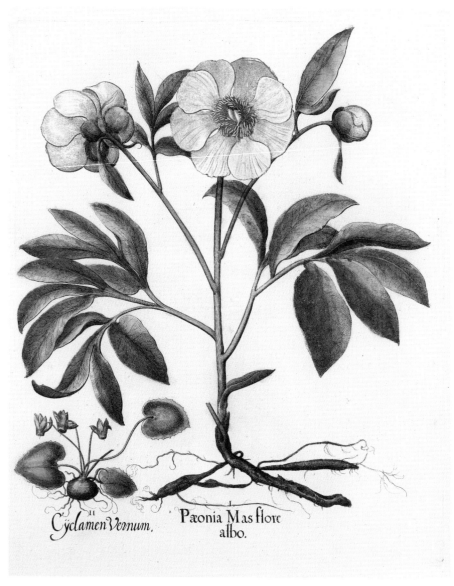

Cyclamen Vernum. Pæonia Mas flore albo.

CYCLAMEN REPANDUM

Persian violet, Alpine violet,
Sowbread

PAEONIA MASCULA

Peony

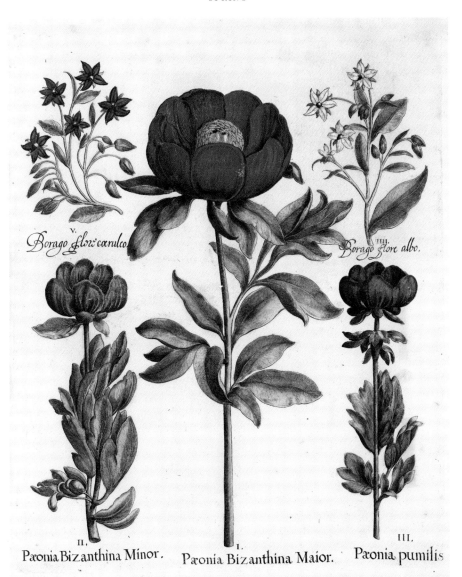

Borago flor' cærulco V.

Borago flore albo. IIII.

II.
Pæonia Bizanthina Minor.

I.
Pæonia Bizanthina Maior.

III.
Pæonia pumilis

BORAGO OFFICINALIS,
IV.–V.
Tailwort, Borage

PAEONIA PEREGRINA,
I.–III.
Common peony

Plate 107 141

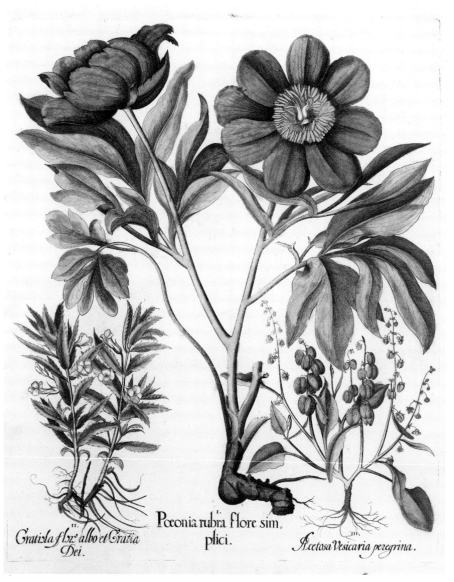

Gratiola flor: albo et Gratia
Dei.

Pœonia rubra flore sim
plici.

Acetosa Vesicaria peregrina.

GRATIOLA OFFICINALIS
Hedge hyssop, Gratiole

PAEONIA OFFICINALIS
Common peony

RUMEX VENOSUS
*Sheep's sorrel, Wild begonia, Wild
hydrangea, Sour greens*

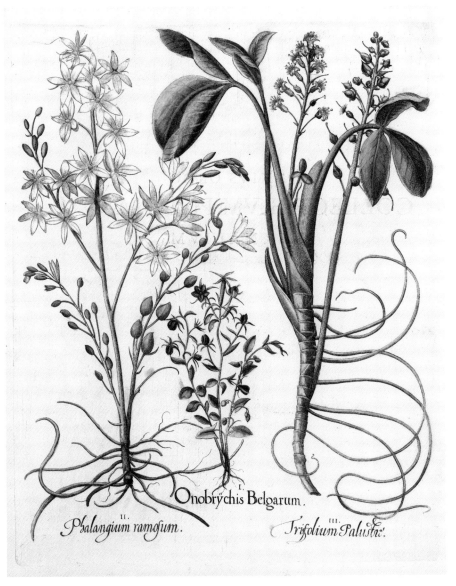

I.
Onobrÿchis Belgarum.

II.
Phalangium ramosum.

III.
Trifolium Palustre.

ANTHERICUM RAMOSUM	LEGOUSIA SPECULUM-VENERIS	MENYANTHES TRIFOLIATA
Ramified antheric	*Venus' looking glass*	*Bog bean, Buck bean, Marsh trefoil*

Plate 109

143

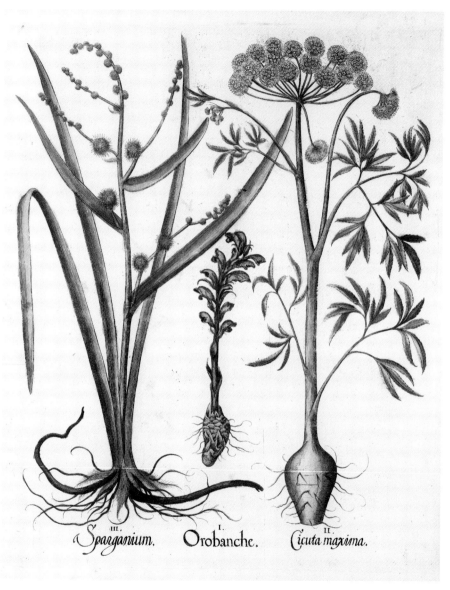

III.
Sparganium.

I.
Orobanche.

II.
Cicuta maxima.

SPARGANIUM ERECTUM
Ramified bur-reed

OROBANCHE SPEC.
Broomrape

CICUTA VIROSA
Long-leaved cowbane

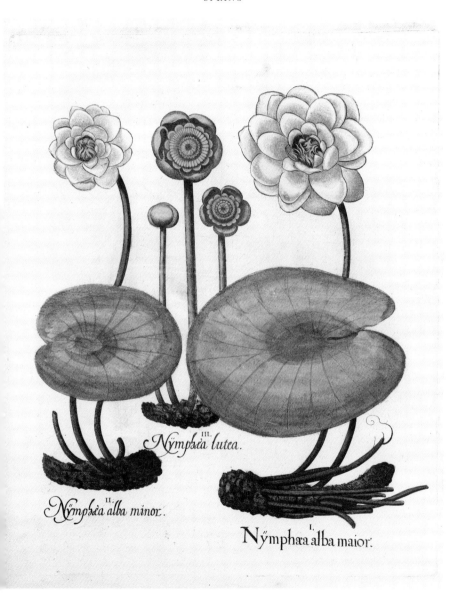

NYMPHAEA ALBA, I.–II.
European white water lily

NUPHAR LUTEA
Yellow water lily, Brandy bottle

Plate 111

145

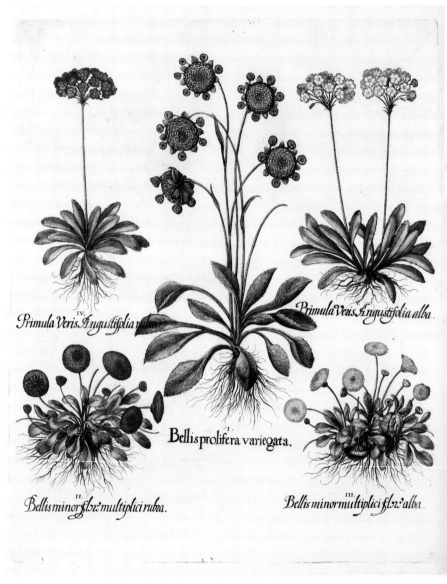

Primula Veris Angustifolia nubra

Primula Veris Angustifolia alba

Bellis prolifera variegata.

II.
Bellis minor flo: multiplici rubra.

III.
Bellis minor multiplici flo: alba.

BELLIS PERENNIS, II.–III.
Common daisy

BELLIS PERENNIS
Common daisy

PRIMULA FARINOSA, IV.–V.
*Mealy primrose, Bird's-eye
primrose*

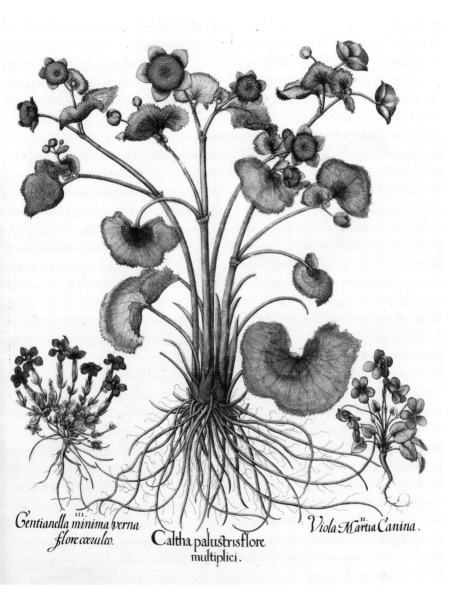

Gentianella minima verna
flore cœruleo.

Caltha palustris flore
multiplici.

Viola Martia Canina.

GENTIANA VERNA
Spring gentian

CALTHA PALUSTRIS
Kingcup, Marsh marigold,
Meadow bright, May-blob

VIOLA CANINA
Dog violet, Heath violet

Plate 113

147

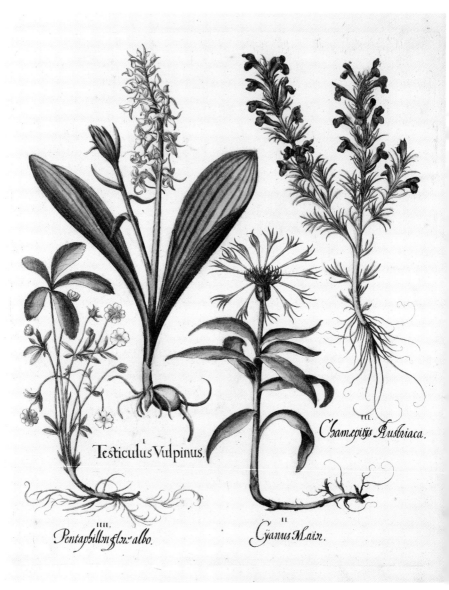

Testiculus Vulpinus.

Chamæpitys Austriaca.

Pentaphillon flx: albo.

Cyanus Maior.

POTENTILLA ALBA	PLATANTHERA SPEC.	CENTAUREA MONTANA	DRACOCEPHALUM AUSTRIACUM
Cinquefoil, Five-finger	*Butterfly orchid*	*Perennial cornflower*	*Dragon's head*

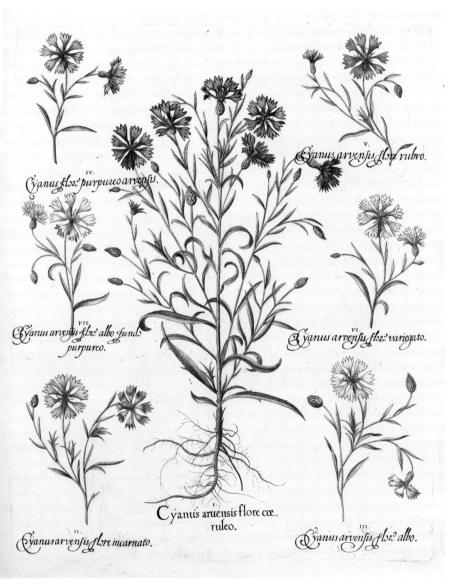

v.
Cyanus arvensis flore rubro.

IV.
Cyanus flos purpureo arvensis.

VII.
Cyanus arvensis flore albo fundo purpureo.

VI.
Cyanus arvensis flore variegato.

I.
Cyanus aruensis flore coeruleo.

II.
Cyanus arvensis flore incarnato.

III.
Cyanus arvensis flore albo.

CENTAUREA SPEC.,
II.–VII.

Knapweed, Star thistle

CENTAUREA
CYANUS

Cornflower,
Blue-bottle

Plate 115 149

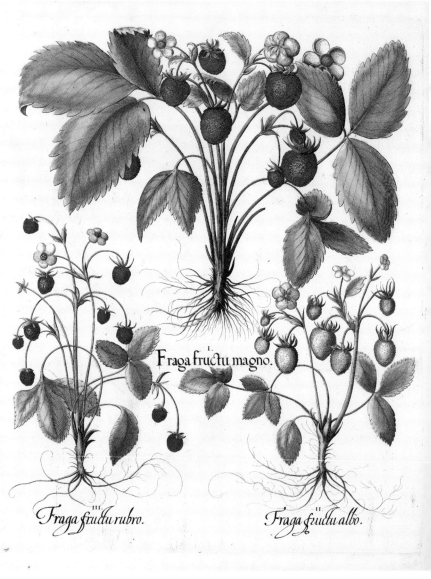

I.
Fraga fructu magno.

III.
Fraga fructu rubro.

II.
Fraga fructu albo.

FRAGARIA SPEC.
Small-fruited strawberry

FRAGARIA SPEC.
Large-fruited Strawberry

FRAGARIA SPEC.
White-fruited strawberry

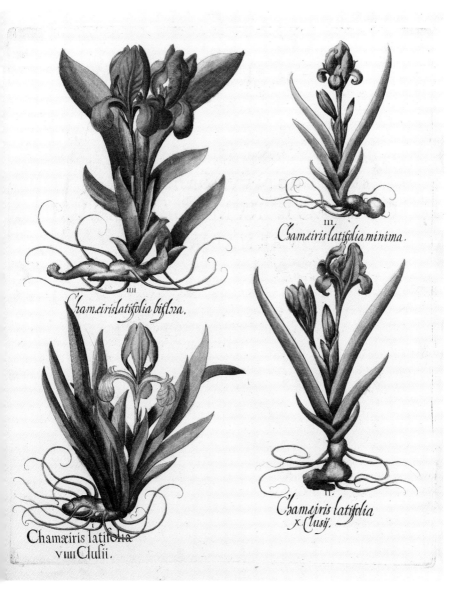

III.
Chamæiris latifolia minima.

IIII.
Chamæiris latifolia biflora.

II.
Chamæiris latifolia
x Clusij.

I.
Chamæiris latifolia
vini Clusii.

IRIS PUMILA

Blue dwarf
bearded iris

IRIS PUMILA

Dwarf bearded iris
with multi-coloured
flowers

IRIS PUMILA

Bright yellow dwarf
bearded iris

IRIS PUMILA

Dark red dwarf
bearded iris

Plate 117

151

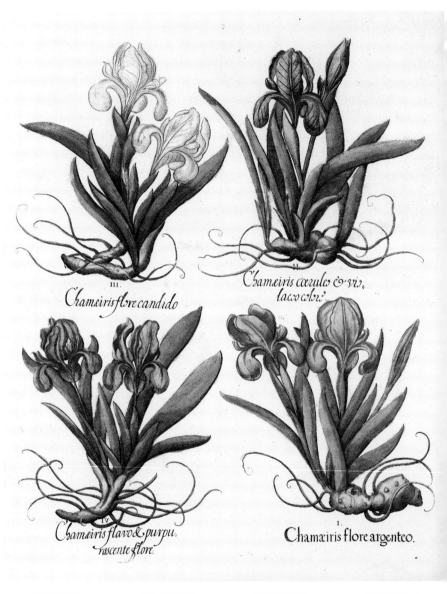

III.
Chamæiris flore candido

II.
Chamæiris cœrules & vio-laco colore

IV.
Chamæiris flavo & purpu-rascente flore

I.
Chamæiris flore argenteo.

IRIS PUMILA
*White dwarf
bearded iris*

IRIS PUMILA
*Dwarf bearded iris
with multi-coloured
flowers*

IRIS PUMILA
*Mid-blue dwarf
bearded iris*

IRIS PUMILA
*Silver-white dwarf
bearded iris*

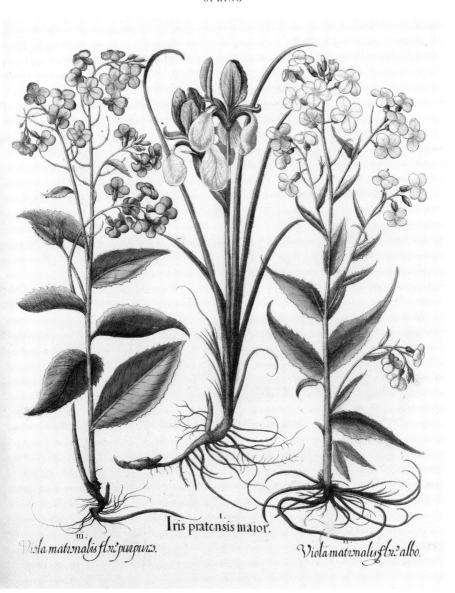

Iris pratensis maior.

Viola matronalis flo: purpureo.

Viola matronalis flo: albo.

HESPERIS MATRONALIS, II.–III.

*Damask violet, Dame's
violet, Sweet rocket*

IRIS SIBIRICA

Siberian iris

Plate 119

153

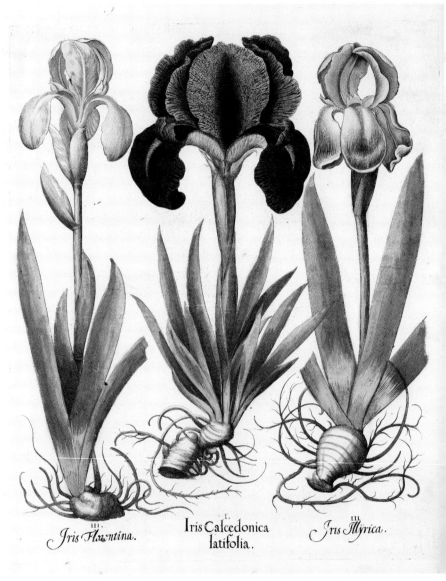

Iris Florentina. *Iris Calcedonica latifolia.* *Iris Illyrica.*

IRIS FLORENTINA
Orris root

IRIS SPEC.
Iris

IRIS PALLIDA
Dalmatian iris

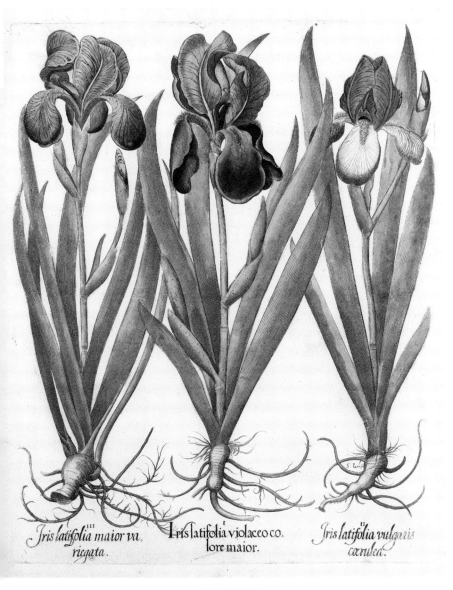

Iris latifolia maior va. riegata.

Iris latifolia violaceo co. lore maior.

Iris latifolia vulgaris cœrulea.

IRIS GERMANICA
German iris

Plate 121

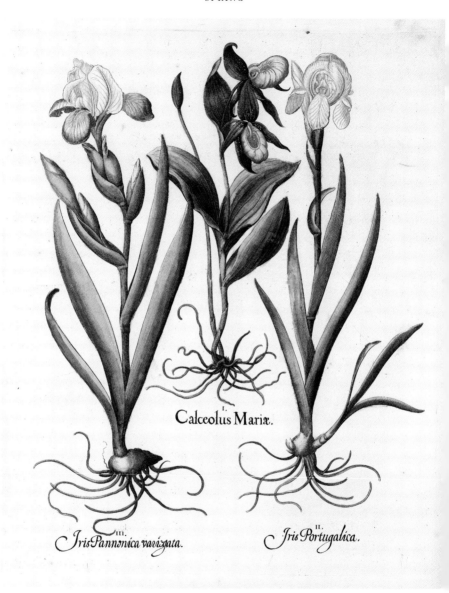

Calceolus Mariæ.

Iris Pannonica variegata.

Iris Portugalica.

IRIS SPEC.

*Variegated iris with multi-
coloured flowers*

CYPRIPEDIUM CALCEOLUS

Lady's slipper orchid

IRIS SPEC.

Iris

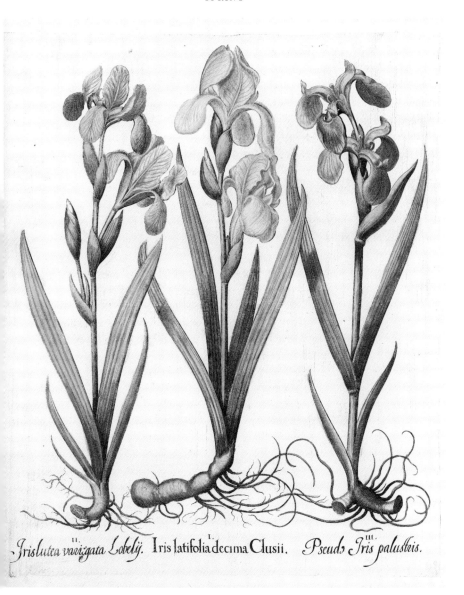

Iris lutea variegata Lobelij. *Iris latifolia decima Clusii.* *Pseud. Iris palustris.*

IRIS VARIEGATA IRIS PALLIDA IRIS PSEUDOACORUS
Variegated iris *Dalmatian iris* *Yellow flag*

Plate 123 157

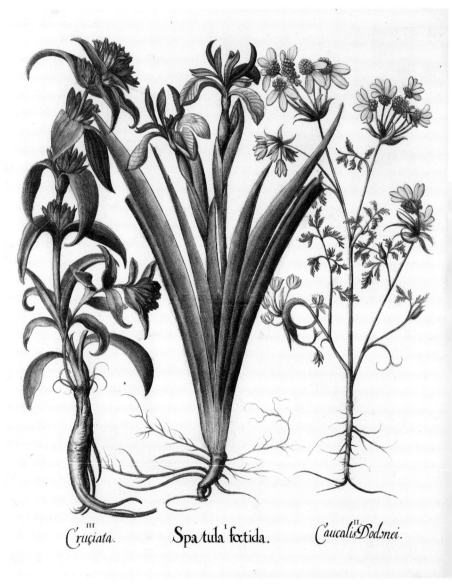

Cruçiata. Spatula foetida. *Caucalis Dodonei.*

GENTIANA CRUCIATA
Crosswort gentian

IRIS FOETIDISSIMA
*Roast beef plant,
Gladwyn, Gladdon iris,
Stinking gladwyn*

ORLAYA GRANDIFLORA
Orlaya

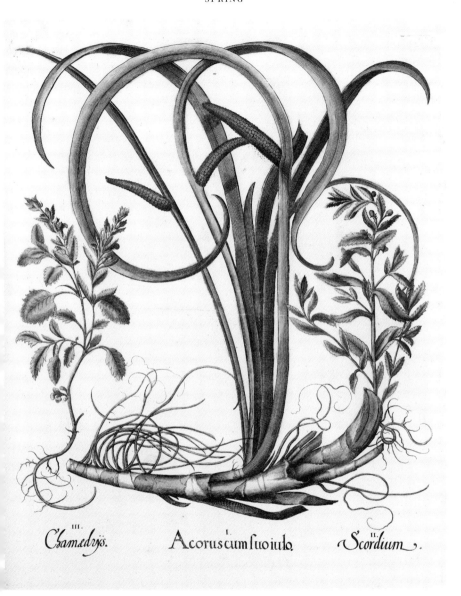

Chamedrys. *Acorus cum suo iulo.* *Scordium.*

III. I. II.

TEUCRIUM CHAMAEDRYS ACORUS CALAMUS TEUCRIUM SCORDIUM
Wall germander *Sweet flag,* *Water germander*
Sweet calamus, Myrtle flag,
Calamus, Flagroot

Plate 125

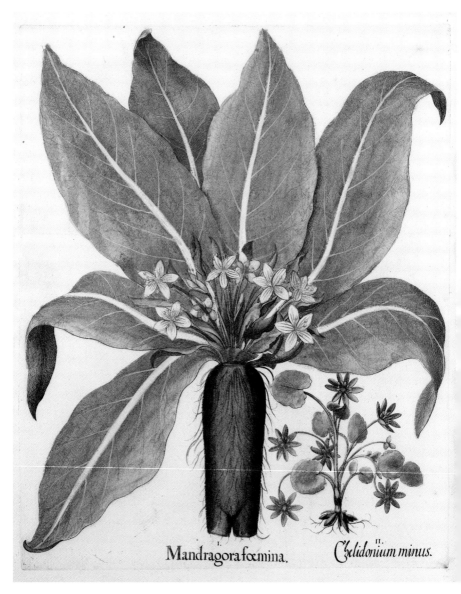

Mandragora fœmina. Chelidonium minus.

MANDRAGORA AUTUMNALIS RANUNCULUS FICARIA
Autumn mandrake *Lesser celandine,*
 Pilewort

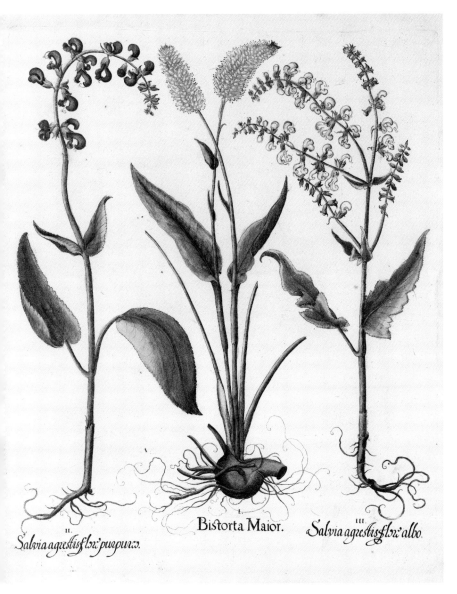

II.
Salvia agrestis flƷ: purpur.Ʒ.

I.
Bistorta Maior.

III.
Salvia agrestis flƷ: albo.

SALVIA PRATENSIS
Blue meadow clary

POLYGONUM BISTORTA
*Bistort, Snakeweed,
Easter ledges*

SALVIA PRATENSIS
White meadow clary

Plate 127

161

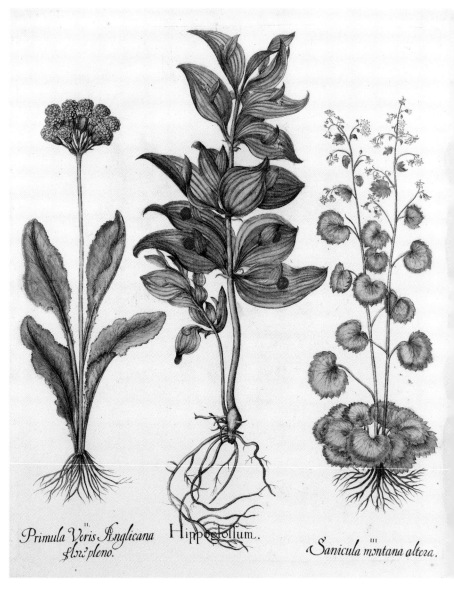

Primula Veris Anglicana flo: pleno. *Hippoglossum.* *Sanicula montana altera.*

PRIMULA SPEC.	DANAË RACEMOSA	SAXIFRAGA ROTUNDIFOLIA
Primrose, double form	*Alexandrian Laurel*	*Round-leaved saxifrage*

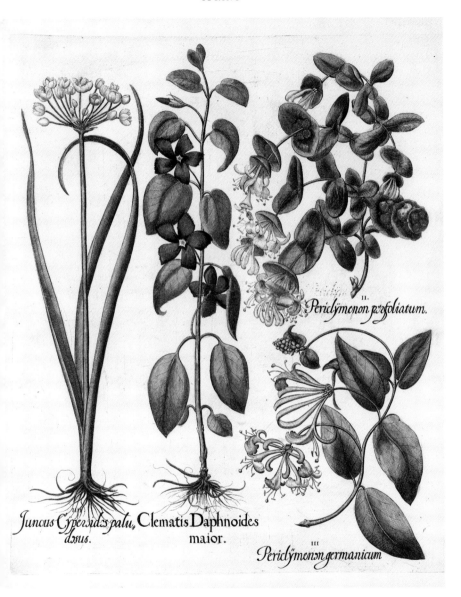

Juncus Cyperoides palu, Clematis Daphnoides dosus. maior.

II. Periclymenon perfoliatum.

III. Periclymenon germanicum

BUTOMUS UMBELLATUS	VINCA MAJOR	LONICERA CAPRIFOLIUM	LONICERA PERICLYMENUM
Flowering rush, Water gladiolus, Grassy rush	*Greater periwinkle*	*Italian woodbine, Italian honeysuckle*	*Woodbine, Honeysuckle*

Plate 129

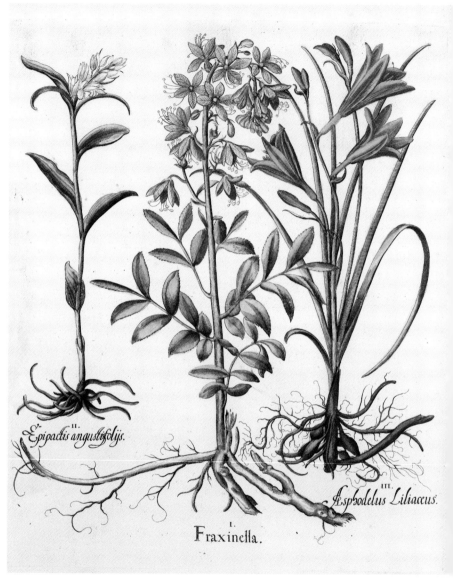

Epipactis angustifolijs.

Asphodelus Liliaceus.

I.
Fraxinella.

CEPHALANTHERA
DAMASONIUM

White helleborine

DICTAMNUS
ALBUS

Dittany, Burning bush

HEMEROCALLIS
LILIOASPHODELUS

Yellow day lily

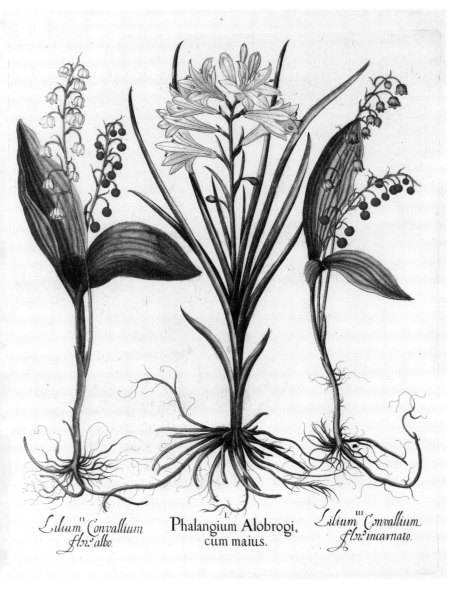

Lilium II *Convallium flxe: albo.*

Phalangium Alobrogi, cum maius.

Lilium III *Convallium flxe: incarnato.*

CONVALLARIA
MAJALIS

Milk blue lily of the valley

PARADISEA
LILIASTRUM

St Bruno's lily, Paradise lily

CONVALLARIA
MAJALIS

Pink lily of the valley

Plate 131 165

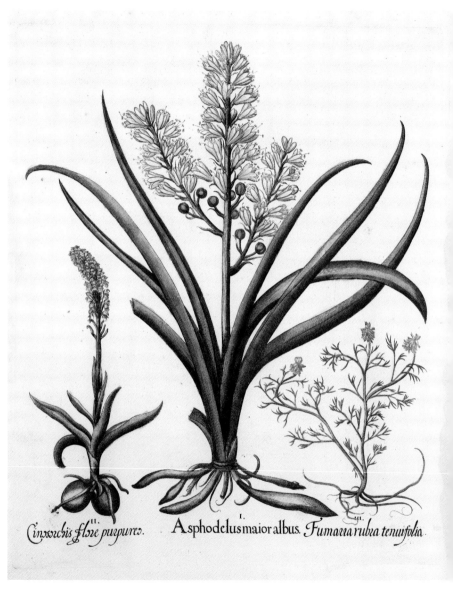

Cinsorchis flore purpureo. Asphodelus maior albus. Fumaria rubra tenuifolia.

ORCHIS USTULATA ASPHODELUS RAMOSUS FUMARIA SPICATA
Burnt orchid *Asphodel* *Fumitory*

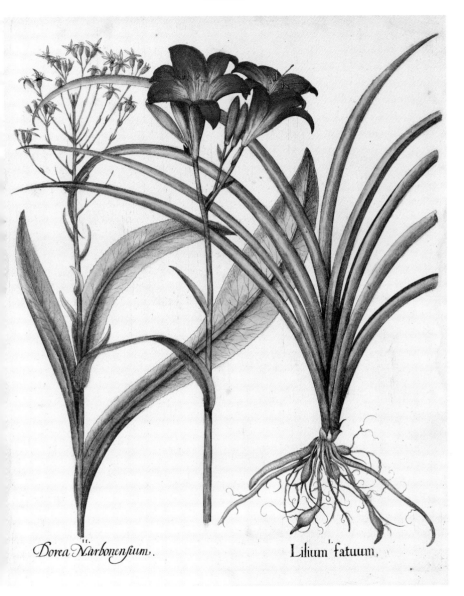

Dorea Narbonensium.

Lilium fatuum.

SENECIO DORIA
Groundsel

HEMEROCALLIS FULVA
Red-yellow day lily

Plate 133

167

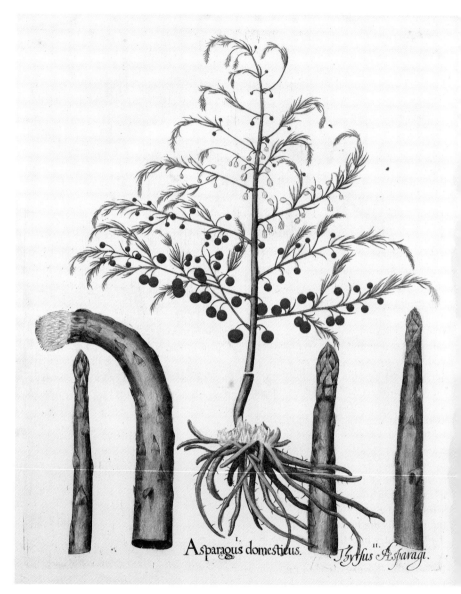

I.
Asparagus domesticus.

II.
Thyrsus Asparagi.

ASPARAGUS OFFICINALIS
*Asparagus with flowers
and fruits*

ASPARAGUS OFFICINALIS
Spears of asparagus

 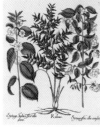 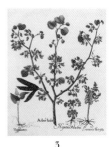

1 2 3

SPRING TREES AND SUBSHRUBS
PLATE 1

The first illustration in the Eichstätt picture gallery is an unspectacular but horticulturally important ornamental shrub, the box tree (1, I). It is known almost exclusively in the form of a clipped and shaped bush or living flower-bed edging rather than a tree, and it was indeed valued as evergreen hedging by gardeners as early as Roman and medieval times. By the time of the Renaissance and Baroque gardens, it had become an indispensable element of the large estates of the nobility. Its fine-grained, hard wood, which is also excellent for turning, is also highly prized by wood carvers. In the past, the leaves were even used for medicinal purposes as a laxative and antipyretic.

Towering above the box – and not only on the plate – is the lilac (1, II and III), which made its entry into German gardens from Asia in the second half of the 16th century. Besler uses flower colour to differentiate between the two types of *Syringa*, which he calls *Spanisher Springsbaum* (Spanish syringa tree): he calls those on the left-hand branch ash-coloured or silver, while those on the right-hand branch he calls blue.

PLATE 2

The same Latin name *Syringa* occurs on the next plate (2, II and III), but it is immediately apparent that this is not a genuine lilac, although its flowers are also very fragrant. Today the plant is generally referred to as mock orange. There were already two different white-flowering forms in the Eichstätt garden, one with single flowers (2, III) and the other with double (2, II). Butcher's broom (2, I) occurs in the wild in southern Europe and is familiar to us today primarily in dried flower arrangements. It is a popular choice because of its red berries and the contrasting dark green of its distinctive "leaves", which are actually green cladophylls (flattened leaf-like shoots). Extracts from the rhizome of this member of the Ruscaceae family are also valued in medications to constrict the capillaries and strengthen the veins.

PLATE 3

A particularly striking feature of the Judas tree (3, I), a representative of the carob family indigenous to the Mediterranean and Near East, is the phenomenon of "cauliflory", whereby flowers are produced

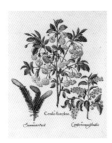 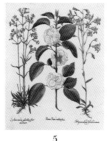

4 5

directly from the branches. The pinky red flowers, which appear in April before the leaves unfold, are borne in small groups directly from the bare wood. The plant acquired its strange name because Judas is alleged to have hanged himself from this tree. However, this is also said to be true of the indigenous elder tree.

The little false lily of the valley (3, II), a graceful shade-lover, brings life to the shady ground in deciduous woods. It has only two leaves, between which the white clusters of flowers stretch skywards.

The common moonwort (3, III), a fern related to the adder's tongue fern, and which gets its name from the half-moon shape of its leaves, is not much taller, and even the golden saxifrage (3, IV), with its inconspicuous yellow flowers, rarely grows to a height of more than 20 cm.

Plate 4

The composition of plate 4 may seem very strange, since the beautiful flowering cherry or bird cherry (4, I and II) is very different from the little spruce branch (4, III). It is rather puzzling that the Norway spruce should find any place at all in the Bishop's magnificent garden,

which otherwise makes a great display of choice plants. The cherry, long popular for its edible fruits, is one of the relatively old cultivated plants that has been considerably improved by crossing two species – the sweet bird cherry and sour Saint Lucie cherry. As with most hardy top-fruits, in botanical terms they belong to the rose family. Breeding has "doubled" their five white petals, which grow in bunches, albeit at the expense of edible fruits.

Cherry blossom is particularly important in Japanese culture. However, cherries are also found in the late Middle Ages and the Renaissance in pictures of the Christ Child, which show the child enjoying the sweet fruits, while the blood-red juice foretells the suffering of the Passion. The bird cherry, with its clusters of blossom, is not grown for its fruit but solely for its ornamental value.

Plate 5

Traces of apples (5, I) have been found in the remains of human settlements dating from prehistoric times. Although they originated from wild forms with very small, inconspicuous fruits, a wide range

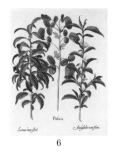

6

of apples with a high nutritional value and good flavour was subsequently deliberately bred. Their German names are mentioned in documents dating back to the time of Charlemagne. The fateful mention of the apple in the Bible led to its becoming a symbolic fruit, often appearing in pictorial art. Besler illustrates the branch of a double hybridised form. The German catchfly (5, II) with its five red petals is a very familiar sight in German meadows. Its common name alludes to its sticky secretions, contact with which costs many an insect its life. Besler's name for *Campanula patula* (5, II) is *Wilde Rapuntzel mit purpurweißen Blumen* (wild corn salad with purple-white flowers). This is the first time a bellflower appears in the *Hortus*, although many more plates are devoted to them in the summer section (plates 151–156, 216, 301).

PLATE 6

Plate 6 presents three plants whose fruits and/or seeds are still valued today for their flavour. The pistachio (6, I) was a highly valued medicinal plant even in Classical times, when not only the fruits and leaves, but also the bark and the root were used for medicinal purposes. Particularly sought after, however, was the resin, which flowed from incisions made in the trunk. It was used in its solidified form (mastic) as an ingredient in medicines and cosmetics, and was also processed for technical applications such as adhesives, lacquers and varnishes. The best sort came from the island of Chios in the Aegean Sea, where mastic was also used as a strong-tasting resin for flavouring wines. The plant's green, almond-shaped, oil-rich nuts have been used in cooking and in confectionery for their aromatic flavour, similar to that of the almond.

In this respect, it is no coincidence that the almond (6, III) is shown on the same page. Two varieties of this tree are still planted today: the sweet and the bitter almond. The sweet almond is used almost entirely for food production, such as marzipan, while, because of their toxic nature, the nuts of the bitter almond are used only to flavour liqueurs and in the perfume industry. In the garden, they are of interest primarily for their attractive early blossom; many ornamental varieties, some with double flowers, have been produced.

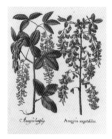
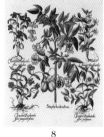

7 8

The botanical Latin name of the bay tree, *Laurus nobilis* (literally "noble laurel"), is an indication of the high regard in which this plant, indigenous to the Mediterranean region, has long been held. A mythological scene frequently depicted in art is associated with the bay laurel (6, II). When Apollo chased the nymph Daphne, making her fear the loss of her virginity, she invoked the goddess Gaea, who instantly changed her into a bay tree. This striking plant therefore became an emblem of the otherwise highly regarded god, who was also the patron of the sciences, poets and artists. His followers were therefore honoured by being awarded the laurel wreath, which also adorned the *poeta laureatus*. Even today, the laurel is still a sign of outstanding intellectual or creative achievement. The bay laurel, particularly green bay tree oil, is also important in medicine, cosmetics and indeed cooking. It would be hard to imagine some dishes without the distinctive flavour of this aromatic herb.

PLATE 7

Because of its strikingly large, vividly coloured flowers, the laburnum (7, I) is still a popular ornamental tree in parks and gardens of today, even though it is poisonous. The Scotch laburnum (7, II) is depicted here with considerably larger leaves and fuller inflorescences. This plant was introduced into gardens at the end of the 16th century, a good 30 years after the other species. Besler called the two species illustrated here the *Linsenbaum* and *Baumbohnen* (tree bean), because of their pealike flowers. Various hybridised forms of these two species are available today.

PLATE 8

In the centre of plate 8, surrounded by four lesser periwinkles (8, II–V), stands a branch of the pinnate bladdernut (8, I), a shrub or small tree native to central and southern Europe as far as the Middle East, but which also occasionally occurs in southern Germany. The imparipinnate leaves contrast attractively with the white blossoms, which hang down in clusters. The seeds are contained inside inflated but thin-walled capsules and are

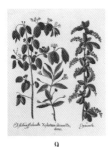 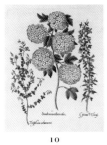

9 10

dispersed with the balloon-like pod by the wind.

Even though it belongs to the dog's-bane family, there is no need to be wary of the lesser periwinkle. Sharp eyes are necessary to discern its blue flowers, however, which appear early on in the season, for although *Vinca minor* produces long stems, these trail over the ground and are easily hidden among the fallen leaves and undergrowth of sunny marginal areas of woods.

PLATE 9

The German common name of the indigenous honeysuckle (9, I and II), *Hecken-kirsche* (hedge cherry) implies that it produces edible cherries, but its name relates solely to the appearance of its red fruits. The fly honeysuckle (9, II) is particularly widespread in Germany. The botanical name used today, *Lonicera*, honours Adam Lonitzer (1528–1586), a German doctor and botanist who latinised his name to Lonicerus. He became famous as the author of a herbal, which went into many impressions.

The common barberry (9, III) is the sole representative of this large genus that is indigenous to Europe. The German name *Sauerdorn* (sour thorn) corresponds with its old name *Oxyacantha*, under which the bark and fruits in particular were used in medicine for diarrhoea and stomach ailments, and also as remedies for liver and gallbladder complaints. In the past, the plant's yellow dye was used for dyeing wool. As the barberry acts as a host plant for wheat rust or *puccinia*, a fungus harmful to wheat, its cultivation has now been greatly restricted, and in some areas is even illegal. As the number three has magical connotations, its triple thorns led to the superstition that branches cut from it under certain specific conditions would ward off evil and protect against insect bites.

PLATE 10

The snowball bush (10, I) used to be called *Sambucus arbor rosea*, or rose elder tree, because of its similarity to theelder tree, which also belongs to the Caprifoliaceae family. The shrub, which is indigenous to Europe and Asia, gets its name from its spherical cymes of white blossom, but its decorative autumn leaf colour also makes it clear why, with its

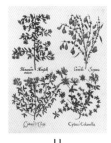
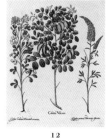

11 12

many varieties and forms, it has long had an established place in gardens.

Cytisus sessilifolius (10, II) has two distinctive features: its yellow pealike flowers, and its 3-palmate leaves, which are of various sizes and arise directly from the stalk. These leaves gave the plant, which grows to over 1 m tall, its old name, *Trifolium arborescens* (tree clover).

Cytisus ciliatus (10, III) is closely related in botanical terms to the broom and is native to the Mediterranean region and south-east Europe.

PLATE 11

Plate 11 presents three more plants with pealike flowers. The hairy canary clover (11, I) and another dwarf broom variety (11, II) also belong to this extremely large family, as does the common broom (11, III). This sheds its leaves early, exposing the bare twigs, and therefore, as its name suggests, really is extremely suitable for making brooms. Its generic name, *Sarothamnus*, from the Greek, meaning broom bush, also refers to this. The plant is still used today in pharmaceutical preparations to raise blood pressure and in cases of irregular heartbeat.

While the jasmine came to Europe from Asia in the 16th century, *Jasminum fruticans* (11, IV), illustrated here, grows in the Mediterranean region. As its leaves also occur in threes, it was previously included in the *Trifolium* genus, despite the fact that its flowers showed that it was clearly not related!

PLATE 12

Lembotropis nigricans (12, III) provides another broom for this *Trifolium* group. It gets its German name *Schwärzender Geißklee* (blackening trefoil) from the fact that it turns black when dry.

The moon trefoil (12, II) reached the Mediterranean region from Asia in Classical times, when it was used as cattle fodder. The strangely spiralling shape of the seedpods is particularly striking.

The bladder senna (12, I) became established as a garden plant at the end of the 16th century, primarily because of its curious fruit formation. The seedpod develops from the golden yellow flower and looks transparently thin, as well as appearing to be inflated. As is the case with the bladdernut (8, I), this phenomenon helps wind-dispersal of the seed.

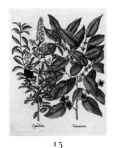 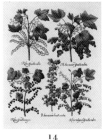 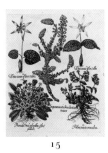

13 14 15

PLATE 13
Under the name *Guajacanum*, Besler is apparently presenting one of the much-used medicinal plants of his day, because guajak wood concoctions and resin preparations have been used in large quantities since the 16th century as a remedy for syphilis, as well as for gout and rheumatism. The plant illustrated here is not, however, a member of the American Zygophyllaceae, but an Asian species from the Ebenaceae family, known as the date plum (13, I).

The common privet (13, II) belongs to the indigenous Oleaceae family and is a close relative of the lilac (1, II and III), although its dark green leaves are much narrower and the white clusters of flowers are considerably smaller. The poisonous black berries were used in the past to make blue and black dye.

PLATE 14
The currant bushes of the Saxifragaceae family fill the last plate of spring-flowering trees and shrubs. The delicate appearance of the mountain or alpine currant (14, I) with its red fruits distinguishes it from the red currant (14, II, IV and V) – including a white-fruited variety – and the black currant (14, III). The shrubs have been cultivated for their sour-tasting berries since the 15th century. The leaves of the black currant have an unpleasant smell, but the fruits are rich in vitamin C.

1ST ORDER OF SPRING
PLATE 15
The toothwort (15, I), a member of the Scrophulariaceae family, grows as a parasite without the chlorophyll that other plants produce to survive. It taps into the roots of suitable host plants and thus gets the nutrients it needs "on tap". The rootstock is pale and densely covered with scales, while the flowers and the stem are a reddish colour. The plant, which is indigenous to Germany, could not have earned a place in the *Hortus Eystettensis* for its rarity: the garden's creator must have taken a fancy to its curious appearance. It may be that the toothwort is shown on this plate between the two European dog's tooth violets (15, II and III) purely because of the name used in the text for the toothwort, *Dentaria*, which, like the English common name, refers to its tooth-like scales. The dog's

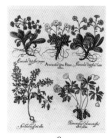

16

tooth violet, a member of the Liliaceae family, gets its name from its long-pointed, tooth-like bulb, from which emerge only two strikingly marked basal leaves, with a flower hanging gracefully above them from the stem. The recurved petals, very similar to those of the cyclamen, give the dog's tooth violet its distinctive appearance, although this cannot be seen from the illustration in the *Hortus Eystettensis*. Of the 16 species, this is the only one indigenous to Europe.

As its name suggests, the lungwort (15, IV) is one of the old medicinal plants used for respiratory complaints, coughs and pulmonary disease. The reason for this was the speckling of the leaves, which seemed to resemble the changes that occurred to spots in the lungs of tuberculosis sufferers. The lungwort is also remarkable for the fact that pink and blue flowers can often be found at the same time on the same plant, because they change colour after pollination. The first representative of the primulas is the primrose (15, V), which has long been in garden cultivation and which was very important for breeding bushy, low-growing primulas.

PLATE 16

The three alpine auriculas (16, I–III) in the top row of the plate belong to the same genus. *Corydalis cava* (16, IV), a hollow-tubered perennial, is in fact indigenous to Germany, but occurs in the wild in only a very few places, albeit in large quantities there. Its white or purple flowers appear in early spring. Until just a few years ago, this member of the Papaveraceae family was still used for medicinal purposes as a mild sedative.

The delicate white flowers of the wind-flower (16, V) flutter in the slightest breeze and open even earlier than *Corydalis cava* under hedges or in other shady places. It was not an important plant for the early herbalists, as it was not used for medicinal purposes. This herald of spring was well known in folklore, as the numerous common names prove. Besler calls the windflower, shown here in its double form, *Waldhenlein* (little wood hen), clearly referring to the shape of the leaves, which in English gave rise to the name "crowfoot" for plants in this family.

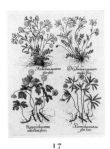 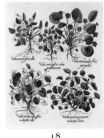 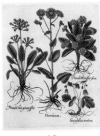

17　　　　　　　　18　　　　　　　　19

PLATE 17

Two more windflowers are included: the snowdrop windflower (17, I), also in its double cultivated form, and *Anemone ranunculoides* (17, II), which occurs in damp mixed forests in Germany.

The cuckoo flower (17, III and IV), shown here in a double and a single form, belongs to the Brassicaceae family. Although this plant is sometimes also called meadow cress, the name cuckoo flower is appropriate as the spittle bug or froghopper nymphs frequently leave a frothy deposit, which appears to come from the plant itself and which is known as cuckoo spit.

PLATE 18

"Upon the mead a violet stood, retiring and of modest mood; it was a violet e'er so sweet" – the beginning of Goethe's poem fittingly characterises the shy beauty of one of the most popular indigenous plants, which reveals itself to sight and smell only as you draw close to it. Made into bunches or woven into garlands, violets have always occupied a special place in the popular imagination. The English violet (18, I–V) appears five times in the

Hortus Eystettensis in various sizes, flower shapes and colours. In addition to violet and blue flowers, reddish, yellow and white-coloured species, which are sometimes hard to distinguish, also occur in the wild. Many hybridised forms have been developed, particularly in the 19th century, and these have met with more or less continuous commercial success. The violet has played an important role as a symbolic plant in pictorial art. Because of its habit and blue flower colour, it appeared to symbolise the humility of the Virgin Mary, whose legendary blue cape promised to shelter those people of earlier centuries in the greatest need. The petals, the whole plant and the seeds were also used in medicine. The so-called violet root that was given to teething children to bite on, however, did not come from the *Viola* species but from the iris, and acquired its name only because it smelt like a violet.

PLATE 19

The fact that a plant is called after the mountain goat, as it is in German (*Gemswurz* or mountain goat root), makes it clear that it must be a mountain or

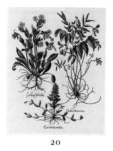 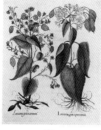 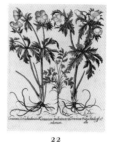 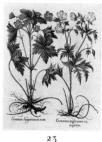

20 21 22 23

alpine plant. This is also the case for the great leopard's bane (19, I), *Kriechende Gemswurz* in German (creeping mountain goat root). It is a composite plant, indigenous to Europe, which, because of its beautiful yellow flowers, made a very early appearance in gardens. German natural history authors from previous centuries claimed that the plant was named after the goats because they liked to eat its roots to stop them from feeling dizzy. However, as the root also contained indigestible fibres, these remained in the stomach, became encrusted and developed there into a solid bezoar stone, often found in the stomachs of dead animals. In line with medieval analogical thought, the pulverised bezoar stone was used as an ingredient in medications to help cure dizzy spells, while wearing the whole bezoar stone as an amulet warded off danger.

The water avens (19, II), a member of the rose family, with its bell-shaped, characteristically coloured flowers, prefers moist and shady conditions. It gets its German common name, *Bach-Nelkenwurz* (river clove pink), because its rootstock smells similar to the mother clove (*Nelkenwurz*

in German). The name *Benediktenwurz* (Benedict root), commonly used in the German herbals, was also popular.

As already illustrated on plate 16, there are two further primroses (19, III and IV) here, whose different habits demonstrate how much even closely related plants, especially garden hybrids, can differ in appearance.

PLATE 20

There is nothing rare or even exotic about the three plants on this plate. The creeping bugle (20, I) can often be found in meadows and gets its name from its creeping roots, from which numerous runners grow. The curious German name, *Günsel*, is derived from the old Latin word *consolida*, a term used for plants which actually or supposedly have wound-healing properties.

The non-creeping spring vetch (20, II) is remarkable for the colour of its beautiful pealike flowers, which change from glowing pink to a strong blue. However, despite its simple flowers, the red campion (20, III) has no difficulty competing alongside it.

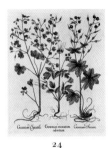
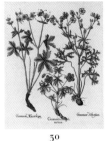
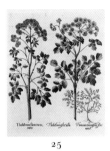

24 30 25

PLATE 21

Two species of honesty, the perennial honesty (21, I) and the annual honesty (21, II), both indigenous to central and southern Europe, stand next to each other here. They get their German name *Silberblatt* (silver leaf), and indeed the English name of satin flower, from the dividing wall of the seedpod, which persists as a silvery, oval membrane pulled taut over a frame after the other parts have fallen away. As this structure also resembles a silver coin, it is known in some areas of Germany as the *Judassilberling* (Judas penny) and in America and England as silver dollar and penny flower. It is also called *Papstbrille* (pope's glasses) and other similar names because it looks like a spectacle lens.

PLATES 22–24, 30

Four plates are devoted to plants of the cranesbill family, which includes among others the popular hardy geraniums. Two heron's bills (22, I; 24, I) and nine cranesbills (22, II, III; 23, I, II; 24, II, III; 30, I–III) are shown here. Nearly all of them are indigenous to Germany. The genus gets its name from the shape of the fruit, which forms a long bill, with the seed at its base. When the fruit dries out, a special mechanism catapults the seed away and thus disperses it. As healing properties were attributed to some members of this genus, some of which are difficult for the average gardener to differentiate, the name *gratia dei* (grace of God) took hold early on. Red-flowering species or those with reddish-tinged stems were thought to be good for stopping bleeding and, according to Hildegard of Bingen, cranesbill preparations were a good remedy for melancholy.

PLATE 25

The meadow rue plants (25, I and II) that belong to the Ranunculaceae family have distinctive, strangely spherical flowers, which have no visible petals but unusually long stamens. *Thalictrum aquilegiifolium* (25, I) is also fascinating for its soft pinnate leaves. According to Besler, the other species, which can no longer be identified with any certainty, differs only in its somewhat broader leaves and its white flowers.

That the hollowroot illustrated here, a member of the Papaveraceae family,

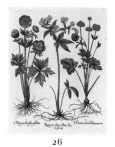 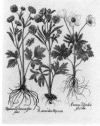 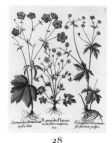

26 27 28 29

cannot be the species used medicinally for gallbladder complaints is clearly shown by the flowers, which are not red-violet, but small and yellowy green, as is true for *Fumaria parviflora* (25, III).

PLATES 26–29
With more than a hundred species distributed throughout the world, the Ranunculaceae family naturally makes repeated appearances in the *Hortus Eystettensis*. After the meadow rue plants of the previous plate come the European globe-flower (26, II), the snowdrop wind-flower (27, III) and 12 different cranesbill species, some of which are indigenous to Europe, the others originating from Asia. In addition to the familiar yellow flowers, white and red colours also occur and they vary greatly in size.

Whereas the German name *Hahnenfuß* (hen's foot) and the English crowfoot refer to the shape of the divided leaves, which resembles a bird's foot, and the commonly used German *Butterblume* (butter flower) and the English buttercup relate to the deep yellow flower colour, the Latin name *Ranunculus* actually means "little frog", reflecting the fact that

most species of this genus prefer moist conditions. Many species contain poisonous acrid compounds, which is why cattle avoid plants growing on pastures. The plants are not harmful in hay, since these toxins quickly break down as the plant dries out. The common European globe-flower does not have any green sepals, making the spherical yellow flower even more striking. Its German name is *Trollblume* (troll flower). This does not, as was previously thought, relate to the trolls of Nordic mythology, but derives from a Germanic root that meant much the same as "roll away", because of the spherical shape of the flower, and which survives in the German phrase *sich trollen*, to toddle/ trot off.

PLATES 31, 32
Anemones, especially the early flowering ones, are still among the most popular garden plants today. They are indigenous to large parts of Europe, being especially widespread in the Mediterranean region, and numerous garden forms have been bred. Legend has it that a French flower enthusiast, despite having the very best anemones, was not prepared to exchange

31 32 33

the much sought-after plants with other interested individuals. A visitor to the garden therefore played a cunning trick. He deliberately dropped his fur coat on the anemones and was then able to plant the ripe seeds plucked from the hairs of his coat when he got home.

The story told in Ovid's *Metamorphoses* to explain how the beautiful flowers came into existence is much older. According to him, the red anemones arose from the blood of Adonis, who had been killed by a wild boar. The white-flowered anemones, on the other hand, sprang from the tears shed by Aphrodite on the death of the handsome youth. The actual origin of the word anemone is as unclear as these old explanations are charming. As a result of the similarity with the Greek word for wind, it could, as Ovid states, refer to the fact that the leaves are very easily torn off by the wind, although appearances and experience do not support this. It is more likely, also based on an old nickname for Adonis, that the Arabic word for blood gave the flower its name and established the link to the Greek myth.

2ND ORDER OF SPRING
PLATE 33

The cuckoo-pint (33, I, II), which Besler also calls *teutscher Ingwer* (German ginger), is one of the most striking indigenous plants and has an impressively sophisticated pollination technique. The shape of the flower is determined by the pale green spathe that opens upwards like a bag. The lower part, however, is firmly closed, widening beneath into a bowl shape. Inside is a long spike, coloured violet at the top, which has bristly flowers that create an obstacle at the constricted end. As can be seen from the withered flower on the right of the plate, the separate male and female flowers are produced in the bowl-shaped base. To attract pollinating insects, the flower exudes a (to humans) most unpleasant smell of rotten meat. The plant also secretes oil droplets on the inside of the spathe, thus preventing insects that have flown in from gaining a foothold. They therefore slip down to the bottom, passing the trap-like barrier of hairs on the way to the bowl, where they can fertilise the female flowers with the pollen they have brought with them. When this happens, the plant

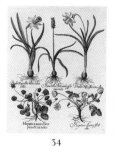
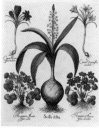
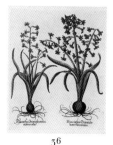
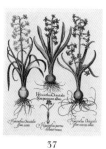

34 35 36 37

secretes nectar to feed its unwilling guests and soon afterwards the male flowers discharge their pollen into the base, where it sticks to the insects. It is only now that the bristly hairs open the exit once more, so that the insects can finally escape from the slippery trap, only to go through the same process again to pollinate other cuckoo-pint plants. The female flowers develop as orange-red berries (cf. 342, III) that stand out in brilliant contrast against the dark green of the speckled leaves.

Bulbocodium vernum (33, III) is a member of the Liliaceae family that grows in a few isolated areas in the Alps. It is similar to the crocus but is considerably smaller than the well-known autumn crocus. It used to be classified in the genus *Colchicum*, as is the case in the *Hortus Eystettensis*.

Scilla amoena (33, IV) is a graceful representative of the genus *Scilla*. Although it now occurs in some areas of the Mediterranean region, it is probably as an "escape" of a garden form of unknown origin, rather than as an originally indigenous plant.

Plate 34

The early-spring-flowering *Hepatica nobilis* (34, I and II; 35, IV and V) belongs to the Ranunculaceae family and is indigenous to Germany. The Eichstätt garden included four artificially bred examples that varied in colour and flower form. It got its German name *Leberblümchen* (little liver flower) from the leathery 3-lobed leaves, which reminded doctors-cum-botanists of old of the liver, which was believed to be similarly lobed. It was thus a logical, if totally ineffective, deduction to use it medicinally in cases of liver disease, kidney complaints and various other ailments.

Both the two narcissi (34, III and IV) and the grape hyacinth (34, V) are the first representatives of their genera, many more of which appear on subsequent plates.

Plate 35

The sea onion (35, I) is called scilla or squilla in all the old herbals and continued to be used as a diuretic and heart medication right up to the 20th century. When the plant was re-classified in 1834, its scientific name was changed to the one still in use today, *Urginea maritima*, the

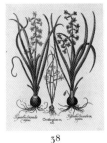

38

new generic name being derived from the Algerian Berber tribe of Beni Urgin. It occurs, however, throughout the entire Mediterranean region, where the inflorescence, carried on stems over 1 m tall, is very striking with its many white individual flowers. In the past, the large bulbs, which often protrude above the soil, were dried and, if not processed into effective medicines, the horn-like pieces were used to make mouse poison.

The Dutch crocus (35, II and III; 47, IV), which belongs to the Iridaceae family, is the species from which most of the modern garden hybrids developed. With its white and purple flowers, it is native to many alpine meadows and its charming flowers can often be seen there growing through the slowly retreating snow. Its autumn-flowering cousin, *Crocus sativus*, the prized saffron crocus, does not make an appearance until plates 191 and 349.

PLATES 36–40, 46, 47

The next five consecutive plates are concerned almost exclusively with hyacinths, although they are also represented once again a little later on (36, I and II; 37, I–III; 38, II and III; 39, II and III; 40, I and II; 44,

II and III; 45, III; 46, I–V; 47, I–III). Although the plant name *Hyakinthos* and other derivatives occur in Classical sources, it can be assumed that the flower now known by that name was not yet in cultivation at that time. The Romans may, however, have known it from their eastern provinces. There are many legends, however, concerning how the flower came into existence. Here there are obvious parallels with the anemone and the Adonis legend. Hyakinthos, an exceedingly handsome youth, was sought after by both Apollo and Zephuros, the god of the west wind, for his beauty. When, however, he favoured the god of the sun, who then wanted to teach him discus, the jealous Zephuros sent a gust of wind that drove the flying disc towards the young man's head. Mortally wounded, he sank to the ground and even Apollo could not bring him back to life. From his blood arose the plant, called after the youth, the petals of which form the letters AI, the cry of anguish issued by the powerless god. It is precisely this detail that makes it clear that this is not the oriental hyacinth, the originator of all subsequent garden forms, as this feature is not to be found there.

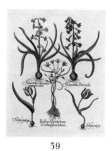
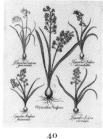
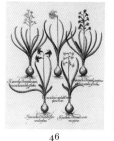
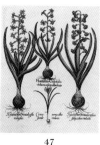

39 40 46 47

According to a second tradition, it was not the blood of the Spartan Hyakinthos that produced the plant, but that of the heroic Ajax, a combatant in the Trojan war, who, having been driven mad by Athena, fell on his own sword.

These gory stories and the fact that it therefore became a symbol of death for the Greeks did not detract from the plant's popularity in central Europe. When it came to Europe from the Middle East around the middle of the 16th century, it soon spread in gardens, although in the first specimens, the single flowers were very much smaller and further apart on the stem than on the full inflorescences familiar today. It was only during the last three hundred years that the hyacinth flower developed its luxuriant form. The hyacinth was cultivated and bred on a large scale, particularly in Haarlem in the Netherlands, where reportedly about two thousand different hybridised varieties were known by the early 18th century, and also in Berlin, where the plant had been introduced by Huguenot immigrants. Around 1830, four and a half million hyacinths were being grown each year in the sandy soil of south-east Berlin, and many of them were placed in specially shaped glasses and forced into flower by being shaded from the light by a card cone.

The twinleaf squill (37, IV), the star-of-Bethlehem (38, I; 43, III) and *Gagea villosa* (39, I) were thought graceful and beautiful enough to be included with the hyacinths. The narrow leaves emphasise the sparse flowers, which appear between March and May. A particularly striking feature of the star-of-Bethlehem is that its flowers open exceptionally late in the morning and then only for a very short time. It pays for this "sleepiness" with common names such as *Slaapmütz* (sleepyhead) in northern Germany, the French *dame d'onze heures* (eleven o'clock lady), the English Jack-go-to-bed-at-noon and American sleepy Dick. All three liliaceous plants are native to Europe, although they are rare in parts. The two early-flowering tulips (39, IV and V) give a taste of the extensive catalogue to come of these ornamental flowers, so strongly represented in the *Hortus Eystettensis*.

The English bluebell (40, III–V) is now assigned to a different botanical genus from the hyacinth, but the fact that it is very similar and is closely related to the

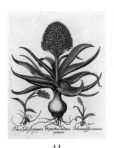
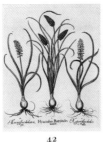

41 42

hyacinth is reflected in its Latin name, *Hyacinthoides*. Besler called the plant the *englischer Hyacinth* (English hyacinth), and thus agrees with John Gerard, who notes in his *Herball* of 1597 that these plants flowered more profusely in England than anywhere else. There are two explanations of the species name *non-scripta*, or undescribed. It can reflect the fact that Apollo's cry of anguish and the special sign AI supposedly found on hyacinths cannot be found on its petals. On the other hand, it is said that Dodonaeus, when he described the plant, ascertained that no author had as yet undertaken this work, so that it had not been described scientifically.

PLATE 41

The name *Scilla peruviana* (41, I) is deceptive, as the profusely flowering plant originates not from South America but from the Iberian peninsula, the Mediterranean region and the Canary Islands. It was the famous botanist Clusius who was the actual originator of this misunderstanding. When staying in Bristol in 1591 looking for new plants, he enquired about *Scilla*, among others, and

learnt that the plant had arrived there only recently on a ship called *Peru*. As a result, Clusius formulated the name *Hyacinthus Stellatus Peruvianus* for today's *Scilla peruviana*.

The first representatives of the Orchidaceae family are two orchids (41, II and III). Although they still have the same German name *Knabenkraut* (lads' leaves), they are now assigned to two different genera, the scientific names of which are both derived from the shape of the tuber. The one on the left (41, III) is clearly divided up like a hand, which is why it was called *Dactylorhiza*, from the Greek words for finger and root. The testicular shape of the other tuber (41, II) also led to the corresponding name, *Orchis*, and to the German *Knabenkraut* (lads' leaves), an indirect reference to the same part of the male anatomy. Both species are native to Germany, as are the later flowering ones that appear on subsequent plates in the *Hortus Eystettensis*.

PLATE 42

Musk, the famous secretion of the male Asiatic musk deer, and bought at great expense for medicines and perfumes,

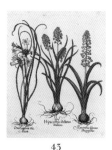
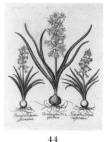
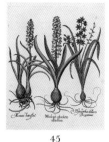
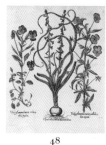

43 44 45 48

gave the grape hyacinth (34, V; 42, I–III; 45, I and II; 49, I; 50, IV and V) its Latin generic name. The word *muscus* developed, perhaps via the corresponding Arabic word, to become finally the word commonly used by botanists today, *Muscari*, which recalls the sometimes musk-like but always intense scent of these attractive ornamental plants. They have become more common in European gardens since the end of the 16th century, and the blue-flowered form is now indigenous to the entire Mediterranean region and even to Germany, where they frequently occur in vineyards.

PLATE 43

The blue-flowered *Hyacinthoides italica* (43, I), known in German as the Italian grape hyacinth, belongs to the liliaceous family of plants, as does the *Bellevalia* (43, II), known in German as the dark grey hyacinth. Although both of them bear the word "hyacinth" in their German names, neither of them actually belongs to the *Hyacinthus* genus.

PLATE 44

The umbelliferous star-of-Bethlehem has already appeared on Plates 38 and 43. This plate shows another representative of the genus, which has been identified as *Ornithogalum nutans* (44, I). It gets its German name *Nickender Milchstern* (nodding milk star) from its milky white flowers. This analogy is also conveyed by its botanical name, *Ornithogalum*. Roughly translated, this means "bird's milk", which in Classical times referred to egg white.

PLATE 45

Two grape hyacinths (45, I and II) and a hyacinth (45, III) serve as another reminder of the genera already discussed.

PLATE 48

The flowers of the late-flowering hyacinth (48, I), which in the *Hortus Eystettensis* concludes the coverage of this genus, many varieties of which are shown here, was described by Besler as being "deer-coloured".

The pansy (48, II and III) (*Stiefmütterchen* or little stepmother in German) also belongs to the genus *Viola*, although its

appearance has since changed greatly, particularly in the 19th century. Starting with the small but pretty flowers of the heartsease, the so-called wittrockiana hybrids, known today as large-flowered garden pansies in an infinite variety of colours, were bred by crossing with other *Viola* species. Various stories and popular traditions are linked with the original three-coloured heartsease, which as early as the 15th century was called *Stiffmuttrigen* in German. The trinity of flower colours made the pansy an appropriate religious emblem and also explained why this *Viola* species is unscented. According to legend, the plant originally grew in wheat fields and was much sought after for its captivating scent. However, in its quest, many ears of corn were trodden under, ruining the vital bread cereal. The Creator therefore saw fit to remove its peerless scent, to prevent starvation as a result of it. The Lord was so impressed by its humility that, while removing the heartsease's scent, he did, however, give it in return its holy trinity of colours.

In many popular traditions, the unusual German name of *Stiefmütterchen* (little stepmother) derives from the composition of the flower. Close inspection reveals that, of the five petals, one is markedly larger than the others, two more are clearly smaller, but with just as beautiful colours, while the two remaining petals are self-coloured. It was also noticed that the five green sepals are also uneven: the large petal seems to require two, the two smaller, multi-coloured ones one each, the last sepal being shared by the two self-coloured petals. On the basis of the popular image of the wicked stepmother, familiar from many fairy tales, people saw in the large petal the splendidly dressed stepmother sitting on two chairs, with her similarly gaudy natural daughters on either side, with a chair each, while the simply clad stepdaughters have to share a single chair, which is why these petals partially overlap. The pansy was also much used as a medicinal plant. The hope that it would help with infantile spasms (*Frais* in German), the symptoms of which were cramps and a rash, gave it the German name *Freisamkraut*. Even today, the pansy is still used in popular medicine in infusions for skin complaints.

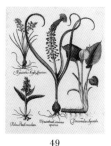
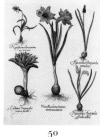
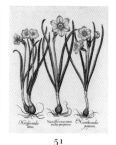
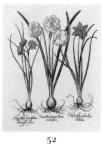

49 50 51 52

PLATE 49

Of the four plants shown on this plate, only the bog arum (49, IV) introduces a new genus. The tassel grape hyacinth (49, I) belongs to the genus *Muscari* (34, V; 42, I–III; 45, I and II; 50, IV, V), but differs from the other representatives in that it grows to an imposing height of up to 50 cm, and has a distinctive urn-shaped flower. Besler calls it *Groß Mertzen-Hyacinth* (large cast-off hyacinth). He also uses the term *Hyacinthus* for the English bluebell (49, II), already illustrated on plate 40.

Palma Christi, the old name used in the *Hortus Eystettensis* for the heath spotted orchid (49, III), can easily cause confusion. It does not refer to the palm leaves of Palm Sunday at all, but is derived from *palma*, the Latin word for the palm of the hand, as the root resembles the shape of a hand (cf. 41, III).

The flower of the bog arum (49, IV) looks very like the cuckoo-pint (33, 1 and II), to which it is closely related. Unlike the cuckoo-pint, however, its white spathe opens much more fully and the spadix (spike) is not so elegantly elongated. Its widely used German common name,

Schlangenwurz (snake root), derives from its creeping, spreading root, which can be clearly seen on the margins of still stretches of water. Besler cites its old Latin form, *Dracunculus aquatalis*, because it was identified in the Middle Ages using the Classical name of the dragon arum (192, I), to which it is also related.

3RD ORDER OF SPRING
PLATES 50–55, 60–64

Bulbocodium vernum (50, III) is also illustrated on a previous plate (33, III), and a double-flowered species with a slightly stronger colour is again illustrated here. The final appearance of two of the typical representatives of the grape hyacinth (50, IV and V) makes it clear that their flowering period is coming to a close. On the other hand, another charlacterful plant is just beginning to appear, and its distinctive flowers with their glowing colours will now be a defining feature of the garden for some time to come. The next six or seven plates show numerous daffodils in various forms, sizes and colours. What they all have in common is the distinctive corona, which is used as a defining characteristic of the

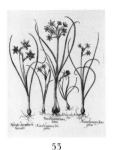 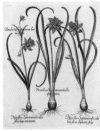 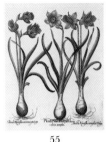 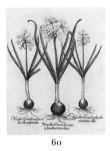

53 54 55 60

various divisions of the genus, which belongs to the Amaryllidaceae family.

In the case of the trumpet narcissi (e.g. 34, III, IV; 50, I; 55, III), which are also often called daffodils, the petals are separate and the long corona is at least as long as the petals. When the corona is not so long (e.g. 51, I–III), they are called large- or small-cupped narcissi, depending on the size of the corona. The double forms (e.g. 52, I–III; 54, III), which were for a long time the goal of many plant breeders, were created by increasing the number of petals and/or coronas. Spain, southern France, the Mediterranean region and the Balkans are the home of the multi-flowered *Narcissus jonquilla*, from which the jonquil hybrids (e.g. 53, I, III, IV; 56, II) are derived. These have spreading petals, a shallow corona and a particularly strong scent.

The Tazetta narcissi (61, I–III; 63, I; 64, I–III) occur in the Mediterranean region and also in the Middle East and Far East. They are also multi-flowered, and some varieties can produce up to 20 individual flowers on each stem. Finally, mention should be made of the late-flowering, fragrant Poet's narcissus (51, I; 62, I, II), whose white petals contrast particularly attractively with the shallow yellow, red-orange-rimmed crinkly cup. This trinity of colours (white, yellow and orange/red) combines with the great variety of flower shapes to make the genus *Narcissus* a surprisingly diverse and varied group of brilliant spring flowers.

It is still not entirely clear how this plant came to be called *Narcissus*. According to Ovid's story, Narcissus, the son of a river god and the nymph Leiriope, was loved by both men and women because of his exceptional beauty. He, however, spurned all affection. Even when Echo, a beautiful nymph who had been cursed by Hera and so could only repeat the last word spoken, fell in love with him, he remained so aloof that she withdrew to the woods in despair and wasted away until only her voice remained. Another spurned lover, however, prayed to Nemesis for revenge, and the goddess punished the handsome yet heartless young man by making him fall passionately in love with his own reflection when he bent down to drink from a pool on Mount Helicon. He now found it impossible to turn away from his reflection in the water and finally died there, sapped of his strength. According to

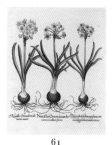
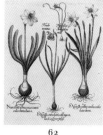
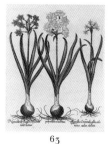
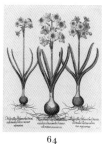

61 62 63 64

another story, he drowned when he fell into the water in an attempt to get as close as possible to his reflection, and the gods turned his body into the narcissus.

Alternatively, according to Pliny, the greatest natural history writer of Classical times, the plant was so named because of its intoxicatingly strong scent, *Narcissus* being derived from the Greek word *narke*, which means paralysis or anaesthetisation. Zeus also clearly made good use of this property when he wanted to allow his brother Hades, the god of the underworld, to abduct Persephone. He made a narcissus grow near the young woman, the flower's scent rendering her powerless to resist, and so Hades was able to run off with her into the land of the dead. At the request of her mother, Demeter, she was later allowed to return to the earth for at least six months each year, and for this reason she became a symbol of the Resurrection and the central figure of the Eleusinian mysteries, the most important celebrations held in Attica. The garland of Eleusis was threaded with narcissi, in the same way as, according to Sophocles, they were used to adorn the hair of the Furies, who contrived to paralyse their victims with the scent from the flowers.

The narcissus did not play any significant role in medicine. It could not be used much internally, as the bulbs are slightly poisonous, although it was sometimes used as an emetic, in cases of poisoning, for example. On the other hand, both the bulbs and the fragrant flowers of the Poet's narcissus were used in various ointments and oils, particularly for healing purposes and for rheumatism, although they would not have had any lasting effect. In the event of an overdose, however, it could lead to unpleasant skin irritations, as any gardener whose skin has come into contact with the sap from freshly cut narcissi will know.

In his herbal, which appeared in 1679, Lonitzer also mentions that the narcissus (which he calls *Josephs-Stäblein* or Joseph's rod) is "cheerful rather than useful". This old German name, which Besler also uses, could have two origins. The source of one of them is thought to be an old legend. According to this legend, when Joseph, together with other, younger men, was wooing Mary, all the suitors were given a rod and told that

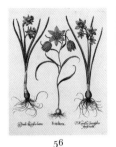
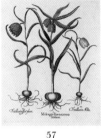
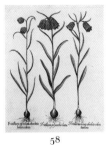
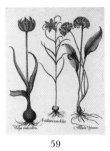

56 57 58 59

whoever's rod had grown leaves by the next morning would be chosen. Naturally, it was Joseph's rod, which had even sprouted flowers, Joseph going on to become Jesus' foster father. However, since the various legends also mention the white lily as well as the narcissus, we should not take this "rod" too literally. The other, more sober explanation refers to the approximate flowering time, which occurs around 19th March, Joseph's name day, which was observed in earlier times.

PLATES 56–58

The fritillaries (56, I; 57, I–III; 58, I–III; 59, I), or narcissus lilies as Besler calls them, introduce a genus which, in the *Hortus Eystettensis*, divides the narcissi. It has about 100 known species, found almost throughout the world. With the exception of two illustrated examples (57, III; 58, II), the petals show the characteristic marking that has given these plants, which are indigenous to Germany, their German common names: *Schachblume* or *Schachbrettblume* (chess or chessboard flower) and the English chequered lily. Their Latin name recalls a different game. It is derived from *fritillus*, the dice shaker,

and refers to their beaker-shaped flowers. Their exquisite beauty, which made them so desirable for the garden, was also why they became a religious symbol of warning. As the impressively ornate purple flowers bow down towards the earth and do not reach up towards heaven, tradition has it that they thus bring to mind many people's love of show. Such display is directed only towards this earthly life, even though their life is just as fleeting as the delicate snake's head fritillary, which withers soon after flowering.

PLATE 59

It is a matter for speculation whether the wild garlic (59, II), *Bärlauch* or bear's garlic in German, got the first part of its German name because it grows in woods where bears also used to roam. That it belongs to the genus *Allium* becomes immediately apparent when it is seen in its natural habitat in spring, because an unmistakable garlicky smell emanating from the densely packed plants is immediately noticeable. The lush, curled green leaves, which at this stage resemble those of the lily-of-the-valley, appear first, followed by a hemispherical white umbel

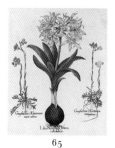 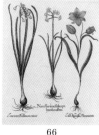 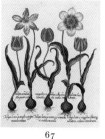 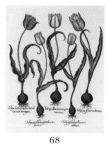

65 66 67 68

with numerous six-petalled single flowers on a slender stem between the unfurled pair of leaves. The wild garlic was not considered an ornamental plant until the second half of the 16th century, although people had long been familiar with it as a useful plant. With total justification, it was used just like garlic as a herb and vegetable, and also as a medicinal plant. It was known to be good for digestive complaints. It was also known that the juice pressed from the bulb was a good vermifuge, and that it generally promoted good health. The striking and unpleasantly pungent smell, however, led to its recommendation as an apotropaic, as having the power to ward off evil. To protect against the influence of evil spirits, or at least those with a delicate sense of smell, garlic was rubbed into a few areas of the body. Its ability to ward off vampires has been common knowledge since the Dracula literature of the 19th century.

As on plate 39, a single tulip (59, III) appears again here. Its lush green flower is particularly striking and makes us even more curious to discover which particular colours can be expected in the fourth order of spring.

PLATE 65

The sea lily (65, I) is indigenous to rocky areas on some Mediterranean islands, and also to the French Mediterranean region, although it has now become rare. Besler calls them the *Constantinopolitanisch Gilgen-Narcissen* (Constantinople lily narcissi), thus suggesting the route that these attractive flowering bulbous plants may once have taken in the late 16th century. The flower form is very similar to that of the narcissus, to which the sea lily is related.

The German name *Katzenpfötchen* (cat's paws) (65, II and III), like the English pussy-toes, for *Antennaria dioica*, which is indigenous to northern and central Europe, is a charming and appropriate description of the soft, compact flowerheads of this unspectacular plant, which makes few demands of its dry habitat. Leaves, stem and calyx are covered in white hairs. The stems, which grow to barely 20 cm tall, are picked for their attractive red and white flowerheads, which can be dried and used in flower arrangements. This also explains their popular German names of *Strohblume* (straw flower) and *Immortellen*

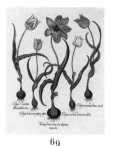
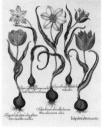
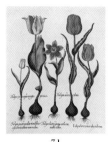
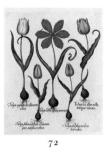

69　　　　　　　70　　　　　　　71　　　　　　　72

(immortals). They were long used in popular medicine, but nowadays their practical use is restricted to herbal tea mixtures.

PLATE 66

The paper-white narcissus (66, I) here is a final reminder of this genus, which is so strongly represented in the *Hortus Eystettensis*, and a wild tulip (66, II), which has now become very rare in Germany, provides a taste of the plates yet to come in the book.

The summer snowflake (66, III), which, despite its name, flowers as early as March and April, and thus only slightly later than the spring snowflake, differs from the latter not only by being taller but more particularly because it produces a greater number of single white flowers.

4ᵀᴴ ORDER OF SPRING
PLATES 67–78

Apart from another summer snowflake (76, II) and a single white narcissus (76, III), these twelve plates are devoted to a single genus, the tulip (plates 67–75; 76, I; 77 and 78).

It was in 1554 in the palace gardens of the High Caliph, Suleiman II, that Ogier

Ghislain de Busbecq, imperial envoy to the Sublime Porte, first saw the plant known to the Persians as *Lâle* and to the Turks as *Tulipan*. He was able to send the bulb and seed of this plant to the imperial gardens in Vienna. In 1559, several tulips were also flowering in an Augsburg garden, probably brought over via Venice. Two years later, Konrad Gesner was the first to describe these tulips in botanical terms. Tulips may have reached Portugal as early as 1530, although they did not create much of an impact there. From 1577, this plant, whose flowers were originally red, was called *Tulipan* in German, through its similarity to a turban draped round with a red cloth. From this, the German word *Tulpe* and the English tulip developed, via the Dutch *Tulp*, in the middle of the 17ᵗʰ century.

The real father of tulip breeding was Carolus Clusius, Director of the Imperial Gardens and, from 1593, professor of botany in the Dutch town of Leyden. He tried to sell the bulbs, sometimes at a very high price, and supplied them to the Dutch and English markets. In the 1720s and 1730s, the general enthusiasm for the hybrids, of which there were now a great many with

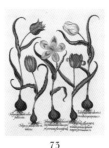 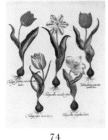 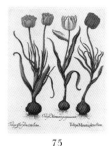

73 74 75

different flower shapes and, more impor-
tantly, colours, gradually took on gro-
tesque proportions in the Netherlands.

People were prepared to pay 1,000 florins
and more for a single bulb of the most
desirable varieties. Others were sold by
weight at comparable expense. This spec-
ulative fever ("tulipomania") gripped
many. In the hope of making their
fortune, they risked and usually lost their
entire capital on the tulip market, by deal-
ing in a particular type of futures busi-
ness, from which swindlers had also long
before taken their profit. In January 1637,
this trade in hot air rapidly collapsed and
legal regulations had to be found to settle
outstanding transactions. Even though
people talked about this tulip hysteria
for a long time after, this did not harm
the plant's popularity. Growers in the
Netherlands, England, France and Germany
continued to lead the way in breeding
new forms, although many amateurs were
also simultaneously undertaking this
delightful activity.

Even now, we cannot be definite about
the origin of the garden tulips of today,
usually lumped together under the botan-
ical name *Tulipa gesneriana*. The

forebears probably came from the Middle
East and central Asia and then spread to
parts of southern Europe. However, the
Persians were cultivating the tulip in
Turkish gardens long before it was known
in Europe. In the 16th century, Turkey
already had almost 1,400 different varie-
ties. The tulips in the *Hortus Eystettensis*
have mainly goblet- or star-shaped flow-
ers, with yellow, white and shades of red
predominating, although the highly desir-
able green and purple do sometimes
occur. Looking at these plates gives some
idea of the pleasure the Bishop took in
these brilliantly coloured and expensive
exotic plants in his garden and of the
pride with which he showed them to
occasional visitors.

Even almost four and a half centuries
after they first became known, tulips still
enjoy great popularity as a first-rate
spring-flowering garden plant. The many
hybrids that have been developed are now
divided into at least 17 groups, according
to flowering period and flower shape.
Plant breeders long tried to achieve the
most striking colour variegations, some-
times caused by a virus or other disorders
in the plant's metabolism, as is the case

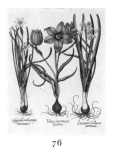
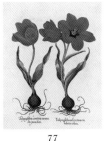
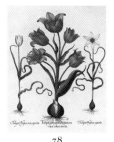
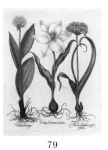

76 77 78 79

with the particularly popular "feathering". In the 19th century, dominating pure colours once again became the main focus of attention. At the same time, new wild tulip species reached Europe from Asia and opened up further interesting possibilities for hybridisation. Unlike almost any other flower, the tulip has a clear and rather austere outline, making it unsuitable as a specimen plant. It works its magic only in group plantings. Where it does occur singly, however, it needs accessories if it is to be displayed at all effectively. This is why the Dutch developed the specially shaped tulip vase that could display even a single stem to its best advantage, and which the masterly painters of Baroque floral still lifes included as a focal point in their luxuriant bouquets.

PLATE 79

It almost seems as though the last tulip in the *Hortus Eystettensis*, a white, late-flowering variety (79, I), wanted to demonstrate once again that it did not need the intensively bred colours of its sisters. It opens its six petals extremely wide – which is why Besler calls it *Stern-Tulipa* (star tulip) – and is devoid of colour, its only decoration being the contrasting pistil and stamens.

Nevertheless, the two *Allium* varieties flanking the tulip stand up well to such beauty. Both have spectacular historical connections. The golden garlic (79, II), which is native to some parts of Spain, is still valued as an ornamental plant in many gardens today. Botanists gave it the Latin name *Allium moly*, a name that can be found as early as Homer. When Circe, the enchantress, had used her magic potion to turn Odysseus' followers into pigs, Odysseus sought to avenge them. However, he was restrained by Hermes, who gave him the herb *Moly*, which was held in high esteem by the gods. Odysseus was able to use this successfully to break the spell. Even in Classical times people tried to guess which plant this *Moly* could

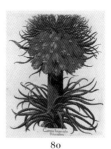 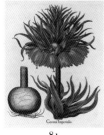 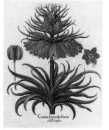 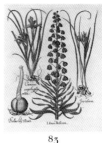

80 81 82 83

be, without reaching any conclusion. It is still a matter for speculation.

The meadow saffron has been mentioned, among others, as has the other *Allium* species shown here, the spotted ramson (79, III). This is still found occasionally on rocky slopes. One of its distinctive features is the unusual appearance of its bulb, which looks more like a rootstock surrounded by a fibrous husk. According to the medieval notion of analogical thought, this feature had to relate to the properties of the bulb, which must therefore be of a remarkable and similar nature. It was therefore popularly accepted that the root was surrounded by seven skins and that it would protect anyone wearing it as a talisman just as well as a seven-piece suit of armour. This explains its German name *Allermannsharnisch* (the common man's armour).

5ᵀᴴ ORDER OF SPRING
PLATES 80–82

Of the various representatives of the genus *Fritillaria*, the crown imperial (80; 81; 82) is definitely the most magnificent. According to Dodoens, this liliaceous plant, which comes from the north-west

Himalayas, Afghanistan and Persia, reached Vienna from Constantinople in 1575. There it was successfully cultivated and has continued to provide a beautiful flowerbed feature ever since. In all three examples from the Eichstätt garden, the number of petals has been greatly increased by breeding. The one in the third plate even has a second crown, making this form particularly fascinating. Unfortunately, these plants smell as unpleasant as they look beautiful, which is why even today they are planted to deter voles.

PLATE 83

Although this plant is called *Persische Lilie* in German (Persian lily) (83, I and IV), it actually belongs to the genus *Fritillaria* and is thus related to the crown imperial and snake's head fritillary described above.

PLATES 84–87

With the fire lily (84, I; 85, I and II; 86, I and II; 87, I) a new genus of impressive flowering plants now dominates the Eichstätt garden. This plant, which grows on alpine meadows, is unmistakable with

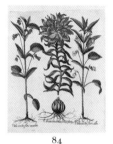 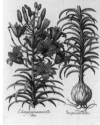 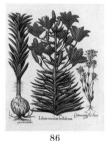 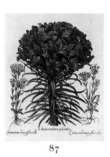

84 85 86 87

its erect flowers, glowing red, orange and sometimes yellow, particularly as it is one of the lily species that produce bulbils (86, II) in their leaf axils. Two of the plants illustrated here are hybridised forms with modified (84, I) or greatly enlarged flowers (87, I). The fire lily can sometimes be found in pictures of the Last Judgment as a symbol of cleansing fire. Ancient traditions and superstition link it with destructive fire.

If it were not for its flowers, *Viola elatior* (84, II and III), with its surprisingly upright growth, would hardly be thought of in connection with its widespread indigenous relatives. It used also to be widespread, but has now become rare and is under threat of extinction.

Surprisingly, two relatively unspectacular but clearly closely related gentians with different flower colours are found among the lilies: the yellow-wort (86, III) and the common centaury (87, II and III). Both are indigenous to Germany, but only the centaury is used as a medicinal plant. When taken before meals, the very bitter taste of the infusion has a beneficial effect on stomach upsets and indigestion. Its unusual German name *Echtes Tausend-*

güldenkraut (genuine thousand florin plant) is derived from its old botanical name *Centauria*, which means Centaur's plant, but which was wrongly understood to mean *centum aurum*, a hundred gold pieces. This was increased to a thousand to express the large numbers in which it grew and also to illustrate how highly this medicinal plant was valued.

PLATES 88, 89

While it is true that the Madonna lily (88, I and III; 89, I and III) is not indigenous to Germany, it has been an essential part of German culture since the Middle Ages, and occurs in many pictures to symbolise the Virgin Mary. In pre-Christian times, it was associated with Juno, who, according to legend, suckled the baby Heracles. While she did this, a gush of milk spurted out, which arched through the sky to form the Milky Way. Wherever it fell in drops on the earth, the shining white lily grew. This flower, with its exquisitely beautiful flower shape and restrained colour, came to symbolise the purity for which the Mother of God was famed. It was a permanent feature of farm gardens. The name Susan is derived from the Persian

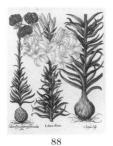
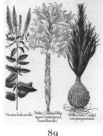
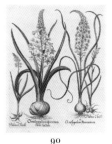
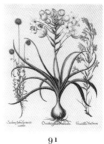

88 89 90 91

name for this lily, *suschan*. To illustrate the imposing stature of the plant, the engraver drew it in two sections. The glowing red, turban-shaped flowers of the scarlet Turk's cap lily (88, II) give a foretaste of the Turk's cap lilies found on subsequent plates.

Veronica longifolia (89, II) is a regal representative of the large speedwell genus, of which over 30 different species are indigenous to Germany alone. It is still a popular garden plant today because of its shining blue flowers, carried in striking spikes.

PLATE 90

Ornithogalum pyramidale (90, I and II), so-called because of its flower shape, presents another star-of-Bethlehem member of the Liliaceae family, which has already been illustrated earlier. This plant almost overshadows the two orchids, called *Palma Christi* elsewhere (cf. 41, III and 49, III), a pink and a blue flowering fragrant orchid (90, III and IV).

PLATE 91

There is no doubt that *Ornithogalum arabicum* (91, I), with its brilliant white flowers, is a star-of-Bethlehem.

The blue-violet flowered sheep's bit (91, II) is much less showy. At first glance, its flowerheads resemble the teasel plant, but it actually belongs to the Campanulaceae family.

Because it contained flavone, the yellow-flowered dyer's greenweed (91, III) was traditionally used to dye wool. It was possible to obtain a range of colours from it from yellow to light green. However, the results produced by this process were not fade-resistant, which is why from the middle of the 19th century natural dyes have been almost entirely replaced by synthetic ones.

PLATE 92

With Besler's *Spanische Stern-Blume* (Spanish star flower) comes another star-of-Bethlehem (92, I), although it literally takes second place behind the two Solomon's seal plants.

The common Solomon's seal (92, II) and its scented relative *Polygonatum odoratum* (92, III) are indigenous to Germany, where they are fairly common. The unusual shape of the pale, jointed rhizome was noticed very early on, and the scars left by flowers that had died back

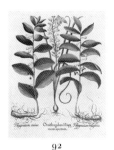
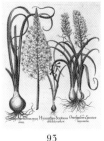
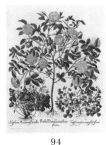
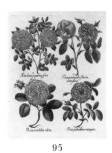

92 93 94 95

were thought to resemble seal marks, which were then attributed to the biblical King Solomon, who reputedly was interested in natural history. Since the *sigillum Salomonis*, the hexagram, was used for all sorts of magical practices, many such ideas came to be associated with the plant.

PLATE 93
The three plants illustrated here belong to genera that have already occurred in earlier plates. The hyacinth (93, I), with its distinctive tubular corona, is identified by Aymonin as *Dipcadi serotinum*, whereas the two *Ornithogalum* species (93, II and III) cannot be identified clearly.

6ᵀᴴ ORDER OF SPRING
PLATES 94–99
Garden roses have long been sought after as ornamental plants for their attractive flowers and rich scent. Breeding began very early on, with the Persians being particularly famous for this. It is often very difficult now to classify the early crosses exactly in botanical terms, as Aymonin, whose nomenclature is also followed here, demonstrates in detail with regard to the

roses (94, I; 95, I–IV; 96, I–IV; 97, I–IV; 98, I–IV) of the *Hortus Eystettensis*. European hybridised roses have their origin in the species of the dog rose, *Rosa canina*, the corumb rose, *Rosa corymbifera* and the French rose, *Rosa gallica*, all of which are indigenous to Germany, as perhaps the Asiatic musk rose may become. In addition to these, some other species and forms also became familiar by way of the Crusades and those areas of Europe occupied by the Arabs in the Middle Ages. These roses, such as the strongly scented damask rose, were very popular. Since the 19th century, many new hybrids have been developed, improved by species previously unknown in Europe. These include the remontant roses, which flower several times a year, the bourbon and portland roses, and the polyantha roses as well as the tea roses, which originated in the Far East and have long been treasured. Originally, the colour range was limited to every conceivable tone of red, white and yellow. Recently, blue colours have successfully been achieved. Now more than 20,000 different hybrids are registered.
Even in the oldest cultures there is evidence of roses, with luxurious rose

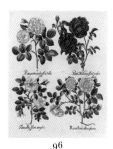 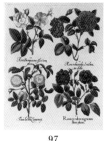

96 97 98 99

gardens being mentioned in literature and illustrated in pictures. Sacred to Venus, the rose came to symbolise love, and also mourning for loved ones. The beauty of the symmetrical flower made it a symbol of the Virgin Mary, the *Rosa mystica*, which appears again in the rose garland and in the numerous depictions of the Madonna of the Rose Hedge. Roses played an important part in the stories of various saints, such as Saints Dorothea, Rosalia and Elizabeth. They also symbolised the blood of the Martyrs. The English War of the Roses, which shook the second half of the 15th century and which is described in Shakespeare's plays, was between the white and the red rose, the emblems of the Houses of York and Lancaster respectively.

Rose preparations were often used in the past for medicinal purposes. Rosewater has survived to this day in cosmetics and marzipan manufacture. The rose oil it contains, which is produced mainly in Bulgaria from the petals of damask roses, is one of the most expensive essential oils. It is solid at room temperature and releases its precious scent only when greatly diluted.

Both the sorrel species (94, II and III), which crouch beneath the blossoming branch of a white-flowering rose, are indigenous to Germany. The wood sorrel (94, II) with its white petals outlined in violet and the procumbent yellow sorrel (94, III) acquired their German names (*Waldsauerklee* – wood sour clover, and *Hornsauerklee* – horn sour clover) because of the pungent, acrid taste of the leaves, produced by the oxalic acid they contain. The name cited by Besler, *Malerkraut* (painter's weed), also refers to this acid, because, as Camerarius reports, it could be used to remove foxing from canvases, which could then be painted without producing any troublesome impurities. Other species from this genus are highly prized for their "four-leaved clover" leaves, which are traditionally exchanged every New Year in Germany to bring good luck.

PLATES 100–108

The *Hortus Eystettensis* depicts a total of eleven peonies. The two double forms (100, I; 101, I), in which some of the stamens have been modified into coloured petals, are particularly striking. In the

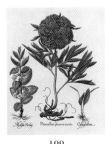 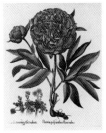 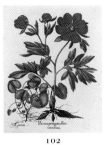 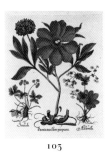

100 101 102 103

case of all the other peonies (102, I; 103, I; 104, I; 105, I; 106, I; 107, I–III; 108, I), the stamens, of which there are sometimes a great many, can clearly be seen inside the open flower. In religious art, it came, as the "thornless rose", to symbolise the Virgin Mary, while it was used in medicine for infantile epileptic seizures. It was also considered suitable for curing lunar illnesses, by which people meant illnesses caused by adverse radiation from the moon. Some peonies are indigenous to Europe, although most come from the Far East, where they were a popular decoration, particularly in Chinese art.

The adder's tongue (100, II), an extremely inconspicuous indigenous species of fern that has now become rare, is related to the moonwort (3, III). It nearly always grows only one leaf, above which the spiky sporangium then rises. The plant gets its name from its pointed, elongated shape. However, as people thought this was also a reference to the lance with which Christ's side was pierced, the *lancea Christi* also came to be very important as a vulnerary plant in healing ointments. The bastard balm (100, III), which originally came from the Mediterranean region, has now become naturalised in many parts of Germany. Although this plant differs greatly from the lemon balm in the size of its flowers, its leaves have often been confused with the similar-looking ones of the lemon balm, a highly valued medicinal plant.

The alpine houseleek (101, II), which belongs to the Crassulaceae family, has many sub-species that are native to the Alps and other European mountain regions and are closely related to the common houseleek (298, I), which will be discussed later.

The asarabacca (102, II), which can be found in woodland throughout Germany, is noteworthy principally for its leathery, glossy dark green, kidney-shaped leaves, since the short-stemmed brown flowers are usually hidden in the dead foliage shed by the surrounding trees. The characteristic shape of its leaves led to the attribution of diuretic qualities to the asarabacca, as well as emetic properties because of its peppery taste. The leaves used to be fed to cows, because it was thought that it could improve milk yield and prevent the dreaded milk retention magically caused by evil-doers.

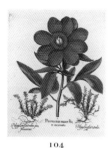 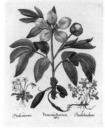 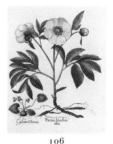 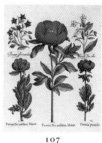

104 105 106 107

The lady's mantle (103, II) belongs to the Rosaceae family and gets its name from its pleated leaves, which look like the elegant cloak shown in many portrayals of the Virgin Mary. As nearly all plants ascribed to the Virgin Mary were thought to have medicinal properties, lady's mantle was frequently used in the past as an ingredient in gynaecological medicines. When the plant is seen in its natural habitat, it is noticeable that there is nearly always a large drop of water in its funnel-shaped leaves. As this was assumed to be morning dew, the plant was called *Sin(t) au* (ever dew) in many places in Germany. The 16th-century Latin name, *Alchemilla*, is also derived indirectly from the above-mentioned water-collection feature. As the alchemists preferred this supposed dew for their experiments, the new botanical term was based on the word "alchemy".

Hildegard of Bingen was the first to call an indigenous plant from the Apiaceae family "sanicula", and it is still called sanicle (103, III) today. It is derived from the Latin *sanare*, which shows how highly it was regarded as a medicinal plant, and was much used in the past to treat bronchial illnesses, haemorrhages and also wounds.

The two examples of the milkwort (104, II and III) differ only in their flower colour. These ornamental plants also occur in the wild with red, blue or violet flowers grouped in a cluster at the end of a thin stalk. The botanical name *Polygala* comes from the Greek and can be translated as "much milk", actually an allusion to the milky white petals of another species altogether. In popular medicine, the name was used as a reason to prepare infusions from the plant for breast-feeding women to increase milk production. Another yellow-flowered species of the milkwort is *Polygala chamaebuxus* (105, III), which is found in central Europe. An extremely rare evergreen plant, which produces only a single flower on each stem, is *Moneses uniflora*, the wood nymph (105, II).

We now usually see the cyclamen (106, II) only as a pot plant, as the species that are indigenous to Germany and to the Mediterranean region are very rarely found in the wild. As the other species concerned here flower only in the autumn (cf. plates 347 and 348), this Eichstätt example must be a representative of the spring-flowering sowbread, *Cyclamen repandum*, which used to be called *Cyclamen vernale*.

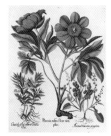

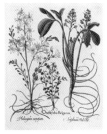

108 109

Borage (107, IV and V), which is so popular with the bees and after which the Boraginaceae family of rough-leaved plants is called, is known in Germany as *Gurkenkraut* (cucumber herb), because it has long been used as a culinary herb. It gets its name from the Arab *abu 'araq*, which roughly translates as "father of sweat". The fact that the plant has long been used as a diuretic and diaphoretic makes it clear how it got its unusual name. The hedge hyssop (108, II) was long used medicinally as a strong purgative and emetic, but it has now become very rare in the wild.

Besler's names for the sheep's sorrel (108, III) illustrated on this plate are *fremd Ampffer mit aufgeblasenen Schöttlein* (foreign sorrel with inflated pod) and *Acetos americana*. Because of its characteristic fruit formation, it can be identified as *Rumex vesicarius* or – as indicated by Aymonin – as *Rumex venosus*, because of the epithet *americana*.

7ᵀᴴ ORDER OF SPRING
PLATE 109

Venus's looking glass (109, I) does not look as though it belongs to the Campanulaceae family, because its 5-lobed violet flowers are saucer-shaped. Although it used to be widespread in the Mediterranean region, the plant has now become rare.

Although *Anthericum ramosum* (109, II) occurs over large parts of Europe, it is still rare. Besler calls it *Erd-Spinnenkraut* (earth spider plant), because it was reputed to help with the dreaded bites of spiders, which were thought to be poisonous.

In German, the bog bean (109, III), a bog plant belonging to the Meryanthaceae family, is confusingly called *Fieberklee* (fever trefoil) because of its 3-palmate leaves and its bitter taste. Many bitter-tasting plants were used to reduce temperature and also to stimulate digestion.

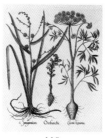
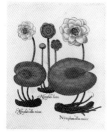
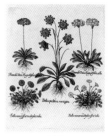

110 111 112

PLATE 110

Having no chlorophyll itself, the brown broomrape (110, I) lives as a parasite on the roots of other plants. The plant was not important in human medicine, but was used empirically in veterinary medicine as an aphrodisiac for cattle.

The Apiaceae cowbane (110, II) is one of the most poisonous plants native to Germany. Besler gives the German name of the plant as *Groß Wutscherling* (large rage hemlock) as, when poisoned by the plant, people experienced cramps and severe unrest, which they described as rages.

Sparganium erectum (110, III) needs damp conditions close to a riverbank if it is to thrive. It produces extremely striking spherical flowerheads that develop into spiky fruits.

PLATE 111

It goes without saying that the *Hortus Eystettensis* could not omit the European white lily (111, I and II) and the yellow water lily (111, III). These exotic plants with their large leaves floating on the surface of the water are so beautiful, and require only a small pool. According to

popular myth, the water lily was really a bewitched mermaid, who was jealously guarded by evil spirits, which is why anyone who swam up to her was often dragged down into the depths. The great many stems lying under the surface of the water and the creeping rootstock provide a realistic, if not very poetic, explanation for this story. The German common name used today for the yellow water lily, *Mummel* or *Nixblume* (water nymph flower), is also derived from the name for female water nymphs.

PLATE 112

The Latin name for the common daisy (112, I–III), *Bellis perennis*, is entirely appropriate, for there is no doubt that its small, white composite flowers are beautiful, and everyone knows from their own experience that it flowers practically the whole year through, hence *perennis*. It is often found in old paintings. Botticelli uses it as a symbol of Venus. With its simple white flowers and unassuming habit, it has become a typical symbolic plant for the Virgin Mary and is found among the flowers of the late medieval books of hours. The double garden form,

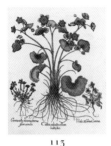
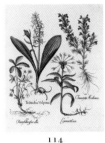
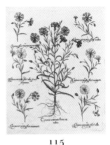
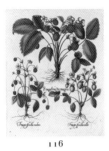

113 114 115 116

which Besler shows here, is also known as *Maßliebchen*. This word, which comes from the Dutch, is confusing in German, as it means "dear to Mary", not "Love measure" (Maß der Liebe), despite the age-old custom of picking off the petals as a love oracle (she loves me, she loves me not ...).

The mealy primrose (112, IV and V) is so called because its leaves are covered with white hairs underneath, which makes them look as though they have been dusted with flour. It is still a popular garden plant in many hybridised forms, its various coloured flowers being shown to good advantage by the leafless stem. It is now found rarely on the water meadows that used to be its home.

PLATE 113

With its yolk-yellow rounded flowers and dark green leaves, the marsh marigold (113, I) can often be found in moist sites. The species illustrated here is a double-flowered cultivated form, as grown at the beginning of the 17th century.

Having already introduced various violets, Besler now presents the dog violet (113, II), which is widespread in central and

northern Europe and gets its derogatory prefix from the fact that it has no scent.

The flowers of the spring gentian (113, III) create islands of deep blue on chalky alpine meadows. In the Bavarian Tyrol region, the name of *Schusternagel* (cobbler's nail) has become established and refers to the shape of the long tubular flowers and the wide-spreading lobe, which looks like a nail.

PLATE 114

The German name *Waldhyazinthe* (wood hyacinth) for this *Platanthera* species (114, I) leads up a false botanical trail, since this is not a liliaceous plant. It is in fact a rare orchid, indigenous to Germany, although the cluster of flowers at the end of the stem growing from its two leaves does actually look slightly like a hyacinth. The perennial cornflower (114, II) serves to introduce the following plate, which is devoted entirely to the genus *Centaurea*.

Dracocephalum austriacum, or *Österreichischer Drachenkopf* (Austrian dragon's head) as it is known in German (114, III), with its distinctive large blue lipped flowers came into cultivation at the end of the 16th century.

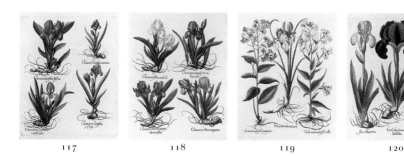

117 118 119 120

Unlike almost all its indigenous relatives, as befits its name *Potentilla alba* (114, IV) does not have yellow flowers. The silvery hair on the underside of the leaves has also given it the German name of *Seiden-Fingerkraut* (silk finger plant).

PLATE 115

The centaurs, particularly their king, Chiron, who was skilled in the art of healing, gave the botanical genus *Centaurea* its name. This genus includes the blue cornflower (115, I) and numerous other knapweeds (115, II–VII), whose delicate flowers occur in white, red, yellow and mixed colours. Although it is really an unwanted weed, with hard stems that blunted scythes, in the past the cornflower was always at the top of the popularity stakes for indigenous plants. Throughout the entire 19th century, but particularly in Prussia under Kaiser Wilhelm I, it was a recurrent motif, especially as the blue of the *Dragonerblume* (Dragoon flower) was similar to the colour of the uniforms.

PLATE 116

The strawberry is in fact one of the rosaceous plants indigenous to Germany, but the large, fleshy fruits we know today are the result of breeding campaigns carried on over a long period of time to maximise flavour and size. Besler presents three different plants, with the large-fruited one (116, I) already resembling the varieties we know today, although they were not introduced until around 100 years later. The small-fruited strawberry (116, III) is still about the size of the wild strawberry, and the white-fruited strawberry (116, II) must surely have attracted attention because of the absence of the usual colour. The strawberry can often be found in medieval art, where the white flowers refer to Mary's joys, while the red ones, with their fruits pointing down to the earth like a falling drop of blood, correspond to the pain caused by her son's Passion. They are frequently found in the context of paradise as the food of the angels and also providing sweet sustenance for the souls of dead children. Their 3-palmate leaves linked them with the Holy Trinity, while their five petals were a reminder of the five wounds of the Lord. In popular

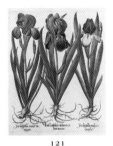
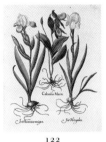
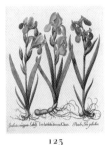
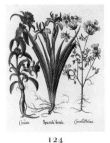

121 122 123 124

medicine, magical connotations meant that the red fruits in particular were used for illnesses that caused inflammations, e.g. of the skin or the throat.

8ᵀᴴ Order of Spring
Plates 117–124

The spectrum of the rainbow seemed to the Greeks to correspond to the wealth of colours of the iris, which is why they gave it the name, this being the Greek word for that glowing link between the sky and the earth. This is also why it became a Christian symbol, since after the Flood, God created the rainbow as a sign of his bond with man. The erect leaves, the long, narrow shape of which gave them the High German name *swertel* and the current German name *Schwertlilie* (sword lily), refer, in connection with the Virgin Mary, to her suffering with the Passion of her son. In relation to Jesus, they emphasise his royal dignity, for the stylised iris flower adorned the monarch's sceptre. The "lily" in the coats of arms of the French kings is actually an iris, which is also found on the coat of arms of Florence. In botanical terms, irises can be divided into rhizomatous irises and bulbous irises,

depending on their underground organs. The irises illustrated here (117, I–IV; 118, I–IV; 119, I; 120, I–III; 121, I–III, 122, II and III; 123, I–III; 124, I) are rhizomatous, whereas the bulbous irises first appear on later plates (185–202). The presence or absence of a "beard" on the petals can also be used as a distinguishing characteristic. The genus, which has over 150 species, is found throughout the northern hemisphere. Many species are indigenous to Germany.

In the past, the aromatic rhizome was used in medicine, in Germany under the confusing name *Veilchenwurzel* (violet root), and cut into pieces for teething children to bite and suck on. When ground down into a fine powder and used in face powders, its slightly irritant effect promoted a fresh, rosy complexion.

Even Kleist's Prince of Homburg enjoyed the scent of the dame's violet (119, II and III), a Brassicaceae plant indigenous to Germany, with white or violet flowers. Although it originates from southern Europe and western Asia, it reached more northerly gardens in the 16ᵗʰ century.

Lady's slipper (122, I) is one of Germany's most beautiful native orchids. Sadly it has

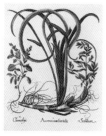 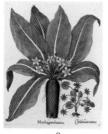

125 126

been wiped out in some places because of its unusual flowers. It is one of the few plants that, as can be seen from homeopathy, have practically never been used for medicinal purposes and that are not mentioned in the large herbals of the 16th century.

The orlaya (124, II), which occurs very rarely in Germany, comes from southern Europe. Many of its old Latin and common names, such as *Lappa agrestis* (field burr) or *Ackerlaus* (field louse) refer to its burr-like fruits.

The crosswort gentian (124, III) does not actually fit in with the generally accepted idea of how the typical alpine plant looks, as the blue flowers crowd into the axils of the cross-shaped whorled leaves. This apparent cross shape led to all sorts of healing properties being attributed to the plant.

PLATE 125

The genuine myrtle flag (125, I), which originates from the Orient, came to Germany in the middle of the 16th century and began to be cultivated for its unusual appearance. Its creeping rhizome means that it can gain a sufficiently secure hold even in marginal areas by stretches of water. The most striking feature of this plant, which is related to the cuckoo-pint, is the spadix, although this is unable to reach maturity in Germany. Therefore it has to be propagated by division of the aromatic rhizome. Extracts from the rhizome are still used today in medicines to stimulate the appetite and to treat indigestion.

In popular medicine, the same is true for the wall germander (125, III) and the water germander (125, II), which, as members of the Labiatae family, contain essential oils and bitter constituents.

9TH ORDER OF SPRING
PLATE 126

The poisonous autumn mandrake (126, I), a member of the Solanaceae family indigenous to the Mediterranean region, is one of the major magical plants. The reason behind the traditional ideas, as spectacular as they are speculative, was the appearance of the root, which, with its frequently forked tip and secondary roots, looks like a headless male torso with two legs and two arms. Anything resembling the human body found in the dark, damp and cold earth could only mean something demonic. The root was

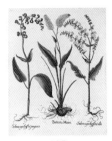

127

therefore assumed to be a demon that was not dangerous so long as you did not actually pull it out of the soil. If you did, however, in order to collect the root, which was also sought after for medicinal purposes, it was said that such a terrible death cry would be emitted that you would yourself immediately fall down dead. For this reason, legend has it that to facilitate collection a hungry dog was tied to the plant, and would tear the root out of the soil while eagerly leaping after a piece of meat that had been thrown for it. However, as the root gatherer had carefully blocked his ears with wax and arranged for a horn to make such a noise as to drown out everything else, he survived this wickedness, unlike the dog. The dried root was prized as an expensively acquired talisman, which was sometimes dressed and kept like a small doll, so that it lost none of its lucky power for warding off evil. The leaf rosette and the spherical fruits – the "love apples" of the Bible – are also found as decoration in ancient Egyptian art. The mandrake superstition, however, appears repeatedly right up to the present day.

The lesser celandine (126, II), which displays its yellow flowers early on in the spring, acquired its German name *Scharbockskraut* (scurvy weed) from that illness, more or less eliminated nowadays. In the past, however, it occurred because people – particularly sailors, who had to go for long periods without fresh vegetables or fruit – suffered from a lack of vitamin C, which caused teeth to fall out, wounds to be slow to heal and bleeding. Eating the leaves of this plant as salad was believed to prevent this.

PLATE 127
The red-white, spiked flowers of the bistort (127, I), also called snakeweed because of its twisted rhizome, stand out brightly in moist alpine meadows. In popular medicine, because of the tannins it contains, it was used to stop diarrhoea and to check bleeding.
Sage is well known as a medicinal and culinary plant because of its essential oils. The plant illustrated by Besler here, however, is the meadow clary (127, II and III), frequently found in Germany. In addition to the common bright blue-violet flowering form, Besler also refers

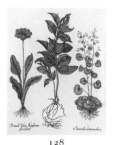
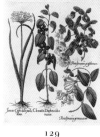
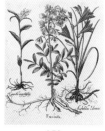

128 129 130

to a white one that occurs only rarely in the wild.

PLATE 128

The *Danäe* species, also called Alexandrian laurel (128, I) because of its dark leaves, belongs to the Ruscaceae family and is closely related to the butcher's broom. It is flanked by a double form of the primrose (128, II), which probably came from England, and the round-leafed saxifrage (128, III), with its small, red-spotted white flowers.

PLATE 129

The lesser periwinkle has already been shown on plate 8. Now we are shown the greater periwinkle (129, I), which is indigenous to southern Europe and which grows to two or three times the height of the lesser periwinkle and has considerably larger leaves.

The common German name for Italian honeysuckle (129, II) is *Jelängerjelieber* (the longer, the sweeter). This could refer to the fact that the striking flowers are more fragrant in the evening, so that it is worth tarrying a while by this beautiful climber. Peter Paul Rubens was clearly

also of this opinion, as he painted a portrait of himself with his wife in a honeysuckle bower. In botanical terms, it is closely related to the woodbine (129, III), whose vigorous habit made it too very popular in gardens.

The flowering rush (129, IV) prefers a site by or in water, but is found in Germany only extremely rarely and has therefore also been included in the list of endangered species.

PLATE 130

The dittany (130, I), which is found in central and southern Europe, but also in parts of Asia, is not only a very attractive plant, but also a very surprising one. On hot days it can secrete enough essential oil to produce a vapour cloud so concentrated that it can be ignited. This gives it its other English common name, burning bush. However, its German name, *Asch-Wurz* (ash root), does not derive from this alleged combustion, but from the ash-like appearance of its leaves.

The white helleborine (130, II) gets its name from its white flowers and is one of Germany's indigenous orchids.

Like its common name, the Latin generic

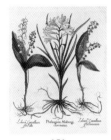

131

name for the day lily, *Hemerocallis*, suggests that its flowers are beautiful for only a single day. Despite this, day lilies have been among the most sought-after garden plants since the late 16th century and have recently become one of the most intensively bred. They originated in East Asia and have now become naturalised in large parts of Europe. The yellow day lily (130, III), like the orange-coloured variety, is one of the species which have the longest history of cultivation.

PLATE 131

The lily of the valley (131, II and III) is found in its usual white-flowering form in shady, preferably wooded sites throughout Europe. A thin stem emerges between two dark green leaves, which are tightly rolled when they first arise from the rhizome. At the top of the stem is a soft, unilateral raceme of 5 to 10 intensely fragrant bell-shaped white flowers. This ornamental plant was introduced into European gardens as early as the middle of the 16th century, and the pink-flowered variety became known towards the end of that century. Forcing lilies-of-the-valley was also popular because it brought a fragrant

breath of spring into the house even in the depths of winter.

The lily of the valley is frequently represented in almost all periods of art, and not just for its beauty. Particularly in the Middle Ages, it was an important symbolic plant, again associated with the Virgin Mary. It used to be called *Lilium convallium*, and this European liliaceous plant thus seemed to correspond to the "lily of the valleys" mentioned in the biblical Song of Songs. This term was later used in praise for the Mother of God, whose purity was apparently symbolised by the white flowers.

The lily of the valley also had many medicinal uses. Distilled lily-of-the-valley water was particularly popular and was said to be a remedy for all sorts of afflictions, from speech impediments to fainting, from eye complaints to strokes. Finally, mention should also be made of snuff, which used to be taken medicinally as it supposedly fortified the brain. This also contained crushed lilies-of-the-valley.

The German name used by Besler, *Fremd Spinnen-Kraut* (foreign spider plant), does not seem at all appropriate for the shining white paradise lily (131, I). However, he is

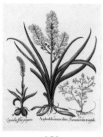
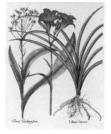

132 133

not describing the appearance of this flower, which is indigenous to the southern Alps and Pyrenees, but its supposedly beneficial effect on poisonous spider bites.

PLATE 132

The plants illustrated on these plates belong to three different botanical families. *Asphodelus ramosus* (132, I) is native to the Mediterranean region. Its name can be traced right back to Classical Greek times, where tradition has it that the white-flowering asphodel adorned the meadows of the underworld, although it is not known exactly which plant this refers to.

The burnt orchid (132, II), which has now become rare in Germany, is more attractive than most of its relatives. A particularly unusual feature is that, before it opens, its flower appears to be covered in black, making it look as though it has been burnt.

The Mediterranean *Fumaria spicata* (132, III) differs from the other species indigenous to Germany in its terminal flowerheads.

PLATE 133

The red-yellow day lily (133, I) appeared in European gardens at about the same time as its yellow-flowered sister. It was highly prized for its glowing colour and was often illustrated for this reason. Its imposing height – it can grow to well over one metre tall – made it particularly useful in garden design, although this meant it had to be divided into two sections for the *Hortus Eystettensis*.

The German name *Kreuzkraut* (cross plant) for the following genus of composite plants, which comprises well over 1,000 species and is found throughout the world, could possibly be a popular corruption of the literal German translation of the Latin name, *Senecio*: *Greiskraut* (old man's plant). It refers to the white hairs that help the wind-dispersal of the seeds, in the same way as the seedhead of the dandelion. It reminded Classical authors of old men's white hair. Besler names southern France as the region of origin for the yellow-flowering *Senecio doria* (133, II).

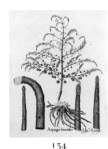

134

PLATE 134

The long list of spring plants is completed by a plant now primarily considered a vegetable and therefore an unexpected find in a luxurious ornamental garden: the asparagus (134, I and II). It is only one of many representatives of its genus, which is found throughout the Classical world, but particularly in the Mediterranean region. This is probably the origin of the edible species, *Asparagus officinalis*, which came to Germany in the Middle Ages and has been recorded there since the Renaissance by botanists and enjoyed by gourmets as a vegetable or salad. Special cultivation techniques, whereby the sandy soil is earthed up high above the roots, encourage the plant to produce long shoots that are not turned bluish red and then green by the light, which has a detrimental effect on their flavour. Towards the end of the 18th century, asparagus growers in Berlin discovered that they could produce the highly desirable young white shoots (134, II) as early as in January or February by covering the special forcing boxes with manure. If asparagus "bolts", it produces an imposing but delicate shoot with greenish white flowers, which (on female plants) develop into beautiful red berries (134, I). Asparagus was and still is used very successfully in medicine as a diuretic.

PLANTARVM

HORTI EYSTÆT

TENSIS.

Classis Æstiva.

SUMMER

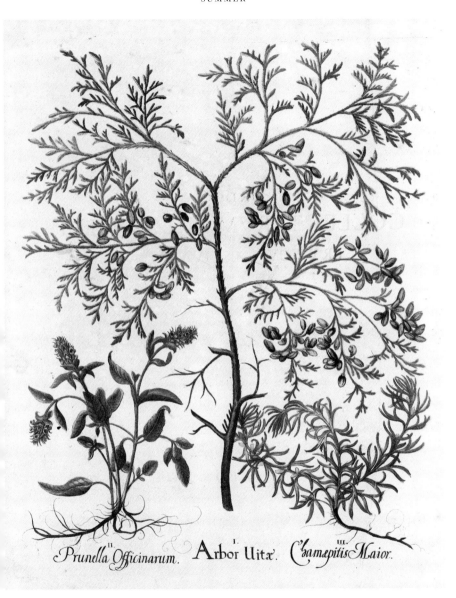

Prunella Officinarum. **Arbor Uitæ.** *Chamæpitis Maior.*

PRUNELLA VULGARIS	THUJA OCCIDENTALIS	AJUGA CHAMAEPITYS
Self-heal, All heal	*White cedar, American arbor-vitae*	*Yellow bugle, Ground pine*

Plate 135

215

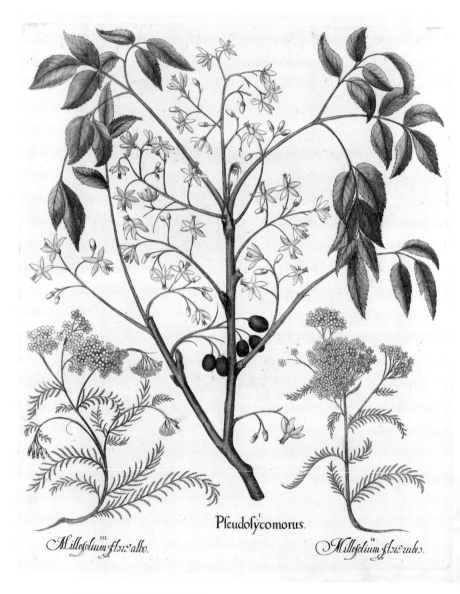

Millefolium flore albo. III.

Pseudosycomorus.

Millefolium flore rubro. II.

ACHILLEA MILLEFOLIUM, II.–III.

*Soldier's woundwort, Yarrow,
Milfoil*

MELIA AZEDARACH

*Chinaberry, Persian lilac, Pride
of India, Bead tree*

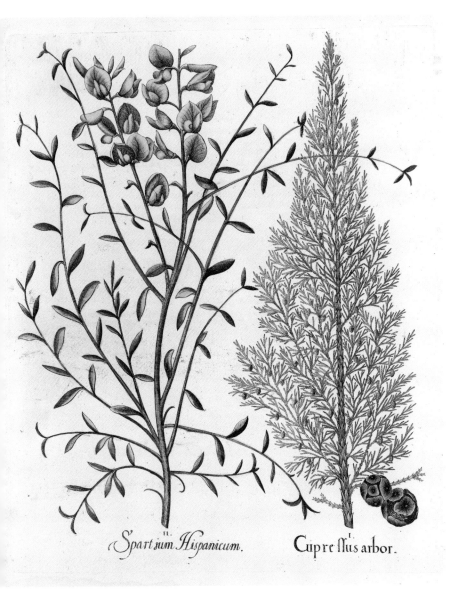

Spartium Hispanicum. *Cupreſſus arbor.*

SPARTIUM JUNCEUM CUPRESSUS SEMPERVIRENS
Spanish broom, Weaver's broom *Italian cypress*

Plate 137 217

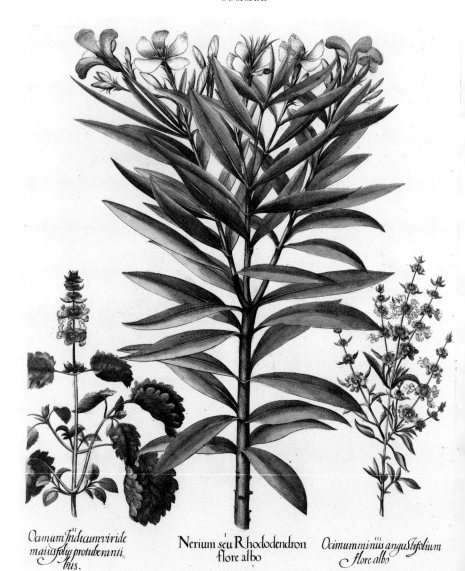

Ocimum Indicum viride maius folys protuberanti bus.

Nerium seu Rhododendron flore albo

Ocimum minus angustifolium flore albo

OCIMUM BASILICUM

Common basil,
Sweet basil

NERIUM OLEANDER

Oleander, Rose bay

OCIMUM BASILICUM

Common basil,
Sweet basil

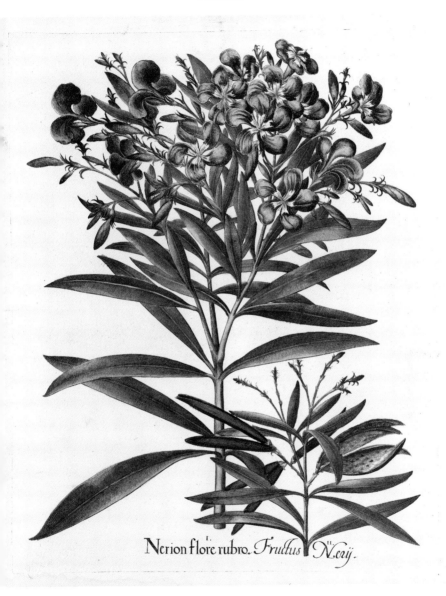

Nerion flore rubro. Fructus Nerij.

NERIUM OLEANDER
Rose bay, Oleander

NERIUM OLEANDER
Rose bay, Oleander (in fruit)

Plate 139

219

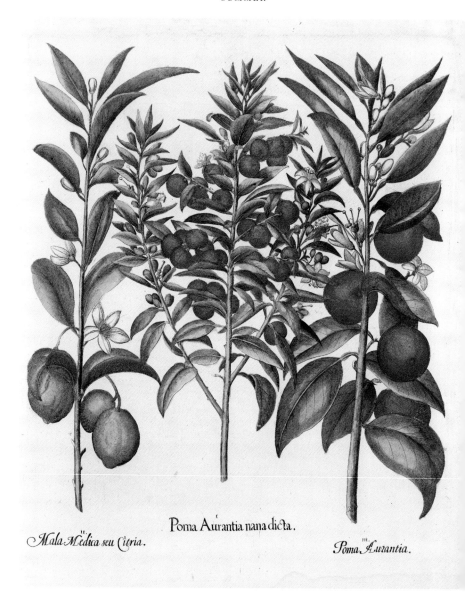

Mala Medica seu Citria.

Poma Aurantia nana dicta.

Poma Aurantia.

CITRUS MEDICA
Citron

CITRUS AURANTIUM
*Seville orange, Bitter orange,
Sour orange, Bigarade*

CITRUS SINENSIS
Common orange, Sweet orange

Plate 140

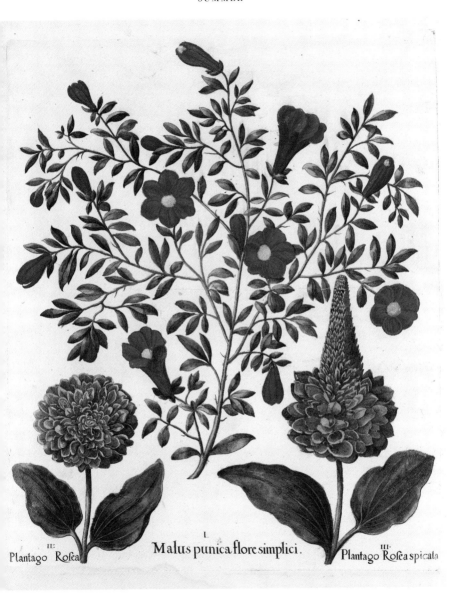

II:
Plantago Rofea

I.
Malus punica flore simplici.

III.
Plantago Rofea spicata

PLANTAGO MAJOR, II.–III.
*Common plantain, White-man's foot,
Cart-track plant*

PUNICA GRANATUM
Pomegranate

Plate 141

221

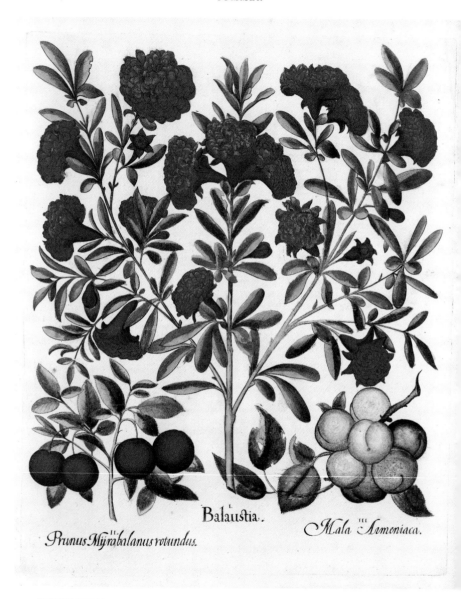

Balaustia.

Prunus Myrabalanus rotundus.

Mala Armeniaca.

PRUNUS CERASIFERA
Cherry plum, Myrobalan

PUNICA GRANATUM
Pomegranate with fruits

PRUNUS ARMENIACA
Apricot

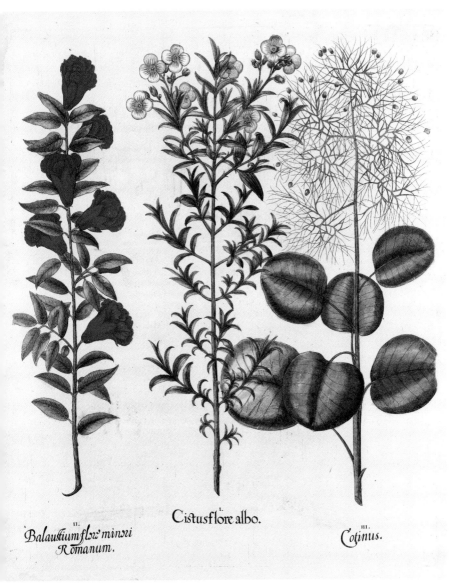

II.
Balaustium flx minori Romanum.

I.
Cistus flore albo.

III.
Cotinus.

PUNICA GRANATUM
Pomegranate in flower

CISTUS MONSPELIENSIS
Montpellier rock rose

COTINUS COGGYGRIA
*Smoke tree, Venetian sumac,
Wig tree*

Plate 143 223

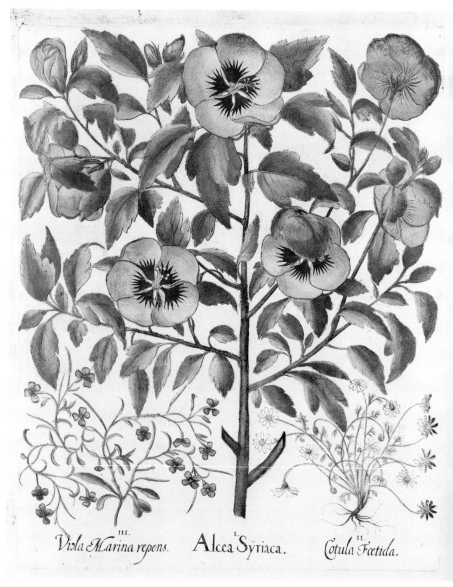

Viola Marina repens. Alcea *Syriaca.* Cotula *Fœtida.*

MALCOLMIA MARITIMA
Virginia stock

HIBISCUS SYRIACUS
*Mallow, Rose mallow,
Giant mallow*

ANTHEMIS COTULA
Mayweed, Stinking chamomile

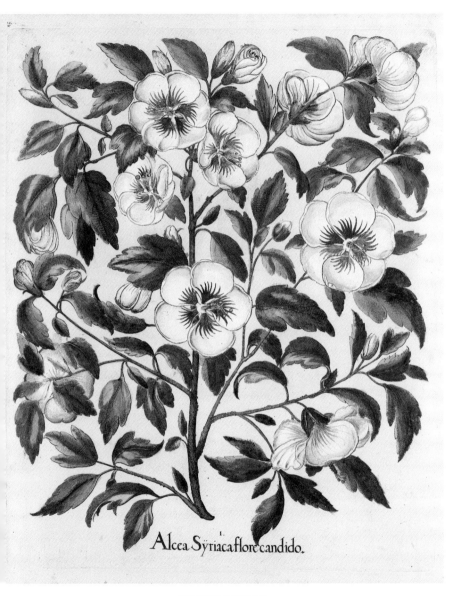

Alcea Syriaca flore candido.

HIBISCUS SYRIACUS

White-flowering mallow,
Rose mallow, Giant mallow

Plate 145

225

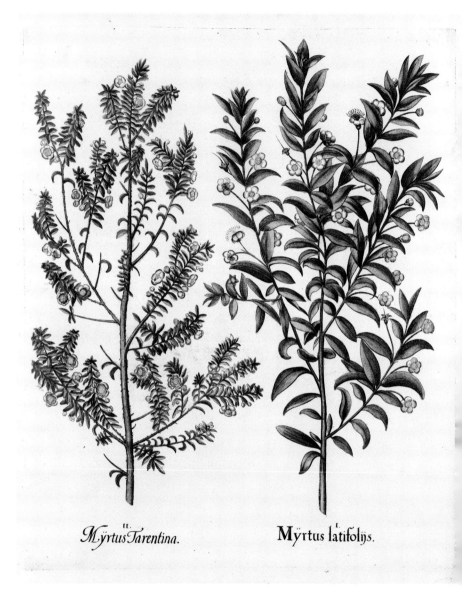

Mÿrtus Tarentina.
II.

Mÿrtus latifolÿs.
I.

MYRTUS COMMUNIS SSP.
TARENTINA

Tarentum myrtle

MYRTUS
COMMUNIS

Common myrtle

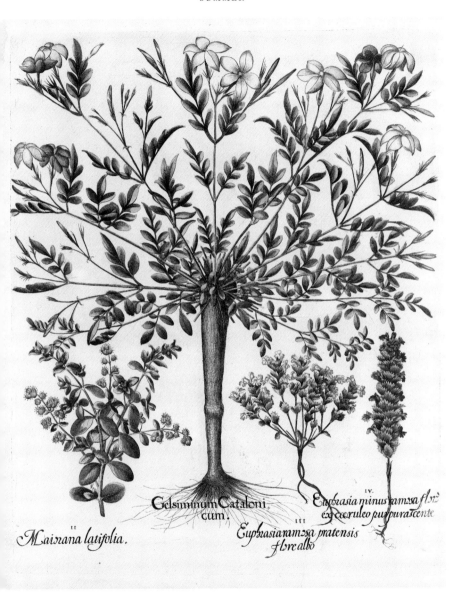

Maixana latifolia.

Gelsiminum Cataloni, cum.

Euphrasia ramosa pratensis flore albo

Euphrasia minus ramosa flore ex cœruleo purpurascente

ORIGANUM
MAJORANA

*Sweet marjoram,
Knotted marjoram*

JASMINUM
GRANDIFLORUM

Jasmine, Jessamine

EUPHRASIA
SPEC., III.–VI.

Eyebright

Plate 147

227

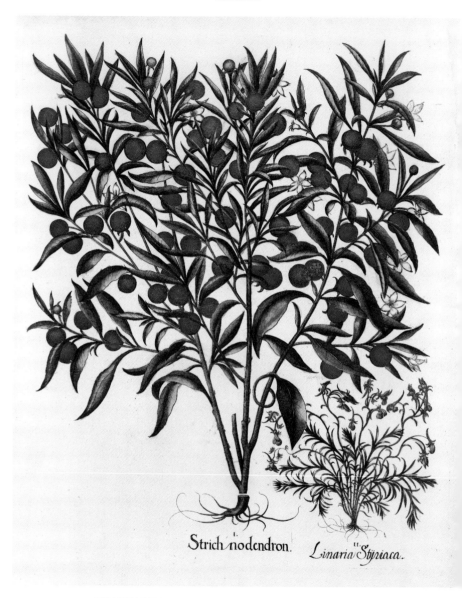

Strich nodendron. Linaria Styriaca.

SOLANUM PSEUDOCAPSICUM
Winter cherry, Jerusalem cherry,
Madeira winter cherry

LINARIA ALPINA
Alpine toadflax

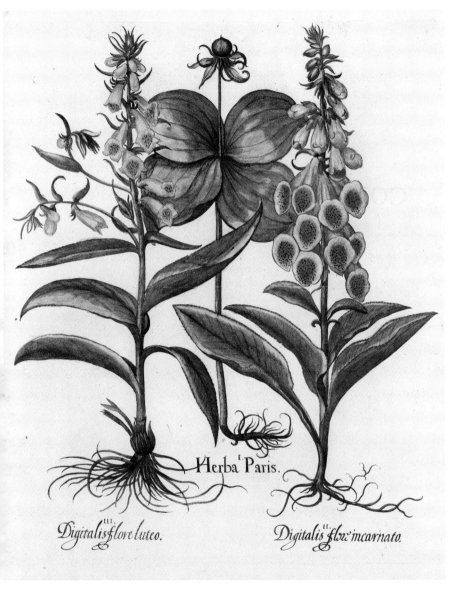

Herba Paris.

Digitalis flore luteo.

Digitalis flor: incarnato.

DIGITALIS GRANDIFLORA
Large foxglove

PARIS QUADRIFOLIA
Herb Paris

DIGITALIS PURPUREA
Red foxglove

Plate 149 229

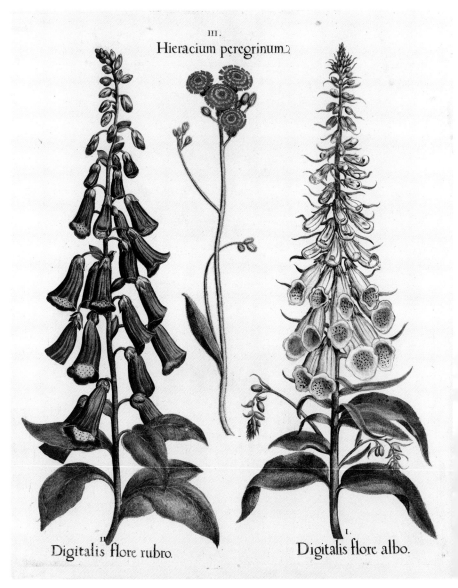

III.
Hieracium peregrinum

II.
Digitalis flore rubro.

I.
Digitalis flore albo.

DIGITALIS PURPUREA
Red foxglove

HIERACIUM AURANTIACUM
Fox and cubs,
Orange hawkweed

DIGITALIS PURPUREA
White foxglove

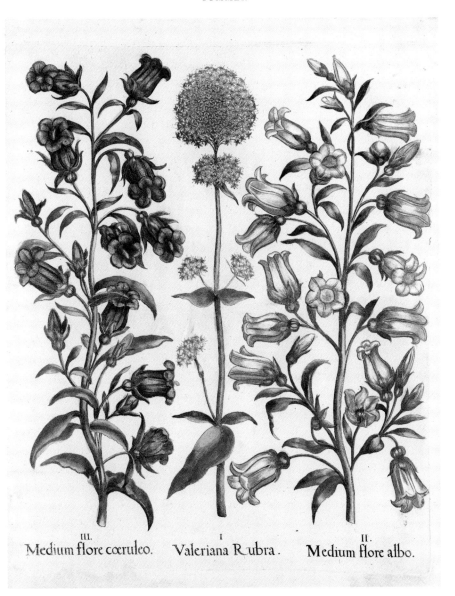

III.
Medium flore cœruleo.

I.
Valeriana Rubra.

II.
Medium flore albo.

CAMPANULA MEDIUM

Blue canterbury bells,
Cup and saucer

CENTRANTHUS RUBER

Red valerian,
Jupiter's beard, Fox's brush

CAMPANULA MEDIUM

White canterbury bells,
Cup and saucer

Plate 151 231

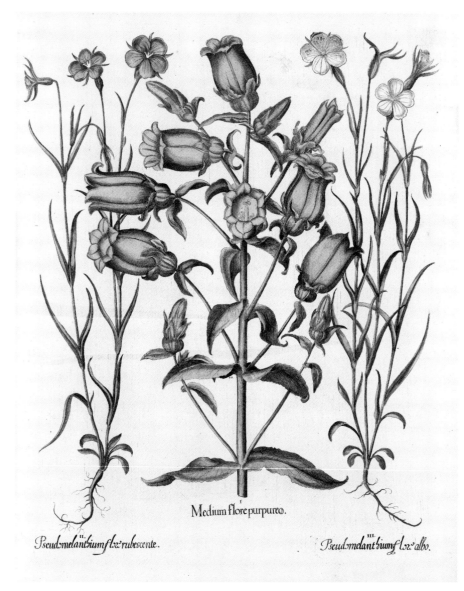

Medium flore purpureo.

Pseudomelanthium flore rubescente.

Pseudomelant:bium flx albo.

AGROSTEMMA GITHAGO

Purple corn cockle

CAMPANULA MEDIUM

Dark blue canterbury bells,
Cup and saucer

AGROSTEMMA GITHAGO

White corn cockle

Plate 152

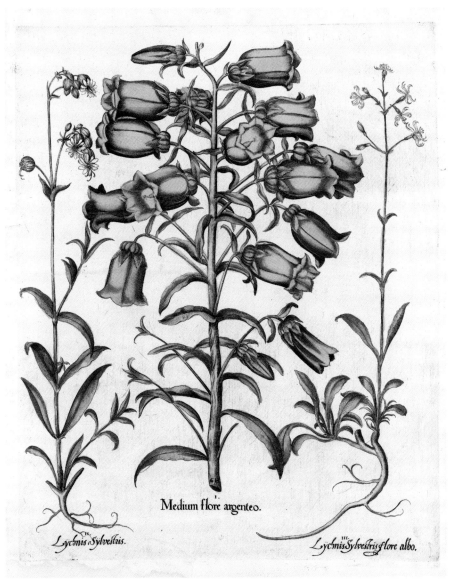

Medium flore argenteo.

Lychnis Sylvestris.

Lychnis Sylvestris flore albo.

SILENE VULGARIS
Bladder campion, Catchfly

CAMPANULA MEDIUM
Canterbury bells,
Cup and saucer

SILENE NUTANS
Campion, Catchfly

Plate 153
233

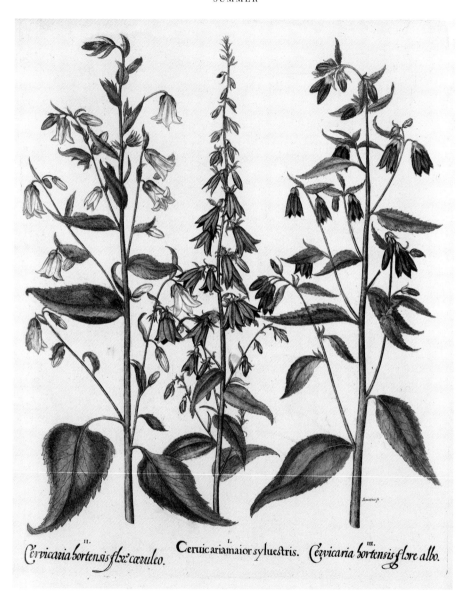

Cervicaria hortensis floe cæruleo. *Ceruicaria maior syluestris.* *Cervicaria hortensis flore albo.*

CAMPANULA SPEC.
White bellflower

CAMPANULA RAPUNCULOIDES
Creeping bellflower

CAMPANULA SPEC.
Blue bellflower

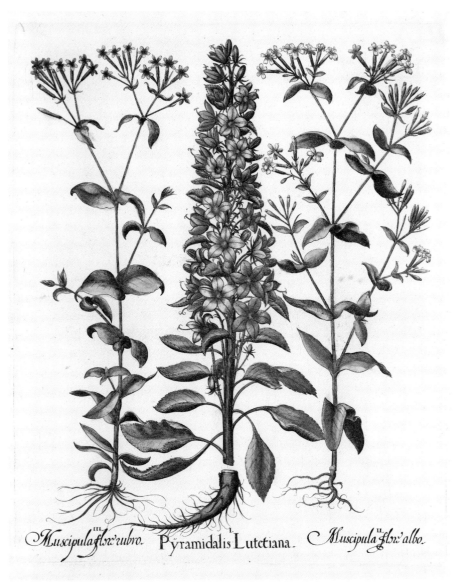

Muscipula flx.ʳubro. Pÿramidalis Lutetiana. *Muscipula flx.ʳalbo.*

SILENE ARMERIA CAMPANULA PYRAMIDALIS SILENE ARMERIA
Red campion, Catchfly *Chimney bellflower* *White campion, Catchfly*

Plate 155 235

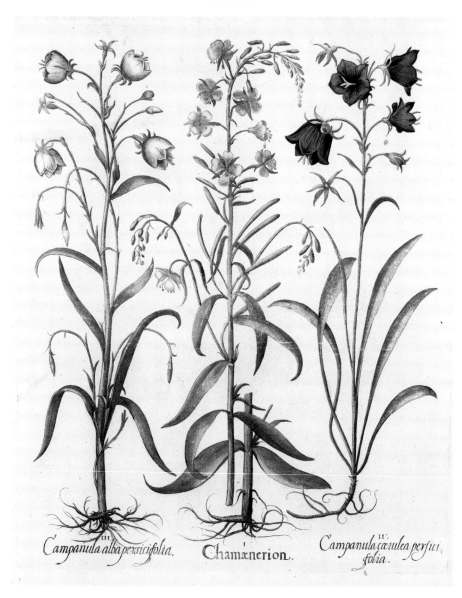

Campanula alba persicifolia. *Chamænerion.* *Campanula cærulea persici folia.*

CAMPANULA PERSICIFOLIA, II.–III. EPILOBIUM ANGUSTIFOLIUM

Willow bell, Peach bells, *Great willowherb, French willow,*
Peach-leaved bellflower *Rosebay willowherb, Fireweed, Wickup*

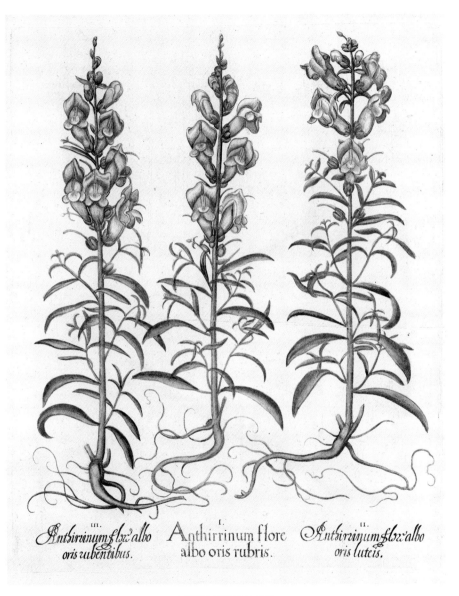

III.
Antirrinum flox albo oris rubentibus.

I.
Anthirrinum flore albo oris rubris.

II.
Antirrinum flox albo oris luteis.

ANTIRRHINUM MAJUS
Snapdragon

Plate 157 237

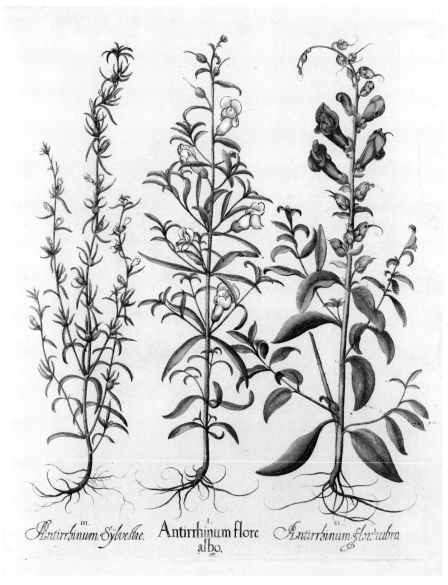

Antirrhinum Sylvestre. *Antirrhinum flore albo.* *Antirrhinum flor: rubro.*

MISOPATES ORONTIUM
Weasel's snout, Calf's snout

ANTIRRHINUM MAJUS, I.–II.
Snapdragon

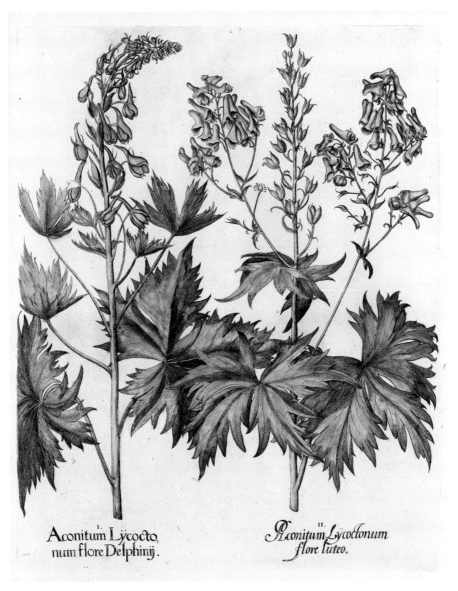

Aconitum Lycocto,
num flore Delphinij.

ᴵᴵ.
Aconitum Lycoctonum
flore luteo.

DELPHINIUM ELATUM
Bee larkspur

ACONITUM VULPARIA
Wolfsbane, Badger's bane, Monkshood

Plate 159 239

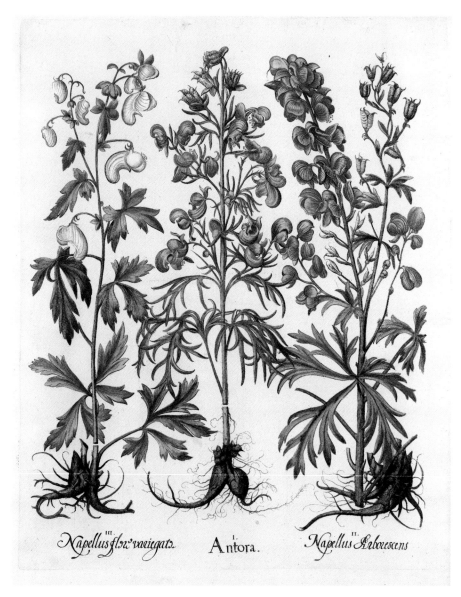

Napellus flor variegats. *Antora.* *Napellus Arborescens*

ACONITUM VARIEGATUM
Variegated aconite, Monkshood

ACONITUM ANTHORA
Monkshood, Badger's bane

ACONITUM NAPELLUS
Helmet flower, Friar's cap, Turk's cap, Bear's foot, Garden wolfsbane, Garden monkshood

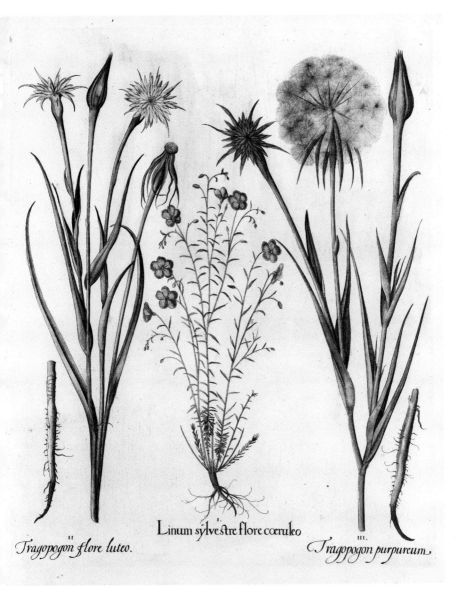

Tragopogon flore luteo.

Linum sylvestre flore cœruleo

Tragopogon purpureum.

TRAGOPOGON DUBIUS
Goat's beard

LINUM PERENNE
Perennial flax

TRAGOPOGON PORRIFOLIUS
*Salsify vegetable oyster,
Oyster plant*

Plate 161

241

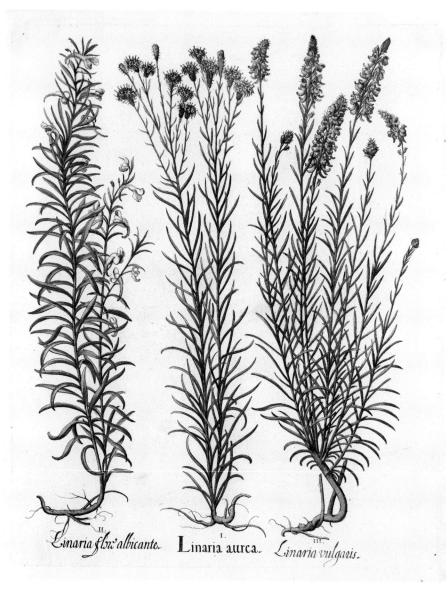

Linaria flox'albicante. I. *Linaria aurea.* III. *Linaria vulgaris.*

LINARIA REPENS
Striped toadflax

ASTER LINOSYRIS
Goldilocks

LINARIA VULGARIS
*Common toadflax, Butter-
and-eggs, Wild snapdragon*

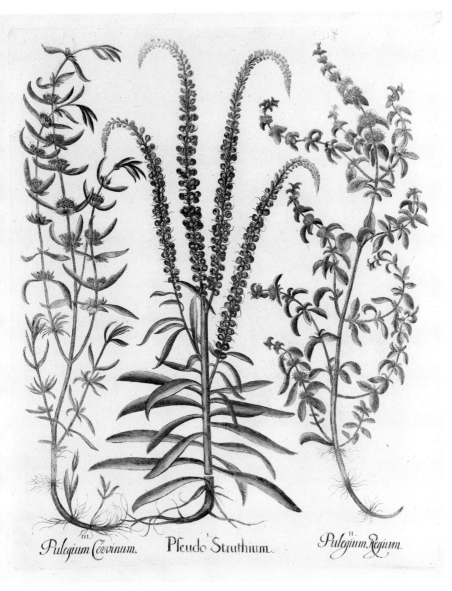

Pulegium Cervinum. Pfeudo Struthium. *Pulegium Regium.*

MENTHA CERVINA RESEDA LUTEOLA MENTHA PULEGIUM
Mint *Mignonette* *Pennyroyal*

Plate 163 243

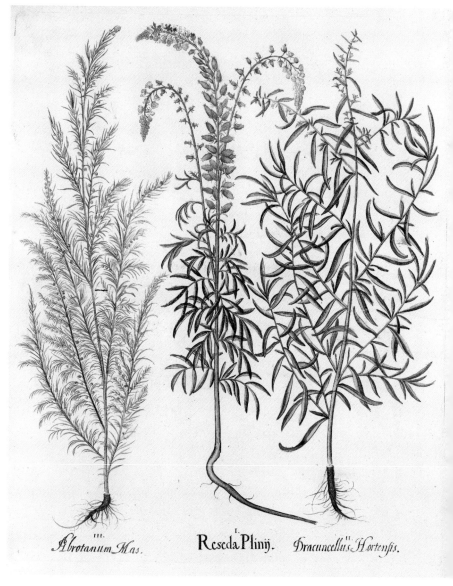

III.
Abrotanum Mas.

I.
Reseda Plinij.

II.
Dracuncellus Hortensis.

ARTEMISIA ABROTANUM

Southernwood,
Lady's love

RESEDA LUTEA

Wild mignonette,
Yellow reseda

ARTEMISIA DRACUNCULUS

Tarragon

Plate 164

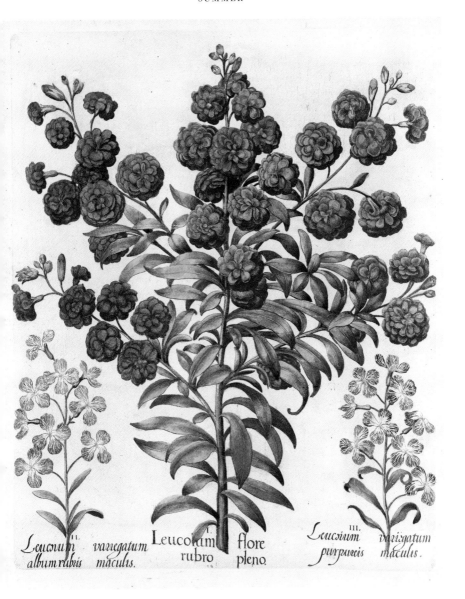

Leucoium II. *variegatum* *album rubis* *maculis.*

Leucoium I. *flore* *rubro* *pleno.*

Leucoium III. *variegatum* *purpureis* *maculis.*

MATTHIOLA INCANA, II.–III. MATTHIOLA INCANA
Gillyflower, Stock *Double pink gillyflower, Stock*

Plate 165 245

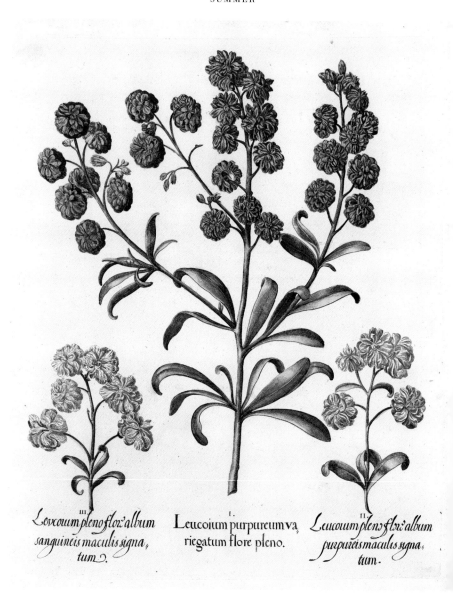

Leucoium pleno flor: album sanguineis maculis signa, tum.

Leucoium purpureum va, riegatum flore pleno.

Leucoium pleno flor: album purpureis maculis signa, tum.

MATTHIOLA INCANA
Gillyflower, Stock

Plate 166

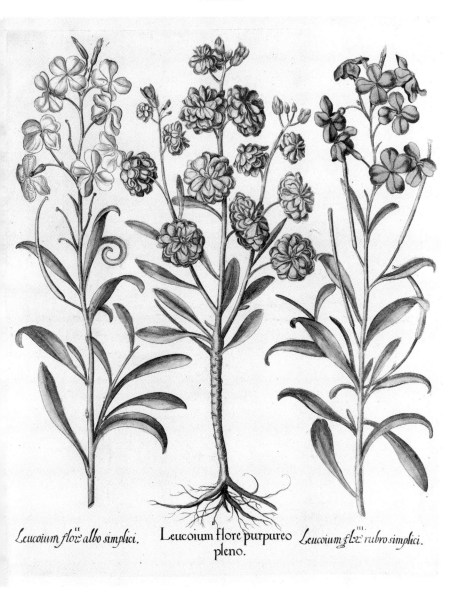

Leucoium flox albo simplici. | *Leucoium flore purpureo pleno.* | *Leucoium flox rubro simplici.*

MATTHIOLA INCANA
Single white gillyflower, Stock

MATTHIOLA INCANA
Double gillyflower, Stock

MATTHIOLA INCANA
Single purple gillyflower, Stock

Plate 167 247

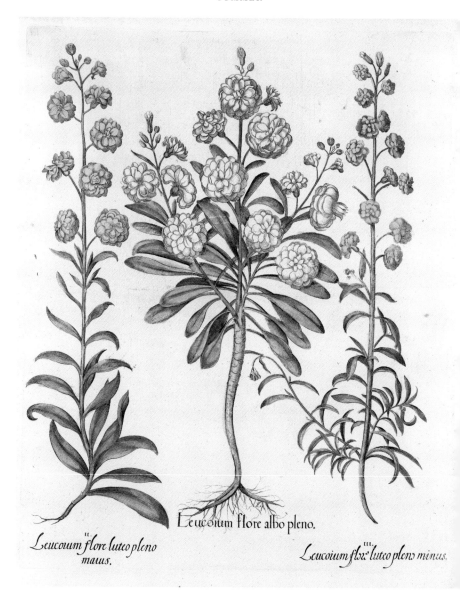

Leucoium flore albo pleno.

Leucoium flore luteo pleno
maius.

Leucoium flor: luteo pleno minus.

CHEIRANTHUS CHEIRI, II.–III.
Double wallflower

MATTHIOLA INCANA
Single white gillyflower, Stock

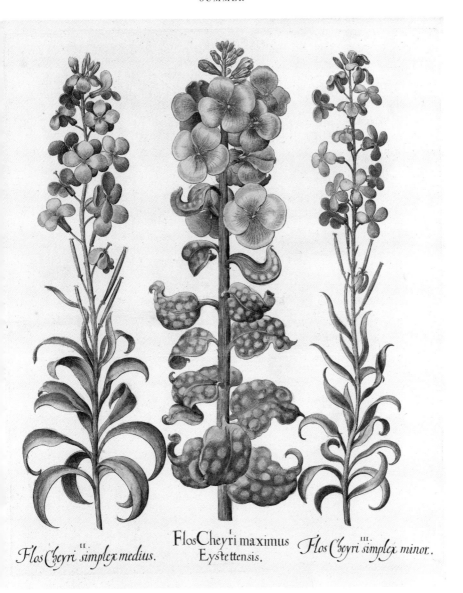

Flos Cheyri simplex medius.
II.

Flos Cheyri maximus
I.
Eystettensis.

Flos Cheyri simplex minor.
III.

CHEIRANTHUS CHEIRI, II.–III.
Single wallflower

CHEIRANTHUS CHEIRI
"Wallflower of Eichstätt"

Plate 169

249

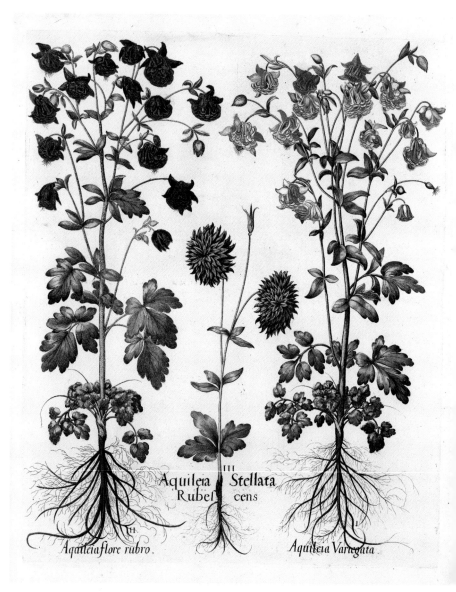

Aquileia Stellata
Rubescens

Aquileia flore rubro.

Aquileia Variegata

AQUILEGIA VULGARIS

Double purple columbine,
Granny's bonnets

AQUILEGIA VULGARIS

Columbine with
pompon-shaped flowers,
Granny's bonnets

AQUILEGIA VULGARIS

Double multi-coloured columbine,
Granny's bonnets

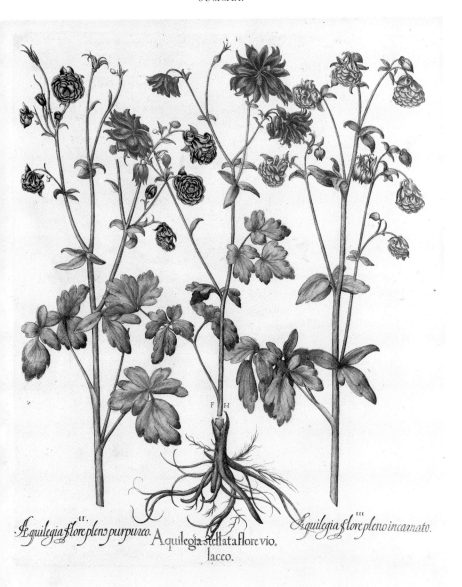

Æ quilegia flore plens purpureo. II.

Aquilegia stellata flore vio. laceo.

Æ quilegia flore pleno incarnato. III.

AQUILEGIA VULGARIS

Double dark purple columbine, Granny's bonnets

AQUILEGIA VULGARIS

Columbine with starlike, double, deep violet flowers, Granny's bonnets

AQUILEGIA VULGARIS

Double pink columbine, Granny's bonnets

Plate 171

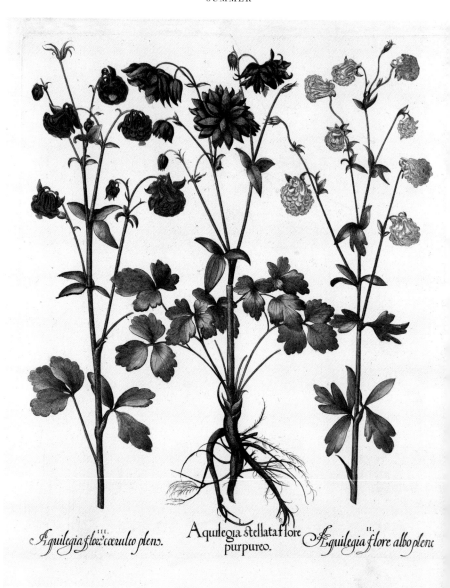

Aquilegia flox cœruleo plens. *Aquilegia stellata flore purpureo.* *Aquilegia flore albo plene*

AQUILEGIA VULGARIS

Double blue columbine, Granny's bonnets

AQUILEGIA VULGARIS

Columbine with starlike, double, deep violet flowers, Granny's bonnets

AQUILEGIA VULGARIS

Double white columbine, Granny's bonnets

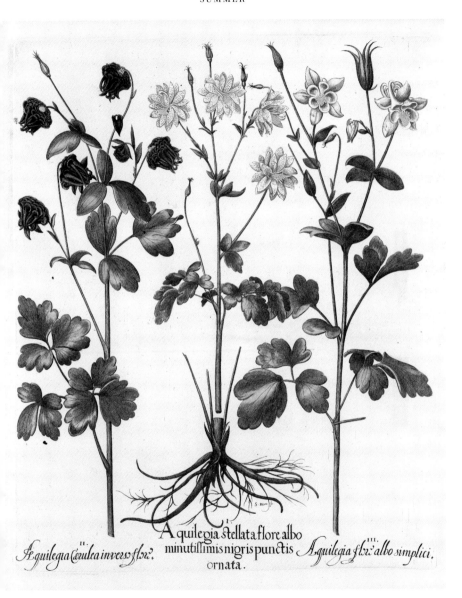

Æguilegia cærulea inverso flxe.

Aquilegia stellata flore albo minutissimis nigris punctis ornata.

Aguilegia flxe albo simplici.

AQUILEGIA VULGARIS

Blue columbine with distorted flowers, Granny's bonnets

AQUILEGIA VULGARIS

Columbine with starlike, white-speckled flowers, Granny's bonnets

AQUILEGIA VULGARIS

White columbine, Granny's bonnets

Plate 173 255

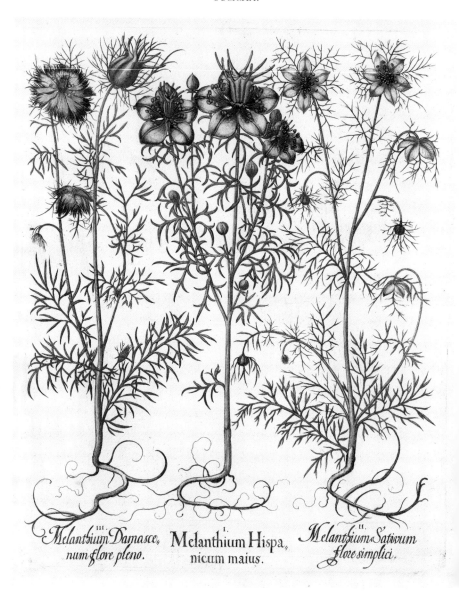

Melantbium Damasce, num flore pleno. III.

Melanthium Hispa, nicum maius. I.

Melantbium Sativum flore simplici. II.

NIGELLA DAMASCENA, II.–III.
Love-in-a-mist, Ragged lady

NIGELLA HISPANICA
Fennel-flower

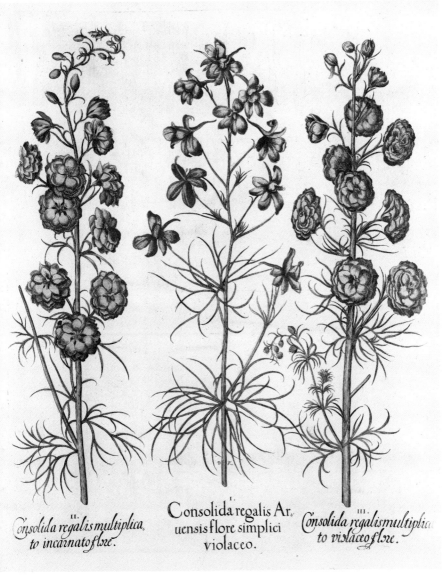

Consolida regalis multiplica,
to incarnato flore.

I.
Consolida regalis Ar,
uensis flore simplici
violaceo.

III.
Consolida regalis multiplica,
to violaceo flore.

CONSOLIDA AJACIS

Pink larkspur

CONSOLIDA REGALIS

Larkspur

CONSOLIDA AJACIS

Double blue larkspur

Plate 175 255

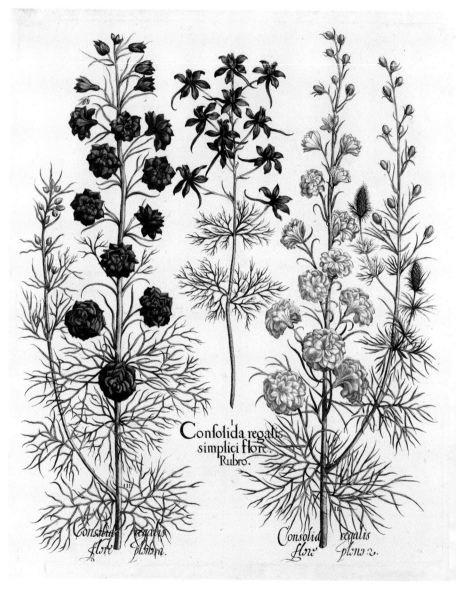

Confolida regalis
simplici flore.
Rubro.

CONSOLIDA AJACIS
Larkspur

CONSOLIDA REGALIS
Pink larkspur

CONSOLIDA AJACIS
Double pink larkspur

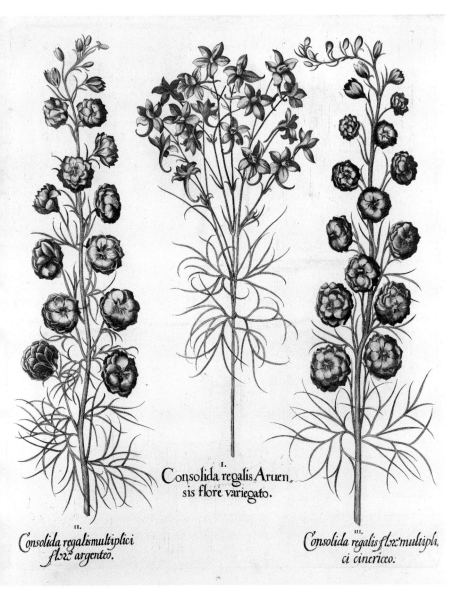

I.
Consolida regalis Aruen„
sis flore variegato.

II.
Consolida regalismultiplici
flxc argenteo.

III.
Consolida regalis flxc multipli,
ci cinericeo.

CONSOLIDA AJACIS
Double silver-white larkspur

CONSOLIDA REGALIS
Bright blue variegated larkspur

CONSOLIDA AJACIS
Double ash-white larkspur

Plate 177　　　　　　　　257

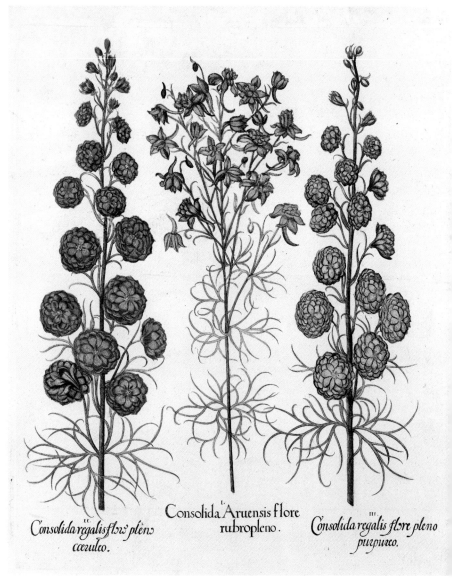

Consolida regalis flore pleno coeruleo.

Consolida Aruensis flore rubropleno.

Consolida regalis flore pleno purpureo.

CONSOLIDA AJACIS
Double deep blue larkspur

CONSOLIDA REGALIS
Double pink larkspur

CONSOLIDA AJACIS
Double purple larkspur

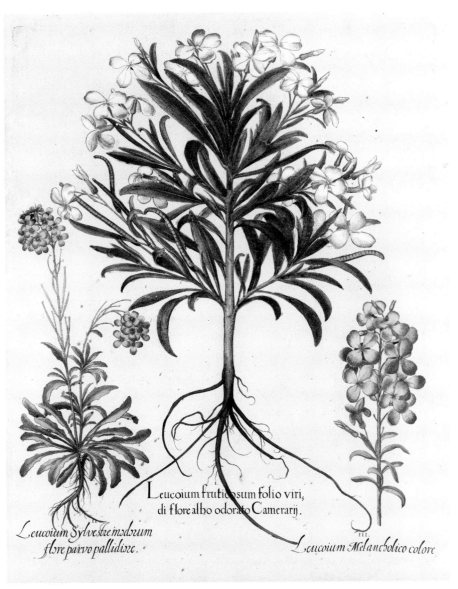

Leucoium fruticosum folio viri, di flore albo odorato Camerarij.

Leucoium Sylvestre modorum flore parvo pallidine.

Leucoium Melancholico colore

ERYSIMUM SPEC.
Wallflower

MATTHIOLA INCANA
Gillyflower, Stock

MATTHIOLA INCANA
Gillyflower, Stock

Plate 179 259

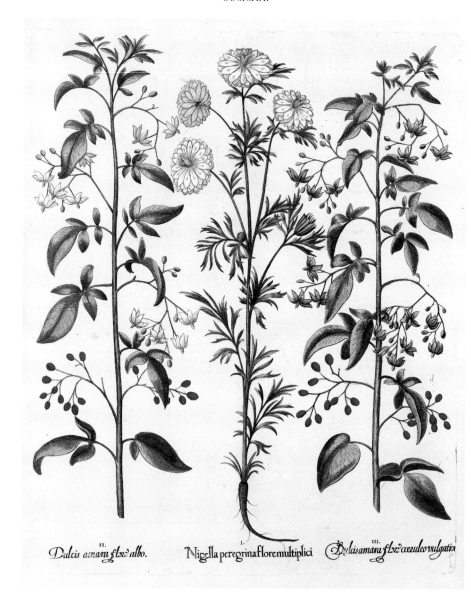

Dulcis amara flxe albo. Nigella peregrina flore multiplici *Dulcisamara flxe coeruleo vulgatir*

SOLANUM DULCAMARA, II.–III.

White bittersweet, Climbing nightshade,
Deadly nightshade,
Poisonous nightshade

NIGELLA SATIVA

Black cumin, Nutmeg flower,
Roman coriander

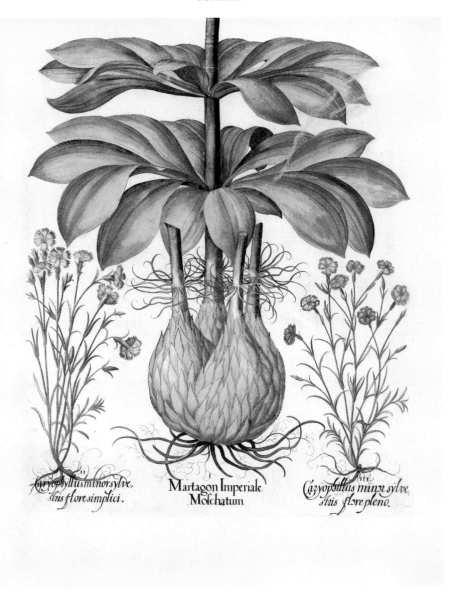

Caryophyllus minor sylve,
stris flore simplici.

Martagon Imperiale
Moschatum

Caryophyllus minu sylve.
stris flore pleno.

DIANTHUS SPEC., II.–III.
Carnation, Pink

LILIUM MARTAGON
*Bulb and basal leaves of martagon,
turk's cap lily*

Plate 181 261

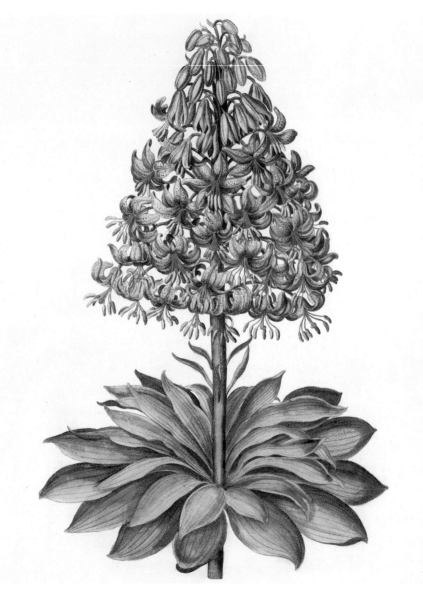

LILIUM MARTAGON
Inflorescence of martagon,
turk's cap lily

Plate 182

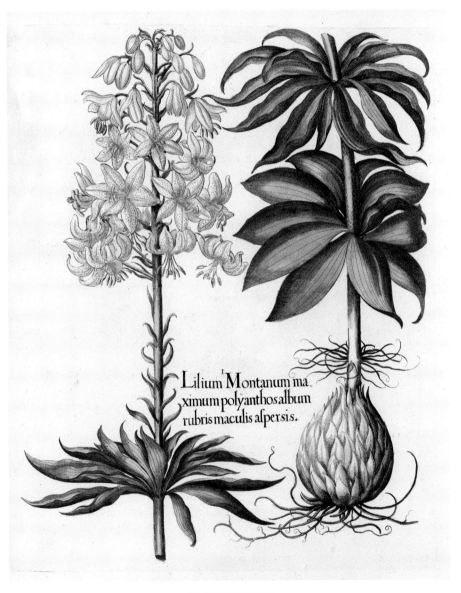

Lilium Montanum ma.
ximum polyanthos album
rubris maculis afpersis.

LILIUM MARTAGON
Martagon lily,
White spotted turk's cap lily with bulb

Plate 183 263

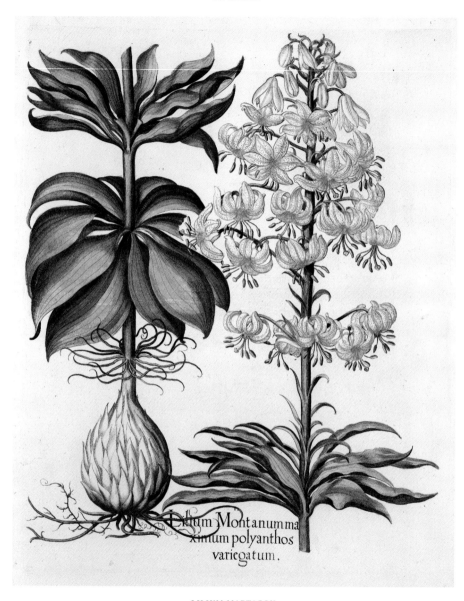

Lilium Montanum ma
ximum polyanthos
variegatum.

LILIUM MARTAGON
Martagon lily, Multi-flowered
spotted turk's cap lily with bulb

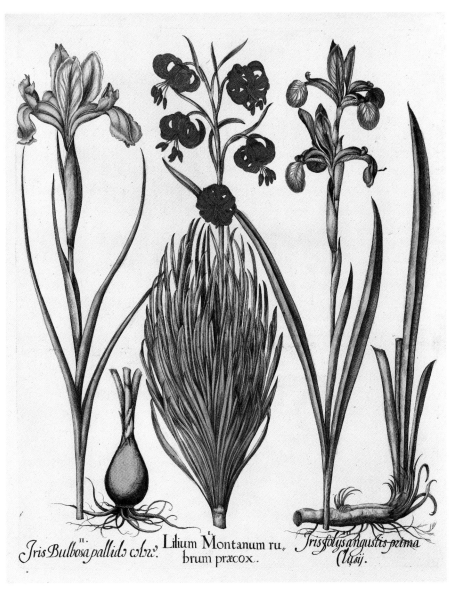

Iris Bulbosa pallide cœru. Lilium Montanum ru, brum præcox. *Iris folys angustis prima Clusij.*

IRIS XIPHIUM
Spanish iris

LILIUM POMPONIUM
Lily

IRIS SIBIRICA
Siberian iris

Plate 185 265

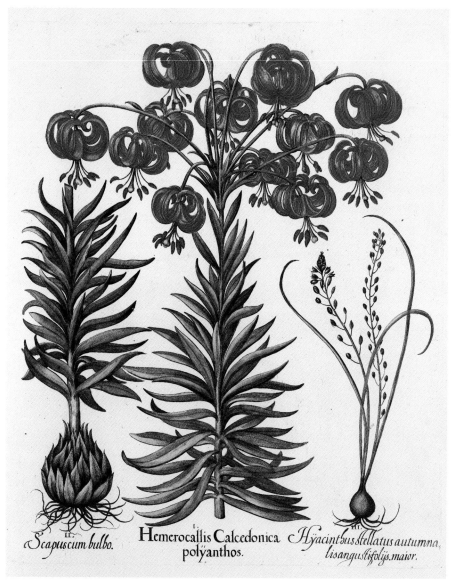

II.
Scapus cum bulbo.

I.
Hemerocallis Calcedonica
polyanthos.

III.
Hyacinthus stellatus autumna,
lis angustifolijs.maior.

LILIUM
CHALCEDONICUM I.–II.

*Scarlet turk's cap lily, Red martagon
of Constantinople with bulb*

SCILLA
AUTUMNALIS

Autumn squill with bulb

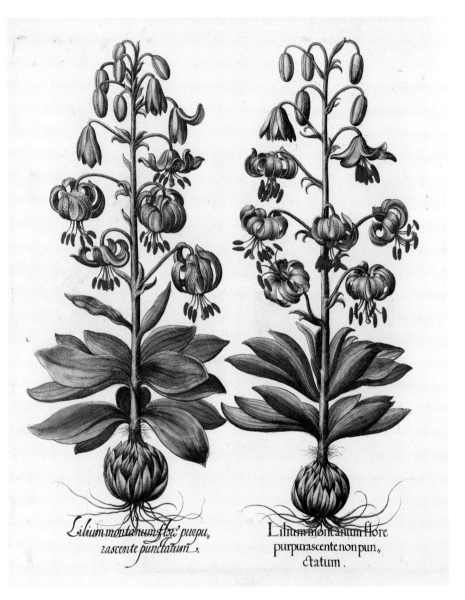

*Lilium montanum flore puepu,
rascente punctatum.*

*Lilium montanum flore
purpurascente non pun,
ctatum.*

LILIUM MARTAGON
Martagon lily, Turk's cap lily

Plate 187 267

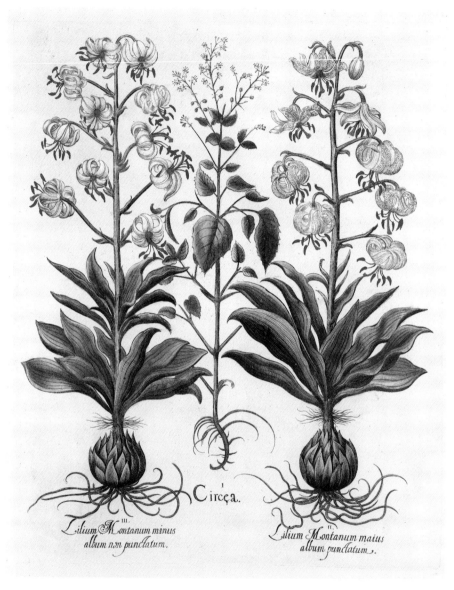

Circæa.

Lilium Montanum minus album non punctatum. III.

Lilium Montanum maius album punctatum. II.

LILIUM MARTAGON, II. – III.
Martagon lily, White turk's cap lily

CIRCAEA LUTETIANA
*Enchanter's nightshade,
Wild mandrake*

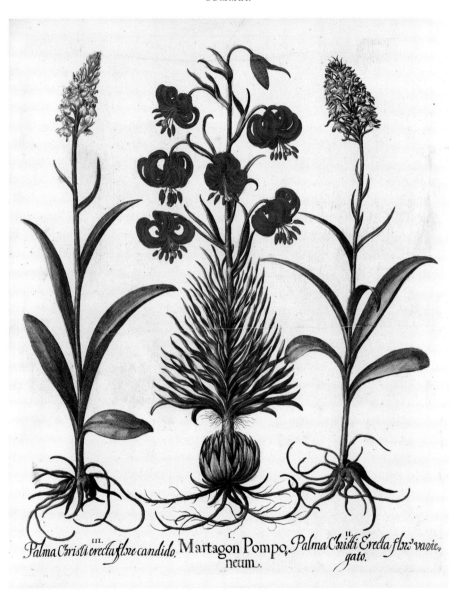

Palma Christi erecta flore candido. Martagon Pompo, Palma Christi Erecta flxe vavie, neum. gato.

DACTYLORHIZA INCARNATA
White early marsh orchid

LILIUM POMPONIUM
Lily

DACTYLORHIZA INCARNATA
Flesh-pink early marsh orchid

Plate 189 269

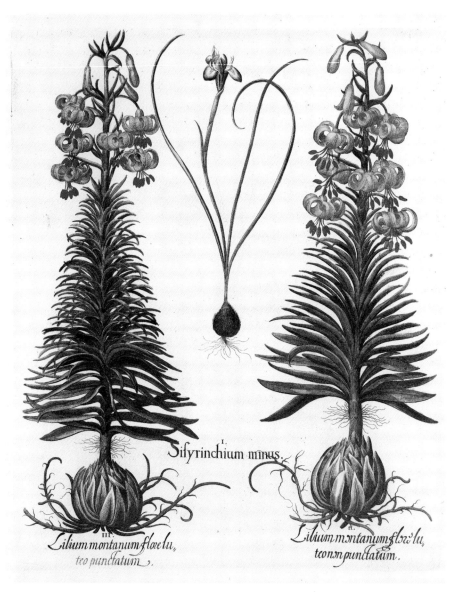

Silyrinchium minus.

Lilium montanum flore lu,
teo punctatum.

Lilium montanum flore lu,
teonm punctatum.

LILIUM
PYRENAICUM

GYNANDRIRIS
SISYRINCHIUM

LILIUM
PYRENAICUM

Yellow spotted turk's cap lily

Iris

Yellow turk's cap lily

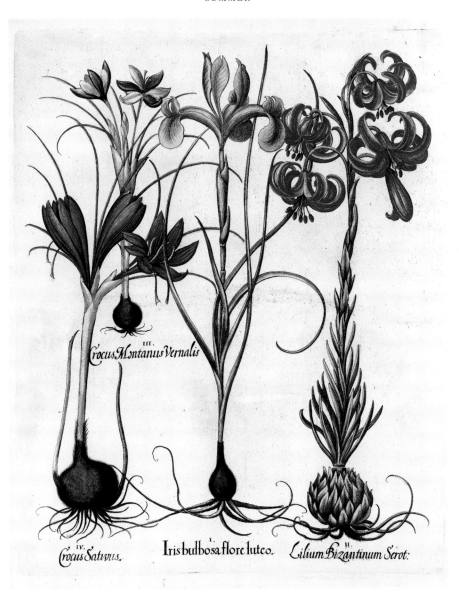

III.
Crocus Montanus Vernalis

IV.
Crocus Sativus.

I.
Iris bulbosa flore luteo.

II.
Lilium Bizantinum Serot:

CROCUS
SATIVUS

CROCUS SPEC.

IRIS
XIPHIUM

LILIUM
CHALCEDONICUM

Saffron crocus

Dutch crocus

Spanish iris

*Scarlet turk's cap lily, Red
martagon of Constantinople*

Plate 191 271

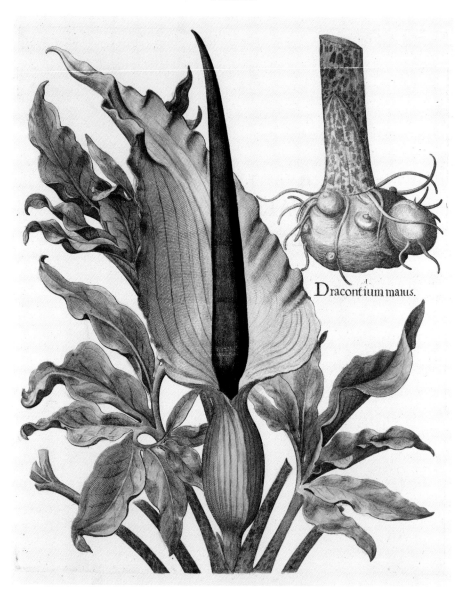

Dracontium maius.

DRACUNCULUS VULGARIS
Dragon arum (with rhizome)

Plate 192

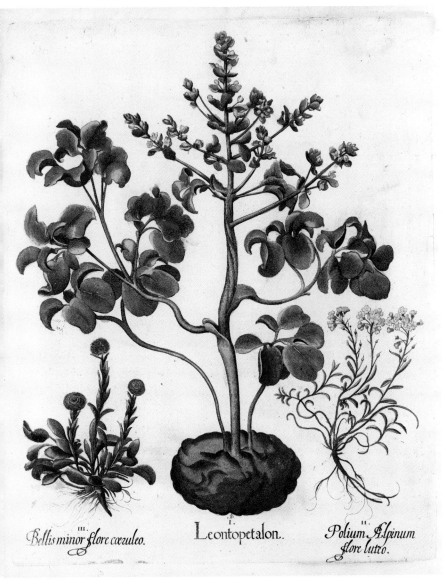

Bellis minor flore cœruleo. *Leontopetalon.* *Polium Alpinum flore luteo.*

GLOBULARIA PUNCTATA
Globe daisy

LEONTICE LEONTOPETALUM
Lion's leaf

ALYSSUM MONTANUM
Madwort

Plate 193 273

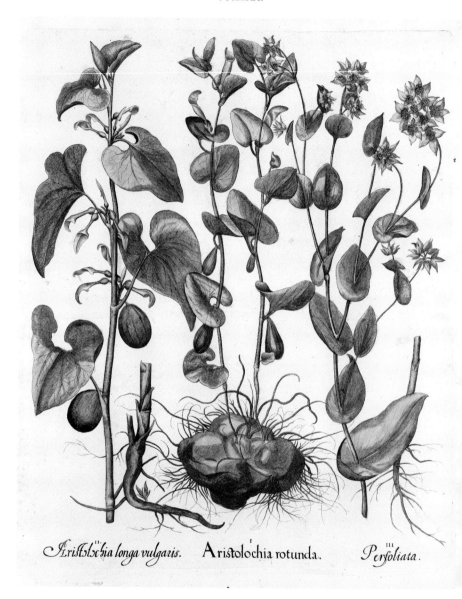

Aristolochia longa vulgaris. A ristolochia rotunda. *Perfoliata.*

ARISTOLOCHIA CLEMATITIS	ARISTOLOCHIA ROTUNDA	BUPLEURUM ROTUNDIFOLIUM
Birthwort, Dutchman's pipe	*Birthwort, Dutchman's pipe*	*Thorow-wax*

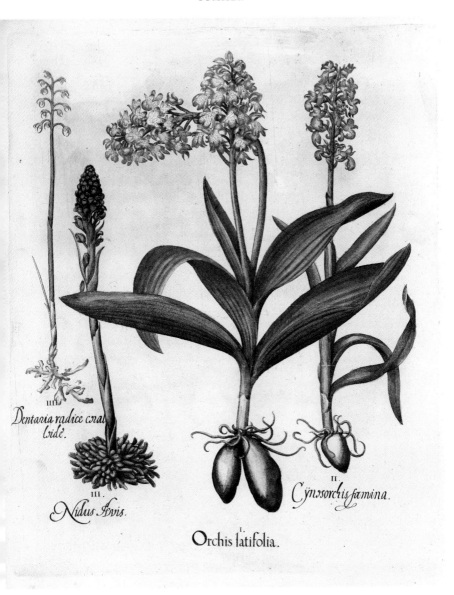

Dentaria radice coral lride.

IIII.

III.
Nidus Avis.

II.
Cÿnosorchis fæmina.

I.
Orchis latifolia.

CORALLORHIZA TRIFIDA	NEOTTIA NIDUS-AVIS	ORCHIS PURPUREA	ORCHIS CORIOPHORA
Coralroot orchid	*Bird's nest orchid*	*Lady orchid*	*Bug orchid*

Plate 195 275

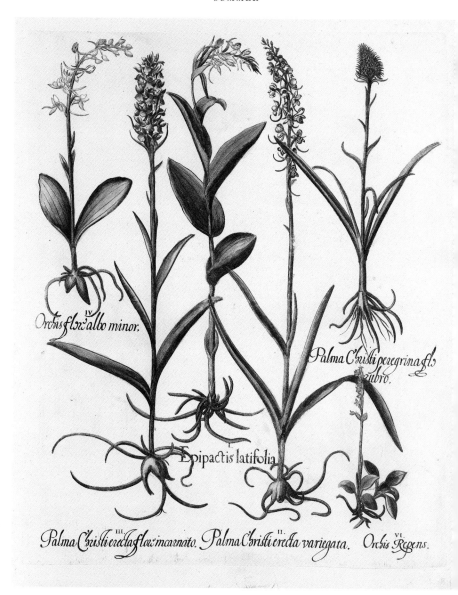

Orchis flox albo minor.

Palma Christi peregrina fls rubro.

Epipactis latifolia

Palma Christi erecta flox incarnato. Palma Christi erecta variegata. Orchis Repens.

PLATANTHERA BIFOLIA	DACTYLORHIZA INCARNATA, II.–III.	EPIPACTIS HELLEBORINE	NIGRITELLA NIGRA	GOODYERA REPENS
Lesser butterfly orchid	*Early flesh-pink marsh orchid*	*Helleborine*	*Black vanilla orchid*	*Lesser rattlesnake plantain*

Plate 196

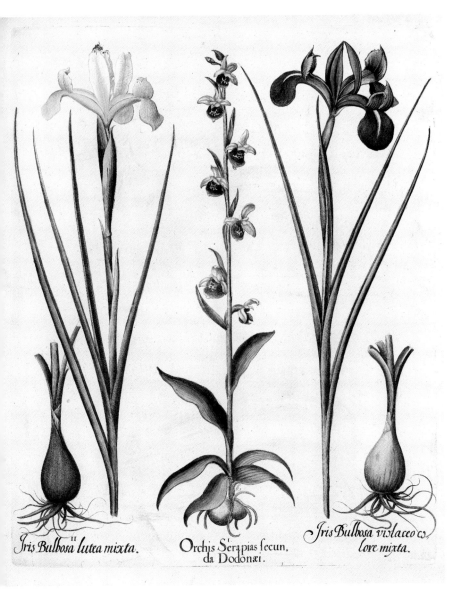

Iris Bulbosa lutea mixta.

Orchis Serapias secunda Dodonæi.

Iris Bulbosa violaceo colore mixta.

IRIS
XIPHIUM

*Spanish iris with
yellow flowers*

OPHRYS
HOLOSERICA

Late spider orchid

IRIS
XIPHIUM

*Spanish iris
with violet flowers*

Plate 197

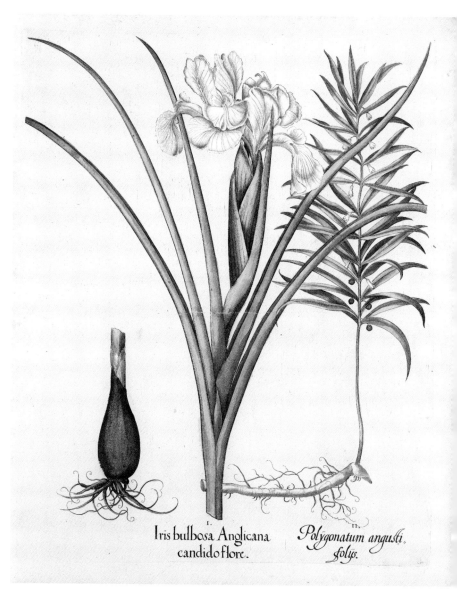

Iris bulbosa Anglicana
candido flore.

Polygonatum angusti
folijs.

IRIS XIPHIOIDES
English iris

POLYGONATUM VERTICILLATUM
Whorled Solomon's seal

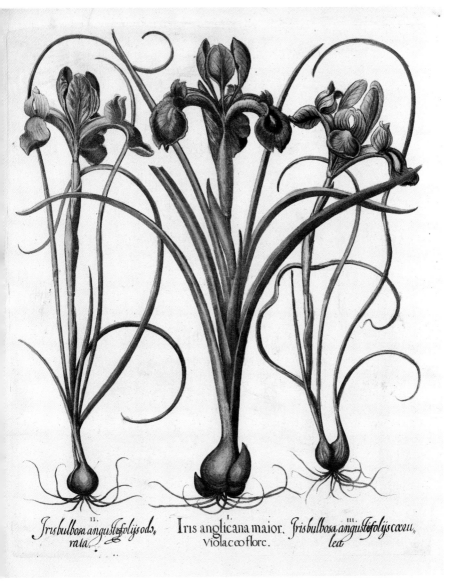

Iris bulbosa angustifolijs odo,
II.
rata.

I.
Iris anglicana maior, *Iris bulbosa angustifolijs cœru,*
III.
Violaceo flore.
lea

IRIS XIPHIUM

*Fragrant bulbous iris with
narrow leaves*

IRIS XIPHIOIDES

English iris

IRIS XIPHIUM

*Fragrant bulbous iris
with narrow leaves*

Plate 199 279

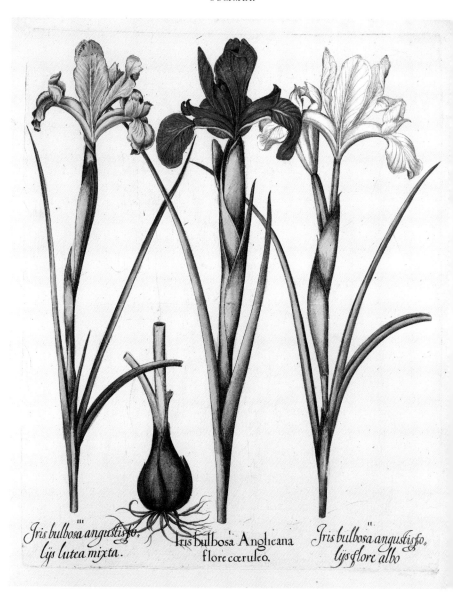

Iris bulbosa angustisso, lijs lutea mixta.

Iris bulbosa Anglicana flore cœruleo.

Iris bulbosa angustisso, lijs flore albo

IRIS
XIPHIUM

*Yellowish iris with
narrow leaves*

IRIS
XIPHIOIDES

English iris

IRIS
XIPHIUM

*White iris with
narrow leaves*

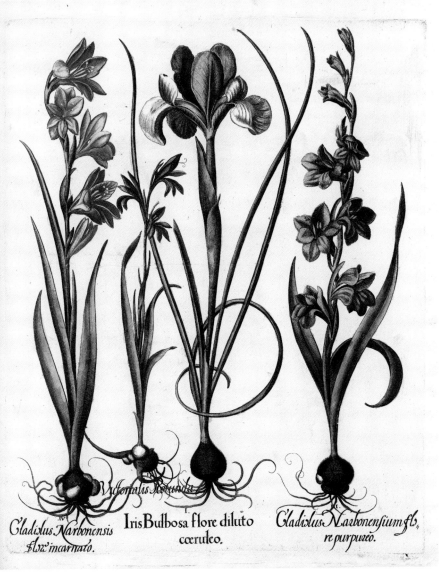

Gladiolus Narbonensis flor. incarnato.

Victorialis Rotunda

Iris Bulbosa flore diluto cœruleo.

Gladiolus. Narbonensium fl, re purpureo.

GLADIOLUS COMMUNIS	GLADIOLUS PALUSTRIS	IRIS XIPHIOIDES	GLADIOLUS COMMUNIS
Common gladiolus with violet flowers	*Marsh gladiolus*	*English iris*	*Common gladiolus with dark flowers*

Plate 201

281

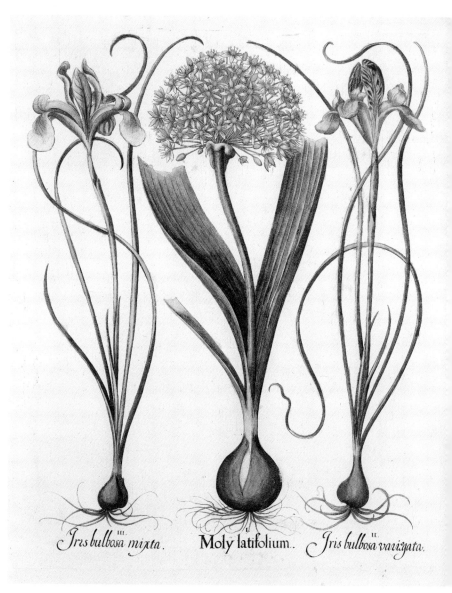

Iris bulbosa mixta. III. Moly latifolium. I. *Iris bulbosa variegata.* II.

IRIS XIPHIUM, II.–III. ALLIUM AMPELOPRASUM
Spanish iris *Wild leek, Levant garlic, Kurrat*

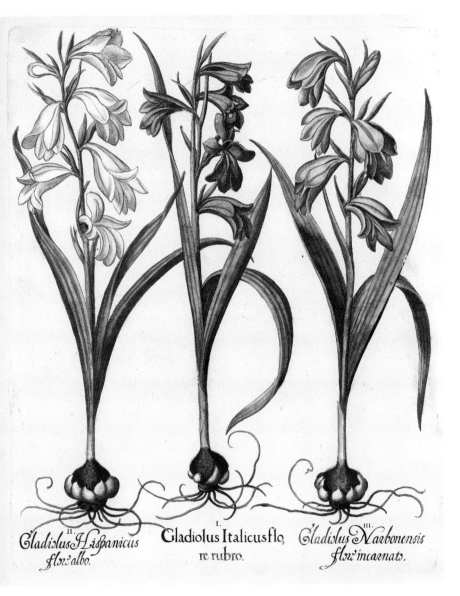

Gladislus Hispanicus flo albo.

I.
Gladiolus Italicusflo, re rubro.

Gladislus Narbonensis flo incarnats.

GLADIOLUS COMMUNIS
Common gladiolus

Plate 203

283

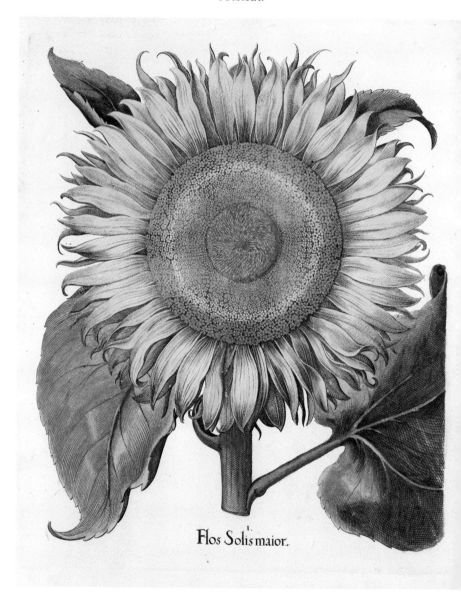

Flos Solis maior.

HELIANTHUS ANNUUS
Common sunflower

Plate 204

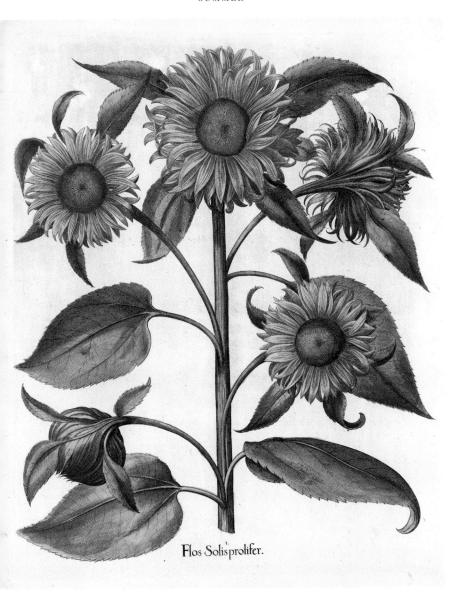

Flos Solis prolifer.

HELIANTHUS X MULTIFLORUS
Sunflower

Plate 205

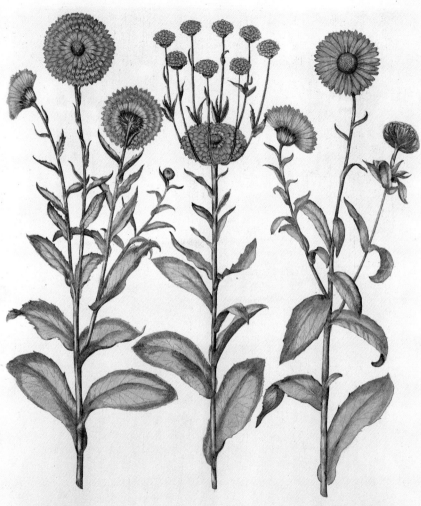

Calendula lutea flore pleno. *Calendula prolifera.* *Calendula lutea medioruffa.*

CALENDULA OFFICINALIS

Ruddles, Common marigold,
Scotch marigold, Pot marigold

CALENDULA ARVENSIS

Field marigold

CALENDULA SPEC.

Marigold

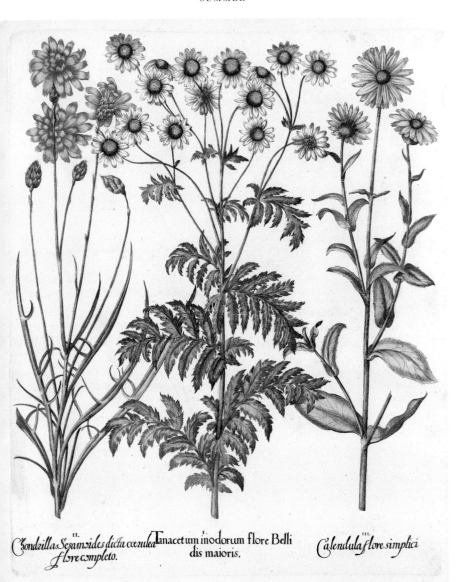

Chondrilla Sesamoides dicta coerulea flore completo.

Tanacetum inodorum flore Bellidis maioris.

Calendula flore simplici

CATANANCHE CAERULEA
Blue cupidone, Cupid's dart

TANACETUM CORYMBOSUM
Tansy

CALENDULA SPEC.
Marigold

Plate 207 287

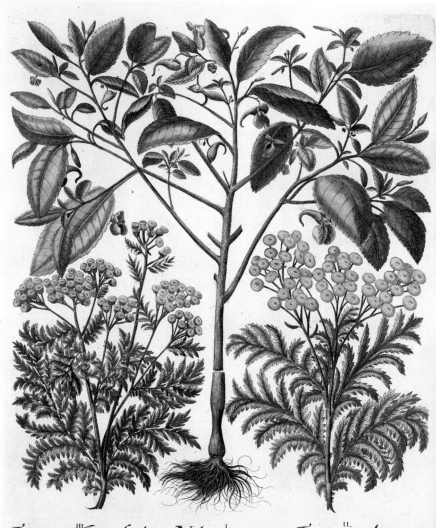

Tanacetum Cristatum Anglicum. Noli me tangere. *Tanacetum vulgare.*

TANACETUM VULGARE, II.–III. IMPATIENS NOLI-TANGERE
Tansy, Golden buttons *Touch-me-not*

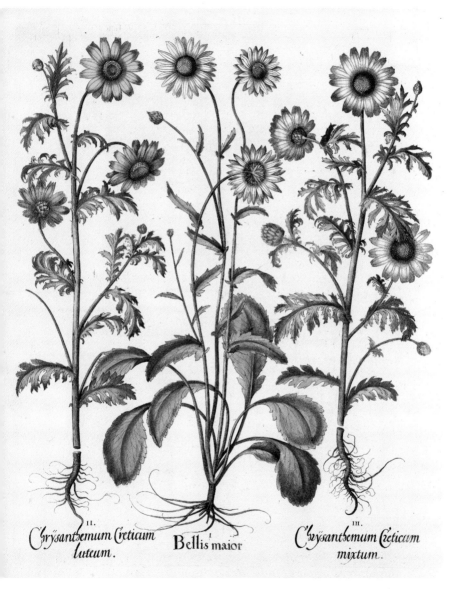

II.
Chrysanthemum Creticum luteum.

Bellis maior

III.
Chrysanthemum Creticum mixtum.

CHRYSANTHEMUM
CORONARIUM, II. – III.

Crown daisy

LEUCANTHEMUM
VULGARE

*Ox-eye daisy, Moon daisy,
Marguerite*

Plate 209

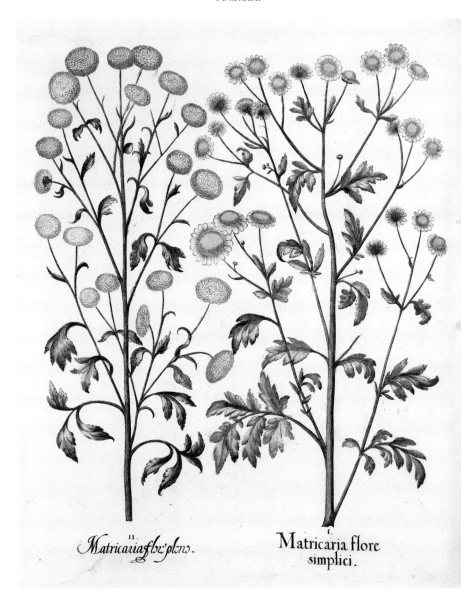

Matricaria flre. pleno.

Matricaria flore simplici.

TANACETUM PARTHENIUM

Feverfew

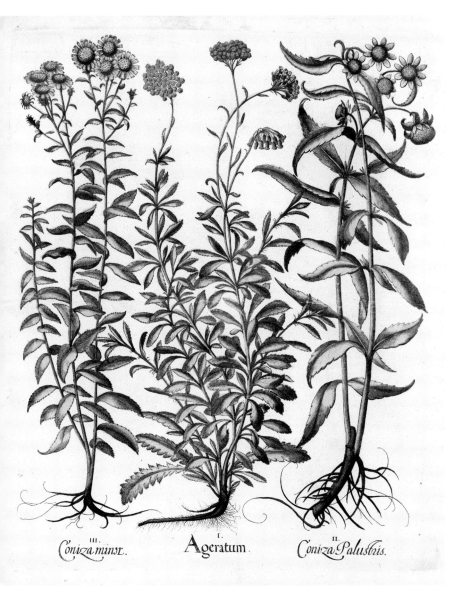

Coniza minor. *Ageratum.* *Coniza Palustris.*

INULA SALICINA ACHILLEA AGERATUM BIDENS CERNUA

Willow-leaved inula *Sweet Nancy* *Nodding bur-marigold*

Plate 211 291

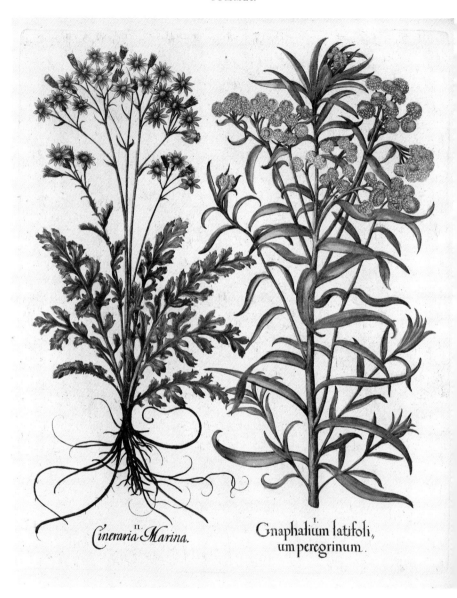

Cineraria Marina.

Gnaphalium latifoli, um peregrinum.

SENECIO BICOLOR SSP.
CINERARIA

Ragwort

ANAPHALIS
MARGARITACEA

Pearly everlasting

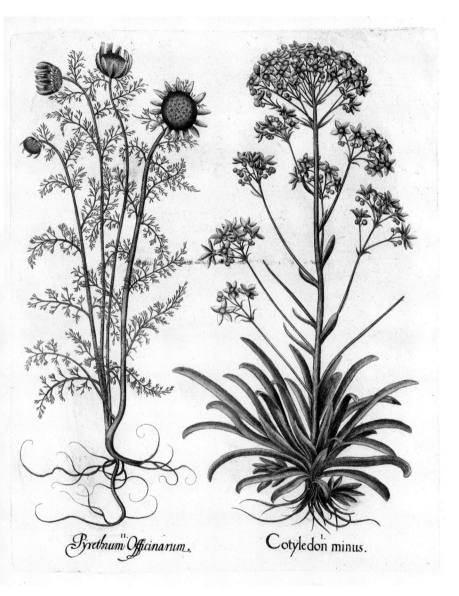

Pyrethrum Officinarum.

Cotyledon minus.

ANACYCLUS PYRETHRUM
Mount Atlas daisy

SAXIFRAGA COTYLEDON
Great Alpine rockfoil,
Greater evergreen saxifrage

Plate 213

293

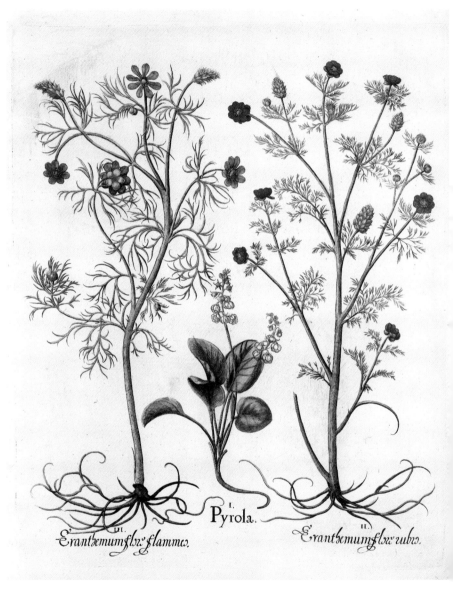

I.
Pyrola.

III.
Eranthemum flōr: flammœ.

II.
Eranthemum flōr: rubro.

ADONIS FLAMMEA | PYROLA MINOR | ADONIS ANNUA
Flame-coloured pheasant's eye | *Lesser wintergreen* | *Pheasant's eye*

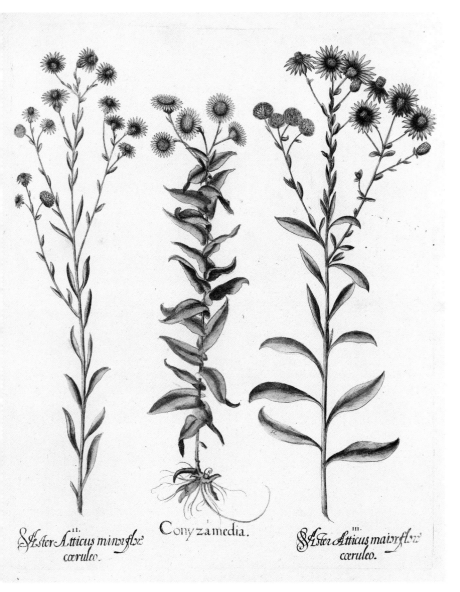

*Aster Atticus minor flore
cœruleo.*

Conyzamedia.

*Aster Atticus maior flore
cœruleo.*

ASTER AMELLUS, II.–III. PULICARIA DYSENTERICA
Italian Starwort *Fleabane*

Plate 215 295

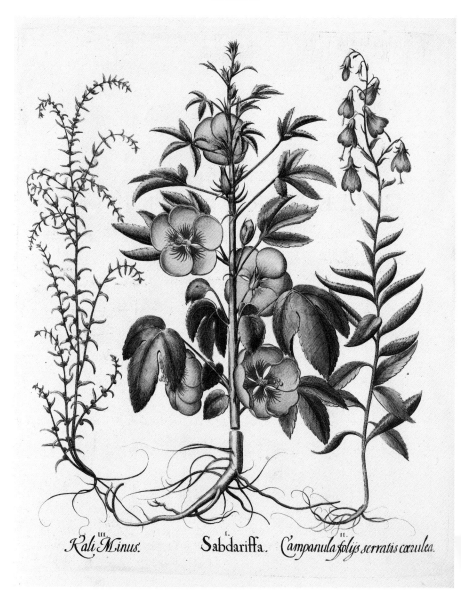

Kali Minus. *Sabdariffa.* *Campanula folijs serratis cœrulea.*

SALSOLA KALI

Prickly saltwort

HIBISCUS SABDARIFFA

*Roselle, Jamaica sorrel,
Red sorrel*

CAMPANULA LATIFOLIA

Bellflower

296 *Plate 216*

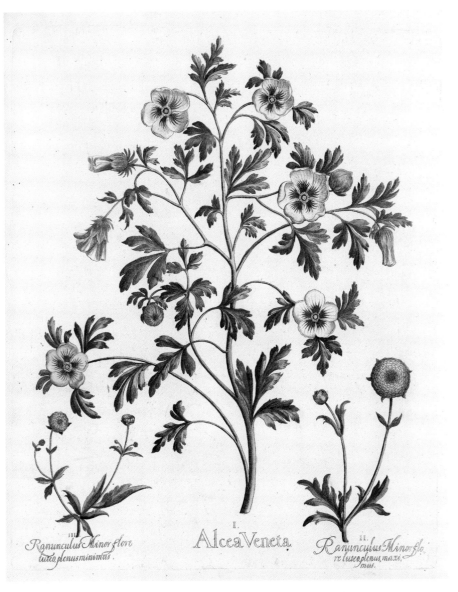

III
Ranunculus Minor flore
luteo plenus minimus.

I.
AlceaVeneta.

II.
Ranunculus Minor flo-
re luteo plenus maxi-
mus.

RANUNCULUS REPENS, II.–III.
Creeping buttercup

HIBISCUS TRIONUM
Flower-of-an-hour,
Bladder ketmia

Plate 217 297

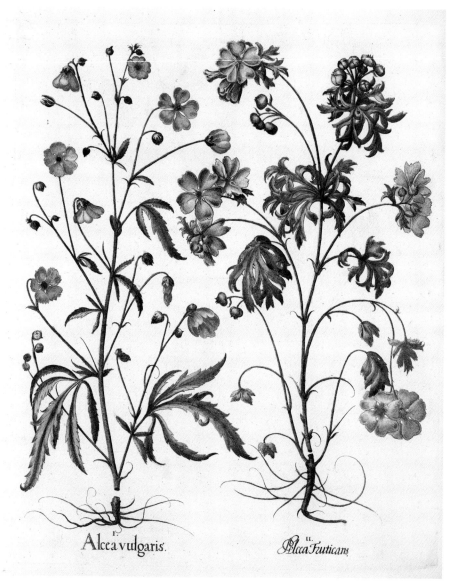

Alcea vulgaris.

Alcea Fruticans

ALTHAEA CANNABINA
Virginian Hemp

MALVA MOSCHATA
Mallow

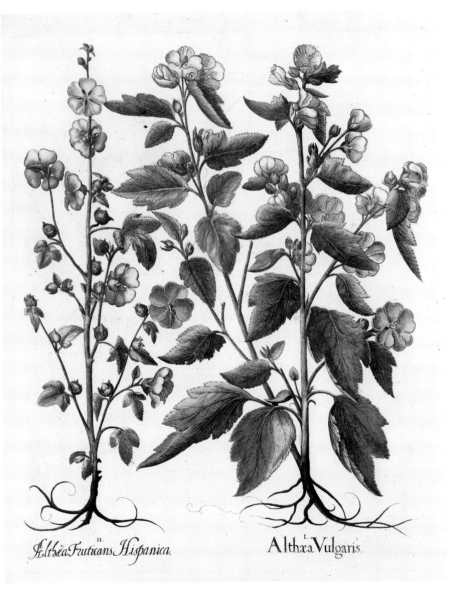

Althæa Fruticans Hispanica. Althæa Vulgaris.

MALVA ALCEA
Hollyhock mallow

ALTHAEA OFFICINALIS
Marsh Mallow

Plate 219 299

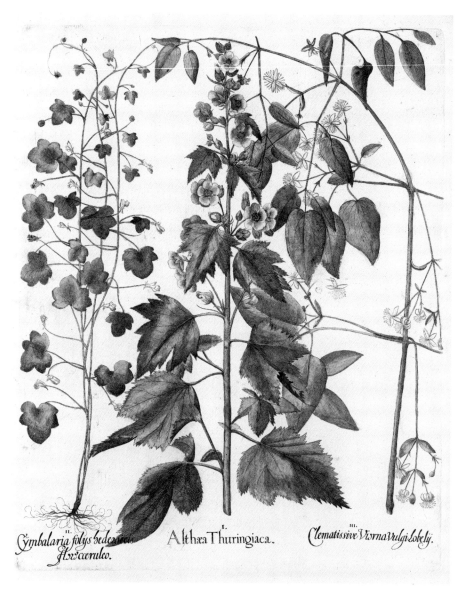

CYMBALARIA MURALIS

Kenilworth ivy, Coliseum ivy,
Pennywort, Ivy-leaved toadflax

LAVATERA THURINGIACA

Tree lavatera

CLEMATIS VITALBA

Traveller's joy,
Old man's beard

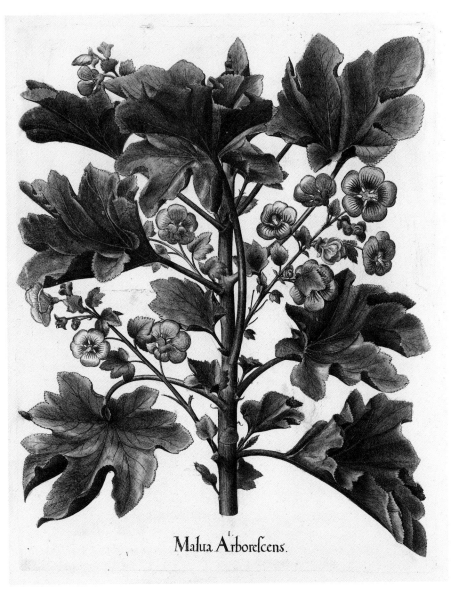

Malua Arborefcens.

LAVATERA ARBOREA
Tree mallow

Plate 221 301

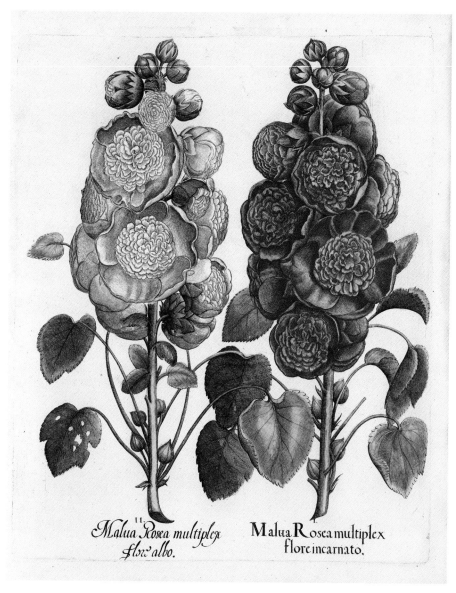

Malua Rosea multiplex flor: albo.

Malua Rosea multiplex flore incarnato.

ALCEA ROSEA
Double blue hollyhock

ALCEA ROSEA
Double pink hollyhock

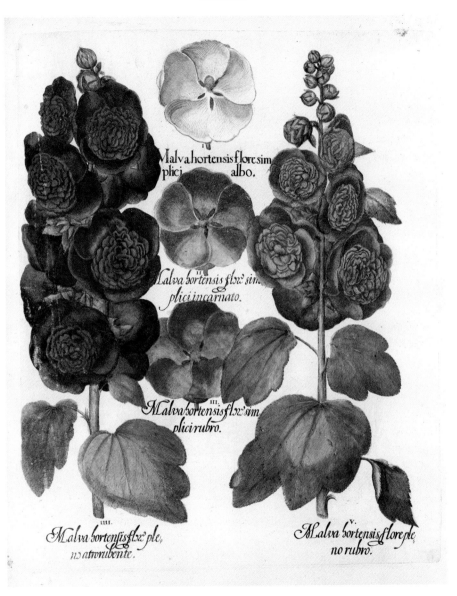

Malua hortensis flore sim
plici albo.

Lalua hortensis flx sim
plici incarnato.

Malua hortensis flx sim
plici rubro.

Malua hortensis flx ple,
no atrorubente.

Malua hortensis flore ple,
no rubro.

ALCEA ROSEA

*Double dark purple
hollyhock*

ALCEA ROSEA

White hollyhock

ALCEA ROSEA

Pink hollyhock

ALCEA ROSEA

Purple hollyhock

ALCEA ROSEA

*Doule purple
hollyhock*

Plate 223 305

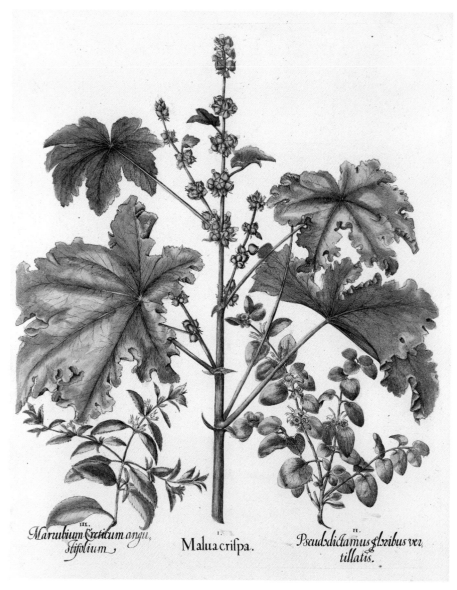

Marrubium Creticum angu, ftifolium

Malua crifpa.

Pseudodictamus floribus ver, tillatis.

MARRUBIUM PEREGRINUM
Peregrine horehound

MALVA VERTICILLATA
Mallow

BALLOTA PSEUDODICTAMNUS
Horehound

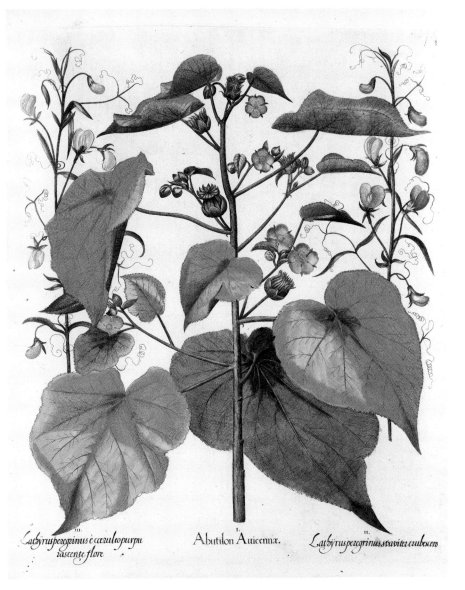

III. *Lathyrus peregrinus è cœruleo purpurascente flore*

I. *Abutilon Auicennæ.*

II. *Lathyrus peregrinus suaviter erubescens*

LATHYRUS SATIVUS, II.–III.

Indian pea, Riga pea,
Dogtooth pea, Khesari

ABUTILON THEOPHRASTI

Velvet leaf, Butter-print,
China jute

Plate 225 305

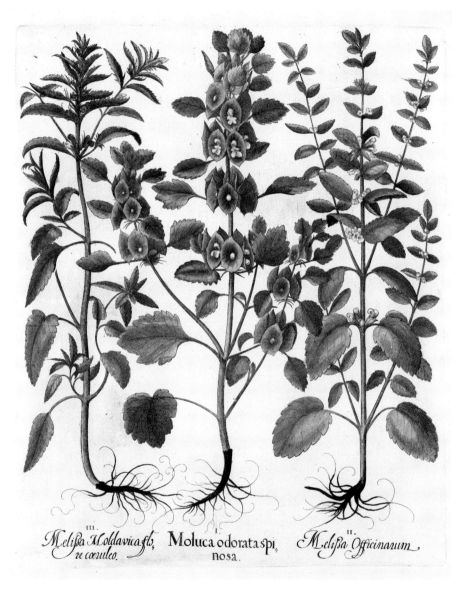

Melissa Moldavica fls, re coeruleo.

Moluca odorata spi, nosa.

M. elissa Officinarum

DRACOCEPHALUM MOLDAVICA
Dragon's head

MOLUCCELLA SPINOSA
Spiny shell-flower

MELISSA OFFICINALIS
Bee balm, Lemon balm

Plate 226

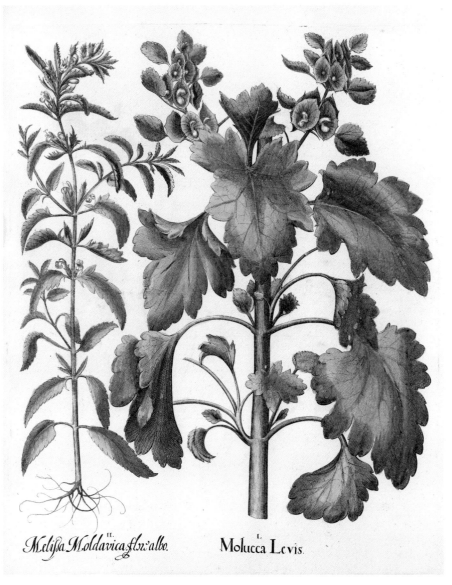

Melissa Moldavica flor. albo. *Molucca Levis.*

DRACOCEPHALUM MOLDAVICA MOLUCCELLA LAEVIS
Dragon's head *Bells of Ireland, Shell-flower*

Plate 227 307

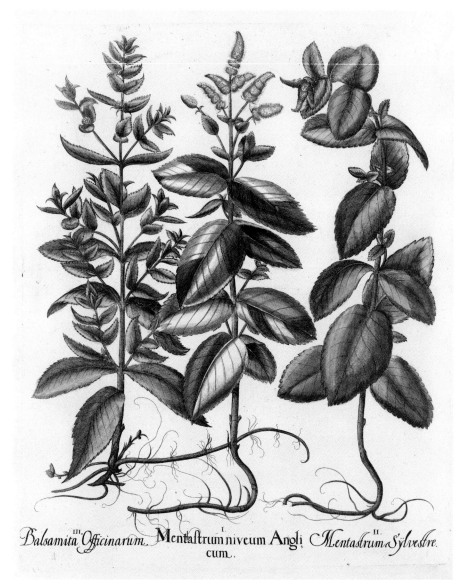

Balsamita III Officinarum. Mentastrum niveum Angli I, Mentastrum II Sylvestre. cum.

MENTHA SPEC.　　　　MENTHA LONGIFOLIA, I.–II.
Mint　　　　　　　　*Horsemint*

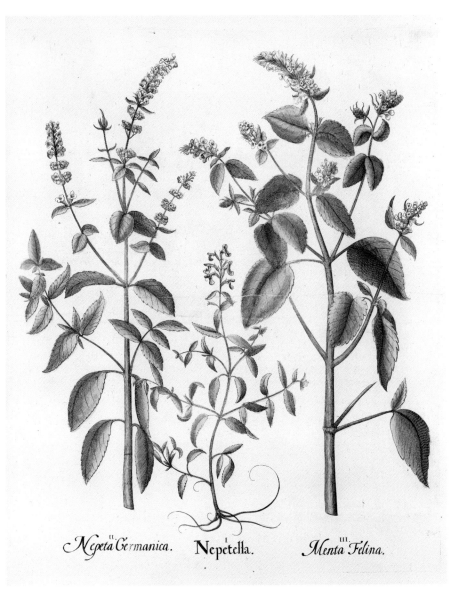

Nepeta Germanica. Nepetella. Menta Felina.

NEPETA NUDA
Catmint

NEPETA NEPETELLA
Catmint

NEPETA CATARIA
Catnip, Catmint

Plate 229 309

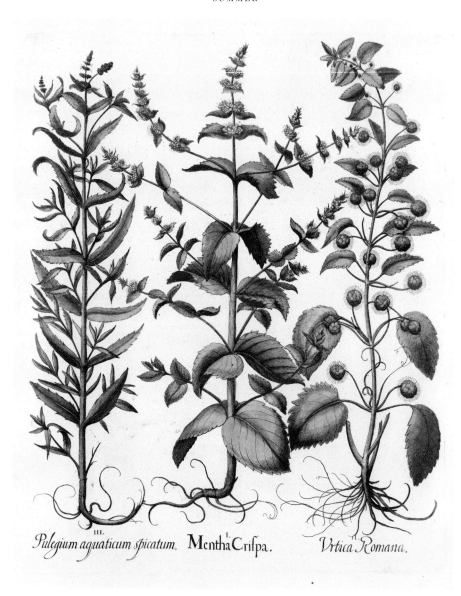

Pulegium aguaticum spicatum. Mentha Crispa. *Vrtica Romana.*

MENTHA LONGIFOLIA
Horsemint

MENTHA SPICATA
Spearmint

URTICA PILULIFERA
Roman nettle

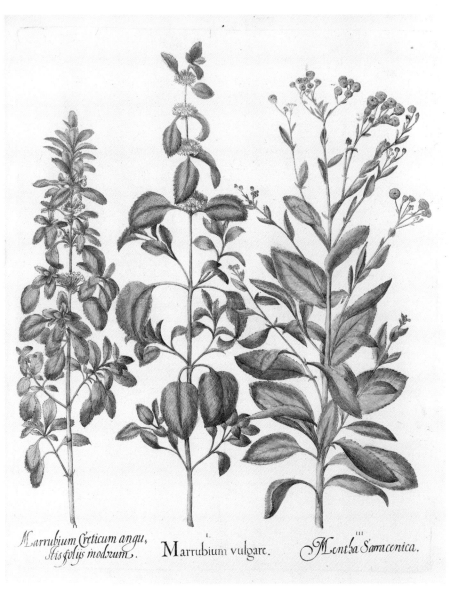

Marrubium Creticum angu, stis folijs modrum.

I.
M arrubium vulgare.

III.
Mentha Sarracenica.

MARRUBIUM PEREGRINUM
Peregrine horehound

MARRUBIUM VULGARE
Common horehound,
White horehound

TANACETUM BALSAMITA
Alecost, Costmary,
Mint geranium

Plate 231

311

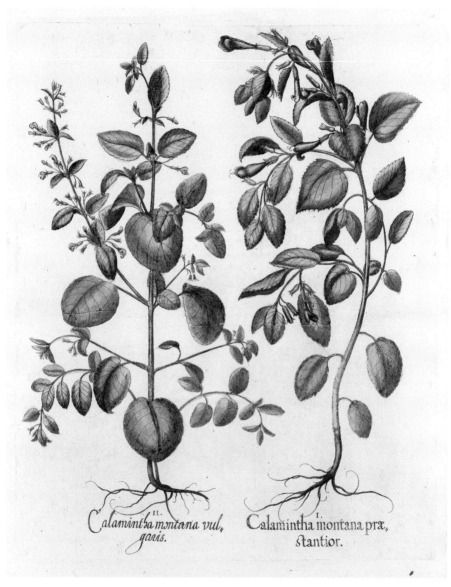

II.
Calamintha montana vul, garis.

I.
Calamintha montana præ, stantior.

CALAMINTHA OFFICINALIS
Calamint

CALAMINTHA GRANDIFLORA
Large-flowered calamint

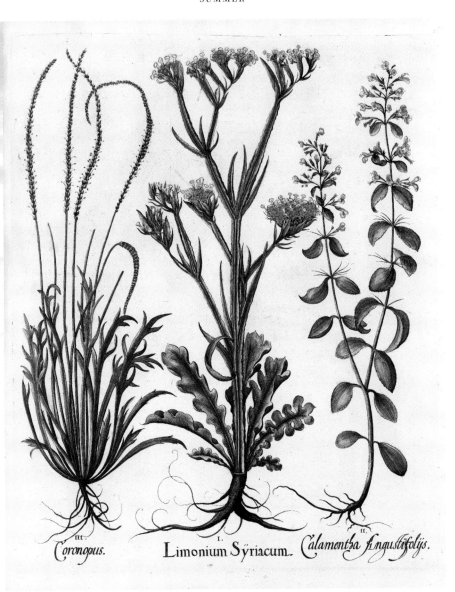

ili. Coronopus.

i. Limonium Syriacum.

ii. Calamentha Angustifolijs.

PLANTAGO CORONOPUS

Cut-leaved plantain,
Buck's-horn plantain

LIMONIUM SINUATUM

Statice

CALAMINTHA NEPETA

Lesser calamint

Plate 233

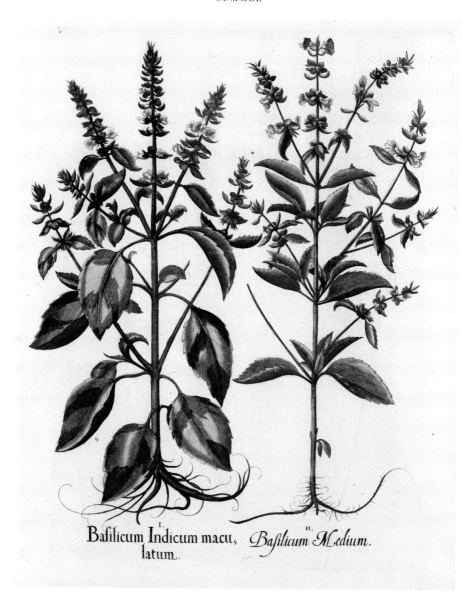

I.
Basilicum Indicum macu, *Basilicum Medium.*
latum.

OCIMUM BASILICUM
Common basil, Sweet basil

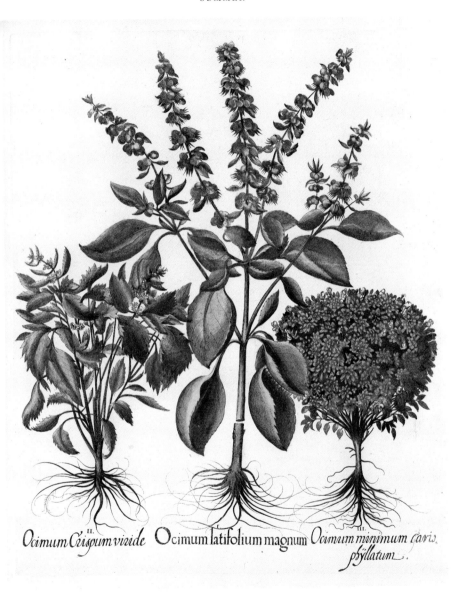

Ocimum Crispum viride **II.** *Ocimum latifolium magnum* **I.** *Ocimum minimum caris-* **III.** *phyllatum.*

OCIMUM CRISPUM
Curly basil

OCIMUM GRATISSIMUM
East Indian basil,
Tree basil, Fever plant

OCIMUM MINIMUM
Bush basil, Greek basil

Plate 235 315

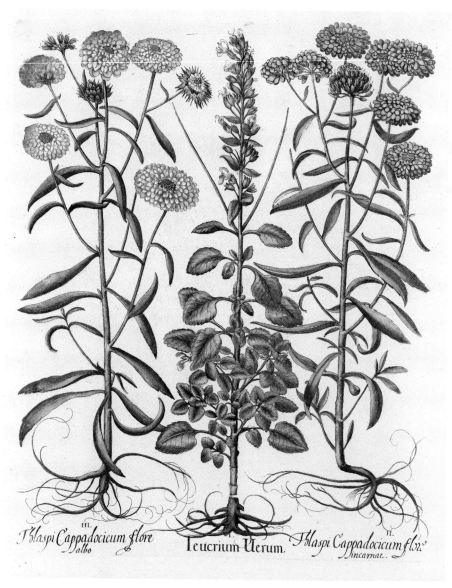

Thlaspi Cappadocicum flore *albo* *Teucrium Uerum* *Thlaspi Cappadocicum flore* *incarnat.*

IBERIS UMBELLATA, II.–III. TEUCRIUM SCORODONIA
Common candytuft *Wood sage, Sage-leaved*
germander

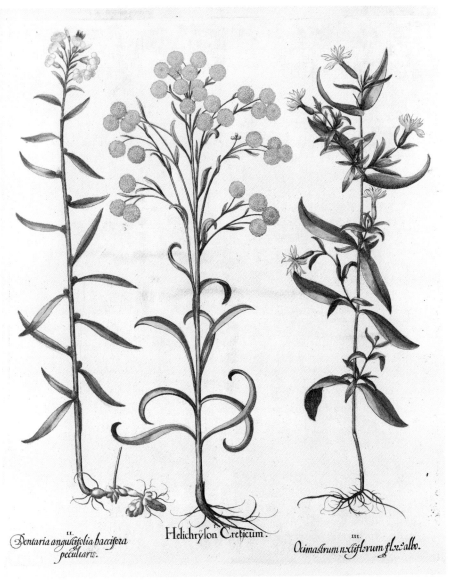

II.
Dentaria angustifolia baccifera peculiaris.

Helichryson Creticum.

III.
Ocimastrum noctiflorum flore albo.

DENTARIA BULBIFERA
Coral root bittercress, Coralwort

HELICHRYSUM ORIENTALE
Everlasting flower

SILENE NOCTIFLORA
Night-flowering catchfly

Plate 237 317

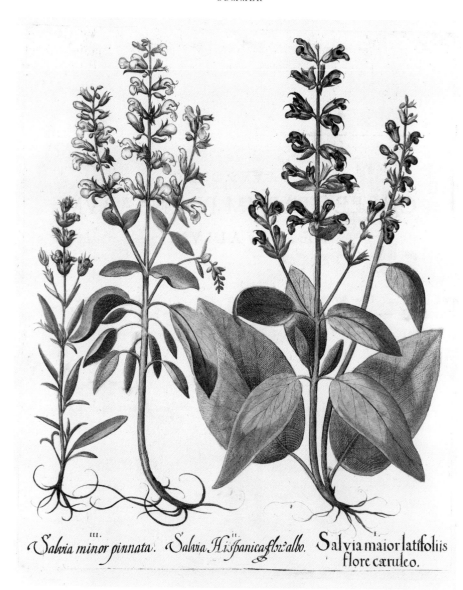

Salvia minor pinnata. ^{III.} *Salvia Hispanica flo: albo.* ^{II.} Salvia maior latifoliis ^{I.} flore cæruleo.

SALVIA NEMOROSA SALVIA OFFICINALIS SALVIA GRANDIFLORA

Sage *Common sage* *Sage*

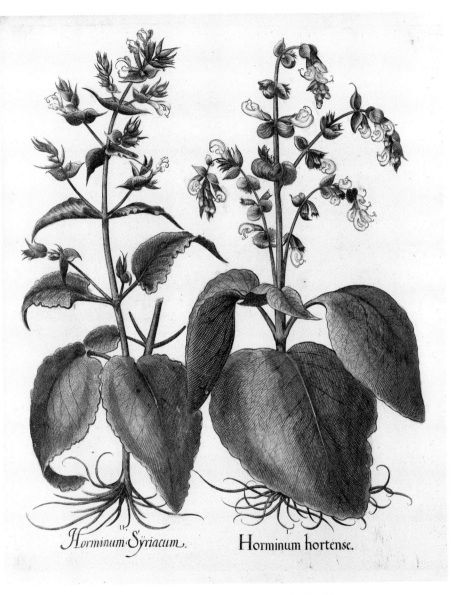

Horminum Syriacum. Horminum hortense.

SALVIA SYRIACA
Syrian sage

SALVIA SCLAREA
Clary

Plate 239 319

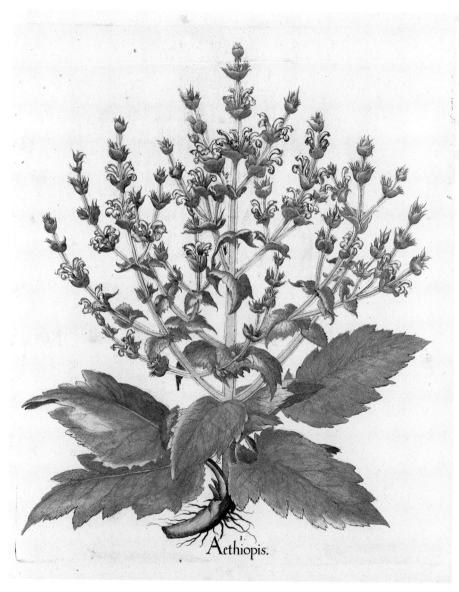

SALVIA AETHIOPIS
African sage

Plate 240

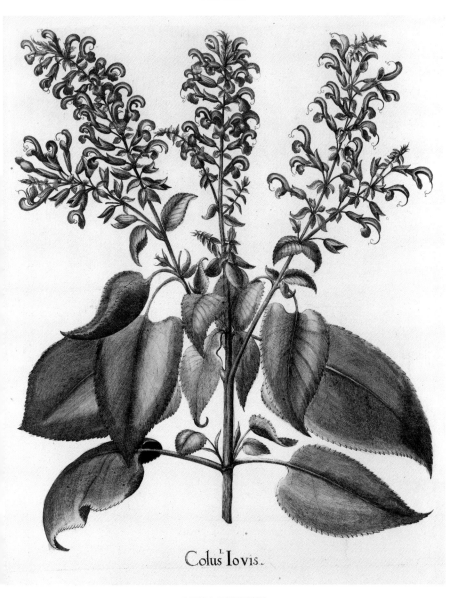

Colus Iovis.

SALVIA GLUTINOSA
Jupiter's distaff

Plate 241 321

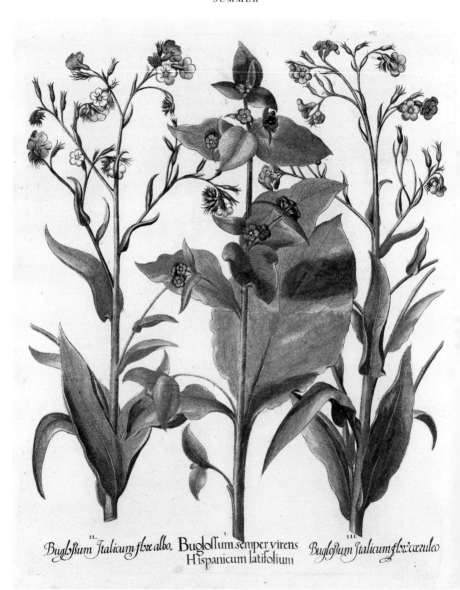

Buglossum Italicum flore albo. *Buglossum semper virens* *Buglossum Italicum flore coeruleo*
Hispanicum latifolium

ANCHUSA AZUREA,
II. – III.

Alkanet

PENTAGLOTTIS
SEMPERVIRENS

Green alkanet

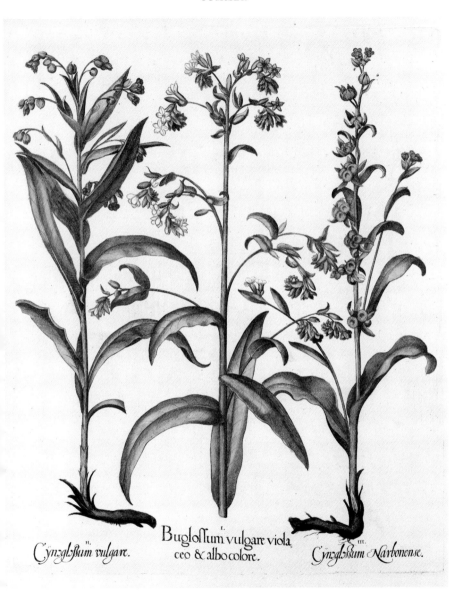

Cynglossum vulgare.

Buglossum vulgare viola, ceo & albo colore.

Cynglossum Narbonense.

CYNOGLOSSUM
OFFICINALE
Hound's tongue

ANCHUSA
OFFICINALE
Common alkanet

CYNOGLOSSUM CHEIRIFOLIUM,
CYNOGLOSSUM CRETICUM
Hound's tongue

Plate 243　　　　　323

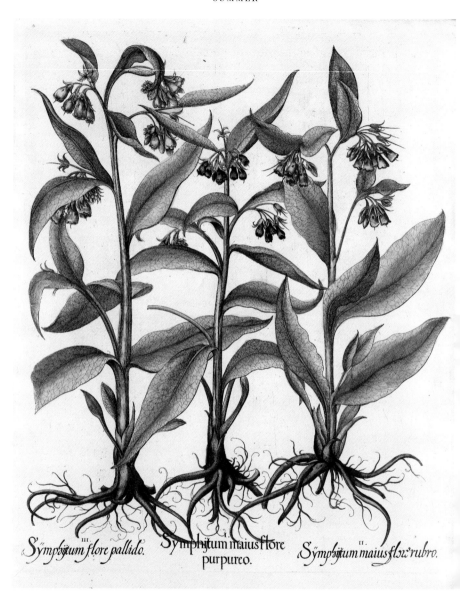

Symphytum flore pallido. iii.

Symphytum maius flore i.
purpureo.

Symphytum maius flor. rubro. ii.

SYMPHYTUM OFFICINALE
Common comfrey

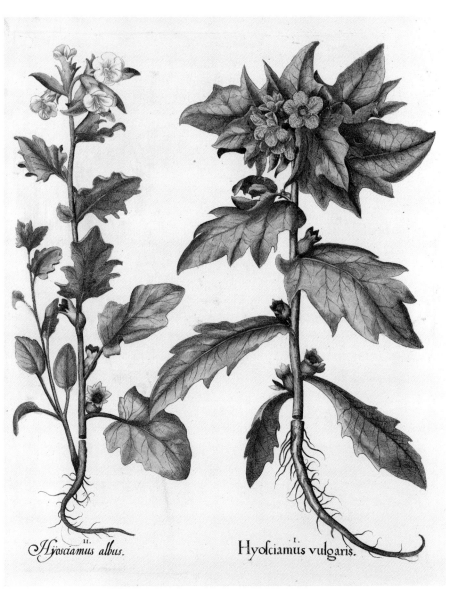

Hyosciamus albus.

II.

I.

Hyosciamus vulgaris.

HYOSCYAMUS ALBUS
Russian henbane, White henbane

HYOSCYAMUS NIGER
*Black henbane, Stinking
nightshade*

Plate 245

325

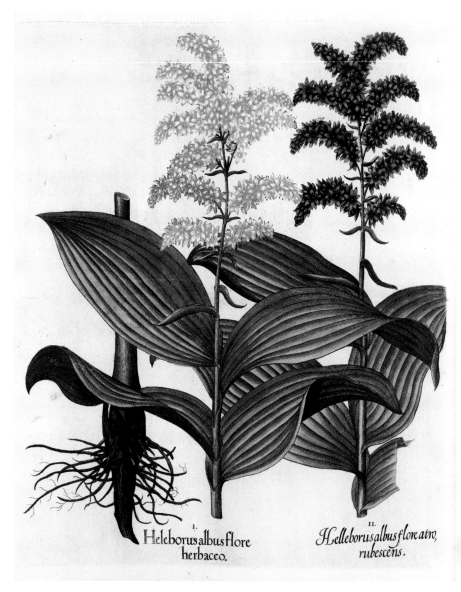

I.
Heleborus albus flore
herbaceo.

II.
Helleborus albus flore atro,
rubescens.

VERATRUM ALBUM
False hellebore, White hellebore

VERATRUM NIGRUM
Black hellebore

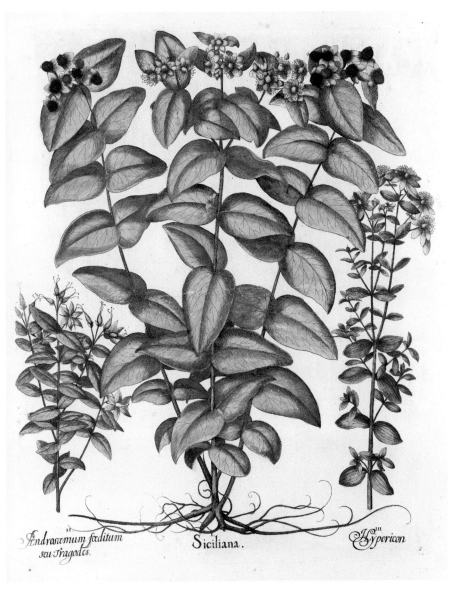

Androsæmum fœditum seu Tragodes. *Siciliana.* *Hypericon.*

HYPERICUM HIRCINUM	HYPERICUM ANDROSAEMUM	HYPERICUM MACULATUM
St John's wort	*Tutsan*	*St John's wort*

Plate 247 327

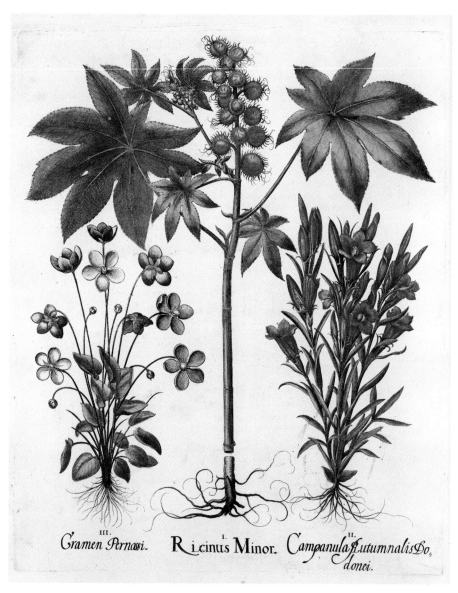

III.
Gramen Pernassi.
I.
Ricinus Minor.
II.
Campanula Autumnalis Do,
donei.

PARNASSIA PALUSTRIS

Grass of Parnassus

RICINUS COMMUNIS

*Castor oil plant, Palma
Christi, Castor bean plant*

GENTIANA PNEUMONANTHE

Marsh gentian, Calathian violet

Plate 248

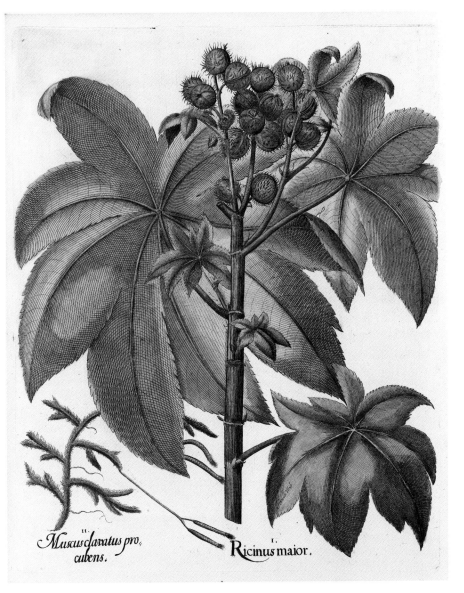

Muscus clavatus pro, cubens.

Ricinus maior.

LYCOPODIUM CLAVATUM

Ground pine, Running pine

RICINUS COMMUNIS

Castor oil plant, Palma Christi, Castor bean plant

Plate 249

329

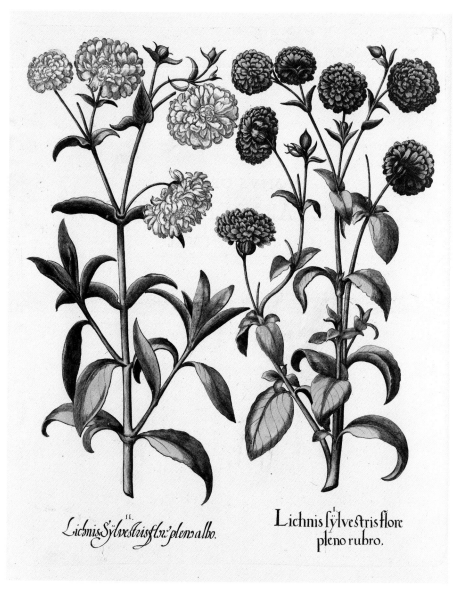

Lichnis Sylvestris flx. plens albo.

Lichnis sylvestris flore pleno rubro.

SILENE DIOICA
Double white campion

SILENE DIOICA
Double pink campion

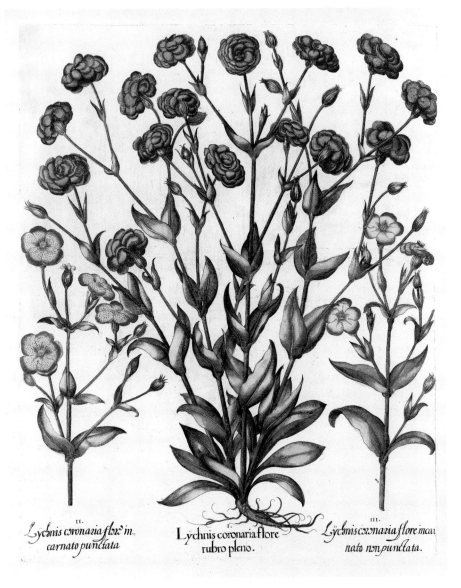

Lychnis coronaria flore incarnato punctata

LYCHNIS CORONARIA
*Dusty miller, Single rose campion
with speckled flowers*

*Lychnis coronaria flore
rubro pleno.*

LYCHNIS CORONARIA
*Dusty miller,
Double purple rose campion*

Lychnis coronaria flore incarnato non punctata.

LYCHNIS CORONARIA
Dusty miller, Rose campion

Plate 251 333

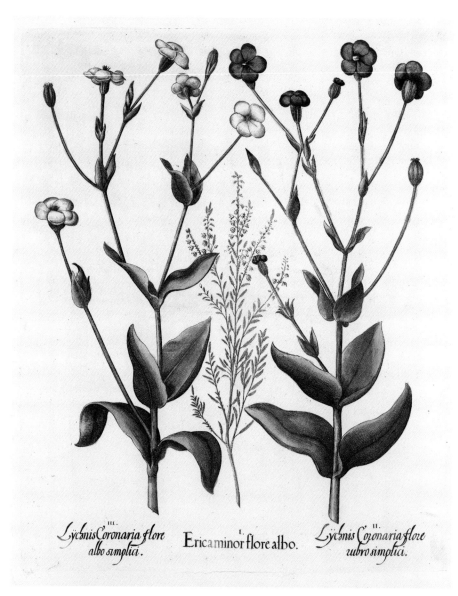

Lychnis Coronaria flore
albo simplici.

Erica minor flore albo.

Lychnis Coronaria flore
rubro simplici.

LYCHNIS CORONARIA
Dusty miller,
Double white rose campion

CALLUNA VULGARIS
Heather, Ling

LYCHNIS CORONARIA
Dusty miller,
Carmine rose campion

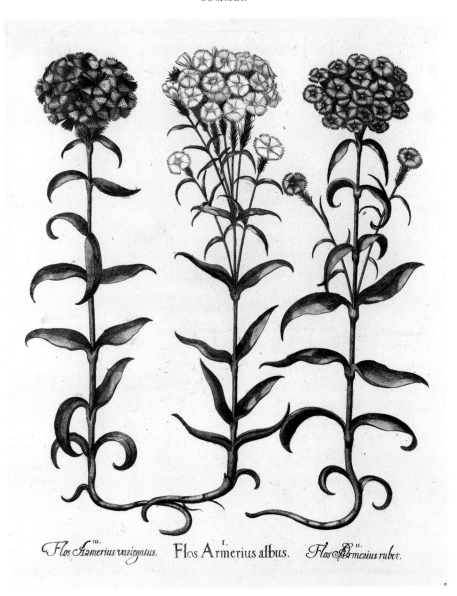

Flos Armerius variegatus. *Flos Armerius albus.* *Flos Armerius ruber.*

DIANTHUS BARBATUS DIANTHUS BARBATUS DIANTHUS BARBATUS
Sweet William with *Sweet William* *Sweet William*
multi-coloured flowers *with white flowers* *with purple flowers*

Plate 253 335

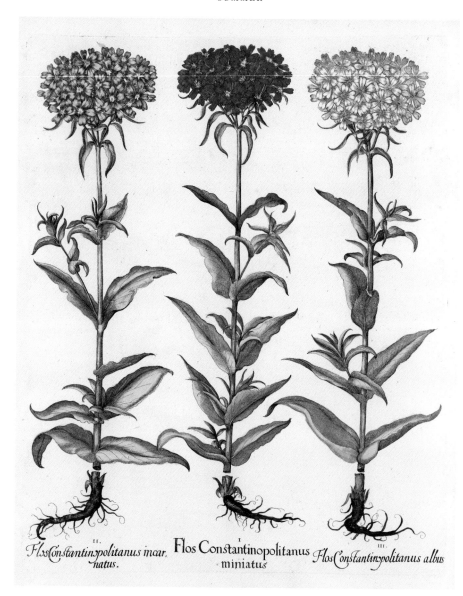

Flos Constantinopolitanus incar-
natus.

LYCHNIS CHALCEDONICA

Maltese cross
with pink flowers

Flos Constantinopolitanus
miniatus

LYCHNIS CHALCEDONICA

Maltese cross
with red flowers

Flos Constantinopolitanus albus

LYCHNIS CHALCEDONICA

Maltese cross
with white flowers

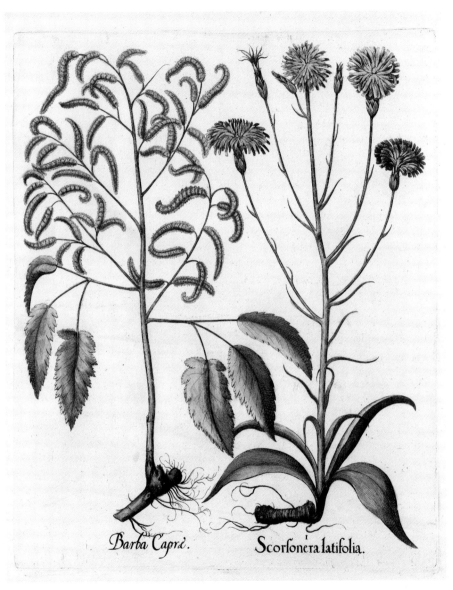

Barba Capra.

Scorſonéra latifolia.

ARUNCUS DIOICUS
Goat's beard

SCORZONERA HISPANICA
Common viper's grass

Plate 255

335

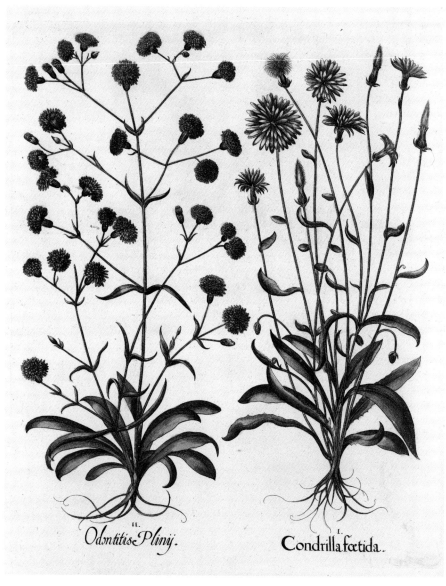

II.
Odontitis Plinij.

I.
Condrilla fœtida.

LYCHNIS FLOS-CUCULI
Ragged Robin

CREPIS RUBRA
Hawk's-beard

Plate 256

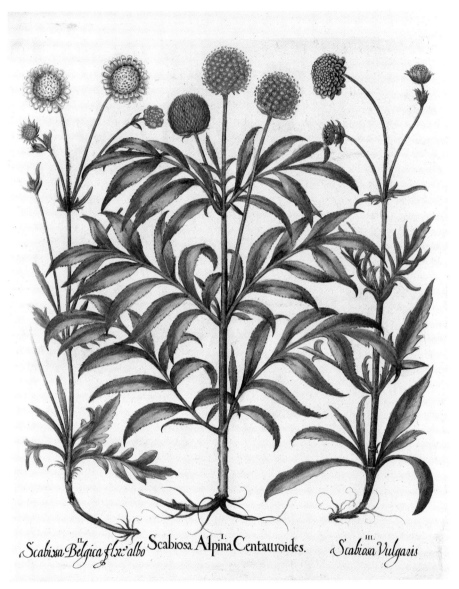

Scabissa Belgica flx: albo *Scabiosa Alpina Centauroides.* *Scabiosa Vulgaris*

SCABIOSA STELLATA
Pincushion flower, Scabious

CEPHALARIA ALPINA
Alpine scabious

KNAUTIA ARVENSIS
Blue buttons, Field scabious

Plate 257 337

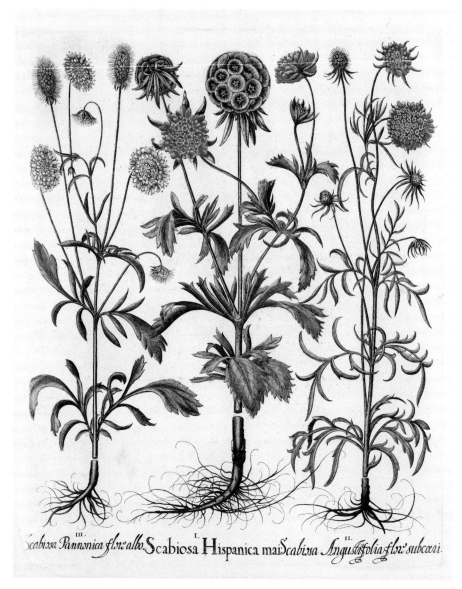

Scabiosa Pannonica flor: albo. Scabiosa Hispanica mai Scabiosa Angustifolia flor: subcani.

SCABIOSA OCHROLEUCA
Pincushion flower, Scabious

SCABIOSA STELLATA
Pincushion flower, Scabious

SCABIOSA COLUMBARIA
Small scabious

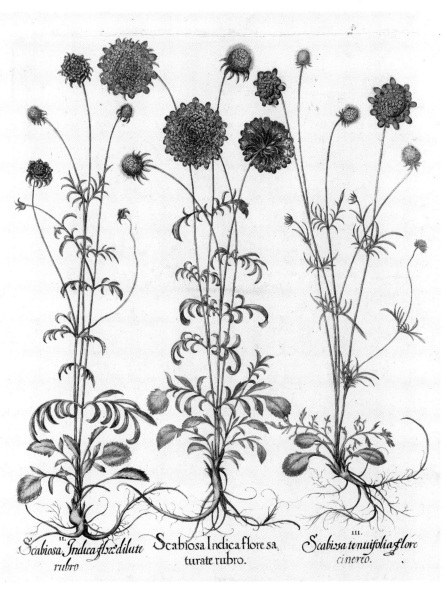

Scabiosa Indica flx̄ dilute rubro

Scabiosa Indica flore saturate rubro.

Scabissa tenuifolia flore cinereo.

SCABIOSA ATROPURPUREA

*Mournful widow,
Sweet scabious, Pincushion
flower, Egyptian rose*

SCABIOSA ATROPURPUREA

*Mournful widow, Double sweet
scabious, Pincushion flower,
Egyptian rose*

SCABIOSA COLUMBARIA

Small scabious

Plate 259

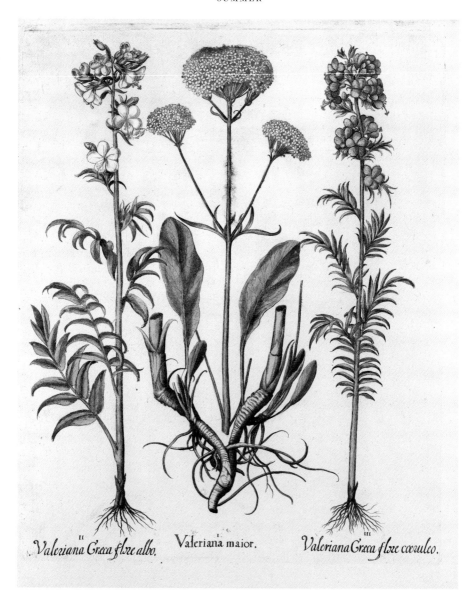

Valeriana Græca flore albo.
Valeriana maior.
Valeriana Græca flore cœruleo.

POLEMONIUM COERULEUM

*Jacob's ladder, Greek valerian
with white flowers, Charity*

VALERIANA PHU

Valerian

POLEMONIUM COERULEUM

*Jacob's ladder, Greek valerian
with mauve flowers, Charity*

Plate 260

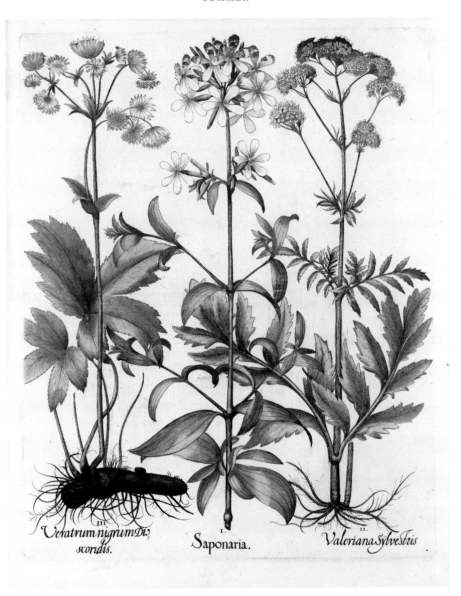

Veratrum nigrum Dis-
scoridis.

Saponaria.

Valeriana Sylvestris

ASTRANTIA MAJOR
Greater masterwort

SAPONARIA OFFICINALIS
Soapwort

VALERIANA SAMBUCIFOLIA
Elder-like valerian

Plate 261 341

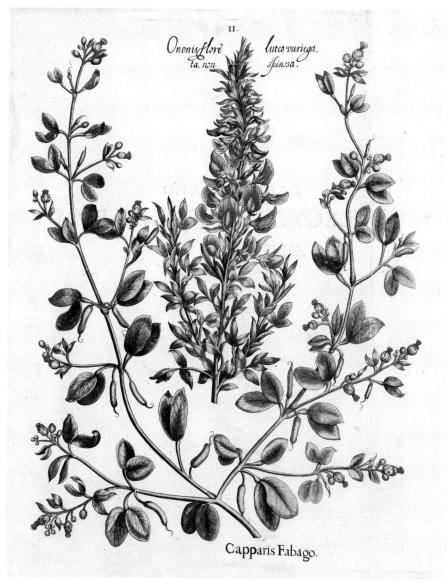

II.

Ononis flore luteo variega-
ta, non spinosa.

Capparis Fabago.

ONONIS NATRIX ZYGOPHYLLUM FABAGO
Restharrow *Syrian bean caper*

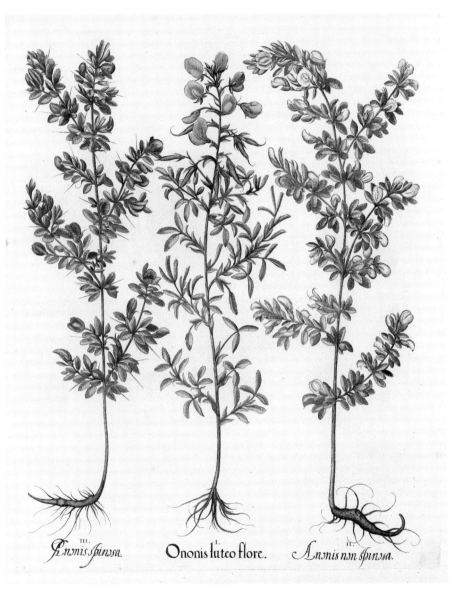

III.
Anonis spinosa.

I.
Ononis luteo flore.

II.
Anonis non spinosa.

ONONIS SPINOSA
Restharrow

ONONIS NATRIX
Restharrow

ONONIS ARVENSIS
Restharrow

Plate 263

343

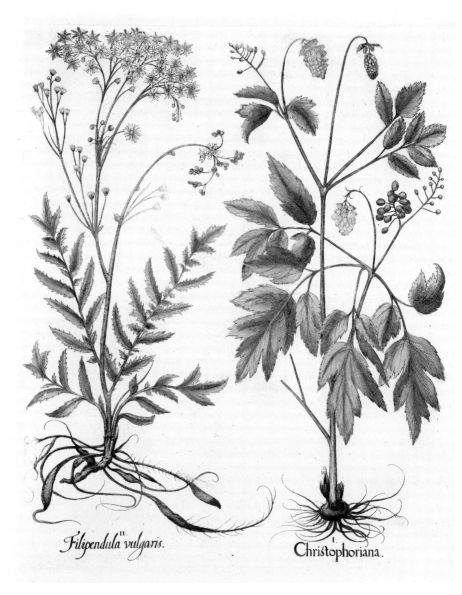

Filipendula vulgaris.

Christophoriana.

FILIPENDULA VULGARIS
Dropwort

ACTAEA SPICATA
Herb Christopher

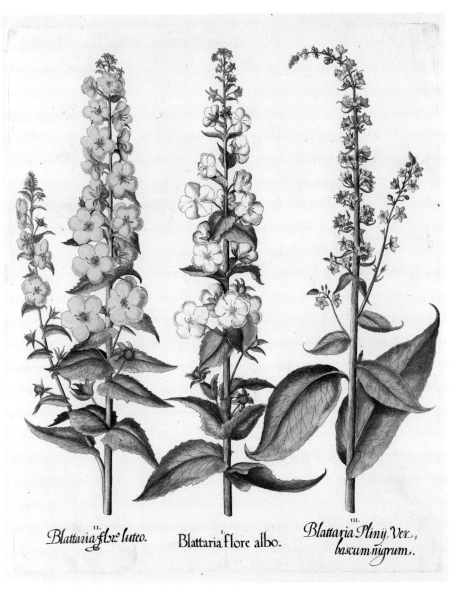

Blattaria flx° luteo. *Blattaria flore albo.* *Blattaria Plinij, Ver-bascum nigrum.*

VERBASCUM BLATTARIA, I.–II. VERBASCUM NIGRUM
Moth mullein *Dark mullein*

Plate 265 345

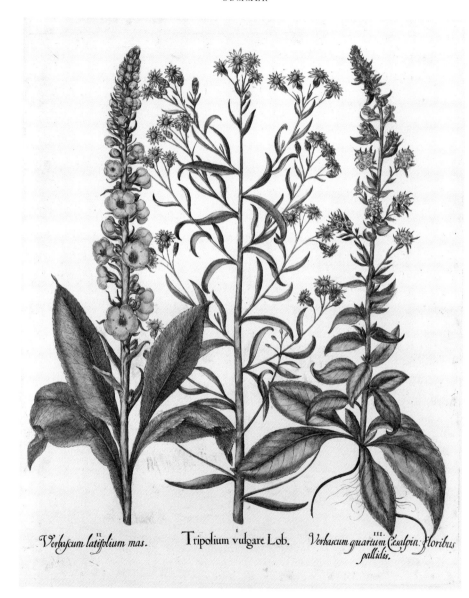

Verbascum latifolium mas. Tripolium vulgare Lob. *Verbascum quartum Cæsalpin. floribus*
pallidis.

VERBASCUM THAPSUS ASTER TRIPOLIUM VERBASCUM LYCHNITIS
Aaron's rod, Hag taper, Torches *Sea aster* *White mullein*

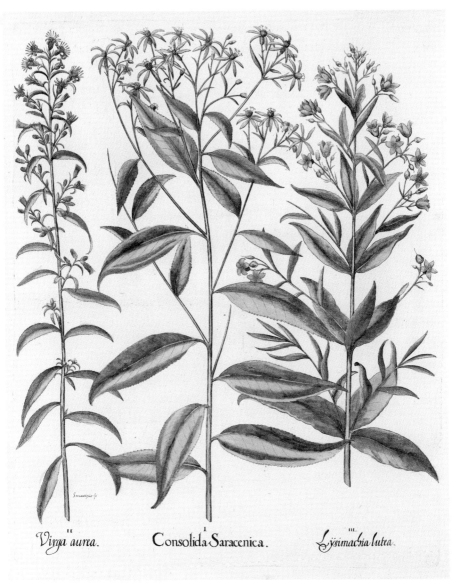

Virga aurea. Consolida Saracenica. *Lysimachia lutea.*

SOLIDAGO VIRGAUREA SENECIO FLUVIATILIS LYSIMACHIA VULGARIS
Golden rod *Broad-leaved ragwort* *Yellow loosestrife*

Plate 267 347

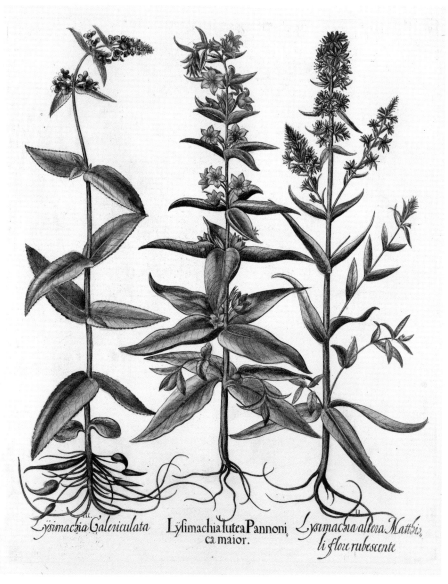

Lysimachia Galericulata

Lysimachia lutea Pannoni,
ca maior.

Lysimachia altera. Matthi,
li flore rubescente

STACHYS PALUSTRIS
Marsh woundwort

LYSIMACHIA PUNCTATA
Loosestrife

LYTHRUM SALICARIA
Purple loosestrife

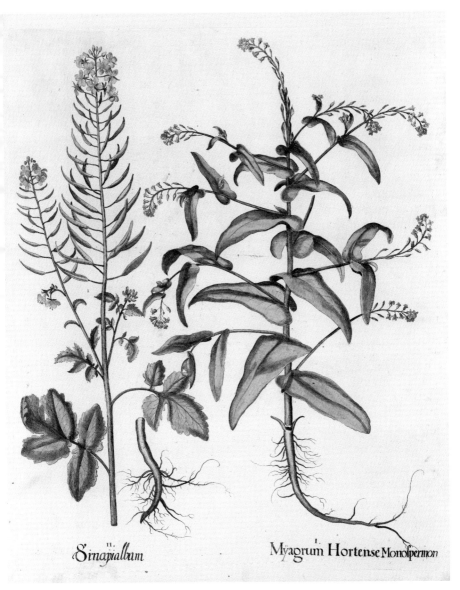

Sinapialbum

Myagrum Hortense Monospermon

II.

I.

SINAPIS ALBA
White mustard

MYAGRUM PERFOLIATUM
Mitre cress

Plate 269

349

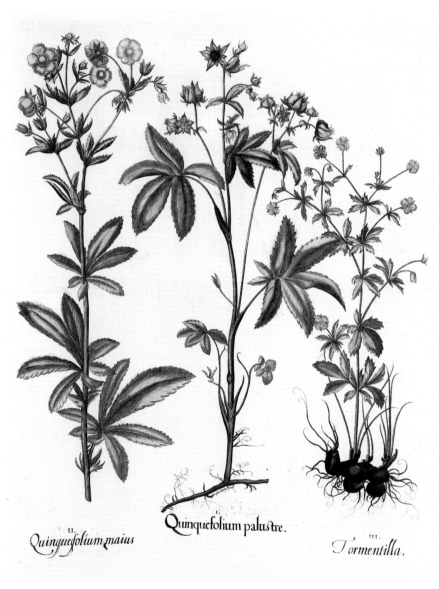

II.
Quinquefolium maius

Quinquefolium palustre.

III.
Tormentilla.

POTENTILLA RECTA
Sulphur cinquefoil

POTENTILLA PALUSTRIS
Marsh cinquefoil

POTENTILLA ERECTA
Tormentil, Bloodroot

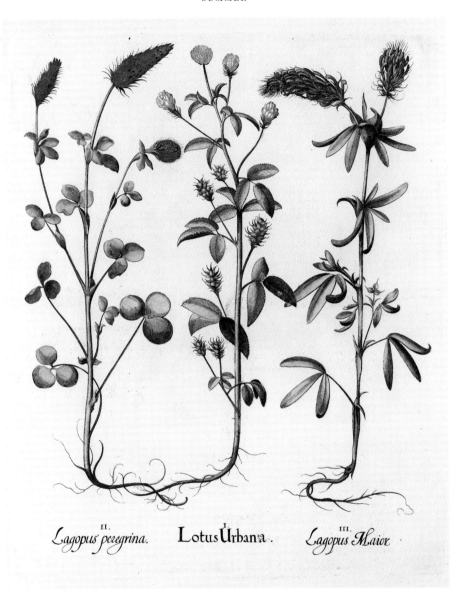

Lagopus peregrina. II.

Lotus Urbana. I.

Lagopus Maior. III.

TRIFOLIUM INCARNATUM
Italian clover, Crimson clover

TRIGONELLA CAERULEA
Sweet trefoil, Blue fenugreek

TRIFOLIUM RUBRUM
Clover, Trefoil

Plate 271

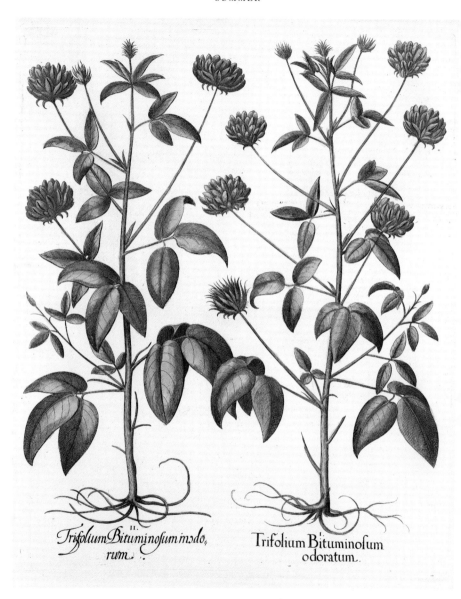

Trifolium Bituminosum inodorum. II.

Trifolium Bituminosum odoratum.

ASPALTHIUM BUTIMINOSUM
Arabian pea, Pitch trefoil

Plate 272

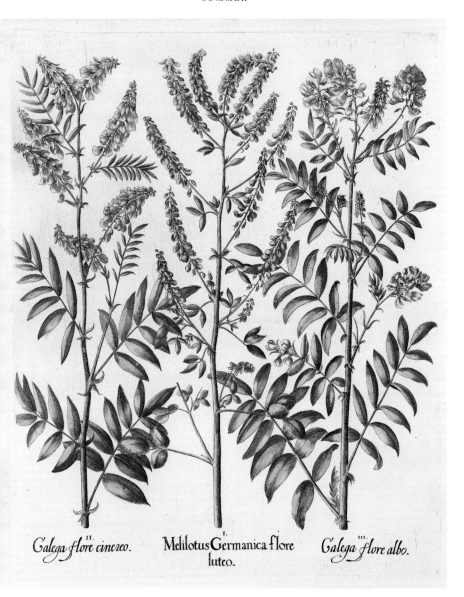

Galega flore cinereo. Melilotus Germanica flore luteo. Galega flore albo.

GALEGA OFFICINALIS, II.-III. MELILOTUS OFFICINALIS
Arabian pea, Pitch trefoil Yellow melilot, Ribbed melilot,
Yellow sweet clover

Plate 273

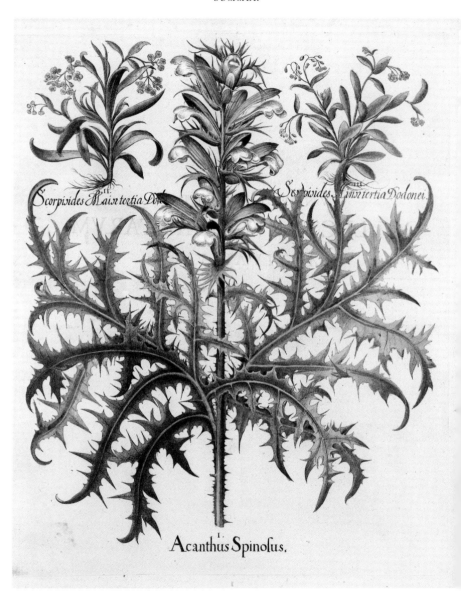

Scorpioides Maior tertia Do... *Scorpioides Minor tertia Dodonei.*

Acanthus Spinosus.

MYOSOTIS SYLVATICA, MYOSOTIS PALUSTRIS	ACANTHUS SPINOSUS	MYOSOTIS ARVENSIS
Blue forget-me-not, *Blue water forget-me-not*	*Bear's breeches*	*Pale blue forget-me-not*

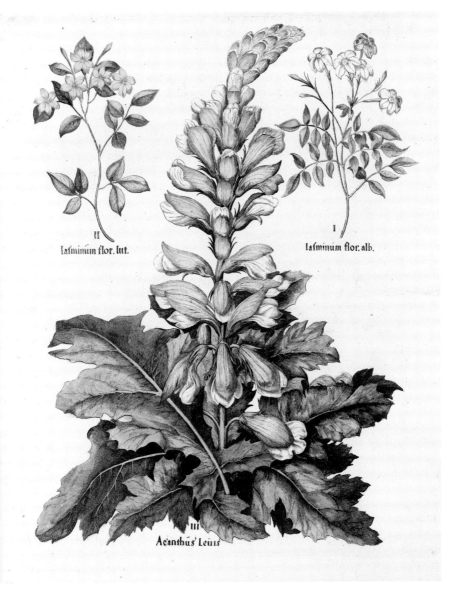

II
Iasminum flor. lut.

I
Iasminum flor. alb.

III
Acanthus Leuis

JASMINUM ODORATISSIMUM, JASMINUM FRUTICANS	ACANTHUS MOLLIS	JASMINUM GRANDIFLORUM, JASMINUM OFFICINALE
Jasmine, Jessamine	*Bear's breeches*	*Common jasmine, True jasmine, Jessamine*

Plate 275

355

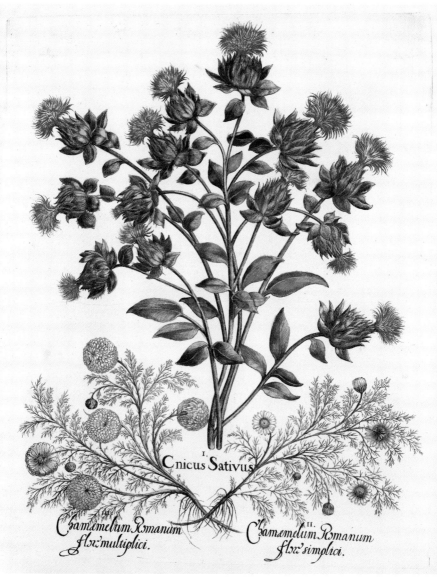

I.
Cnicus Sativus

Chamæmelum Romanum
flox'multiplici.

Chamæmelum Romanum
flox'simplici.

CHAMAEMELUM NOBILE
*Double chamomile, Roman
chamomile*

CARTHAMUS TINCTORIUS
*Safflower,
False saffron*

CHAMAEMELUM NOBILE
*Chamomile,
Roman chamomile*

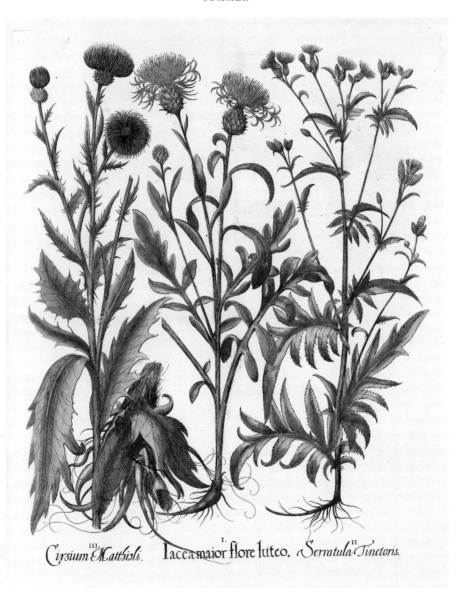

Cirsium Matthioli. I. *Iacea maior flore luteo.* II. *Serratula Tinctoris.*

CIRSIUM CANUM	CENTAUREA COLLINA	SERRATULA TINCTORIA
Greyish thistle	*Hill knapweed*	*Sawwort*

Plate 277

357

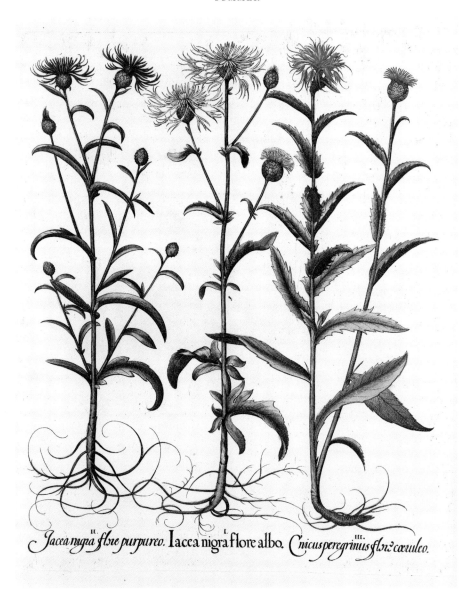

Jacea nigra flore purpureo. Iacca nigra flore albo. Cnicus peregrinus flore coeruleo.

CENTAUREA JACEA, I.–II.
Knapweed, Star thistle

CARDUNCELLUS COERULEUS
Blue thistle

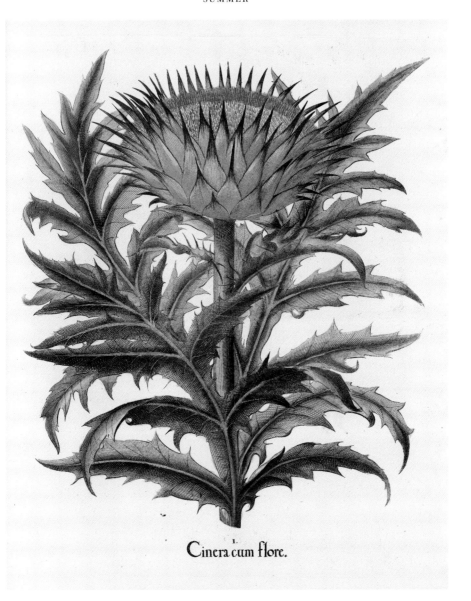

1.
Cinera cum flore.

CYNARA CARDUNCULUS
Cardoon

Plate 279

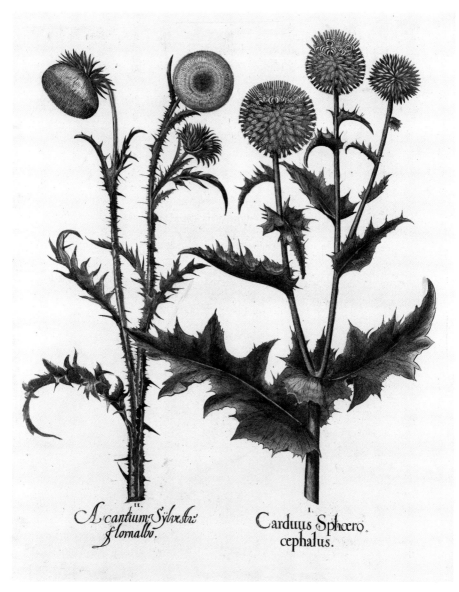

Acantium Sylvestre
flornalbo.

Carduus Sphœro
cephalus.

CARDUUS
NUTANS

Musk thistle

ECHINOPS
SPHAEROCEPHALUS

Globe thistle

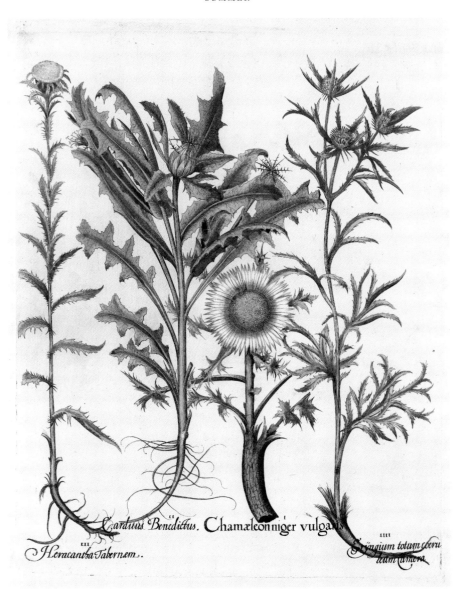

Carduus Benedictus. Chamæleon niger vulgaris

Heracantha Tabernæm.

Eryngium totum cœru
leum umbra

CARLINA VULGARIS	CNICUS BENEDICTUS	CARLINA ACAULIS	ERYNGIUM AMETHYSTINUM
Common carline thistle	*Blessed thistle*	*Stemless carline thistle*	*Eryngo, Sea holly*

Plate 281 361

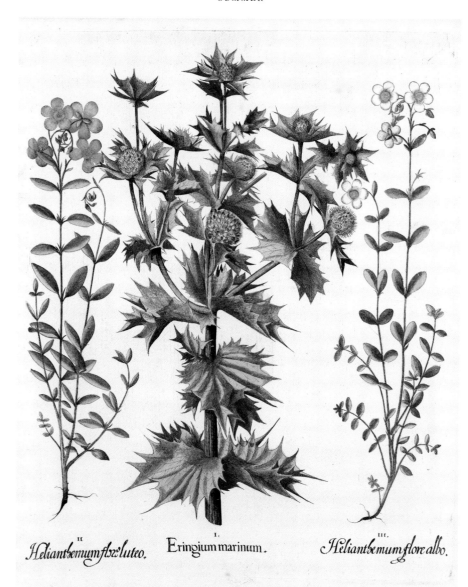

Helianthemum flor: luteo. *Eringium marinum.* *Helianthemum flore albo.*

HELIANTHEMUM NUMMULARIUM
Rock rose, Sun rose

ERYNGIUM MARITIMUM
Sea holly, Sea holm,
Sea eryngium, Eryngium

HELIANTHEMUM APENNINUM
Rock rose, Sun rose

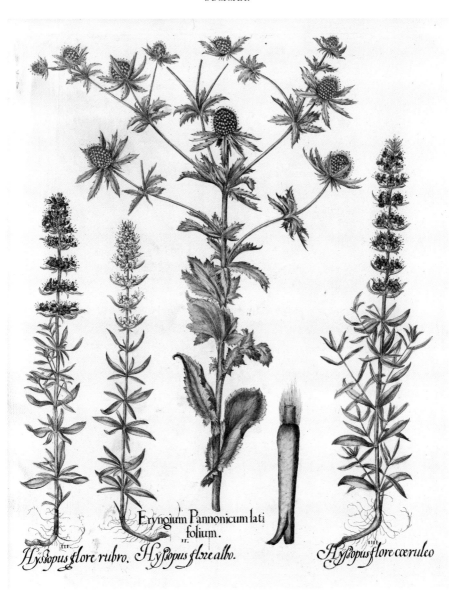

Eryngium Pannonicum lati
folium.
II.

Hyssopus flore rubro. Hyssopus flore albo.
III.

Hyssopus flore coeruleo.
IIII.

HYSSOPUS OFFICINALIS, II.–IV.　　ERYNGIUM PLANUM
Hyssop　　　　　　　　　　　*Eryngo, Sea holly*

Plate 283　　　　　　　363

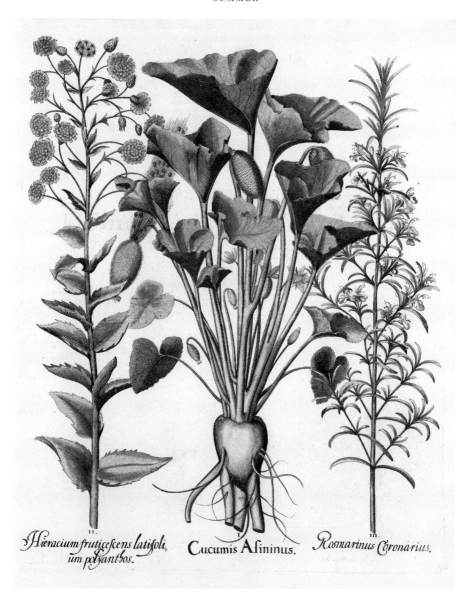

*Hieracium fruticescens latisoli,
um polyanthos.*

Cucumis Asininus.

Rosmarinus Coronarius.

HIERACIUM INULOIDES,
HIERACIUM VULGATUM

Common hawkweed

ECBALLIUM
ELATERIUM

Squirting cucumber

ROSMARINUS
OFFICINALIS

Rosemary

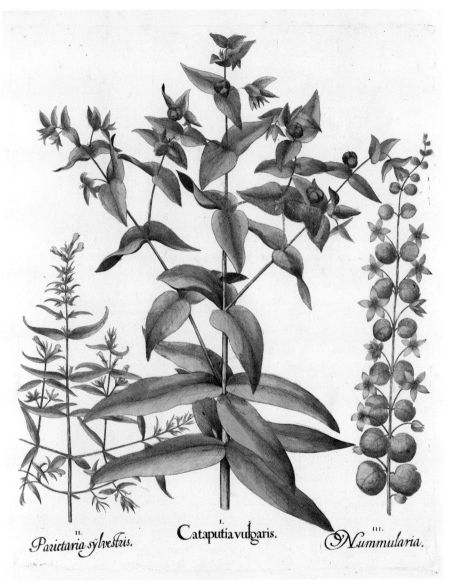

II.
Parietaria sylvestris.

I.
Cataputia vulgaris.

III.
Nummularia.

MELAMPYRUM
PRATENSE

Common cow-wheat

EUPHORBIA
LATHYRIS

*Caper spurge,
Myrtle spurge, Mole plant*

LYSIMACHIA
NUMMULARIA

*Creeping Jenny,
Moneywort*

Plate 285 365

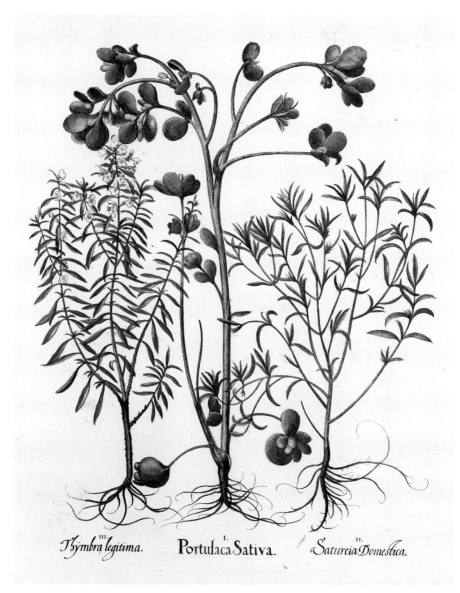

Thymbra legitima. *Portulaca Sativa.* *Satureia Domestica.*

SATUREJA MONTANA PORTULACA OLERACEA SATUREJA HORTENSIS
Winter savory *Purslane, Pussley* *Summer savory*

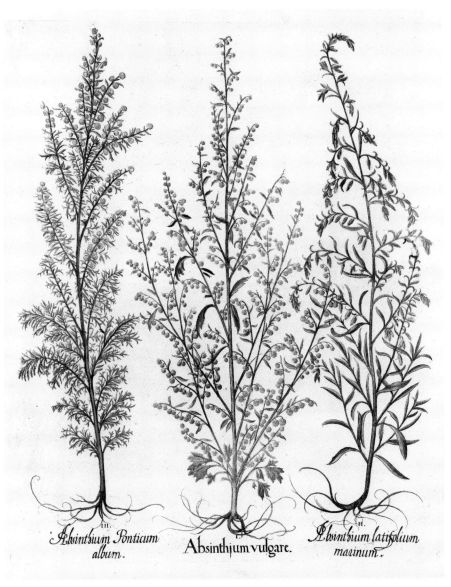

Absinthium Ponticum album.

Absinthium vulgare.

Absinthium latifolium marinum.

ARTEMISIA PONTICA

*Roman wormwood,
Small absinthe*

ARTEMISIA ABSINTHIUM

Wormwood

ARTEMISIA COERULESCENS

Blue wormwood

Plate 287　　　367

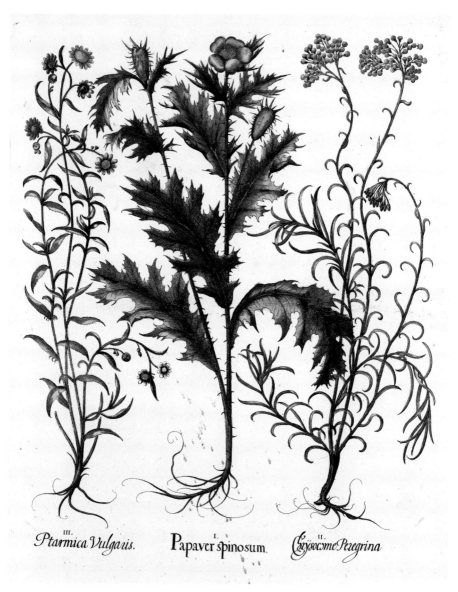

III.
Ptarmica Vulgaris.

I.
Papaver spinosum.

II.
Chrysocome Peregrina

ACHILLEA PTARMICA
Sneezewort

ARGEMONE MEXICANA
Devil's fig, Mexican poppy

HELICHRYSUM ITALICUM
Everlasting flower

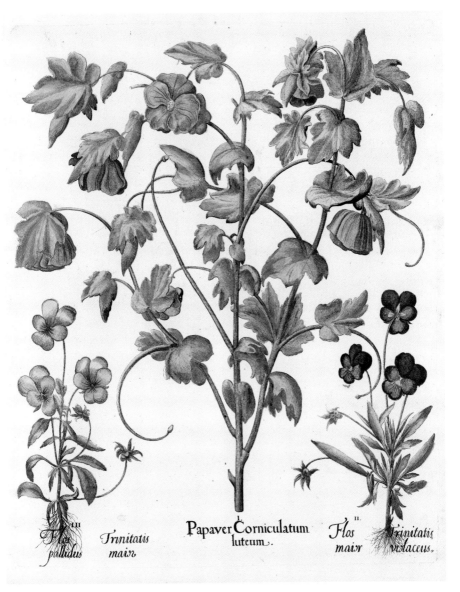

Flos pallidus *Trinitatis maior* Papaver Corniculatum luteum. *Flos maior* *Trinitatis violaceus.*

VIOLA TRICOLOR, II.–III.

Wild pansy, Heart's-ease,
Love-in-idleness, Jonny jump up,
Pink of my John

GLAUCIUM FLAVUM

Yellow horned poppy

Plate 289 369

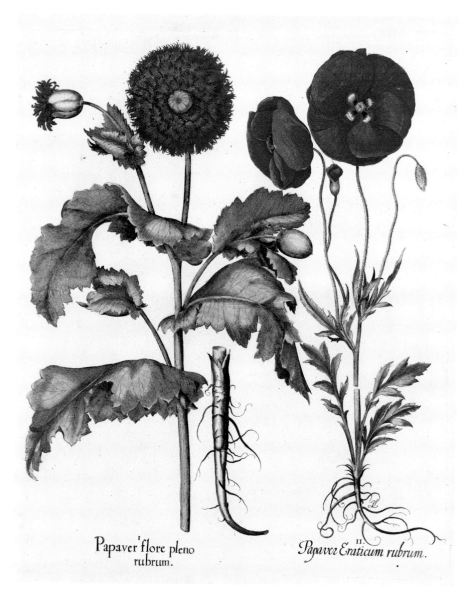

Papaver flore pleno
rubrum.

Papaver Eraticum rubrum.

PAPAVER SOMNIFERUM
Double opium poppy

PAPAVER RHOEAS
Corn poppy, Field poppy

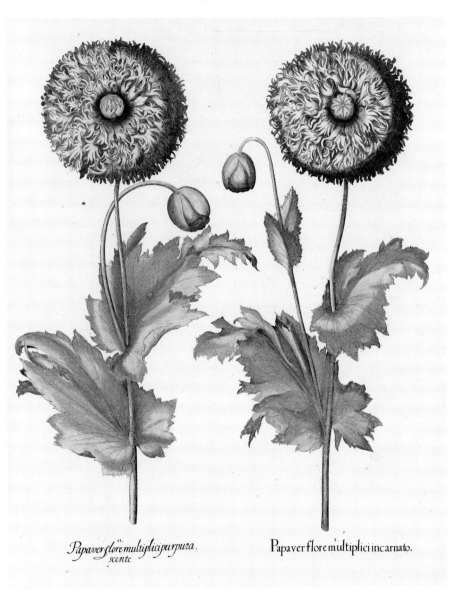

Papaver flore multiplici purpura scente

Papaver flore multiplici incarnato.

PAPAVER SOMNIFERUM

*Double opium poppy
with toothed sepals*

Plate 291

371

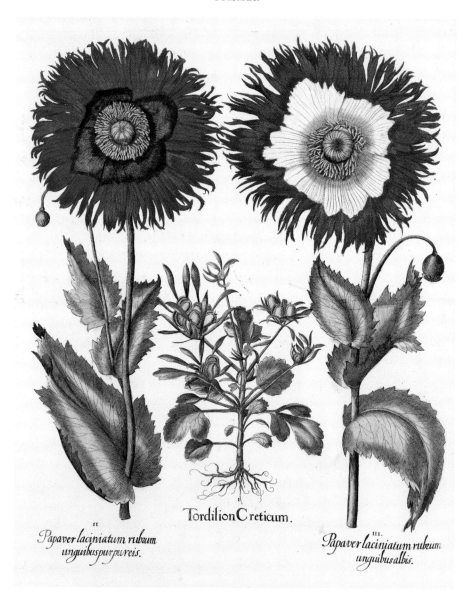

II

*Papaver laciniatum rubrum
unguibus purpureis.*

Tordilion Creticum.

III.

*Papaver laciniatum rubrum
unguibus albis.*

PAPAVER SOMNIFERUM,
II. – III.

*Double opium poppy
with bi-coloured flowers*

TORDYLIUM APULUM,
TORDYLIUM OFFICINALE

Hartwort

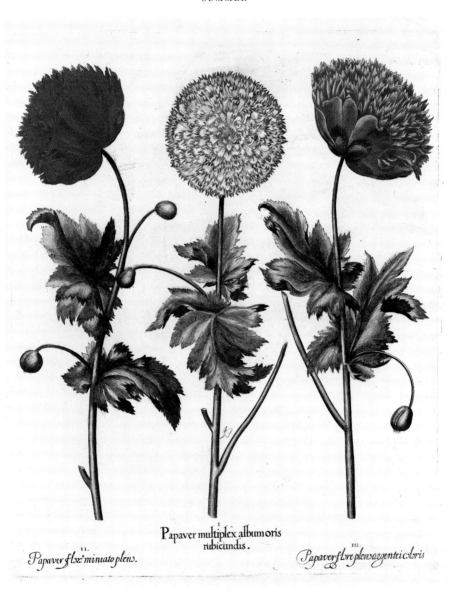

Papaver flor. miniato plens.

Papaver multiplex album oris
rubicundis.

Papaver flore plens argentei coloris

PAPAVER
SOMNIFERUM
Double opium poppy

Plate 293

373

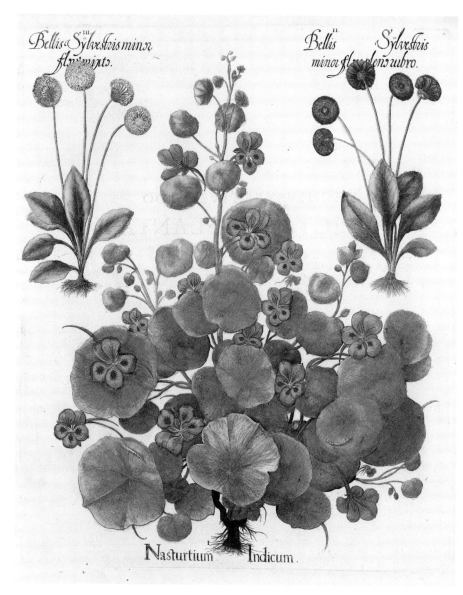

Bellis Sylvestris minx. flore mixts.

Bellis Sylvestris minor flore plens rubro.

Nasturtium Indicum.

BELLIS SPEC., II.–III.
Daisy

TROPAEOLUM MINUS
Nasturtium, Indian cress,
Canary bird vine, Canary bird
flower, Flame flower

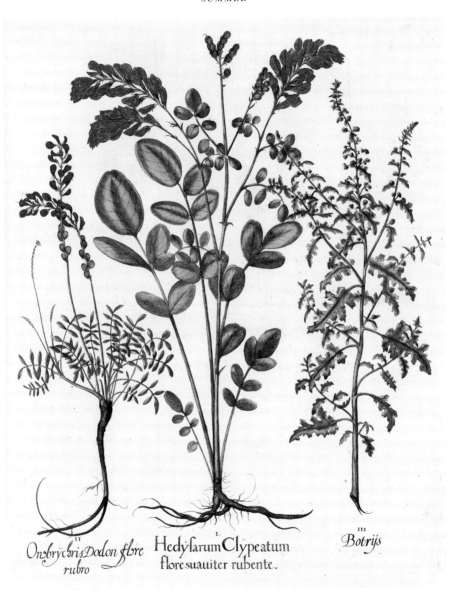

ONOBRYCHIS VICIIFOLIA
Sainfoin, Holy clover, Esparcet

HEDYSARUM CORONARIUM
Italian sainfoin

CHENOPODIUM BOTRYS
*Feather geranium,
Jerusalem oak*

Plate 295 375

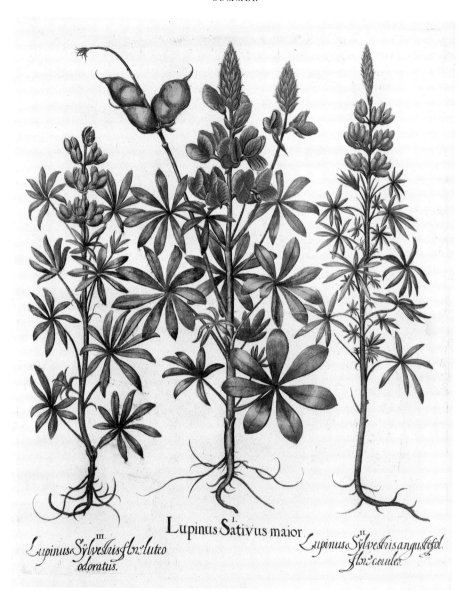

Lupinus Sÿlvestris flr: luteo odoratus.

Lupinus Sativus maior

Lupinus Sÿlvestris angustifol. flr: cœruleo.

LUPINUS
LUTEUS

Yellow lupin

LUPINUS MICRANTHUS,
LUPINUS VARIUS

Blue-flowering lupin

LUPINUS
ANGUSTIFOLIUS

Blue lupin

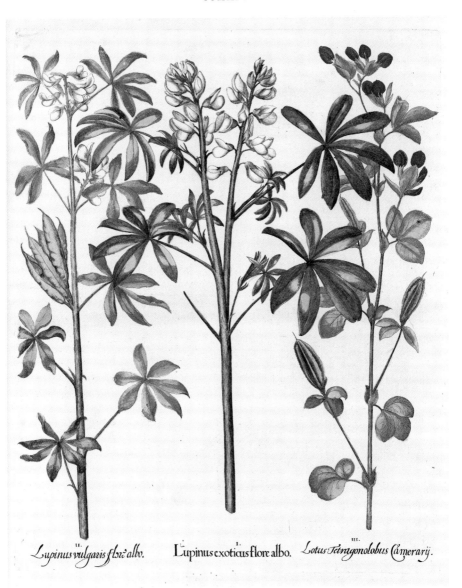

Lupinus vulgaris flore albo. *Lupinus exoticus flore albo.* *Lotus Tetragonolobus Camerarij.*

LUPINUS ALBUS,
I. – II.

*White lupin, Field lupin,
Wolf bean, Egyptian lupin*

TETRAGONOLOBUS
PURPUREUS

Asparagus pea, Winged pea

Plate 297 377

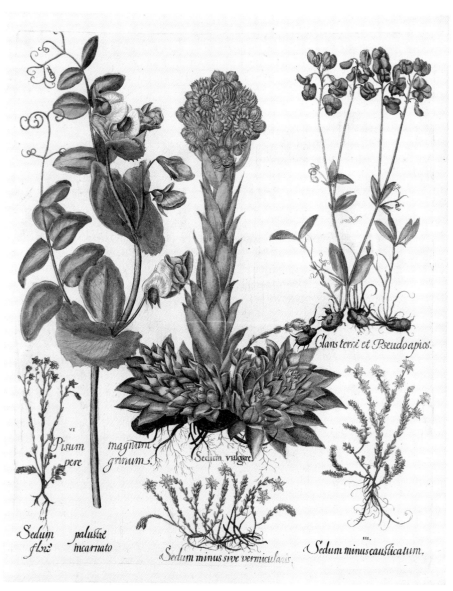

Glans terræ et Pseudo apios.

VI.
Pisum
pere magnum
grinum. Sedum vulgare.

Sedum
flos palustre
incarnato

Sedum minus sive vermiculacis.

III.
Sedum minus causticatum.

SEDUM PILOSUM	PISUM SATIVUM	SEMPERVIVUM TECTORUM	SEDUM SEXANGULARE	LATHYRUS TUBEROSUS	SEDUM ACRE
Stonecrop	*Garden pea*	*Common houseleek*	*Stonecrop*	*Earth chestnut, Tuberous pea, Fyfield pea*	*Stonecrop, Wall pepper*

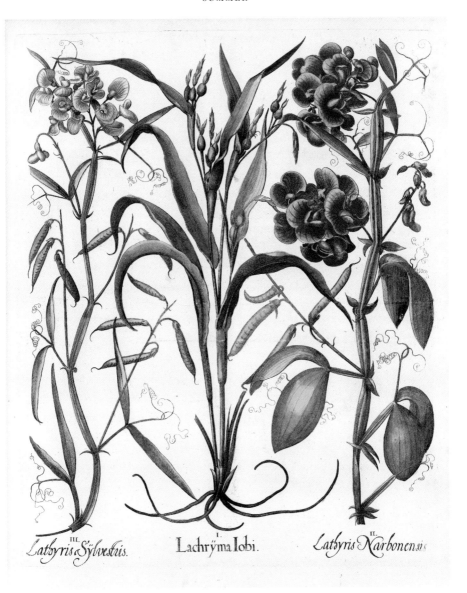

Lathyris Sylvestris. III. *Lachrÿma Iobi.* I. *Lathyris Narbonensis.* II.

LATHYRUS
SYLVESTRIS

*Flat pea, Narrow-leaved
everlasting pea*

COIX
LACRYMA-JOBI

Job's tears

LATHYRUS
LATIFOLIUS

*Perennial pea, Broad-leaved
everlasting pea*

Plate 299

379

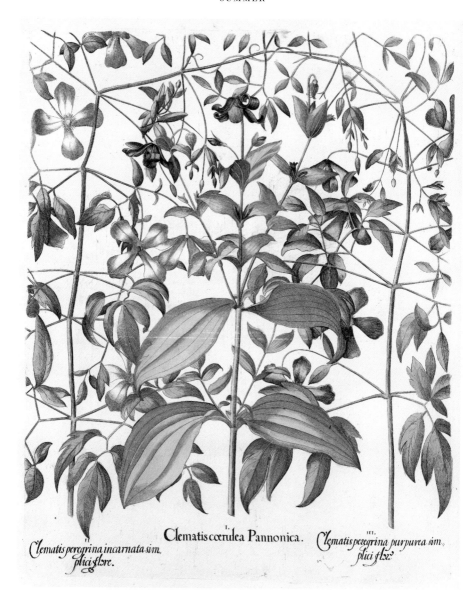

Clematis peregrina incarnata sim. plici flore.

Clematis cœrulea Pannonica.

Clematis peregrina purpurea sim. plici flore.

CLEMATIS VITICELLA, II. – III.
Virgin's bower

CLEMATIS INTEGRIFOLIA
Virgin's bower

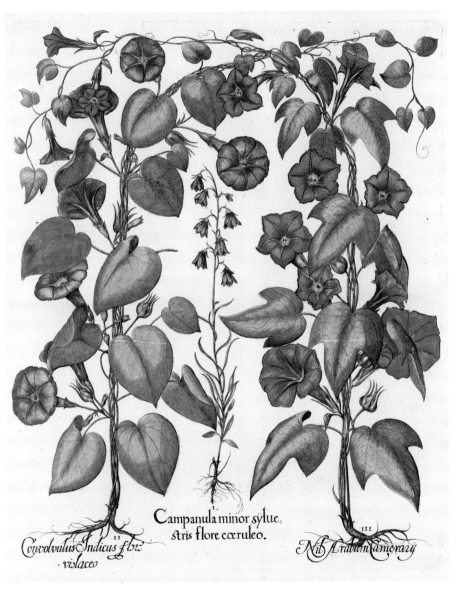

Campanula minor sylue,
stris flore cœruleo.

Convolvulus Indicus flrõ
violaceo

Nil Arabum Camoraÿ

PHARBITIS PURPUREA
Common morning glory

CAMPANULA ROTUNDIFOLIA
Bluebell, Harebell

PHARBITIS NIL
Morning glory

Plate 301 381

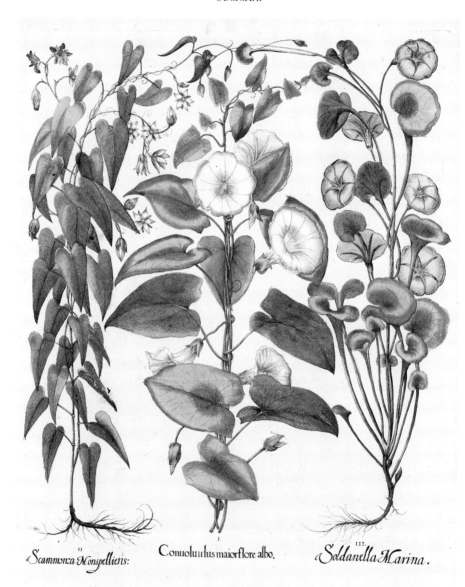

Scammonea Monspelliens:

Conuoluulus maiorflore albo.

Soldanella Marina.

CYNANCHUM ACUTUM
Dog's-bane

CALYSTEGIA SEPIUM
Bindweed, Hedge bindweed,
Wild morning glory,
Rutland-beauty

CALYSTEGIA SOLDANELLA
Sea bindweed

Plate 302

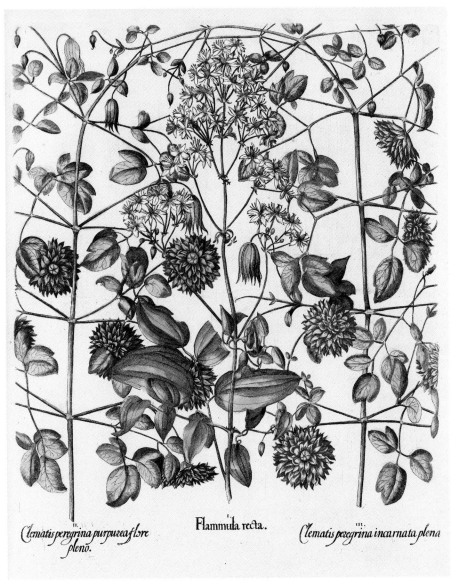

Clematis peregrina purpurea flore pleno. Flammula recta. *Clematis peregrina incarnata plena.*

CLEMATIS VITICELLA, II.–III. CLEMATIS RECTA
Virgin's bower *Herbaceous clematis*

Plate 303 385

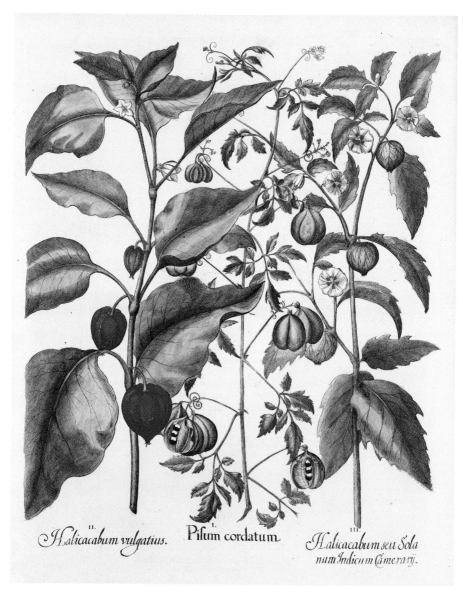

Halicacabum vulgatius. *Pisum cordatum* *Halicacabum seu Solanum Indicum Camerarij.*

PHYSALIS
ALKEKENGI

*Chinese lantern, Winter
cherry, Bladder cherry*

CARDIOSPERMUM
HALICACABUM

Balloon vine, Heart pea

PHYSALIS
SPEC.

Ground cherry, Husk tomato

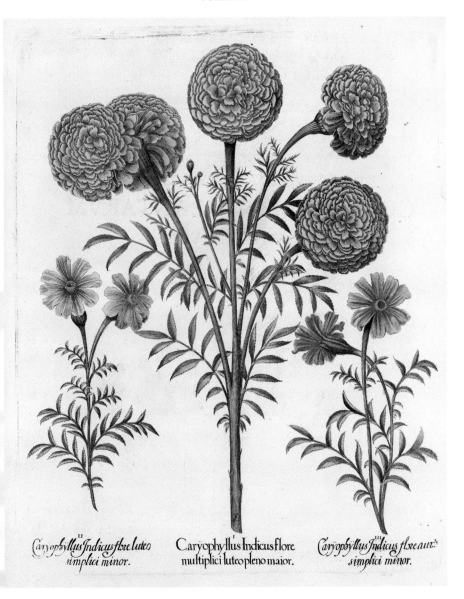

Caryophyllus Indicus flore luteo simplici minor.

Caryophyllus Indicus flore multiplici luteo pleno maior.

Caryophyllus Indicus flore aur.: simplici minor.

TAGETES PATULA,
II. – III.

TAGETES
ERECTA

French marigold

African marigold

Plate 305 385

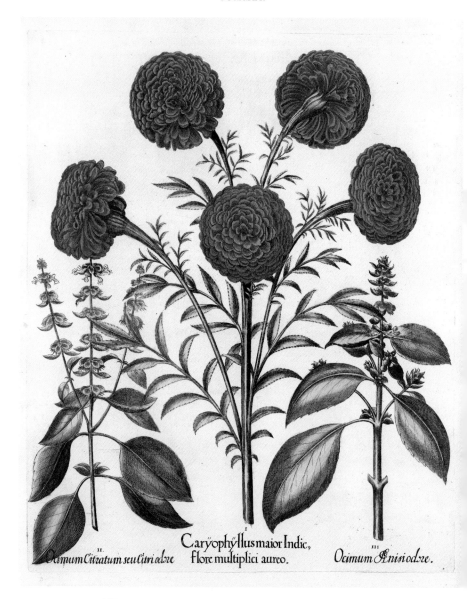

II.
Ocimum Citratum seu Citri odore.

I.
Caryophyllus maior Indic₉
Flore multiplici aureo.

III.
Ocimum Anisi odore.

OCIMUM BASILICUM, II.–III.
Common basil, Sweet basil

TAGETES ERECTA
African marigold

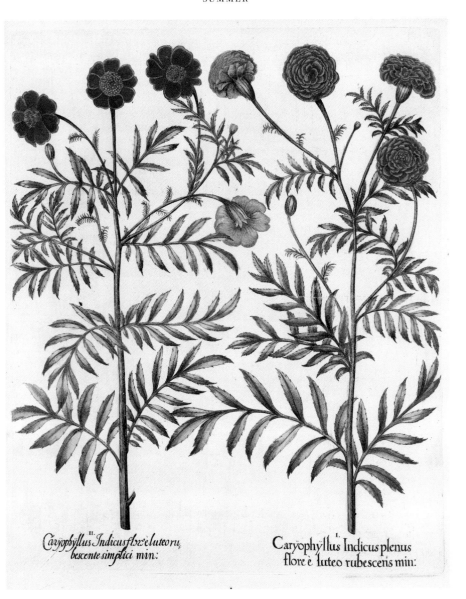

Caryophyllus Indicus flx̃ẽ luteo ru,
bescente simplici min:

Caryophyllus Indicus plenus
flore è luteo rubescens min:

TAGETES PATULA
French marigold

Plate 307 387

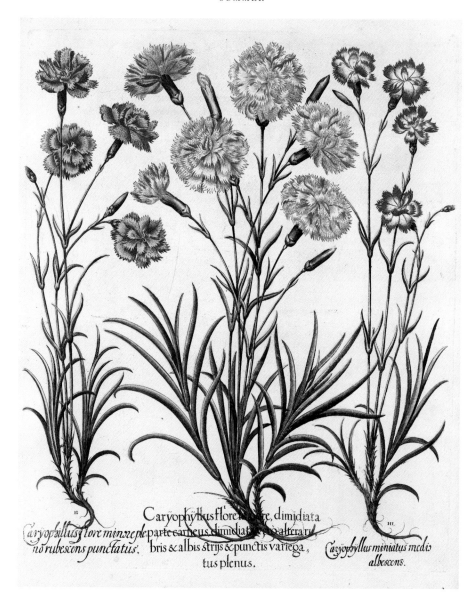

Caryophyllus flore majore, dimidiata
Caryophyllus flore minore ple parte carneus dimidiata vero altera ru
no rubescens punctatus. bris & albis strijs & punctis variega,
tus plenus.

Caryophyllus miniatus medis
albescens.

DIANTHUS
CARYOPHYLLUS
Wild carnation

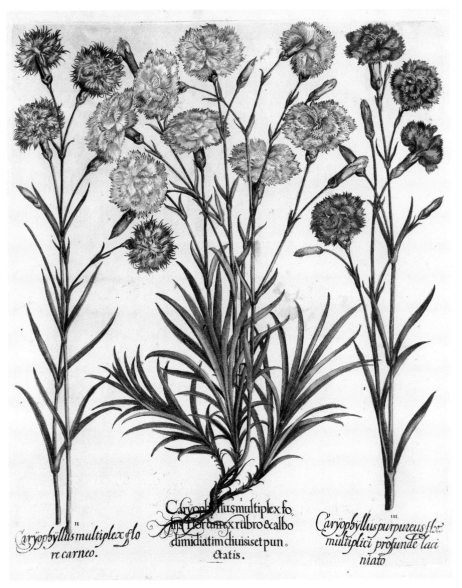

Caryophyllus multiplex flo
re carneo.

Caryophyllus multiplex fo.
lijs florum ex rubro & albo
dimidiatim diuisis et pun.
ctatis.

Caryophyllus purpureus flore
multiplici profunde laci
niato

DIANTHUS
PLUMARIUS

Cottage pink

DIANTHUS
CARYOPHYLLUS, I., III.

Wild carnation

Plate 309

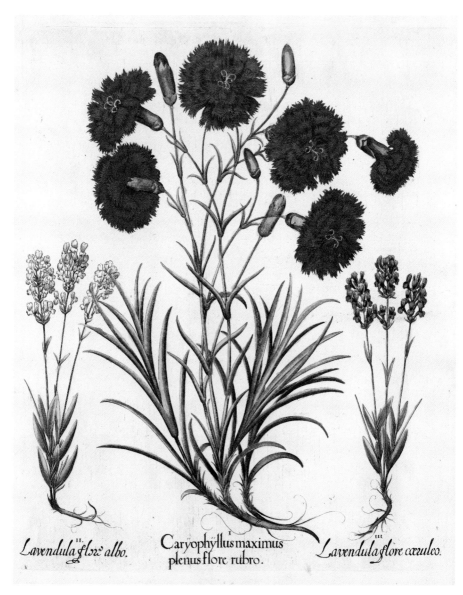

Lavendula floræ albo. **II.**

I.
Caryophyllus maximus
plenus flore rubro.

Lavendula flore cœruleo. **III.**

LAVANDULA SPEC.,
II. – III.

Lavender

DIANTHUS
CARYOPHYLLUS

Wild carnation

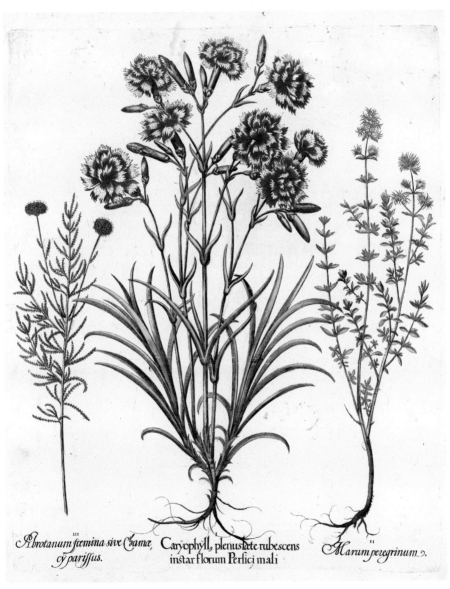

Abrotanum fœmina sive Chamæ cypariſſus.

Caryophyll, plenuslate rubescens instar florum Perfici mali

Harum peregrinum.

SANTOLINA
CHAMAECYPARISSUS

Lavender cotton

DIANTHUS
CARYOPHYLLUS

Wild carnation

THYMUS
MASTICHINA

*Mastic thyme,
Spanish wood marjoram*

Plate 311 391

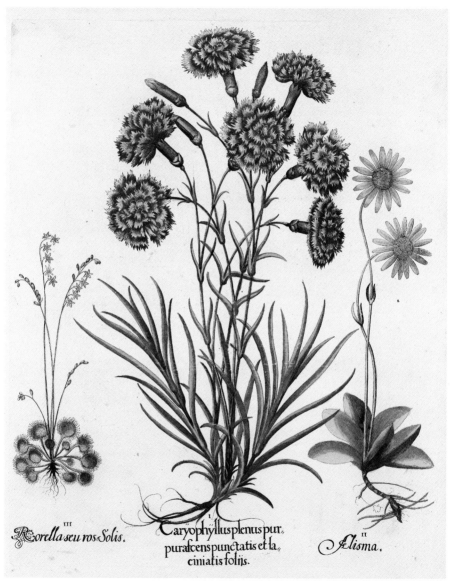

Roorella seu ros Solis.

Caryophyllus plenus pur, purascens punctatis et la, ciniatis folijs.

Alisma.

DROSERA ROTUNDIFOLIA
Round-leaved sundew

DIANTHUS CARYOPHYLLUS
Wild carnation

ARNICA MONTANA
Arnica, Leopard's bane, Mountain tobacco

Plate 312

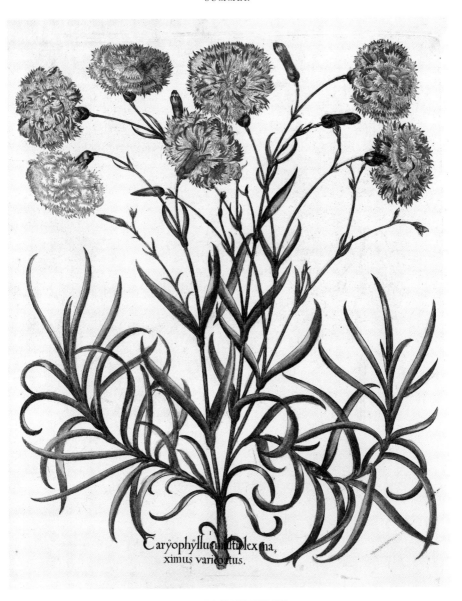

Caryophyllus multiplex ma,
ximus varicostus.

DIANTHUS CARYOPHYLLUS
Wild carnation, Clove pink

Plate 313 393

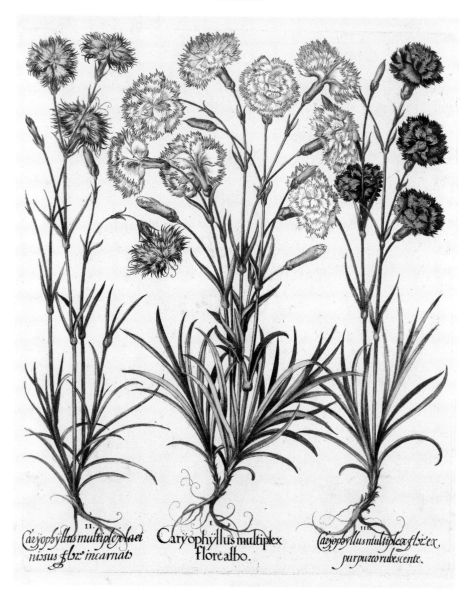

Caryophyllus multiplex laci-
nissus flor. incarnat

II.

Caryophyllus multiplex
flore albo.

I.

Caryophyllus multiplex flr. ex
purpureo rubescente.

III.

DIANTHUS PLUMARIUS DIANTHUS CARYOPHYLLUS, I., III.
Cottage pink *Wild carnation, Clove pink*

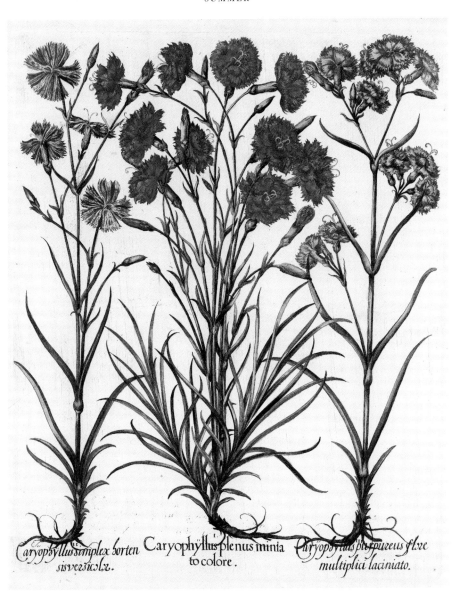

Caryophyllus simplex horten sis versicolx.

Caryophyllus plenus minia to colore.

Caryophyllus purpureus flxve multiplia laciniato.

DIANTHUS PLUMARIUS, I.–II.
Cottage pink

DIANTHUS CARYOPHYLLUS
Wild carnation, Clove pink

Plate 315 395

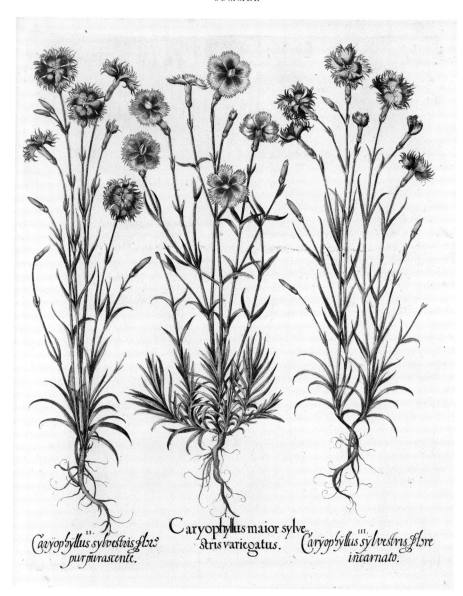

Caryophyllus sylvestris flxr purpurascente.

Caryophyllus maior sylvestris variegatus.

Caryophyllus sylvestris flore incarnato.

DIANTHUS
PLUMARIUS, II.–III.

Cottage pink

DIANTHUS
SYLVESTRIS

Wood pink

Plate 316

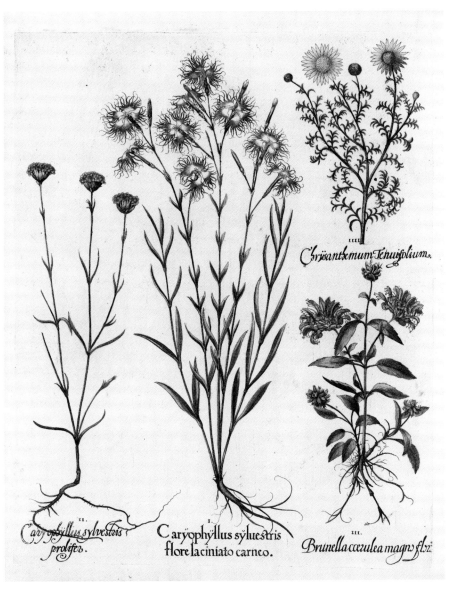

Chrysanthemum Tenuifolium.

Caryophyllus sylvestris prolifer.

Caryophyllus syluestris flore laciniato carneo.

Brunella cœrulea magno flor.

PETRORHAGIA PROLIFERA	DIANTHUS SUPERBUS	ANTHEMIS TINCTORIA	PRUNELLA GRANDIFLORA
Proliferous pink	*Wild carnation, Fringed pink*	*Dyer's chamomile, Yellow chamomile*	*Large self-heal*

Plate 317 397

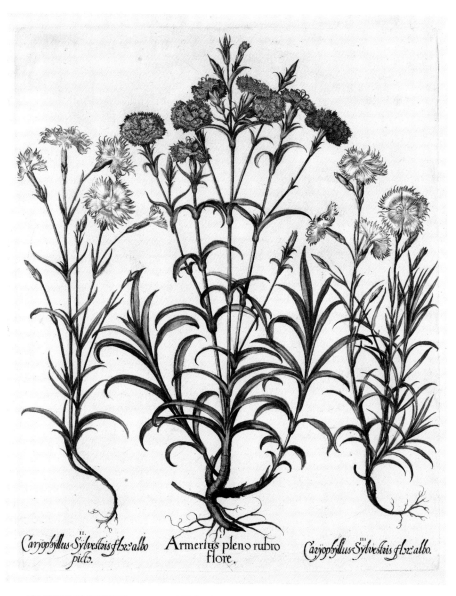

Caryophyllus Sylvestris flx̅ albo pict̅o.

Armerius pleno rubro flore.

Caryophyllus Sylvestris flx̅ albo.

DIANTHUS PLUMARIUS
Cottage pink

DIANTHUS CHINENSIS
Rainbow pink, Chinese pink

DIANTHUS CARYOPHYLLUS
Wild carnation, Clove pink

Plate 318

135 136

SUMMER TREES AND SUBSHRUBS
PLATE 135

As its name suggests, the American arbor-vitae or white cedar (135, I) does indeed come from North America. These poisonous plants, which belong to the cypress family, reached Europe as early as the first half of the 16th century and were often used as evergreen hedging. Since the 18th century, medicinal preparations have been made using the white cedar as a diuretic and diaphoretic medicine. It was also applied externally to relieve rheumatic pain, and the sap was used as a cauterising agent for warts.

Prunella vulgaris (135, II) is a self-heal member of the Lamiaceae family, common in Germany, whose blue-violet petals are surrounded by a brown calyx. In accordance with the medieval doctrine of signatures, the plant was therefore also used in popular medicine to treat diphtheria, although it is now known that it could not have had any specific effect.

The yellow bugle (135, III) is particularly noteworthy for its narrow leaves and its peculiar smell. The fact that it was used medicinally to treat strokes gave it its German common name, *Schlagkräutlein* (little stroke plant), which Besler also uses in his description of the plant.

PLATE 136

The Persian lilac or pride of India (136, I) originates from south-east Asia, but has now become naturalised in the Mediterranean region. It is closely related in botanical terms to the real mahogany tree, whose characteristic red wood has long been valued for making quality furniture.

The soldier's woundwort (136, II and III), a yarrow plant native to Germany and belonging to the Compositae family, is an ancient medicinal herb. It was used to treat haemorrhages and wounds even in Classical times. Since the Middle Ages, popular medicine has attributed a wide range of other alleged effects to it. *Achillea millefolium* was named after Achilles, the healing hero of Troy, who was renowned for his special botanical knowledge with regard to treating wounds. The specific name, *millefolium* ("thousand-leaved"), graphically describes its delicate, very pinnate leaves. In the wild, the white-flowered form is predominant, although red forms are known.

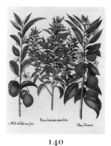

137 138 139 140

PLATE 137

The Italian cypress (137, I) with its characteristic columnar shape is a typical feature of the landscape in many parts of Italy. It originally came from Asia, but was brought to the Mediterranean region by the Phoenicians. It gets its name from the island of Cyprus, although Ovid tells of the legend according to which a handsome youth named Cyparissus, whom Apollo loved, one day accidentally killed his favourite stag and in despair begged the gods to permit him to mourn it eternally. Thereupon, they turned him into a cypress tree, and the sombre tree has been a symbol of death and mourning ever since. It contains an essential oil used in cosmetics and also medicinally as a cough remedy.

The Spanish broom (137, II) grows on even the poorest of soils. The fact that it sheds its leaves early, so that the stem usually has no leaves, unlike this illustration, has led to its German name, *Binsenginster* (rush broom). Its bright yellow flowers, often doubled in its cultivated forms, make it an ideal ornamental shrub.

PLATES 138, 139

The rose bay (138, I; 139, I and II) is one of the commonest shrubs in the Mediterranean region, the Middle East and North Africa. Its pinky red or white flowers contrast beautifully with its dark green leathery leaves. It used to be said that sleeping under the rose bay would ward off all evil, although other stories said the exact opposite and warned of fatal consequences. Popularly, it seems to have been regarded mainly in a negative light, presumably because it is poisonous. In his herbal, Bock calls it *Unholdenkraut* (demon plant), and Besler also adopts this name.

Sweet basil (138, II and III) has long been a popular herb because of its pungent aromatic flavour, but it has also found a place in many gardens. Besler devotes three more plates to it (cf. plates 234, 235 and 306).

PLATE 140

Citrus fruits belong to the Rutaceae family. The three shown on this plate are the Seville orange (140, I), the common or sweet orange (140, III) and the citron (140, II). These plants, which

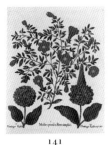 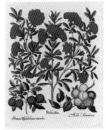 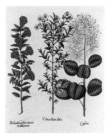

141 142 143

are now grown in large plantations as a food crop, were very desirable ornamental plants in Germany from the Baroque onwards. As they are extremely susceptible to cold, they were housed in "orangeries", which were often fitted out in the height of luxury. The sour and bitter tasting Seville oranges were valued for the strong, sweet scent of their white flowers. Neroli oil is extracted from these as an important ingredient in various perfumes. There is documentary evidence of this "golden apple", *Poma aurantia*, dating back to as early as the year 1000 in the Mediterranean region. This is also where, much earlier, the lemon originated. The lemon was already known to the Romans, whereas the cultivated form of the orange only came to Europe via Portugal at the beginning of the 16th century. Depending on the taste, the fruits were eaten fresh, their juice was made into lemonade drinks, or slices of fruit and the peel were preserved to make candied orange and lemon peel. The bitter-tasting varieties have been used medicinally to improve digestion.

PLATE 141

The rind of the bittersweet fruits of the pomegranate (141, I; 142, I; 143, II) was used medicinally as a cure for worms. Mentioned several times in the Bible, the "Punic apple" can also be found in Classical works of art, where, because of its copious seeds, it is usually interpreted as a symbol of fertility.

These two large flowers seem to be distorted forms of the common plantain (141, II and III).

PLATE 142

The *Runden Myrobalanen* (round myrobalan), as Besler calls the fruits of the cherry plum (142, II), might have been the forebears of the mirabelle plums. However, it should not be confused with the botanically closely related *Marillen*, as the apricot (142, III) is called in Austria.

PLATE 143

The white-flowered Montpellier rock rose (143, I) is found in the Mediterranean region and is closely related to the gum cistus, the sticky resin of which used to be combed from the hides of pasturing sheep and still has medical applications.

144 145 146 147

The irritant smoke bush (143, III), a member of the Anacardiaceae family, is an ornamental plant popular both for its autumn colour and for the woolly appearance of its flowers as they mature. Since Classical times, this tannin-rich plant has been used to produce a dye and also in leather production. It has also been used medicinally as a gargle to relieve throat infections and as an astringent.

PLATES 144, 145

Hibiscus syriacus (144, I; 145), belonging to the mallow family, came from Asia to European gardens, where its large flowers still make it a popular choice today. Besler mentions a red and a white form.

As with many other plants, the German common name for *Anthemis cotula* (144, II), *Stink-Hundskamille* (stinking dog chamomile), uses the prefix "dog" as an expression of the scant regard accorded to it, in this case because of its unpleasant scent. The Virginia stock (144, III), a member of the Brassicaceae family found throughout the Mediterranean region, is still a popular ornamental plant today.

PLATE 146

The common myrtle (146, I and II) was not a feature of marriage ceremonies in Germany until the 16th century, even though, as Venus' plant, it was used as such in Classical times. A myrtle grove served to shelter Aphrodite when she had emerged naked from the sea. The evergreen plant is often mentioned in the Bible and was also used to build the tabernacle.

Whereas the common myrtle (146, I) can often be found in the sclerophyllous woodland of the dry regions of the Mediterranean, the smaller-leaved Tarentum myrtle (146, II) is much rarer. It was widely used for medicinal purposes primarily for its essential oil, but also for its leaves and fruits.

PLATE 147

Jasminum grandiflorum (147, I) has long been valued in the cosmetics and perfume industries for its scent. Its precious essential oil was extracted by means of enfleurage, particularly in the French perfume town of Grasse. In this expensive process, the white flowers are laid on thin layers of fat, which extracts the oil from the pet-

148 149 150

als. The oil then becomes concentrated in the fat and is extracted by applying alcohol. Once the solvent has been carefully removed, the pure essence remains. This is what gives many perfumes their distinctive character.

Sweet marjoram (147, II; 323, II), a member of the Lamiaceae family, is valued as a herb whose essential oil gives food a distinctive taste, which is why it was grown in large quantities in Franconia and Thuringia. Legend has it that it owes its flavour to Amaracus, son of the Cypriot king. He inadvertently broke a container of sweet-smelling ointment and was so appalled at what he had done that he immediately changed into this plant, which has been relatively fragrant ever since.

The botanical name *Euphrasia* means "blithe spirit" and refers to the brightly coloured little flowers of the eyebright (147, III and IV), a member of the Scrophulariaceae family, which acquired its common name and medicinal application from its resemblance to eyelashes.

PLATE 148
The winter cherry (148, I), which belongs to the Solanaceae family, came to Germany from America around 1600. Its shiny red, cherry-sized fruits soon found it a place in many gardens.

A particularly striking feature of the alpine toadflax (148, II), a member of the Scrophulariaceae family, is its attractively spurred flowers, whose bright violet contrasts well with the yellow lip.

1ˢᵗ ORDER OF SUMMER
PLATES 149, 150
The unusual appearance of the herb Paris (149, I) makes it stand out immediately in the wild. Just four large decussate leaves grow on the slender, erect stem, with a solitary inconspicuous flower standing at some distance opposite, from which a shiny black fruit develops. Some liken this to the apple awarded by Paris, after whom the plant gets its botanical name.

The common foxglove, which Besler shows in a pinky red (149, II), a white (150, I) and the usual purple form (150, II), now an important medicinal plant, is found primarily in central and western Europe and was therefore not known to

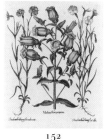
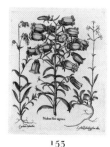
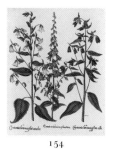

151 152 153 154

the medical authorities of Classical times. In 1543, Fuchs was the first to include the plant in a German herbal, but for its beauty, rather than any medicinal purpose. It was not until the end of the 18th century that an English doctor recognised its beneficial effect on the heart and its diuretic property. However, because of the highly poisonous nature of this plant, it was difficult to get the dosage correct. This problem was solved, however, by using isolated and highly purified extracts. The large yellow foxglove (149, III) has pale yellow flowers and, like the other species illustrated here, grows to a height of about one metre. The foxglove had a regular place in old cottage gardens.

The hawkweeds, an extremely extensive genus of the Asteraceae family, are found throughout the northern hemisphere. It is often difficult to identify them exactly, but there is no doubt about the orange hawkweed (150, III), since it is different in colour to the usual yellow-flowered species.

PLATE 151

Red valerian (151, I) belongs to the Valerianaceae family and is native to the Mediterranean region. Its flowers are usually red, but can occasionally be white. It has recently been used as a sedative as it contains health-promoting elements. The Canterbury bells (151, II and III; 152, I; 153, I), seen here in a white and two blue forms, originally occurred only in certain parts of Italy and France, but have now spread over large parts of Europe, and not only in gardens.

PLATE 152

The corn cockle (152, II and III), a member of the Caryophyllaceae family that has now become rare, used to be a troublesome weed, the black seeds of which contaminated wheat crops. On the other hand, however, its beautiful large flower makes it a very good garden plant. There were two different-coloured forms in the Eichstätt garden.

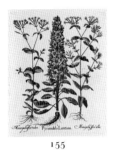

155 156 157 158

PLATE 153

To protect itself against insects climbing up its stem to steal nectar, the catchfly (153, II and III) exudes a sticky secretion during the flowering period that protects its flowers like a lime ring, preserving them for the flying insects it needs for pollination. The swollen-looking calyx of the bladder campion (153, II) has led to its graphic German common name *Tauben-kropf* (pigeon crop). *Silene nutans* (153, III) can often be found in German meadows and is distinctive because, during the day, its whitish flowers look withered, opening fully only in the evening.

PLATE 154

Various bellflowers now come to the fore. The indigenous *Campanula rapunculoides* (154, I), the chimney bellflower (155, I) found in the Mediterranean region, the peach-leaved bellflower (156, II and III) frequently found in Germany and the white (154, II) and blue bellflower (154, III), neither of which can be more closely identified, are illustrated here.

PLATE 155

The white (155, II) and red (155, III) campion or catchfly present two more representatives of the *Silene* genus (cf. plate 153).

PLATE 156

Although many species of willowherb occur in Germany, only the rosebay willow herb (156, I) is included in the *Hortus Eystettensis*. It is often found in clearings in woods or on wasteland and can grow to well over a metre tall. As can be clearly seen from the picture, young unopened flowers, fully open flowers and even mature seed capsules appear together on the elongated inflorescence.

PLATES 157, 158

The characteristic flower shape with its pouting lower lip gave the snapdragon (157, I–III, 158, I and II) its highly appropriate name. It is a member of the Scrophulariaceae family and, although native to southern Europe, it has now naturalised throughout large areas of Europe. The calf's snout (158, III) actually belongs to a different genus, but fits in well here as it has a similar flower.

 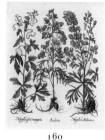 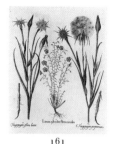 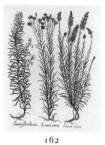

159 160 161 162

PLATES 159, 160

The German names of the five *Ranunuculus* species shown on these two plates evoke the Middle Ages, when there were still knights in armour with spurs and heavy helmets. The bee larkspur (159, I) gets its German common name *Hoher Rittersporn* (high knight's spur) from the distinctive spur that grows from the uppermost of its five petals.

This downward-pointing growth is absent from the aconite, four species of which are presented here, namely the wolfs-bane (159, II), the helmet flower (160, II), the variegated aconite (160, III) and the badger's bane (160, I), which is not native to Germany. In each case, the uppermost petal is curiously hooded so that from the side the flower looks like a helmet with skull and cheek protection. The wolfsbane and the monkshood are particularly poisonous indigenous plants. This also explains their Latin generic name, *Aconitum*. This name was already in use in Classical times for an extremely poisonous plant that has not been precisely identified. According to legend, it grew out of the slaver of the hell-hound, Cerberus, and was used by

the enchantress Medea in her murderous schemes. In complete contrast to this, the helmet flower has often been held to be an antidote to poisons, reflected in its German name *Giftheil* (poison cure). The aconite is now an important element in the homeopathic treatment of feverish conditions and neuritis.

PLATE 161

The perennial flax (161, I) is closely related to flax, one of Germany's most important cultivated plants, which produces fibres and oil.

The two goat's beard plants, *Tragopogon dubius* (161, II) and the salsify vegetable oyster (161, III) with their violet composite flowers, both belong to the genus *Tragopogon*. They get their unusual name from the arrangement of the fruits, whose seeds develop white pappi or flight hairs, which, when seen *en masse*, look like a beard. Both plants have edible roots. The whitish root of the salsify vegetable oyster was long valued as a vegetable for its distinctive flavour, but has subsequently been superseded by the black salsify.

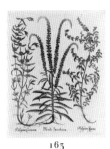
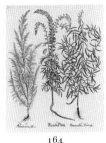
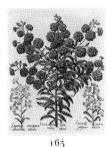
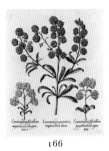

163 164 165 166

PLATE 162

Although, because of their similar leaf structure, Besler describes all the three plants illustrated on this plate as *Linaria*, the flowers make it immediately apparent that this cannot be right. There is no doubt that the *Gülden Leinkraut* (golden linaria) in the middle is definitely goldilocks (162, I), which has now become rare in Germany. It is flanked by the striped toadflax (162, II) on the left and the common toadflax (162, III) on the right. In German, the latter is also called *Löwenmaul* (lion's jaws) from the shape of its flowers, and *Frauenflachs* (ladies' flax) from the shape of its leaf. It is used in popular medicine as a diuretic and to purify the blood. It was also used to protect against witchcraft.

PLATE 163

The tall-growing mignonette (163, I) is an old dyeing plant used to colour fabrics, particularly silk, a fade-resistant yellow and, when used in combination with blue, interesting shades of green. The plant, which originates from southern Europe, has naturalised as an escape from earlier plantations.

The pennyroyal (163, II) and *Mentha cervina* (163, III) are the first representatives of a genus that is presented more extensively on Plates 228 and 230.

PLATE 164

The yellow reseda (164, I) is closely related to the mignonette, but its leaf shape is clearly different. Although the flowers are described as being white, according to Aymonin the botanical details are in line with those of the yellow species.

Although the Latin name for tarragon (164, II), *Artemisia dracunculus*, brings dragons to mind, no danger is attached to the culinary use of the plant, which comes from Siberia. It is closely related in botanical terms to the southernwood (164, III), which also produces an essential oil with a lemon scent. For this reason, it was used in the past in many medications and was a standard feature of old cottage gardens.

2ND ORDER OF SUMMER
PLATES 165–169

The gillyflower (165, I–III; 166, I–III; 167, I–III; 168, I; 179, I and III), a Brassicaceae plant widespread in the Mediterranean region, was given its botanical name in

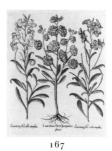 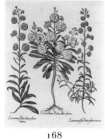 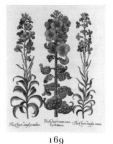 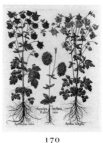

167 168 169 170

honour of Pietro Andrea Matthioli (1500–1577), one of the most important botanists of early modern times. The flowers of this glaucous plant come in pastel shades of white to red-purple. It became established in gardens from the second half of the 16th century. Double and large-flowered forms were soon bred and were much loved in the Romantic period, not least for their scent.

No cottage garden was without the fragrant golden-yellow flowers of the wallflower (168, II and III; 169, I–III), which is closely related to the gillyflower. They can also be found in late medieval pictorial art. It is surprising to see the *Flos Cheyri maximus Eystettensis* (169, I), a species of wallflower which Besler highlights as being a local speciality of the garden because of its great rarity. However, it is obviously not a particular form or even species (at least no proof has yet been found to back this up), but is most likely a modification produced by virus of the examples growing in the garden.

PLATES 170–173

The flower of the columbine (170, I–III; 171, I–III; 172, I–III; 173, I–III) is one of the extravagant beauties of our native flora. Its sepals are coloured and – with the exception of the star-shaped variety (170, III; 171, I; 172, I; 173, I) – are modified into long, straight spurs, slightly bent at the end. The nectar is inside, accessible only to the bumblebee. These five spurs give the flower its characteristic appearance, which brings to mind five doves sitting in a circle, which is why German common names frequently refer to these birds, as indeed does the English name of columbine. From the point of view of symbolism, this provided the ideal reference to the Holy Spirit, often portrayed as a dove. The number five also brings to mind the five wounds of the crucified Saviour and thus his Passion, while the Holy Trinity can clearly be seen in the three lobes of the leaves. The old French name, *ancolie*, which was equated with melancholy, also seems to express the idea of mourning, while Albertus Magnus derived the name *Aquilegia* from the Latin *aquila* (eagle) and gave it a correspondingly religious significance. The *Hortus*

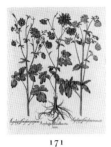 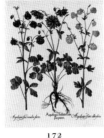 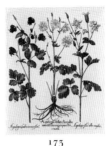 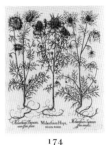

171 172 173 174

Eystettensis illustrates both the wild forms of columbines, usually blue or deep purple, occasionally white, as well as the variously coloured double forms produced by intensive breeding.

The columbine was also used medicinally at the end of the Middle Ages and in early modern times. The name *Tyriakskraut* (treacle plant) refers to the curative properties attributed to the plant. These were thought to be similar to the famous alchemists' treacle, a complex medication that has its origin in Classical times and was reputed to help treat all types of poisoning and illnesses. People had faith in the columbine's curative effect for liver and gallbladder complaints, but also for chronic skin complaints. The chemists of the 19th century, on the other hand, used the juice extracted from its dark blue flowers as a reagent to indicate the presence of acid. Such prosaic applications should not detract from the beauty of its flowers, which even inspired Goethe to write this couplet in the Spring section of the *Four Seasons*:

The lovely columbine reaches upwards and droops its head.
Is it emotion? Or is it playfulness?
It does not tell.

PLATE 174

Both the fennel flower (174, I) and love-in-a-mist (174, II and III) owe their characteristic appearance to the unusually highly divided green bracts that surround the colourful flowers almost like a thorn bush. Most of the German popular names for this member of the buttercup family are therefore derived from this feature: *Jungfer im Grünen* (Spinster in green), *Gretl im Busch* (Gretel in the bush) etc., and perhaps also the English "ragged lady". Although they all have the same generic name, only the seed from the black cumin (180, I) is used as a spice. Here, however, a cultivated form is shown.

PLATES 175–178

A single larkspur is illustrated on Plate 159. Now four whole plates are given over entirely to this plant (175, I–III; 176, I–III; 177, I–III; 178, I–III), illustrating 12 different cultivated forms. Although they used to be grouped into a single genus, the

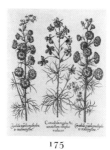
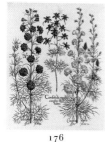
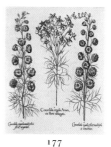
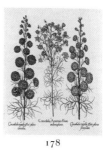

175 176 177 178

species are now divided between *Delphinium* and *Consolida*.

PLATE 179

Alongside the two gillyflowers (179, I and III), left over from plates 165–168, Besler places the wallflower (179, II), which is indigenous to Germany and which also belongs to the Brassicaceae family. Its smaller yellow flowers can compete successfully with the most famous ornamental plants.

PLATE 180

The bittersweet (180, II and III), a valuable medicinal plant, gets its name from a distinctive characteristic: when the dried stems are first chewed, they taste bitter, but then go on to develop an unexpected sweetness. What we now prosaically refer to as the breakdown of the glycosidic compounds used to be regarded as a reminder of the fact that bitterness borne patiently is often followed by sweet reward. The attractive flowers with their recurved violet petals and the circle of anthers are often depicted in a stylised manner as well as naturalistically in the painting of the late medieval books of hours.

3RD ORDER OF SUMMER
PLATES 181–184, 187

Two carnations (181, II and III) accompany the bulbs and the lower stem section of a splendid plant that occurs repeatedly on the following plates: the common Turk's cap lily (181, I; 182, I; 183, I; 184, I; 187, I and II; 188, II and III). Although Besler likes to highlight the exotic, *Lilium martagon*, a parent of many prolific garden forms, is native to chalk-soil areas throughout Europe even in high alpine areas, although it is becoming increasingly rare. This is also confirmed by Hieronymus Bock in his famous herbal of 1577: "Such flowers are grown in gardens for pleasure like other flowers and lilies; elsewhere they grow in high woodland areas, such as in the Black Forest, Helvetica and on the Durstberg mountain towards Wassgaw."

Possibly the name "Turk's cap", which soon became established because of the turban-like shape of its flower, led to the supposition that it was of foreign origin, which is certainly the impression given by the garden forms. The other common German name, *Goldwurz* (gold root), refers to the colour of the bulb, which

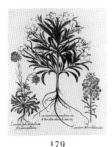
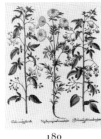
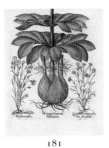
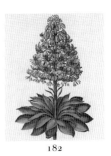

179 180 181 182

alchemists thought might turn metal into gold. In medicine, the bulb was thought to be a diuretic and to assist healing. Its colour also led to its being a popular remedy in Germany for haemorrhoids (called "golden veins" in German). When made into an ointment, the ashes of the burnt bulb were said to reverse hair loss.

The considerable height to which the Eichstätt Turk's cap lilies grew obliged Besler to illustrate them in two sections, so that plate 182 is the continuation of the previous plate. For this reason, the *Hortus Eystettensis* has also only one text for both plates. At that time, great attention was paid to obtaining the maximum number of individual flowers. It is therefore logical for Besler to note with regard to the inflorescence in plate 182 that in 1612 it produced 210 flowers in the Eichstätt garden and that in the same year the plant in plate 183 had been weighed down with at least 46 flowers. Such profuse-flowering specimens do, however, also occur occasionally in the wild, if conditions are favourable to the production of such freaks of nature. The different-coloured example shown in plate 184 serves to illustrate how well informed Besler was,

as he states that Carolus Clusius had found similar plants growing wild in the woods around Frankfurt am Main.

PLATE 185

It is true that the flower shape is similar to that of the Turk's cap lily, but the dense linear leaves instead of the whorl of leaves around the stem immediately reveal that this is a different species. *Lilium pomponium* (185, I; 189, I) occurs only in a very narrow strip of land stretching from the Pyrenees to the Balkans, but nevertheless plays an important role in the breeding of modern garden hybrids.

Although the flowers of the Spanish iris (185, II; 191, I) and *Iris sibirica* (185, III) are very similar, the plants have different storage organs: the former has a bulb, while the latter has a rhizome.

PLATE 186

The scarlet Turk's cap lily (186, I and II; 191, II), which, because of its height, Besler again represents in two sections, is another lily species with bright red Turk's cap flowers arranged in a characteristic outstretched raceme. They first appeared

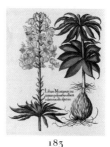

183 184 187 185

in German gardens around 1580 and spread very rapidly.

The pretty *Scilla autumnalis* (186, III) flowers later than its cousins and is indigenous to the eastern Mediterranean region.

PLATE 188

The inconspicuous and widespread wild mandrake (188, I), which belongs to the nightshade family, was called *Circaea lutetiana* after Circe, the famous Classical enchantress, daughter of the sun god Helios and aunt of Medea. This reference led to the German common name *Hexenkraut* (witch's weed) and the English name enchanter's nightshade. However, the reason behind the reference to Paris contained in the modern specific epithet, *lutetiana* (Latin: *Lutetia Parisiorum*), remains unclear. The name Besler uses, *Sankt Stephans-Kraut* (St Stephen's plant), is also used by other botanists, as is the reference to St Rochus, who was honoured as the patron saint of the plague.

PLATE 189

Two different-coloured early marsh orchids (189, II and III) surround a *Lilium pomponium* (189, I). For an explanation of their unusual German common name, *Palma Christi*, see plate 49.

PLATES 190, 191

Gynandriris sisyrinchium (190, I), the Spanish iris (191, I), the yellow Turk's cap lily (190, II and III), the scarlet Turk's cap lily (191, II) and the Dutch crocus (191, III) are all new species of genera already represented many times in the *Hortus Eystettensis*.

The saffron crocus (191, IV), with its brilliant orange pistils rising up out of the flower, has long been treasured. Picked in the autumn and then dried, the flowers produce an expensive spice and a valuable yellow food colourant and tex-tile dye. Saffron was used in medications for the heart, stomach and liver, as an anticonvulsant and, because of its yellow colour, to treat jaundice and many other illnesses. Its high price frequently led to its being adulterated, which is why even in the Middle Ages the saffron symbol of quality assurance was introduced in Venice and Nuremberg.

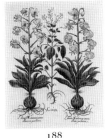
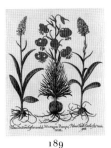
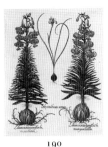

186 188 189 190

4TH ORDER OF SUMMER
PLATE 192

With its unusual flower that can grow to a height of half a metre, the dragon arum (192, I) must surely be one of the most spectacular plants in the Eichstätt garden. Its composition is the same as the cuckoo-pint, except that the upper part of the spathe is open and of deep colour, and the dark spadix extends well clear of it. This foul-smelling plant is indigenous to the eastern Mediterranean, but has also naturalised in some other areas.

PLATE 193

Leontice leontopetalum (193, I) occurs in south-east Europe and in the Middle East. It gets its German name, *Löwen-Trapp* (lion's trap), from its large leaves, which are shaped like a lion's paw. *Alyssum montanum* (193, II) belongs to the Brassicaceae family and, together with other madwort species, is still a popular choice for rock gardens. The globe daisy (193, III), a small member of the Compositae family with a distinctive spherical flowerhead, also prefers stony soil.

PLATE 194

The Dutchman's pipe (194, I and II), which comes from the Mediterranean region and has naturalised in Germany, is an ancient medicinal plant. This is expressed even in its Latin name, *Aristolochia*, which means "the best for the birth", and in its English common name, birthwort, as it was believed to assist in expelling the afterbirth. With its odd-shaped yellowish flowers, which lock in the insects until they have successfully pollinated the plant, the tall-growing Dutchman's pipe provides an interesting focal point in any garden.

Besler describes the thorow-wax (194, III), a member of the Apiaceae family, as *Perfoliata* and *Durchwachs* (perfoliate), because its leaves surround the stem completely, giving the impression that the stem grows through them. This "hole" in the leaf seemed to indicate that the plant would be good for treating wounds and also umbilical hernias.

PLATES 195, 196

These two plates could easily be environmental posters, because it is now illegal in Germany to pick any of these plants,

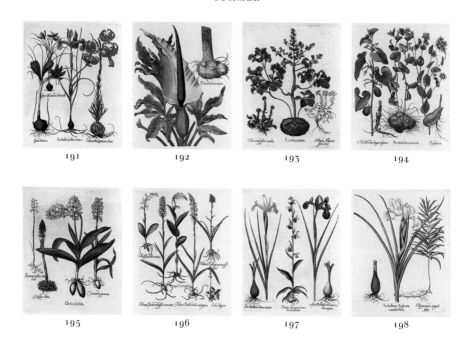

191

192

193

194

195

196

197

198

all of which are orchids. Like the helliborine (196, I), early marsh orchid (196, II and III), lesser butterfly orchid (196, IV), black vanilla orchid (196, V), lesser rattlesnake plantain (196, VI) and late spider orchid (197, I), the lady orchid (195, I), bug orchid (195, II), bird's nest orchid (195, III) and coralroot orchid (195, IV) are all indigenous to Europe, but are now relatively rare. They can, however, occur in great numbers in their respective sites.

PLATES 197–200
Like plates 117–124, the following plates present a selection of various irises, all of which are bulbous rather than rhizomatous. The Xiphium irises, also called Spanish iris (197, II and III; 202, II and III), are shown in various colour forms. The Xiphioides irises, the English iris

(198, I; 199, I; 200, I; 201, I), were first described around 1565 and have been in cultivation ever since. Both originate from Spain, although the latter was relatively quick to travel from Spain to England, where it was cultivated and sold in the Bristol area and therefore came to be thought of as an English plant. The Dutch iris arose from crosses of the two species mentioned, and was itself used as a parent of many later hybrids.

Whorled Solomon's seal (198, II) is closely related to Solomon's seal (92, II), but has a different leaf arrangement. It is native to Germany, although it has become rare.

PLATES 201, 203
The gladioli in the *Hortus Eystettensis* are clearly very different from our modern large-flowered hybrids, which have

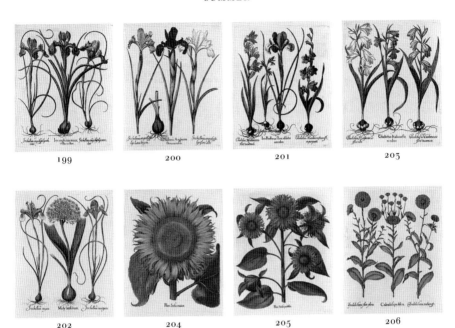

199 200 201 203

202 204 205 206

been bred with increasing success from African species not introduced until the second half of the 18th century. In contrast, Besler shows European species that are indigenous to the Mediterranean region, a few of which are also found in Germany: *Gladiolus palustris* (201, II) and *Gladiolus communis* subsp. *byzantinus* (201, III and IV; 203, I–III). The German common name, *Siegwurz* (victory root), is derived from the fibre-covered corm. As with the German name for the spotted ramson (79, III), *Allermannsharnisch* (the common man's armour), this was interpreted as being the chain mail of a victorious soldier, whereas the Latin *gladiolus* (small sword) relates to the erect, sword-shaped leaves.

PLATE 202
Although many of the *Allium* species are generally regarded as a vegetable or herb, many of them do in fact have decorative flowers, which make them worthwhile garden plants. The species illustrated here has been identified by Aymonin as being the Levant garlic (202, I), from which the leek was subsequently bred as a vegetable.

5TH ORDER OF SUMMER
PLATES 204, 205
The exceptionally large flower of the sunflower (204, I), which came to Germany from Central and South America in the second half of the 16th century, immediately aroused the interest of gardening enthusiasts, who all tried to outdo each other in their reports of how tall it grew.

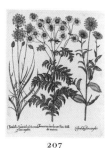
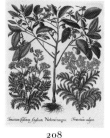

207 208

The sunflower soon found a place in smaller, cottage gardens, so that in 1586 Camerarius was able to state that it was now grown in gardens and in front of windows everywhere, which is why he hardly ever had to describe it. Only slightly later, the multi-flowered *Helianthus multiflorus* (205, I) was introduced. It was not until the 19th century, however, that the seeds were used to produce valuable sunflower oil, which is used for culinary purposes and as engineering oil.

PLATES 206, 207

Although the orange-yellow marigold (206, I–III; 207, III) originates from the Mediterranean region, it has now naturalised throughout Europe. The cottage garden is unthinkable without them and they were indeed also grown specifically as a medicinal plant. Poultices or ointments containing calendula extracts were and still are successfully used to treat wounds, burns and skin complaints. The yellow flowers were also used as a food colourant. In addition to what is thought to be the wild form (207, III), Besler also shows two examples with very different fully double flowers (206, II and III). A

very striking mutation (206, I), with eight small stalked flowerheads raised above its flower, forms the centrepiece of this plate. *Tanacetum corymbosum* (207, I) is closely related to the common tansy, although Besler expressly notes that it has no scent. Cupid's dart (207, II) is indigenous to the western Mediterranean region. Its Latin name, *Catananche*, and its English common names refer to the irresistible powers attributed to the plant as a love charm.

PLATE 208

Two examples are now shown of the tansy (208, II and III), which has already been mentioned. It flowers relatively late in the year, is unfussy as to its soil requirements and is very eye-catching with its bright yellow button-shaped flowerheads. In the past, it was not just popular for its flower, but also as an aromatic medicinal plant, its extract being drunk to get rid of intestinal worms. It was also used against vermin.

Impatiens noli-tangere – it would be hard to find a more appropriate yet equally poetic name for any other plant. The touch-me-not (208, I), a member of the Balsaminaceae family, gets its common

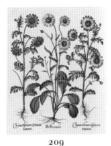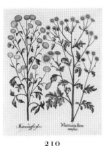

209 210

name from an unusual characteristic that aids its seed dispersal. When the ripe seedpods are touched, they explode to fling out the seeds. It is closely related to garden balsam (322, I), which originates from India, but which has escaped from gardens and is now often found in large quantities in moist sites. It should finally be mentioned that the popular, profusely flowering busy Lizzie also belongs to this genus.

PLATE 209

It looks like the daisy's older sister, and this is indeed why the old French name *Marguerite*, which is derived from the Latin word for pearl, was transferred to the brilliant white ox-eye daisy (209, I), which is also known as marguerite. It used to be classified botanically as *Chrysanthemum leucanthemum*, which roughly translates paradoxically as white-flowering yellow blossom. It is now grouped under its own *Leucanthemum* genus, which thus tallies with the actual flower colour. The yellow colouring is also apparent in the crown daisy (209, II and III), two different varieties of which were in the Eichstätt garden. The

chrysanthemum that is so highly prized today as a showy ornamental, however, originates from an Asiatic variety cultivated in the Far East for well over 2,000 years. Particularly in Japan, the *okikusan* came to be of the greatest cultural importance. At the end of the 17th century, the plant gradually became known in Europe through descriptions and a few cultivated examples, but it was not extensively cultivated and propagated with any success in France and England until about 100 years later. Large-flowered examples, however, were not obtained until the 19th century.

PLATE 210

The feverfew (210, I and II) came to Germany from the Middle East as early as the Middle Ages and has been valued as a medicinal plant ever since, particularly for gynaecological complaints. Its German name, *Mutterkraut* (mother's plant), refers to its alleged effect on the womb, but the "febrifuga" is also said to be a remedy for feverish illnesses, as its English common name suggests.

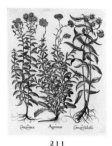
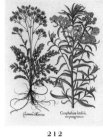
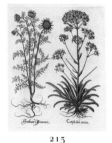
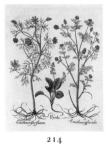

211 212 213 214

PLATE 211

The yellow-flowering yarrow, sweet Nancy, (211, I) comes from southern Europe and used to be called *Leberbalsam* (liver balsam) in German. The name Besler uses, *Ageraton*, can be translated as "never ageing", which could refer to the fact that this member of the Compositae family does not produce a white seedhead, sometimes thought to resemble old men's grey hair, as is the case with *Senecio doria* (cf. 133, II).

The nodding bur-marigold (211, II) gets its name from the two hook-like teeth on its fruits. It originates from America, but is now found throughout Europe. *Inula salicina* (211, III) gets its German name *Weiden-Alant* (pasture horseheel) from the shape of its leaves.

PLATE 212

Anaphalis margaritacea (212, I), a variety of pearly everlasting still popular for its white-woolly leaf hair, also comes from North America and north-east Asia. The hairs on *Senecio bicolor* subsp. *cineraria* (212, II) are even more striking, giving the impression that (with the exception of the yellow flowers) all the plant parts are completely covered with grey ash. This is why the hybrid forms are also called cineraria hybrids or cinerarias after the Latin word for ash, *cinis*.

PLATE 213

Since antiquity, *Anacyclus pyrethrum* (213, II), which is found in the Middle East and North Africa, has been called after the Greek word for fire, *pur*, because its root tastes burning hot. This is also the origin of its German name, *Bertram*, which Besler also uses. It was previously used medicinally, especially for toothache.

The great alpine rockfoil (213, I) is found mainly in the Alps and Pyrenees and has striking long panicles of white flowers and lime-encrusted teeth along the margins of its narrow leaves. Its ability to push through rock led to some native species also being used medicinally to break down bladder and kidney stones.

PLATE 214

Pyrola, the Latin generic name of the lesser wintergreen (214, I), translates as "little pear", so called as its evergreen leaves are the same shape as those of the pear tree.

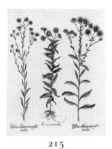
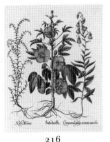

215 216

The genus *Adonis* is represented by the pheasant's eye (214, II) and *Adonis flammea* (214, III). Their red flowers recall the legend of how the flowers grew from the blood of the handsome favourite of the gods, which is why the plant has had this name since the 17th century. The Germans also call it *Teufelsauge* (devil's eye). Besler still calls it *Eranthemum*, which means "red flower".

PLATE 215

Pulicaria dysenterica (215, I), a fleabane, prefers moist sites and has become extremely rare in Germany. Despite its revolting smell, it used to be taken to cure acute dysenteriform diarrhoea. As suggested by its common generic name, fleabane, the smoke produced by burning the plant was said to deter fleas, mosquitoes and other bugs.

Aster amellus (215, II and III) brings the fifth order of summer to a close.

6TH ORDER OF SUMMER
PLATE 216

The Jamaica sorrel (216, I) is closely related to *Hibiscus syriacus* (cf. 144, I; 145) and probably originates from West Africa, although it came to the Caribbean as early as the 16th century and went from there to Indonesia in the 17th century. At any rate, Besler clearly knew of its American origins, because he specifically calls the tropical plant, after Clusius, *Alcea Americana* and *Malva Indica Hispanorum*. The large pale yellow flowers with dark spots made this an attractive ornamental plant, probably grown in a tub, so it could be protected over winter. Today it is important as the source of the pleasantly acidic-tasting, deep red African mallow tea, also called Sudanese tea, which is prepared from the dried calyx and hull and is an equally refreshing drink whether served hot or cold.

A bellflower (216, II) and the prickly saltwort (216, III), a goose-foot plant, complete the plate. The prickly saltwort grows in the sandy tidal area by the sea or by salt marshes, and thus absorbs a large amount of potassium and sodium salts from the soil. For this reason, soda, a valuable commodity, used to be extracted from the ashes.

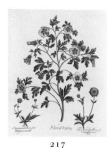

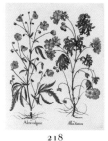

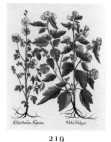

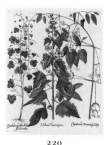

217 218 219 220

PLATE 217

The flower-of-an-hour (217, I) introduces another *Hibiscus* species. It gets its name from the fact that its flowers stay open for only a few hours each day. Like other authors of his day, Besler calls the plant *Venediger-Pappel* (Venetian poplar), in recognition of the fact that it came to European gardens via the northern Italian port that was so important for Levantine trade.

The creeping buttercup (217, II and III) is frequently found in moist conditions in Germany, but the double-flowered form occurs only in cultivated hybrids.

PLATES 218–223

The next few plates are also reserved for the mallow family. *Althaea cannabina* (218, I) is native to southern and south-east Europe, which is confirmed by the name used in the text of the *Hortus Eystettensis, Herba Ungarica.*

It is difficult to provide a positive identification of the mallow (218, II) shown next to it. It could be the musk mallow or a form of the related hollyhock mallow, which is shown on the following plate (219, II), with less deeply lobed leaves.

The marsh mallow (219, I), which is also called *Samtpappel* (velvet poplar) in German because of its softly hairy leaves, is one of the best-known indigenous medicinal plants. Even in Classical times it was a recommended treatment for coughs, ulcers and wounds. Nowadays it is used particularly for bronchial complaints and throat infections because of the mucilage contained in its root and leaves. A Classical writer vividly described the mucus discharge from the root when crushed in water, observing that the marsh mallow curdled the water.

Despite its Latin name, *Lavatera thuringiaca*, the tree lavatera (220, I) originates from eastern Europe, not Thüringen, although it does occasionally occur there. Like the tree mallow (221, I), it differs from the mallows in its fused calyx, which is why it is classified under the genus *Lavatera*, named after the Swiss naturalist Johann Heinrich Lavater (1611–1691).

Besler combines four different double-flowered hollyhocks (222, I and II; 223 IV and V) and three different-coloured single-flowered ones (223, I–III) on two plates. These herbaceous plants with their tall, slender inflorescences were popular

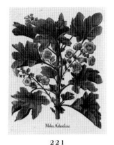

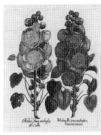

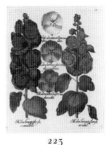

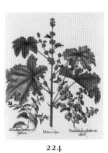

221

222

223

224

not only in the Bishop's garden, but also in cottage gardens, usually in their single form. The deep red to black-red varieties in particular were used in popular medicine as a remedy for sore throats.

Kenilworth ivy (220, II), with its pretty spurred flowers, belongs to the Scrophulariaceae family and likes to grow in narrow nooks and crannies in walls or cliff faces. Its unusual Latin name, *Cymbalaria muralis*, refers to its round leaves, which are slightly dimpled around the stem and therefore look like small cymbals, which also led to its rather less poetic German popular name, *Nabelkraut* (navel plant).

Traveller's joy (220, III) is also the only liana native to Germany. Further species of this genus appear on subsequent plates.

Plate 224

Malva verticillata (224, I) is the last mallow in the *Hortus Eystettensis*. Besler expressly emphasises the unusual height of this plant, which originates from the Orient. It was sometimes used as a vegetable, but also as a medicinal plant to treat uterine disorders. It was also sometimes thought to protect against witchcraft.

Two members of the Lamiaceae family complete the plate. *Ballota pseudodictamnus* (224, II) belongs to the genus *Ballota*, *Gottvergess* in German, meaning Godforsaken. This unusual name relates to its unpleasant smell, which made people think that the Creator had not paid it sufficient attention.

The peregrine horehound (224, III) occurs again on plate 231.

Plate 225

Despite its name, China jute (225, I) is native not only to the Far East but also to the Mediterranean region and southeast Europe. The Latin generic name, *Abutilon*, comes from the Arabic, and the stress is properly on the "i". The specific epithet, *theophrasti*, refers to Theophrastus of Eresos, a pupil of Aristotle and founder of ancient botany.

The Indian pea (225, II and III) is a member of the Papilionaceae family and originates from south-east Europe. It has been in cultivation since antiquity. It is closely related to the vetch and has striking, bright, sometimes multi-coloured flowers.

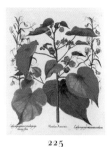 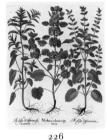 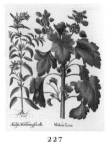 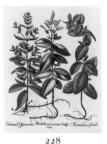

225 226 227 228

7TH ORDER OF SUMMER
PLATES 226, 227
Of the five plants shown on these two plates, the lemon balm (226, II) is undoubtedly the best known. Native to southern Europe, it has long been cultivated for the essential oil contained in its leaves, but it has also been popular in gardens as its flowers, although small, attract bees. It has been used in infusions and tinctures since Classical times for numerous complaints, particularly gynaecological illnesses, and as a sedative. Carmelite water and spirit of melissa were famous. Instead of lemon balm, the latter contained the closely related lime oil.

Dracocephalum moldavica (226, III; 227, II) is a closely related member of the Lamiaceae family that originates from Moldavia, which was occupied by the Turks in the 16th century. Besler calls it *Melissa Moldavica* or Turkish balm. The genus, another species of which has already been seen (cf. 114, III), is still a popular ornamental plant today because of its whorled flowers.

The striking feature of the shell-flower (226, I; 227, I) is the extravagant formation of the calyx when the plant is in fruit. The calyx then becomes papery and bell-shaped; with a little poetic licence these can be described as shell-like, and they give the flowers their characteristic appearance. Two different species were grown in Eichstätt, namely *Molucella spinosa* (226, I) and the imposing bells of Ireland (227, I). Contrary to Linnaeus' supposition, their Latin generic name is not derived from the Molucca Islands, but from the Arabic word *muluk* or king. This could be a reference to their origins in the imperial gardens in Constantinople, from where they were taken to European gardens in the second half of the 16th century.

PLATES 228, 230
Five mints now introduce one of the most important genera of the Lamiaceae family. Some mint species are of economic importance as ornamental and useful plants. The long-leaved horsemint (228, I and II; 230, III) and the spearmint (230, I) are indigenous to Germany. The mint named by Besler as *Balsamita officinarum* (228, III) could be a spearmint/corn mint hybrid. The best-known mint of all, the peppermint, is also a hybrid. It first became known at the end of the 17th

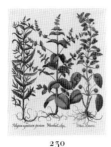 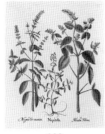 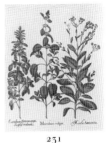 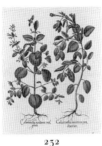

230 229 231 232

century in England, and therefore does not appear in the *Hortus Eystettensis*. All mints contain essential oils, which differ in composition from species to species and do not always have a pleasant smell.

The Roman nettle (230, II), whose spherical female flowers give the plant its characteristic appearance, is mainly found in the Mediterranean region. When touched, its stinging hairs produce the same well-known skin rash as the indigenous stinging nettle.

PLATE 229
Although catmint is closely related to mint, it is now classified within a large genus of its own. *Nepeta nepetella* (229, I), *Nepeta nuda* (229, II) and the genuine catmint *Nepeta cataria* (229, III) are all native to Germany and derive their names from the fact that cats supposedly love these plants and enjoy rolling about in them and even eating them.

PLATE 231
The white horehound (231, I) is a medicinal plant that used to be found throughout Europe, but which has now become very rare. In German, it is sometimes called *Berghopfen* (alpine hop) from the fact that in some areas the bitter plant is added to beer to make horehound ale. Popular medicine has also used the plant for its bitter taste, mainly to stimulate bile flow and improve digestion.

The second horehound species has been identified as the peregrine horehound (231, II), already seen on plate 224, III, and which is now shown again in a form with broader leaves.

No great botanical knowledge is needed to see that, contrary to the claims of the description, the third plant illustrated cannot be mint. The flowerheads clearly show that this plant belongs to the Compositae family. Only its pleasant minty fragrance led to this plant being wrongly named. The costmary (231, III), which originates from south-west Asia, has long been naturalised in Germany, but has now become rare.

PLATES 232, 233
Three species of calamint follow each other here: the large-flowered calamint (232, I), the common calamint (232, II), *Calamintha officinalis*, and the lesser calamint (233, II), *Calamintha nepeta*. In

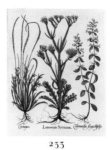
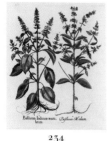

233 234 235 236

the past, they were used for unspecified purposes in popular medicine. With their essential oils, they also made a pleasant-tasting herbal tea. They were also used as a herb, called *Winter-Bohnenkraut* (winter savory) in German.

The statice (233, I), also called *Strand-nelke* (beach pink) or *Geflügelter Strand-flieder* (winged beach lilac) in German, is native to the Mediterranean region and is the only member of the Plumbaginaceae family to appear in the *Hortus Eystettensis*. As its flowering stems last a long time when cut, even without water, they are much used as everlasting or straw flowers in dried-flower arrangements.

The cut-leaved plantain (233, III) is another plant that thrives on a coastal site. It gets its German common names, *Krähenfuß-Wegerich* (crow's foot plantain), *Schlitz-Wegerich* (slit plantain) and *Hirschhorn* (staghorn), from its pinnatifid leaves.

PLATES 234, 235
Besler devotes two plates to basil plants, whose name incorporates the Greek word for king, an indication of the high regard in which basil was held. As a root

of the word basilisk, it also recalls the mythical reptile that was a mixture of a cockerel and a snake. Superstition held that the plants would help protect against its venom. Basil has been naturalised in Germany since the Middle Ages. In addition to the common basil (234, I and II; 138, II and III; 306, II and III), a herb used particularly in French and Italian cooking, Eichstätt also had tree basil (235, I), curly basil (235, II) and bush basil (235, III). All the plants contain essential oils and probably originate from the tropical regions of Asia and Africa.

PLATE 236
The wood sage or sage-leaved germander (236, I) is found across large parts of Europe and was used in popular medicine to lower fever.

The common candytuft (236, II and III) is still sold as a garden plant today in exactly the form in which Besler would have known it, with double flowers in colours ranging from white to red-purple.

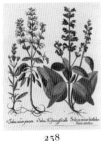

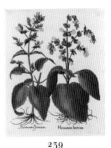

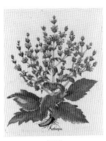

237 238 239 240

PLATE 237

The eastern Mediterranean is the home of *Helichrysum orientale* (237, I), an everlasting flower that is excellent for dried-flower arrangements.

The coral root bittercress (237, II), a very rare member of the Compositae family that is indigenous to Germany, gets its name from the unusual little bulbils that lie in the leaf axils and can be used for propagation.

As its name suggests, the night-flowering catchfly (237, III) does not open its flowers until the evening, when they exude their exquisite scent.

8TH ORDER OF SUMMER
PLATES 238–241

After the meadow clary (see plate 127), the next four pages show more species of sage. The common sage (238, II) is shown here in its white form instead of the usual purple. As with many plants that contain essential oils, its leaves are used both as a herb and medicinally. This comes as no surprise when the derivation of its Latin name is taken into account: *Salvia* from *salvus* (healthy). In addition to essential oil, the plant also contains tannins and

bitter constituents and therefore makes a very effective gargle for throat and mouth infections. It is also used internally for digestive disorders and to suppress excessive perspiration. Other members of this extensive genus are represented by *Salvia grandiflora* (238, I), *Salvia nemorosa* (238, III), *Salvia syriaca* (239, II), the African sage (240, I), also called *Wollsalbei* (woolly sage) and *Silberblatt* (silver leaf) in German because of its hairy leaves, and Jupiter's distaff (241, I). Finally, the biennial clary (239, I) gets its German name *Muskateller-Salbei* (muscatel sage) because it used to be added to wine to give the desired muscatel flavour.

PLATES 242, 243

Besler devotes the next two plates to the alkanets and hound's tongues and thus highlights the features these plants have in common. They are now grouped under three genera, belonging to the Boraginaceae family. The hound's tongue gets its name from its rough, tongue-shaped leaves. The green alkanet (242, I) and *Anchusa azurea* (242, II and III) with their bright blue flowers are still sold as ornamental plants today. The common

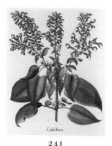
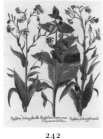
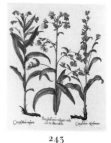
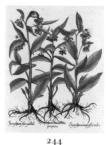

241 242 243 244

alkanet (243, I), which doctors of old claimed acted as a pick-me-up when the leaves were soaked in wine, has been and still is used in popular medicine as an expectorant remedy for coughs and also to cleanse the blood and for diarrhoea. Despite its unpleasant smell, the hound's tongue (243, II) was used as a constituent of wound-healing ointments and soothing cough lozenges. When crushed, the root was said to be effective against rats and vermin. The second hound's tongue (243, III) cannot be identified with absolute certainty in botanical terms. Cretan hound's tongue and *Cynoglossum cheirifolium* have been suggested.

PLATE 244

The common comfrey (244, I–III) is an ancient healing plant used in both clinical and complementary medicine. It is interesting that the names of this member of the Boraginaceae family that are derived from Greek and Latin, *Symphytum*, *Consolida* and *Solidago*, as well as the German names *Beinwell* (leg well) and *Wallwurz* (filling root) embody the idea that the plant would re-join and thus heal broken bones. The root is still used

externally today to encourage the rebuilding of the bone tissue, as well as to treat strains and sprains. It is also sometimes eaten as a vegetable, but recent research suggests that this is inadvisable as it can have potentially serious side effects.

PLATE 245

Since antiquity, the henbane, a member of the Solanaceae family, has been known as a poisonous, medicinal and magical plant. The black henbane (245, I), with its characteristic dirty yellow, violet-veined flowers, is indigenous to Germany, whereas the Russian henbane (245, II) occurs more commonly in the Mediterranean region. Although it was known to be poisonous, the plant was used for its hallucinogenic and mood-enhancing properties in witchcraft. Seeds would be thrown into the fire to put Pythia, the priestess of Delphi, into a trance. According to Shakespeare, Hamlet's father was killed by having henbane juice poured into his ear, and in early modern times, the plant attained notoriety as an important constituent of creams to make witches fly, with tragic consequences. Today, the isolated and purified extracts of the plant

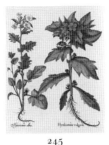 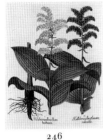 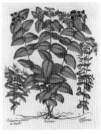

245 246 247

are used medicinally as a painkiller and anticonvulsant.

PLATE 246

Veratrum includes a white species, the false hellebore (246, I), and a black species, *Veratrum nigrum* (246, II), both of which are poisonous. As was customary at the time, Besler still calls this liliaceous plant *Nieswurz* (literally sneezewort, but used for the hellebore). This led to frequent confusion with the Ranunculaceae plant of the same name, which is why Linnaeus introduced the generic name still in use today, *Veratrum*. Despite this, snuff continued to be made out of the pulverised rhizome, as people believed that sneezing could remove excess mucus from the brain.

PLATE 247

Three St John's worts are shown on this plate. The tutsan (247, I), which is native to the Mediterranean area, acquired its German name *Mannsblut* (man's blood) from the red juice produced by rubbing the petals and buds. *Hypericum hircinum* (247, II), on the other hand, gets its Latin and its German name *Bocks-Johanniskraut*

(goat's St John's wort) from its unpleasant smell. *Hypericum maculatum* (247, III) is similar to the well-known perforate St John's wort, one of the most important and popular medicinal plants. Modern research has proved its outstanding effect as a balancing sedative, and it has long been known in popular medicine that the red pigment, hypericin, is good for many skin problems. When held to the light, the large oil glands make the leaves look perforated. Scientific botany therefore coined the Latin name *Hypericum perforatum*, whereas in folklore an explanation was sought in the legend that, angered by its healing effect, the Devil had pricked the plant with needles in an attempt to destroy it. As he did not succeed in doing this, he has been fleeing ever since from the plant, which is said to ward off evil and which in German is therefore also called *Jageteufel* (chase the Devil).

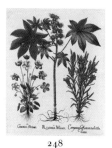

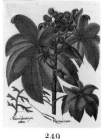

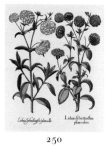

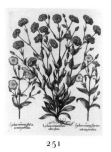

248 249 250 251

PLATES 248, 249

In German, the castor-oil plant (248, I; 249, I), a member of the Euphorbiaceae family, used to be called the *Wunderbaum* (miracle tree). It is also called Palma Christi. Today it is grown as an ornamental plant popular for its large leaves and spiky fruits or alternatively for its medicinal oil. It gets its Latin name, *Ricinus*, from the name of a canine tick, as its large poisonous seeds look like ticks. It gets its common name, Palma Christi, and its German name from the unusual fact that the largest leaves are at the top of the branch and not, as is usually the case, at the bottom. The fatty oil was extracted even in Classical times, but in its untreated form it remained unsuitable for human consumption. The seeds, and later also the oil, were sold in German pharmacies, but were only rarely used. It was not until the 19th century, when the cold-pressed oil was decocted with water to leach out the poisonous protein, that it could be taken internally as a purgative.

Gentiana pneumonanthe (248, II), called the lung gentian in German, got its name from the fact that it was used in medicine to treat bronchial illnesses. It was also recommended, because of its bitter-tasting root, to be taken for poisoning and feverish illnesses.

The grass of Parnassus (248, III), a member of the Saxifragaceae family, is native to the northern hemisphere, but has now become rare in Germany.

The ground pine (249, II), a club moss plant, is an ancient magical plant used in many superstitious practices, in which garlands or belts woven from the runners often played a role in spells to ward off evil. It has many German names, such as *Schlangenmoos* (snake moss), *Sankt Johannes-Gürtel* (St John's belt), *Drudenfuß* (pentagram) or *Hexenpulver* (witch powder). Chemists have stocked the fine yellow powder of the spores since the 17th century, using it to coat pills to prevent them from sticking together. In the theatre, the spores were blown into a flame to produce artificial lightning.

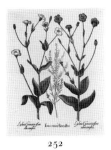
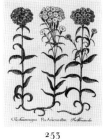

252 253 254 255

9TH ORDER OF SUMMER
PLATE 250

A pink campion (250, I) and a white one (250, II), both with double flowers, are the first of this selection of campions.

PLATES 251, 252

The old German word *vexieren*, meaning to mislead or fool, gave the rose campion (251, I–III; 252, II, III) its German name, *Vexiernelke* (false carnation), as the petals have little flakes which get up the nose of anyone who gets too close to smell the flower. This silver-grey, woolly herbaceous plant is still found in many gardens today.

Heather (252, I) thrives not only on moorland but also in dry areas. In German, it is also called *Besenheide* (broom heath) as it can be used to make a brush for sweeping. There are now more than 500 different hybrid forms of this evergreen ground-cover shrub.

PLATE 253

The sweet William (253, I–III) marks the start of a second showing for representatives of the genus *Dianthus*, to which Plates 308–318 are devoted.

PLATE 254

Maltese cross (254, I–III) is the English name for this campion, which occurs in the wild in Russia and which had already become established in gardens by the 16th century. However, it did not get its appealing German common name *Brennende Liebe* (ardent love) until 200 years later. Besler still calls it *Jerusalem-Blume*, because people thought they could see the Jerusalem cross, better known as the Maltese cross, in its flowers, even though there are five notched petals, so they do not form the shape of the cross.

PLATE 255

Today, the common viper's grass (255, I) is no longer grown as an ornamental plant, but for its root, which makes a very tasty vegetable. The name used by Besler, *Schlangenmord* (snake death), relates to how the root was used in Spain and Italy. Its juice was thought to be the best remedy for bites from the poisonous *(e)scorzo*, which is allegedly why its was given its botanical name, *Scorzonera*.

The goat's beard (255, II), which can grow above head height, is a member of the Rosaceae family native to Europe. Its

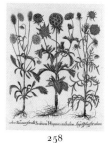
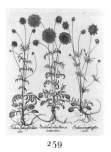

256 257 258 259

characteristic creamy white flowers make it a striking garden plant.

PLATE 256
Crepis rubra (256, I) is a Hawk's-beard native to southern Europe. Its scientific name, *Crepis*, is Greek for basis or foundation.

The ragged robin (256, II) is often found in Germany in water meadows or moorland sites. Foamy deposits from the froghopper, popularly known as cuckoo spit, often appear on it.

PLATES 257–259
Although their names all refer to the scabious, the Alpine scabious (257, I), *Scabiosa stellata* (257, II; 258, I), the blue buttons (257, III), the small scabious (258, II; 259, III) and *Scabiosa ochroleuca* (258, III) are nowadays classified within three separate genera of the Dipsacaceae family. In the past, scabious plants were sometimes used medicinally to treat skin complaints and scabies, hence their Latin name. The extremely dark colour of the sweet scabious (259, I, II), thought to resemble widow's weeds, led to its other common name, mournful widow.

PLATES 260, 261
Valeriana phu (260, I) and *Valeriana sambucifolia* (261, II) are closely related to the valerian used for medicinal purposes, which is well known as a sedative with a characteristic smell and which is being used increasingly again today. This plant used to be called *Katzenkraut* (cat's plant) in German, because of cats' predilection for it.

Jacob's ladder (260, II and III) is a member of the Polemoniaceae family native to large parts of Europe. Besler calls it *Griechischer Baldrian* (Greek valerian), thereby referring, like Jacob's ladder, to its pinnate leaves, which look like those of valerian and can also be seen as a ladder with a central bar across.

The soapwort (261, I) gets its name because it contains foam-forming saponins and has therefore been used instead of soap to remove stains and to wash textiles. It was long used medicinally as an expectorant. In popular medicine it was also applied as a remedy for skin complaints, among other things.

The greater masterwort (261, III) belongs to the Apiaceae family and is native to Germany. The fact that it is called *Veratrum*

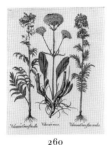
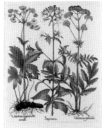

260 261 262 263

nigrum should not lead to confusion with the real black hellebore, as all that they have in common is the crowfoot-shaped leaves and the fact that, when pulverised, the rhizome induces sneezing.

10TH ORDER OF SUMMER
PLATES 262, 263

According to Aymonin, Besler's *Baum Cappern* (caper tree) is the Syrian bean caper (262, I), a southern European bean caper that forms bean-like fruits, and whose buds, as with many other plants, were used as a substitute for real capers.

The restharrow genus of the Papilionaceae family is represented by three species: *Ononis natrix* (262, II; 263, I), *Ononis arvensis* (263, II) and *Ononis spinosa* (263, III). The last is also indigenous to Germany and has long been used as a diuretic. The name used in the original text, *Stallkraut* (horse urine plant), also refers to this property in equine medicine. The German name for restharrow, *Hauhechel* (hay hackle), could well be derived from the thorny species, *Ononis spinosa*, which looks like the hackle or comb used to comb out flax.

PLATE 264

Herb Christopher (264, I) is a member of the Ranunculaceae family and grows into large bushes with clusters of white flowers followed by black fruits. Despite the fact that it is poisonous, it is still a popular garden plant today.

The dropwort (264, II) is also called *Kleines Mädesüß* (little meadowsweet) in German to differentiate it from the *Echtes Mädesüß* (meadowsweet), the spiraea used for medicinal purposes. *Mädesüß* (literally "sweet mead") refers to the old custom of adding this plant to mead to sweeten the honey wine. The swellings on its roots led to its other German name, *Erdeicheln* (earth acorns).

PLATES 265, 266

The moth mullein (265, I and II), the dark mullein (265, III), Aaron's rod (266, II) and the white mullein (266, III) are four indigenous species of the genus *Verbascum*, which belongs to the Scrophulariaceae family. The stems, which are often tall, look like imposing burning candles with their usually bright yellow inflorescences, hence their other common name of torches. They are said

264 265 266 267

to protect against lightning and help with other injuries, particularly if gathered on St John's Day (24th June). Because their leaves are sometimes soft and woolly, they are also called *Wollblumen* (wool flowers) in German. The dried flowers are used to treat bronchial illnesses.

Aster tripolium (266, I) leads on to two further members of the Asteraceae family on the following plate.

PLATE 267

The third and final representative of the groundsel plants is *Senecio fluviatilis* (267, I), which, like the golden rod, *Solidago virgaurea* (267, II), belongs to the Asteraceae family. Both are ancient medicinal herbs, as is borne out by Besler's names *Heidnisch Wundkraut* (literally "heathen wound plant") and *Gülden Wundkraut* (golden wound plant). The scientific generic name, *Solidago*, also means "to solidify, strengthen or reinforce", referring to its bone-setting properties. Golden rod is also used as an important diuretic, but is increasingly being superseded by other species.

PLATE 268

These two loosestrifes, the yellow loosestrife (267, III) and *Lysimachia punctata* (268, I) are both indigenous to Germany. They get their German names, *Felberich* or *Weiderich*, from the deciduous leaves of some species, which look like those of the willow (*Weide*), previously also called *Felber*. This is also true of the purple loosestrife (268, II), called *Blut-Weiderich* in German (blood loosestrife). The red-purple flower colour of this plant is also expressed in its specific epithet, *salicaria*. However, as it belongs to the Primulaceae family, it is not as closely related as its German name would suggest. All these plants prefer moist conditions, as does the marsh woundwort (268, III), a member of the Lamiaceae family, which is also called *Schweinerübe* (pig beet) in German because of its tuberous root swellings.

PLATE 269

The mitre cress (269, I), a south European member of the Brassicaceae family, is rare in Germany and is specified as being foreign by Besler. The white mustard (269, II) belongs to the same family and, in addition to being used

 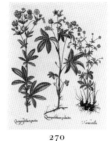 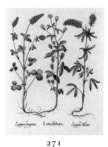

268 269 270 271

as fodder and for its oil, is also used for medicinal purposes, internally to improve digestion, and externally as a skin irritant liniment. It is, of course, also an important spice, mainly used with the hotter black mustard and other ingredients to make table mustard.

PLATE 270

Besler clearly recognised that the three plants shown together on this plate belong to the genus *Potentilla*. The marsh cinquefoil (270, I) is found almost everywhere in Europe, as are *Potentilla recta* (270, II) and the bloodroot (270, III), which, because of its twisted root, is also called tormentil. It was noticed very early on that this rootstock secretes a red juice, which was therefore assumed to have some effect on the blood. Slices of the root laid over minor wounds really did stop them bleeding, this being the effect of the tannins that produce the juice's red colouration. Preparations made from the root are therefore still used internally today for diarrhoea and as a gargle for throat and mouth infections.

PLATE 271

The German name for *Trigonella coerulea* (271, I) is *Schabzigerklee* (Schabziger clover) and is derived from *Schabziger*, a hard Swiss cheese to which the aromatic leaves are added. This fragrant plant was also called *Bisamklee* (musk clover), and was thought to have a particularly intense scent seven times a day. The Italian clover (271, II) was originally indigenous to south-west Europe, but has now naturalised in large areas of Europe, where another species of clover, *Trifolium rubrum* (271, III), is also often found in meadows.

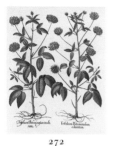 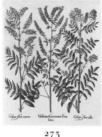 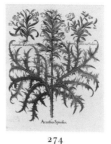 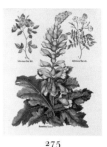

272 273 274 275

PLATE 272

Aspalthium bituminosum (272, I and II), native to the Mediterranean region and the Canary Isles, gets its Latin name from the tar-like smell it produces when rubbed or heated.

PLATE 273

The yellow sweet clover (273, I), which is indigenous to Germany, is also called honey clover in German because the dried plant contains aromatic coumarins. Too much coumarin, which also occurs in woodruff and the punch drink made from it, can, however, lead to headaches and can even thin the blood, and is now deliberately used for this purpose in modern medications.

Research has also been carried out on goat's rue (273, II and III), which originates from the eastern Mediterranean region but has now naturalised in some parts of Germany, to discover whether it is suitable for medicinal use. However, the uncertain effect of the plant has meant that as yet the herb cannot be accepted as reducing the blood sugar level. It is used in popular medicine to increase lactation and as a diuretic.

11TH ORDER OF SUMMER
PLATE 274

The capitals of many Corinthian-style columns and also those of the Renaissance and Baroque periods are unimaginable without the decoration of the leaves of *Acanthus spinosus* (274, I), a form of bear's breeches common in southeast Italy, the Balkans and particularly Greece. Its leaves frequently outshine the beauty of the inflorescence, as the *Hortus Eystettensis* illustrates.

The forget-me-not (274, II and III) is native to all areas of Europe and is very popular for its small, usually blue flowers. No clear explanation of its common name has yet been found, although many stories refer to it. Its scientific name, *Myosotis*, means mouse ear and was probably transferred to the forget-me-not from another plant. Its message is unambiguous, however, in the language of flowers, which has become popular since the 19th century.

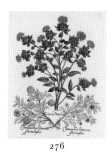 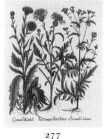 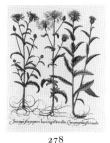 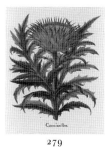

276 277 278 279

PLATE 275

Two different colour forms of jasmine (275, I and II), a member of the Oleaceae family already represented on plate 147, make another appearance here.

PLATES 276–278

The safflower or false saffron (276, I), which originates from the Orient and is in cultivation in Germany, is another dye plant, whose decorative flowerheads make it appropriate for garden use also. It can be used on textiles to create orange to red tones. As its name indicates, the plant used to be compared to the saffron. As its petals are of a similar colour, they were carefully rolled between two plates to produce a substitute for real saffron, which was very expensive. Besler calls *Carduncellus caeruleus* (278, III) *Blawer wilder Saffran* (blue wild saffron).

Roman chamomile (276, II and III) is shown in both a single and a double form, as it has been grown as a medicinal plant in many cottage gardens since the 16th century. It is closely related to chamomile and, although it does not have the same active constituents, it is used in much the same way, but particularly for adding to bath water and for washing blond hair. The hill knapweed (277, I), found in western Europe, and *Centaurea jacea* (278, I and II), which is widespread in Germany, supplements the many species of *Centaurea* that have already been presented in the *Hortus Eystettensis* (cf. plates 114, 115).

The notched leaves and the yellow dye contained in the plant gave the purple-flowering saw-wort (277, II) its German name, *Färber-Scharte* (dyer's notch). Like the greyish thistle (277, III), it is found in large areas of southern, central and eastern Europe, although it is not equally common in all areas.

PLATE 279

The cardoon (279, I), called "vegetable artichoke" in German, appears here ahead of the real artichokes, which will be discussed on plates 357 and 358.

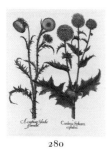
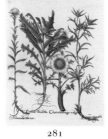
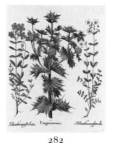
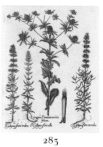

280 281 282 283

Plate 280

Echinops sphaerocephalus (280, I), a globe thistle, gets its botanical name from its inflorescence, which looks like a rolled-up hedgehog. This effect also makes it a good ornamental plant.

Although widespread in Germany, the musk thistle (280, II) is also illustrated here. It seems it was valued for its rare bright colouring.

Plate 281

The Latin name *Carlina*, which has long been used for the stemless carline thistle (281, I), gave rise to the legend about the venerated German Emperor Charlemagne. According to this, he was in dire straits on a Crusade against the infidels as his army had become ill. He prayed to God to save him, after which an angel appeared to him in a dream and prophesied that if he shot an arrow up into the air, it would land on the plant that would cure his army. The arrow fell on the stemless carline thistle, thereby giving it its name; at least, that is how the story goes. The plant illustrated does not look like the typical stemless, clump-forming carline thistle, whose bright metallic

bracts open wide in good weather and were therefore used by peasants to predict the weather. The common carmine thistle (281, III) has a long stem and many smaller flowers. Bouquets of this plant, particularly of specimens with three flowerheads, were offered to the Virgin Mary on the Assumption of the Virgin (15th August).

The blessed thistle (281, II) is so called because it has long been used as a medicinal plant.

Plate 282

The grey-blue bloom covering parts of *Eryngium amethystinum* (281, IV), the sea holly (282, I) and *Eryngium planum* (283, I) makes them attractive, imposingly tall ornamental plants. The two rock roses, *Helianthemum nummularium* (282, II) and *Helianthemum apenninum* (282, III), both members of the Cistaceae family, look delightfully delicate alongside them.

Plate 283

Hyssop (283, II–IV) came from the East as long ago as the Middle Ages and has been used as a culinary herb ever since. It was also used for its essential oil as a

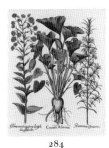
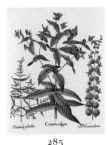

284 285 286

gargle and as an expectorant and to relax spasms in bronchial illnesses. In the East, hyssop leaves are used to prepare the slightly alcoholic drink sherbet.

12TH ORDER OF SUMMER
PLATE 284

Rosemary (284, III), also a member of the Lamiaceae family, can be thought of as a culinary herb as well as a medicinal and ornamental plant. Its essential oil is still used in medicine today in embrocations to improve blood-circulation.

In the past, the fruits of the squirting cucumber (284, I) were used as a strong purgative, but are really more noteworthy for another phenomenon. When the fruit falls from the plant, it squirts out a long jet of bitter juice and with it the seeds, as illustrated in the background of the plate.

The common hawkweed (284, II) is another representative of this extremely broad genus (cf. plate 150, III).

PLATE 285

The caper or myrtle spurge (285, I) gets its name via Old French *espurge* from the Latin *expurgare*, because of the way its

seeds are flung out of the ripe seedpod. Its German name is *Spring-Wolfsmilch* (spring wolf's milk) or *Springkraut* (spring plant). Superstition had it that this plant could open any closed object (as in to spring a lock or trap) or could even blow up rocks (blow up = *sprengen* in German). It was said that a woodpecker would fetch this plant if its tree-hole had become blocked, and hold it in front of the obstacle, which would then immediately spring out.

Melampyrum pratense (285, II), a member of the Scrophulariaceae family that has opposite pointed leaves and pretty flowers, lives as a semi-parasitic plant at the expense of its unwilling host plants, whose roots it taps for water and nutrients.

Another indigenous loosestrife species (cf. plates 267, III and 268, I) is presented by the yellow-flowered moneywort (285, III), whose round leaves reminded early botanists and others of coins.

PLATE 286

The purslane (286, I), also called pussley, originates from west Asia, but is now found throughout Europe. The leaves

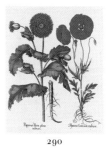

287 288 289 290

of the large-leaved form are used as a vegetable and as a herb. The brightly coloured rose mosses, which are highly prized ornamental plants, originate from the related large-flowered species.

There are two different species of savory, both used as a herb: summer savory (286, II) and winter savory (286, III). This aromatic herb is mentioned in plant catalogues from as early as the time of the Carolingian empire.

PLATE 287

Three artemisia species are shown together here, with the wormwood (287, I) definitely being the best known. The essential oils and bitter compounds contained in this plant mean that it is used with great success to aid digestion and in vermouth and other aperitifs to stimulate the appetite. Absinthe, however, which is much stronger, can seriously damage your health if drunk frequently or else over a long period of time, and has therefore been banned in Germany.

The Roman wormwood or small absinthe (287, III) is more aromatic and less bitter than the real wormwood and is used in the liqueur industry. The third species cannot be identified precisely, although *Artemisia caerulescens* (287, II) has been suggested.

PLATES 288–293

The Mexican poppy (288, I) comes from Central America and starts a sequence of eleven poppy plants in total, although these are now classified within different botanical genera. As its attractive seedheads could cause nausea, the Mexican poppy was also given the name Devil's fig. The yellow horned poppy (289, I) occurs occasionally on the coasts of northern and western Europe, but is grown in gardens as an ornamental plant and has sometimes escaped and become naturalised.

The opium poppy (290, I; 291, I and II; 292, II and III; 294, I–III) and the corn poppy (290, II) are the most popular and most widespread representatives of the genus *Papaver*. Both have many double and multi-coloured cultivated forms, some with fringed petals and more clearly marked black bases. The opium poppy has had a long history as an oil-bearing plant, and its tiny black seeds have been used as a sweet spice. Although the seeds ripen in the seedhead, they contain no

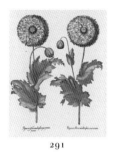
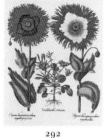
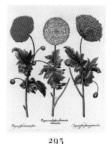
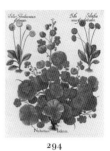

291 292 293 294

alkaloid of opium, which is produced by scarifying the unripe seedhead and collecting the white latex it produces. This had long been used as a pain reliever and sedative but could be prescribed in medicines only with particular care. At the beginning of the 19th century, morphine was successfully isolated from the complex mix of active ingredients. This is now used in cases of severe pain. Particularly in East Asia, opium has also been smoked for its narcotic effect.

Helichrysum italicum (288, II) has a different flower from the yellow-flowered double everlasting straw species already mentioned (237, I).

Like the soldier's woundwort (136, II and III), the sneezewort (288, III) is also used as a tonic. The wild pansy (289, II and III) also occurs in two closely related forms on plate 48. *Tordylium apulum* or *Tordylium officinale* (292, I) is a member of the Umbelliferae family from the Mediterranean region, and is striking for its flat round fruits with notched edges.

13TH ORDER OF SUMMER
PLATE 294

Another "American", the nasturtium (294, I), which Besler calls *Indianische Kresse* or Indian cress, is illustrated here. With their long spurs, the flowers look like a monk's hood, as worn by the Capuchins, and the peppery flavour of the leaves, caused by the presence of mustard oil compounds, is similar to that of the native watercress. This explains the German name for nasturtium, *Kleine Kapuzinerkresse* (little Capuchin monk cress). The seeds are also sometimes pickled and eaten as a substitute for capers.

Two double daisies (294, II and III) complete the page.

PLATE 295

The feather geranium (295, III) was placed in chests and cupboards, to impart to any fabrics stored there its pleasantly aromatic scent, and also to protect them from vermin.

The Italian sainfoin (295, I), a *Hedysarum* species also known as *Spanische Esparsette* (Spanish esparcet) in German, and the esparcet (295, II) both belong to the sub-family of vetch-like papiliona-

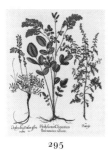 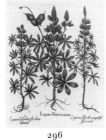 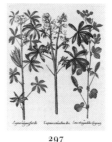 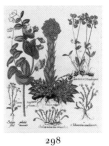

295 296 297 298

ceous plants. They are no longer grown as ornamentals, but are cultivated as valuable fodder plants.

PLATES 296, 297

Now that bitter alkaloids have been bred out of them, lupins (296, I–III; 297, I and II), which belong to the broom-like Papilionaceae family, are also protein-rich fodder plants. They are also used in agriculture as green manure and as a nitrogen fixer for the soil. The significance of the German name used by Besler, *Feigbonen*, remains unclear, but it was already in use in the 10th century and is also used by Hildegard of Bingen. In relatively modern times, the seeds of some lupin species have been used as a substitute for coffee.

The asparagus or winged pea (297, III) was until recently classified botanically under the bird's foot trefoil genus, but now belongs to *Tetragonolobus*, named after the extraordinary edible four-winged fruits, clearly shown in the illustration.

PLATES 298, 299

The common houseleek (298, I), *Sedum pillosum* (298, II), the stonecrop or wall pepper (298, III) and *Sedum sexangulare* (298, IV) all belong to the Crassulaceae family. Houseleeks can still be seen growing on roofs or old farm walls in rural areas, sometimes at a considerable height. This ancient custom dates back to the Middle Ages, although it has long since ceased to have any superstitious significance. In those times, people believed that the *Donnerbart* (thunder beard) planted on the roof could prevent lightning strikes and would also ward off any evil that could afflict the house or its inhabitants. The wall pepper, often considered as a small subspecies of the houseleek, often grows on walls, but is also frequently found on dry, rocky sites. It gets its name from the peppery taste of some types.

Following this botanical excursion into a completely different family, the garden pea (298, VI), perennial pea (299, II), tuberous pea (298, V) and the flat pea (299, III) bring us back to the Papilionaceae family. The pea is one of the oldest vegetables and, in its wild form, can

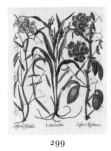
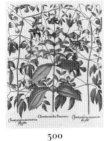
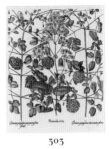
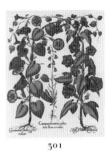

299 300 303 301

be traced right back to the Stone Age. Today's garden peas were bred over the centuries and are now one of the most popular vegetables. Johann Gregor Mendel (1822–1884) carried out research into these self-pollinating plants in connection with his work on the principles of heredity named after him, which led to the foundation of modern genetics.

Job's tears (299, I) is a grass without the benefit of colourful flowers but noteworthy for its unusually hard seed cases. Their droplet-like appearance is reminiscent of tears, which were ascribed in various regions to different saints or biblical characters, including Mary, Joseph, Christ, Moses and also Job, after whom this relative of maize is still called today. The seeds have also been used in the manufacture of rosaries, giving rise to its other German name, *Paternosterkraut* (paternoster plant).

PLATES 300, 303

The clematis plants that Besler shows here on two of the most artistically beautiful plates belong to the Ranunculaceae family: *Clematis integrifolia* (300, I), *Clematis viticella* (300, II and III; 303, II

and III in double form) and *Clematis recta* (303, I). Most of today's hybridised varieties are climbing lianas and are therefore most suitable for training over walls, into trees or similar supports. The latex produced by some species is extremely irritating to the skin and led to its German name *Bettlerblume* (beggar's flower), because beggars were alleged to use it to produce the skin rashes that made people feel sorry for them.

PLATES 301, 302

The common morning glory (301, II), *Pharbitis nil* (301, III), the wild morning glory (302, I) and the sea bindweed (302, III), which belong to two different genera of the Convolvulaceae family, are also interesting climbing plants from a horticultural point of view. The sweet potato is closely related to bindweed. It originates from South America, but is now found throughout the Tropics, where it is an important food for people and animals alike.

Another member of the Convolvulaceae family included in the *Hortus Eystettensis* is *Cynanchum acutum* (302, II), although it has much smaller flowers. It occurs on

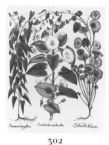

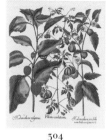

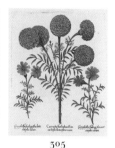

302

304

305

306

salty soils in the Mediterranean region. Alongside these imposing exotic plants, the native bluebell (301, I) looks delicate and a little out of place.

PLATE 304

Cor Indum, Indian heart, was the old name for the heart pea (304, I) from America. It gets its names from the seedpod, which swells into a heart shape, and the seeds it contains.

Although at first glance the Chinese lantern (304, II) might seem to belong to the Sapindaceae family too, it is actually a member of the nightshade family. Its fruit, which is found in the "lantern" of the puffed-up calyx, is edible, hence its other name, winter cherry. The other example could be the related husk tomato (304, III), grown for its delicious fruits.

14TH ORDER OF SUMMER
PLATES 305–307

The African or French marigold (305, I–III; 306, I; 307, I and II) belongs to the Compositae family. It was introduced from America in the first half of the 16th century and is still a popular ornamental plant today. It first arrived in Spain and

then quickly spread from there to southern Europe and North Africa. When the Genoan Andrea Doria conquered Tunis in 1535 and freed the Christians held prisoner there, the plant, which was thought to be indigenous, was taken back to Europe. From then on it was thought of as an African plant, which is why Besler calls it *Tunisblume* (Tunis flower). It did not get its German name *Studentenblume* (students' flower) until the late 17th century, probably as a reference to the brightly coloured student caps and berets.

Common basil (306, II and III) makes its fourth appearance here: it features on plates 138, 234 and 235.

PLATES 308–318

Linnaeus' name for the carnation (308, I–III; 309, I–III; 310, I; 311, I; 312, I; 313, I; 314, I–III; 315, I–III; 316, I–III; 317, I; 318, I–III), various species of which are now shown in the *Hortus Eystettensis*, was *Dianthus*, flower of the gods. This extensive genus occurs almost throughout Europe and the Far East and was familiar to Classical botanists. According to Ovid, the plant came into being when, after an unsuccessful hunt, the goddess Diana

307 308 309 310

came across a herdsman contentedly playing on his oboe-like shawm. Holding him responsible for frightening away her quarry, in a burning rage she tore out and threw away both his eyes. When she regained her composure, she was filled with remorse and turned the eyes into brilliant carnations. The French name for carnation, œillet (little eye), is a reminder of this legend even to this day.

A second legend provides an explanation for the relatively late appearance of the carnation in our gardens. According to this story, *Dianthus caryophyllus* was not discovered until the 7th Crusade of the French King Louis IX during the siege of Tunis. His army had been struck down by an epidemic and he was looking for a plant to cure them. He allegedly found this in the carnation. However, any such help came too late for Louis himself, and he died before the siege was over, on 25th August 1270. His army, however, returned home with the new plant, which soon became established in gardens and was intensively crossed with other species. In the 15th and 16th centuries, the cultivated carnation spread generally throughout Europe, but the florists' carnations, of which there are now numerous varieties, did not arise until the 19th century. The German name for the carnation, *Nelke*, was taken from the German for clove, *Gewürznelke*, to which it is not at all related in botanical terms, but which also exudes an intensely aromatic fragrance. The nail shape of its buds also gave it the German common name *Näglein* (little nail).

The proliferous pink (317, II) is native to central and western Europe, but is found only rarely on dry, sandy soils. Its narrow leaves and purple flowers make lavender (310, II and III) a popular ornamental plant, while its essential oil makes it a well-known aromatic herb. The small flowers are packed in little bags to add a pleasant fragrance to washing or for use as a soothing pillow. The essential oil, which is obtained by means of steam distillation, is much used in the perfume industry and is also used in medications. Two more species are shown on plate 347. Thyme has justifiably long been known not only as a medicinal plant, but also as a popular culinary herb. The thyme shown in the illustration here, however, is not the form used for medicinal purposes (cf. plate 345), but the mastic thyme (311, II)

 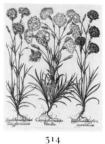

311 312 313 314

found in the Mediterranean region, which Besler calls *Amberkraut* (ambergris plant) because of its aromatic scent.

Although the scientific name, *Santolina*, for lavender cotton (311, III) is derived from a geographical term, when this name was Germanised, it was mistakenly understood to be from the Latin *sanctus* (holy), and the plant was then given the name *Heiligenkraut* (holy plant). However, it retained its older German name, *Zypressenkraut* (cypress plant), which refers to its similar habit. In the past, the dried flowers were used medicinally as a vermifuge.

Arnica (312, II) became very important as a valuable medicinal plant for external use. Goethe regularly drank arnica tea as a cardiac tonic, although internal use is no longer advisable because of potentially strong side effects. The tincture, on the other hand, an alcoholic extract from the flowers, is very good for sprains, bruises, contusions and effusions for compresses or as an additive to embrocations. As arnica is an environmentally protected species, collection from the wild is now illegal.

The round-leaved sundew (312, III), another medicinal plant, is a carnivorous one indigenous to Germany. Its leaves have long, gland-tipped hairs, with drops of liquid at the end. When an insect lands on a leaf, the hairs bend, holding it as if in a trap. Secretions break the creature down, producing nutrients that the plant then absorbs. Sundew extract was proven to be effective in the treatment of whooping cough, but sundew is now a protected species, so it is no longer readily available.

The large self-heal (317, III) is a second representative of this genus, which is widespread across central Europe (cf. 135, II).

The name of the dyer's chamomile (317, IV) is a clear indication of its former use. It was, however, not only used to dye textiles but, as Bock reports, also as a starch, which simultaneously dyed linen the desired saffron colour.

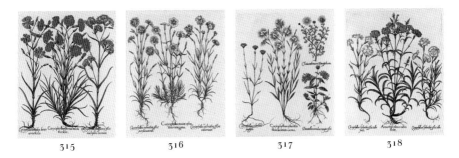

315 316 317 318

PLANTARVM

HORTI EYSTÆT,
TENSIS.

Claſſis Autumnalis.

AUTUMN

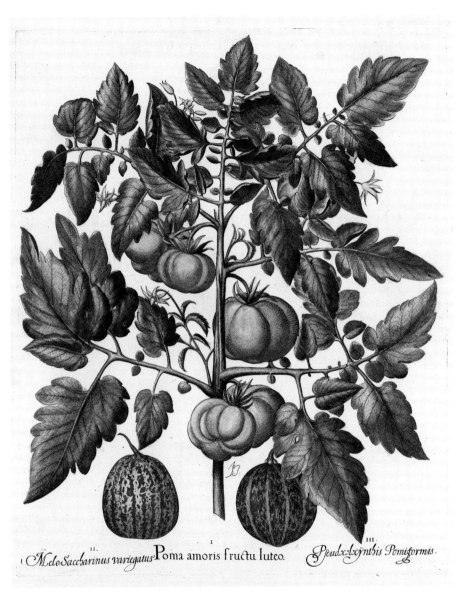

ı. *MeloSaccharinus variegatus* Poma amoris fructu luteo. *Pseudolycinthis Pomiformis.*

CUCUMIS MELO
Melon

LYCOPERSICON SPEC.
*Tomato with
orange-coloured fruits*

CITRULLUS LANATUS
Water melon

Plate 319 447

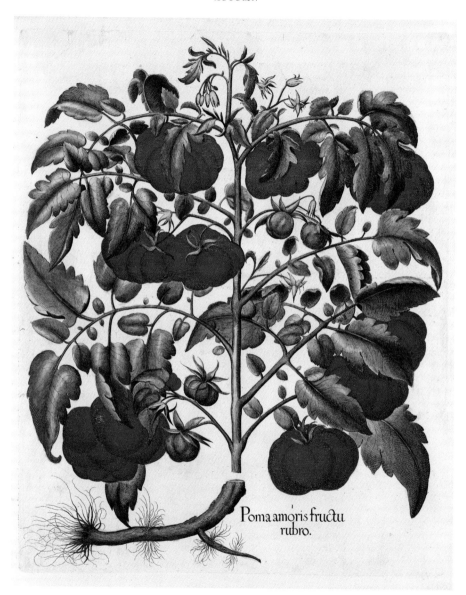

Poma amoris fructu
rubro.

LYCOPERSICON ESCULENTUM
Tomato, Love apple

Plate 320

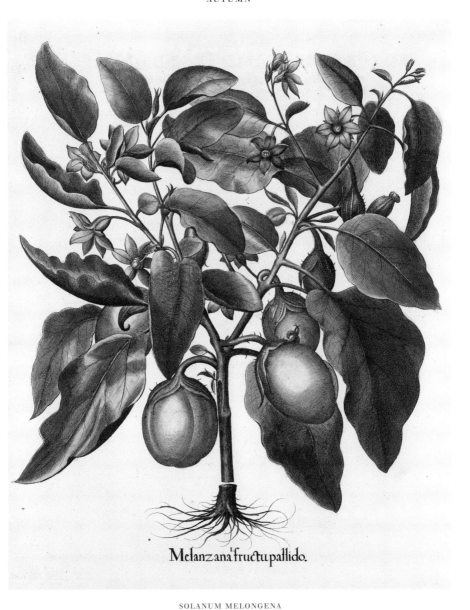

Melanzana¹fructupallido.

SOLANUM MELONGENA
Eggplant, Aubergine

Plate 321

449

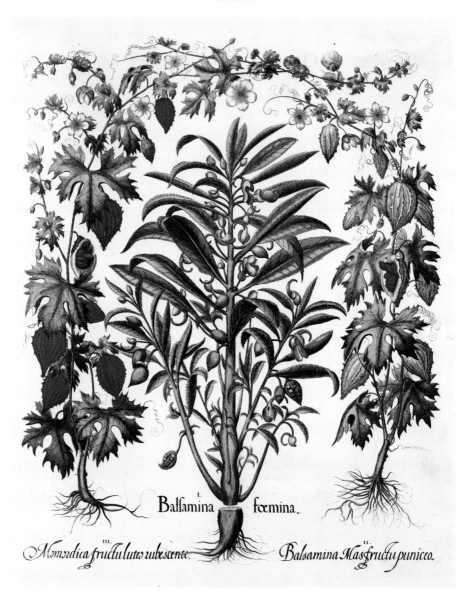

Balsamina foemina.

Momordica fructu luteo rubescente.　　　*Balsamina Mas fructu puniceo.*

MOMORDICA BALSAMINA　　　IMPATIENS BALSAMINA　　　MOMORDICA BALSAMINA
Balsam apple　　　*Garden balsam, Rose balsam*　　　*Balsam apple*

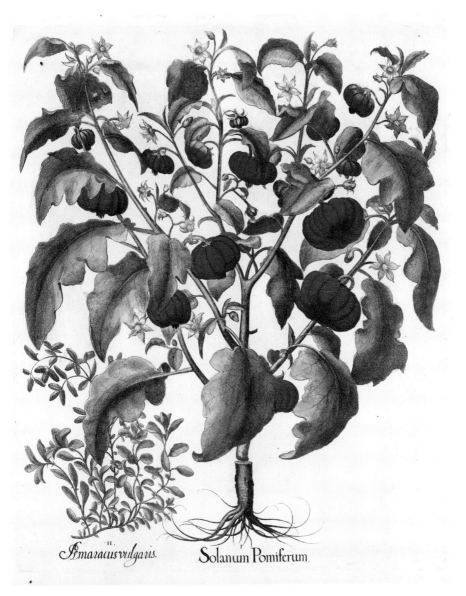

II.
Amaracus vulgaris. Solanum Pomiferum.

ORIGANUM MAJORANA SOLANUM MACROCARPON
Marjoram, Oregano *Nightshade*

Plate 323 451

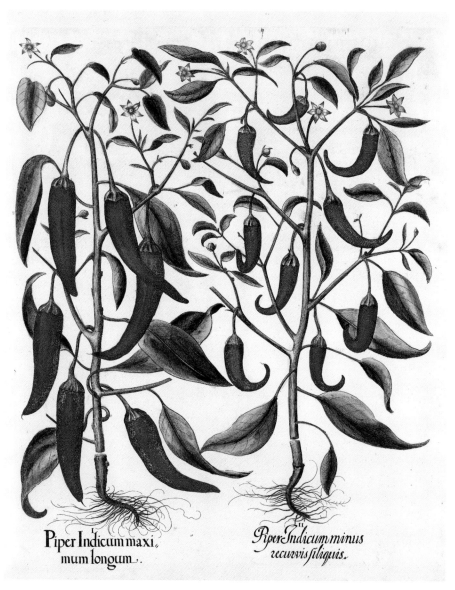

Piper Indicum maxi,
mum longum.

Piper Indicum minus
recurvis siliquis.

CAPSICUM SPEC.
Chilli pepper

Plate 324

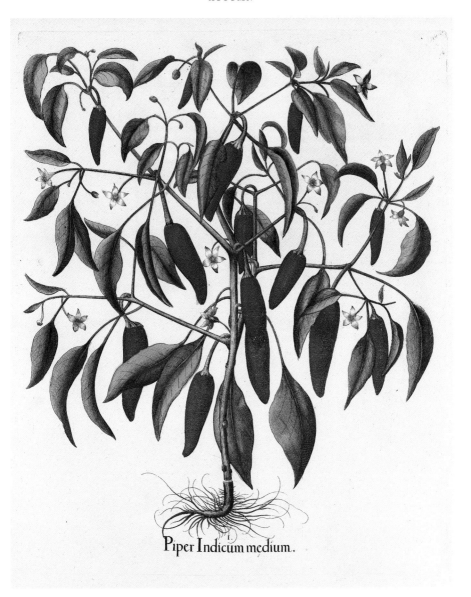

Piper Indicum medium.

CAPSICUM SPEC.
Chilli pepper

Plate 325

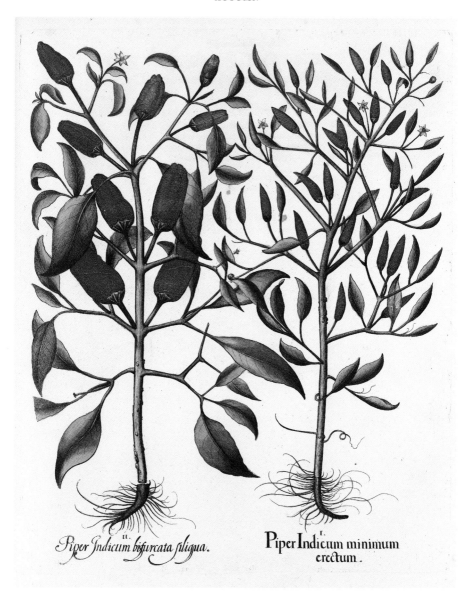

Piper Indicum bifurcata siliqua.

Piper Indicum minimum erectum.

CAPSICUM SPEC.
Chilli pepper

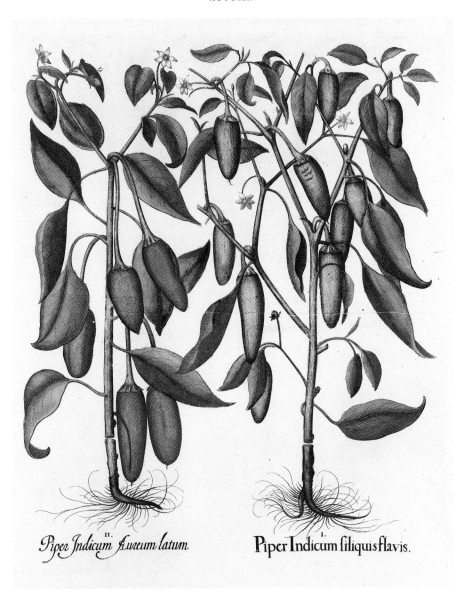

Piper Indicum Aureum latum. **Piper Indicum filiquis flavis.**

CAPSICUM SPEC.
Chilli pepper

Plate 327 455

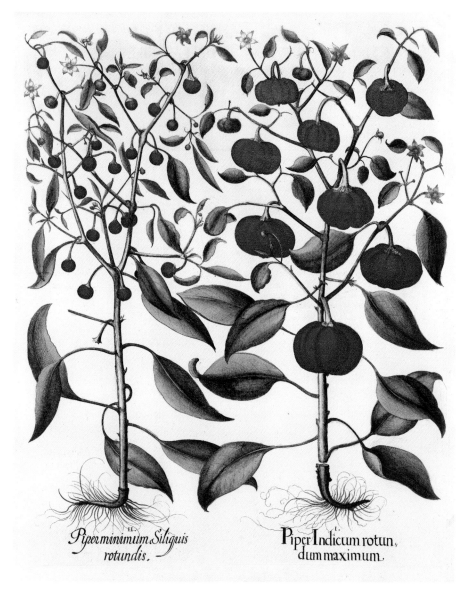

Piper minimum Siliquis rotundis.

Piper Indicum rotundum maximum.

CAPSICUM SPEC.
Chilli pepper

Plate 328

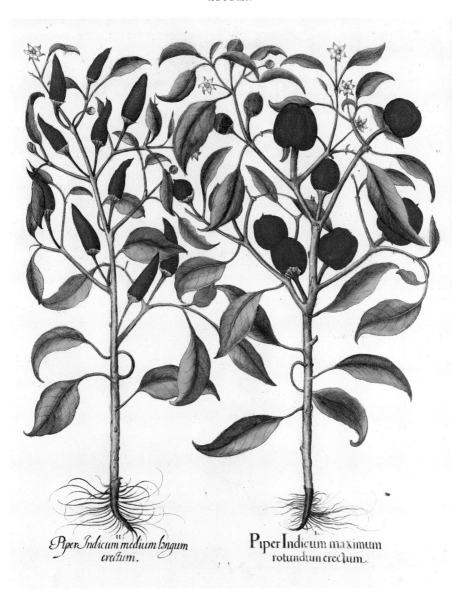

Piper Indicum medium longum
erectum.

Piper Indicum maximum
rotundum erectum.

CAPSICUM SPEC.
Chilli pepper

Plate 329

457

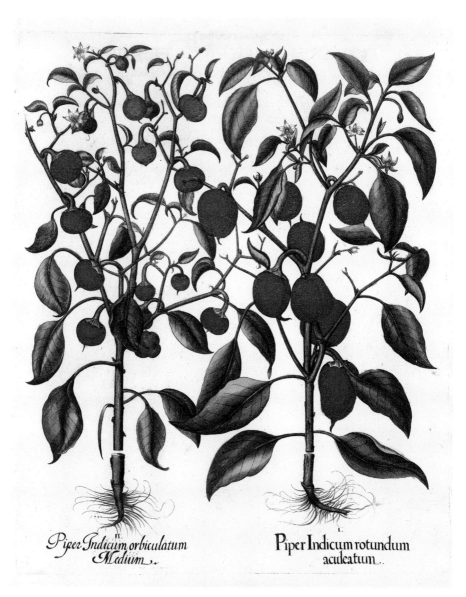

Piper Indicum orbiculatum Medium.

Piper Indicum rotundum aculeatum.

CAPSICUM SPEC.
Chilli pepper

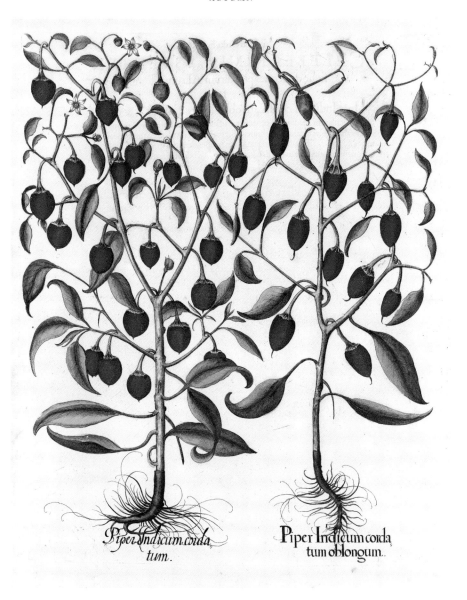

Piper Indicum corda
tum.

Piper Indicum corda
tum oblongum.

CAPSICUM SPEC.
Chilli pepper

Plate 331

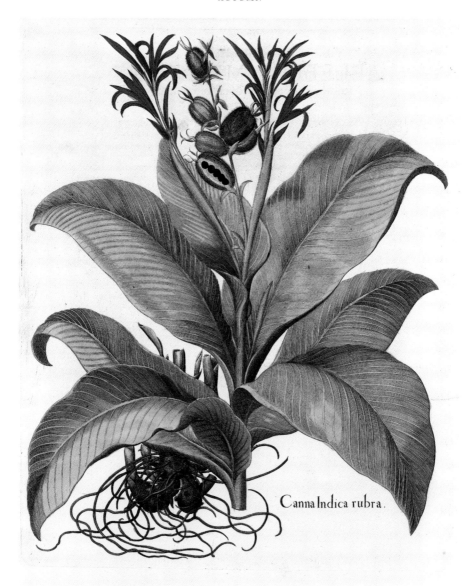

Canna Indica rubra.

CANNA INDICA
Red Indian shot

Plate 332

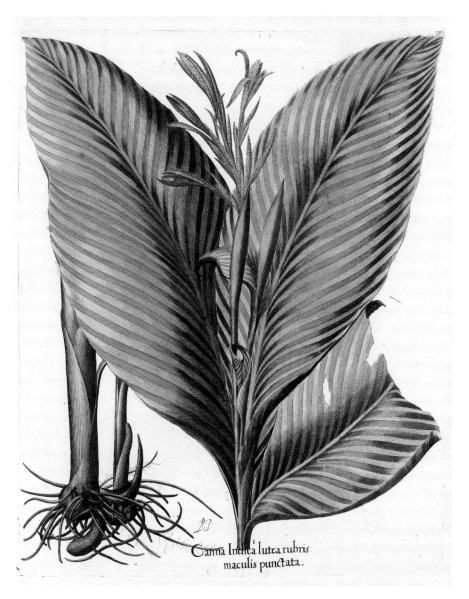

Canna Indica lutea rubris
maculis punctata.

CANNA INDICA
Yellow Indian shot

Plate 333 461

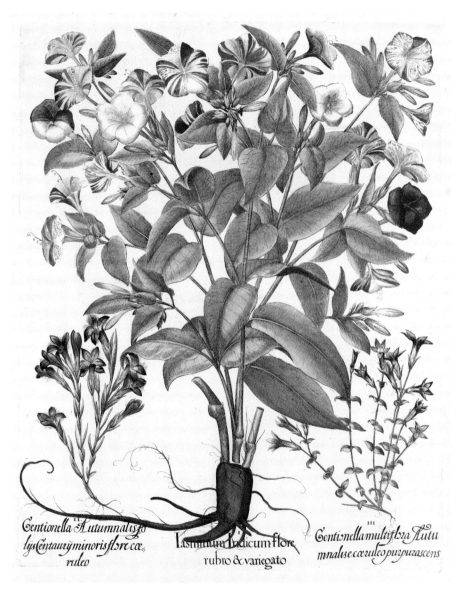

Gentionella Autumnalis
lys centaurij minoris flore cœ
ruleo

Iasminum Indicum flore
rubro & variegato

Gentianella multiflora Autu
mnalis e cœruleo purpurascens

GENTIANELLA CILIATA
Fringed gentian

MIRABILIS JALAPA
Marvel of Peru,
Four-o'clock flower

GENTIANA GERMANICA
Chiltern gentian

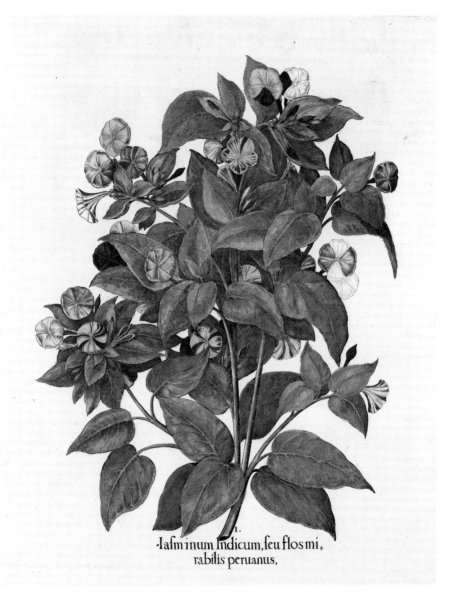

1.
-Iafminum Indicum,feu flos mi,
rabilis peruanus,

MIRABILIS JALAPA
Marvel of Peru, Four-o'clock flower

Plate 335 463

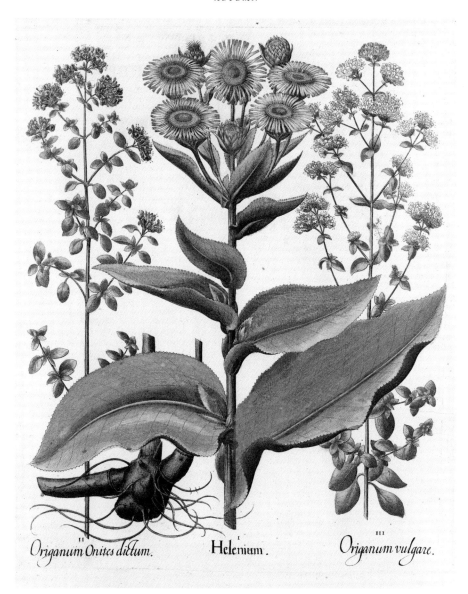

Origanum Onites dictum. Helenium. Origanum vulgare.

ORIGANUM VULGARE, II.–III. INULA HELENIUM
Wild marjoram, Oregano *Elecampane*

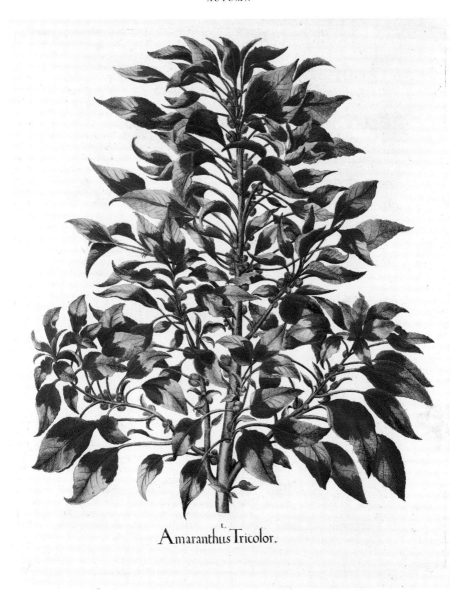

Amaranthus Tricolor.

AMARANTHUS TRICOLOR
Tampala, Chinese spinach

Plate 337 465

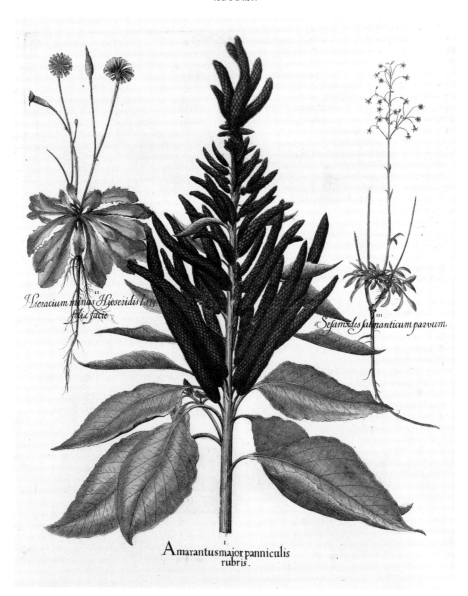

Hieracium minus Hioseridis latt folia facie

Sesamoides salmanticum parvum

I.
Amarantus major panniculis rubris.

CREPIS TECTORUM
Hawk's-beard

AMARANTHUS PANICULATUS
*Purple amaranth,
Red amaranth, Prince's feather*

SILENE OTITES
Spanish catchfly

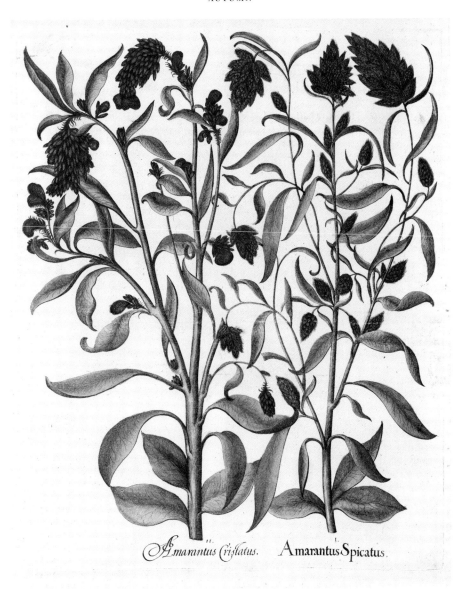

Amarantus Cristatus. *Amarantus Spicatus.*

CELOSIA ARGENTEA
Cockscomb

Plate 339 467

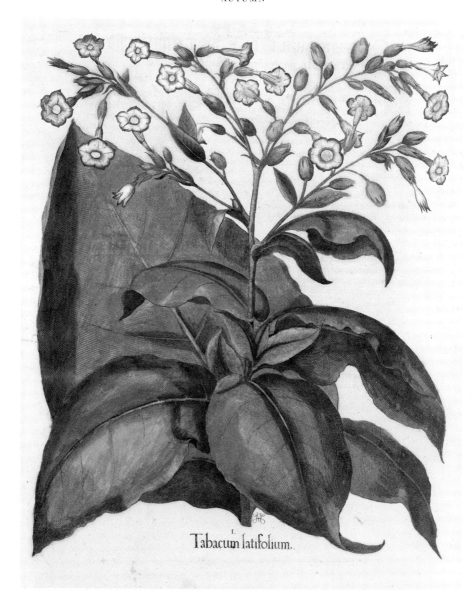

Tabacum latifolium.

NICOTIANA LATISSIMA
Tobacco

Plate 340

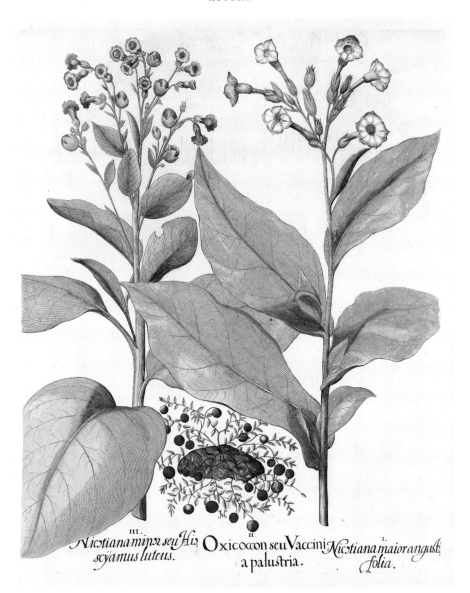

III.
*Nicotiana minor seu Hio-
scyamus luteus.*

II.
*Oxicoccon seu Vaccini-
a palustria.*

I.
*Nicotiana maior angusti-
folia.*

NICOTIANA RUSTICA
Tobacco, Wild tobacco

VACCINIUM OCYCOCCOS
*European cranberry,
Small cranberry*

NICOTIANA TABACUM
Tobacco, Common tobacco

Plate 341

469

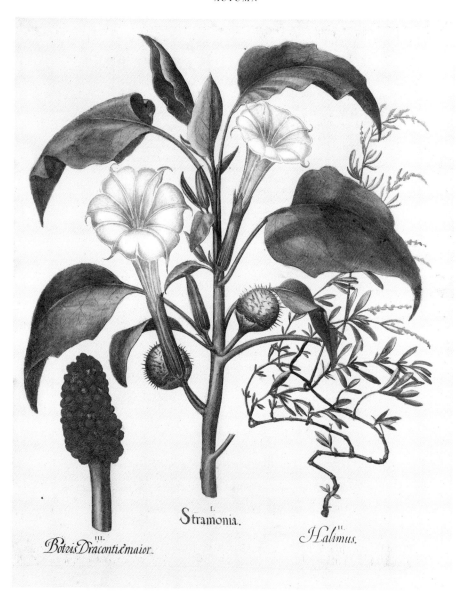

III.
Botris Draconti&maior.

I.
Stramonia.

II.
Halimus.

ARUM MACULATUM

Lords-and-ladies,
Cuckoo pint, Jack-in-the-pulpit

DATURA METEL

Horn of plenty,
Downy thorn apple

HALIMIONE PORTULACOIDES

Sea purslane

Plate 342

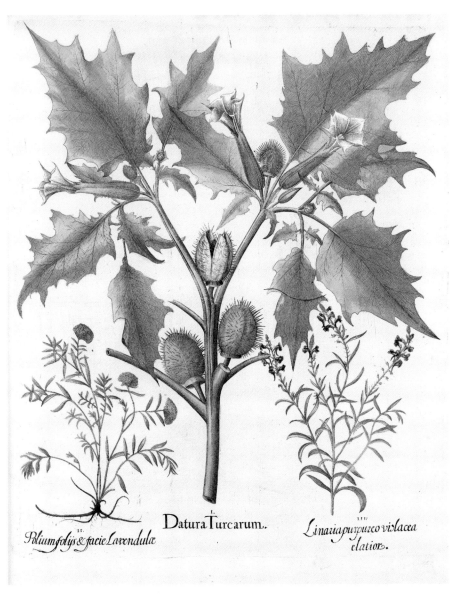

Polium folijs & facie Lavendulæ

Datura Turcarum.

Linaria purpureo violacea
elatior.

TEUCRIUM SPEC.
Germander, Wood sage

DATURA STRAMONIUM
*Jimson weed, Jamestown weed,
Common thorn apple*

LINARIA PURPUREA
Toadflax

Plate 343 471

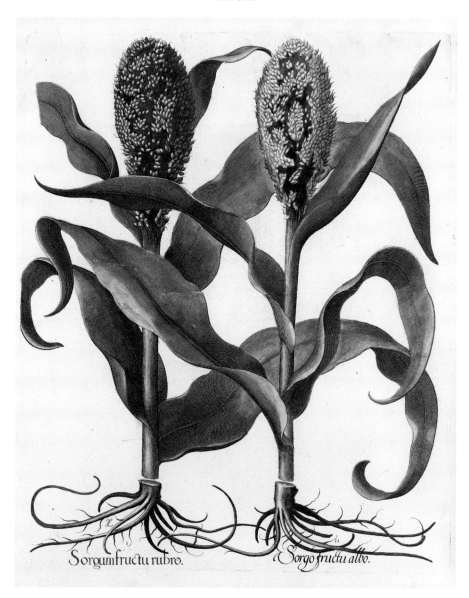

Sorgumfructu rubro. Sorgo fructu albo.

SORGHUM BICOLOR
Sorghum, Great millet, Kafir corn

Plate 344

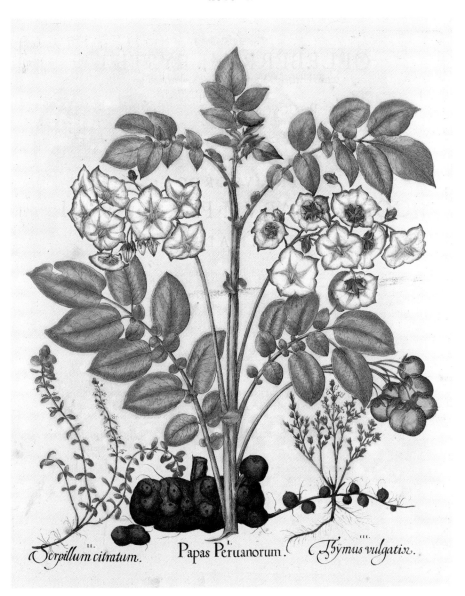

Serpillum citratum. Papas Peruanorum. *Thymus vulgatis.*

THYMUS PULEGIOIDES
Broad-leaved thyme, Large thyme

SOLANUM TUBEROSUM
Potato

THYMUS VULGARIS
Common thyme

Plate 345 473

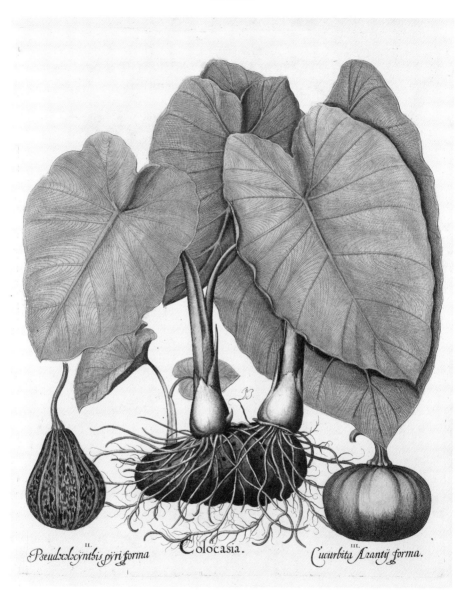

Pseudocolocynthis pyri forma **II.** *Colocasia.* *Cucurbita Arantij forma.* **III.**

LAGENARIA SPEC.

White-flowered gourd,
Calabash gourd, Bottle gourd

COLOCASIA ESCULENTA

Cocoyam, Taro, Dasheen

CUCURBITA PEPO

Pumpkin, Squash,
Marrow, Courgette, Zucchini

474 *Plate 346*

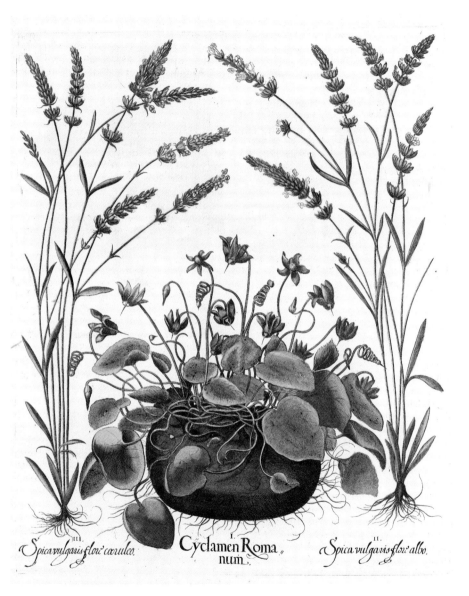

Spica vulgaris flor: cœruleo.
III.

Cyclamen Romanum.
I.

Spica vulgaris flor: albo.
II.

LAVANDULA LATIFOLIA, II.–III.
Spike lavender

CYCLAMEN HEDERIFOLIUM
Sowbread

Plate 347

475

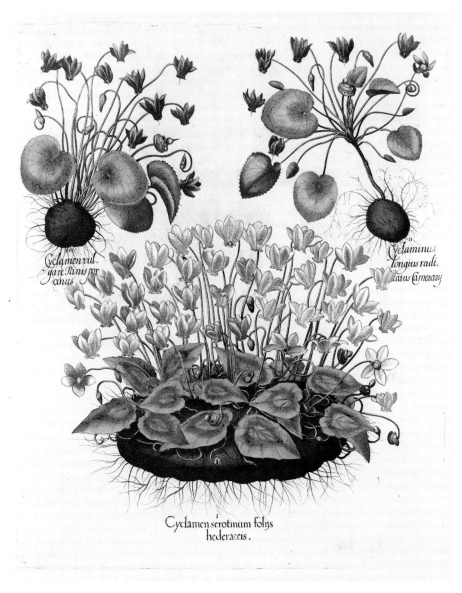

Cyclamen vul-
gare Panis por
cinus

Cyclaminus
longius radi.
latus Cameraxij

Cyclamen serotinum folijs
hederaceis.

CYCLAMEN
PURPURASCENS, II.–III.

Sowbread

CYCLAMEN
HEDERIFOLIUM

Sowbread

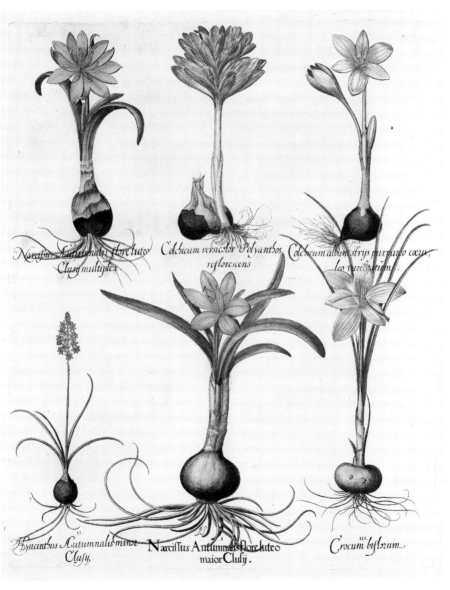

Narcissus Autumnalis flore luteo Clusy multiplex.

Colchicum versicolor Polyanthos reflorescens

Colchicum album strijs purpureo coeru, leo variegatum.

Hyacinthus Autumnalis minor Clusy,

Narcissus Autumnalis flore luteo maior Clusij.

Crocum biflorum

STERNBERGIA LUTEA, I., VI.	SCILLA AUTUMNALIS	COLCHICUM AUTUMNALE	COLCHICUM AUTUMNALE	CROCUS SATIVUS
Autumn daffodil	*Autumn squill*	*Double meadow saffron*	*Meadow saffron*	*Saffron*

Plate 349

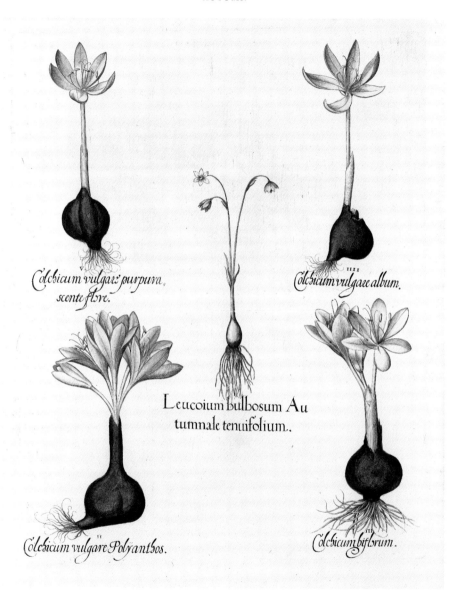

Colchicum vulgare purpura, scente flore.

Colchicum vulgaee album.

Leucoium bulbosum Au tumnale tenuifolium.

Colchicum vulgare Polyanthos.

Colchicum biflorum.

COLCHICUM
AUTUMNALE, II. – V.
Meadow saffron

LEUCOJUM
AUTUMNALE
Autumn snowflake

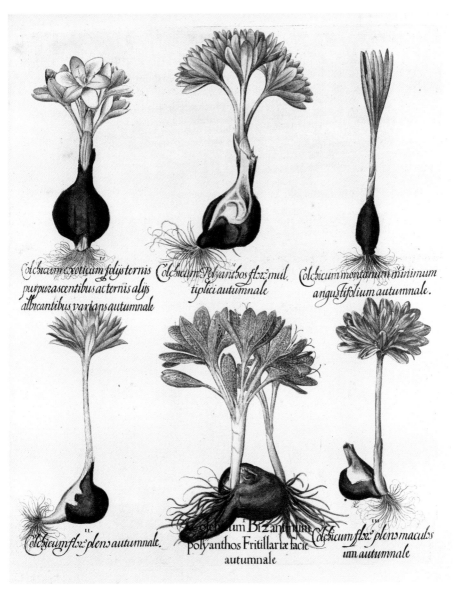

Colchicum exoticum folijs ternis purpurascentibus a ternis alijs albicantibus varians autumnale.

Colchicum Polyanthos flor. multiplici autumnale.

Colchicum montanum minimum angustifolium autumnale.

Colchicum flor. plens autumnale.

Colchicum Bizantinum polyanthos Fritillariæ facie autumnale

Colchicum flor. plens maculosum autumnale

COLCHICUM SPEC.

Autumn crocus with bi-coloured flowers, Naked ladies

COLCHICUM SPEC., II., V.

Double autumn crocus, Naked ladies

COLCHICUM SPEC.

Autumn crocus, Naked ladies

COLCHICUM SPEC.

Autumn crocus, Naked ladies

COLCHICUM SPEC.

Autumn crocus, Naked ladies with striped flowers

Plate 351 479

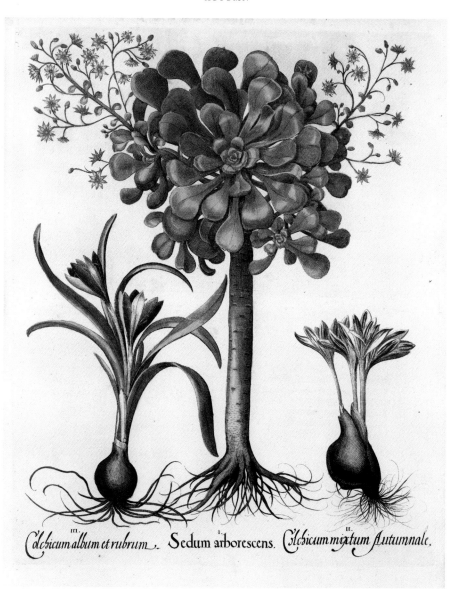

Colchicum album et rubrum. *Sedum arborescens.* *Colchicum mixtum Autumnale.*

<table>
<tr><td>COLCHICUM
SPEC.

*Bi-coloured autumn
crocus in leaf, Naked ladies*</td><td>AEONIUM
ARBOREUM

Houseleek</td><td>COLCHICUM
SPEC.

*Autumn crocus, Naked ladies
with striped leaves*</td></tr>
</table>

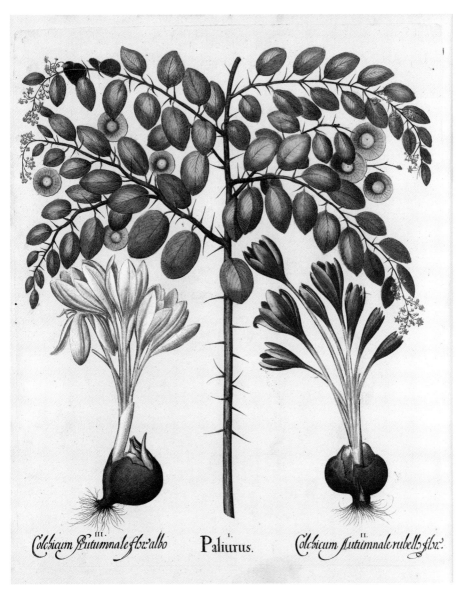

Colchicum Autumnale flx albo Paliurus. Colchicum Autumnale rubells flx

COLCHICUM SPEC.,
II.–III.

*Autumn crocus, Naked ladies
with several flowers*

PALIURUS SPINA-
CHRISTI

Christ's thorn

Plate 353 481

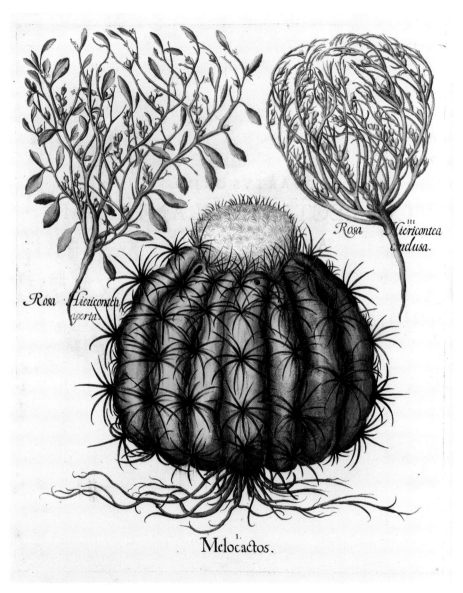

Rosa Hiericontca inclusa.

Rosa Hiericontca aperta.

I.
Melocactos.

ANASTATICA HIEROCHUNTICA

*Rose of Jericho,
Resurrection plant (opened)*

MELOCACTUS INTORTUS

Turk's cap cactus

ANASTATICA HIEROCHUNTICA

*Rose of Jericho,
Resurrection plant (closed)*

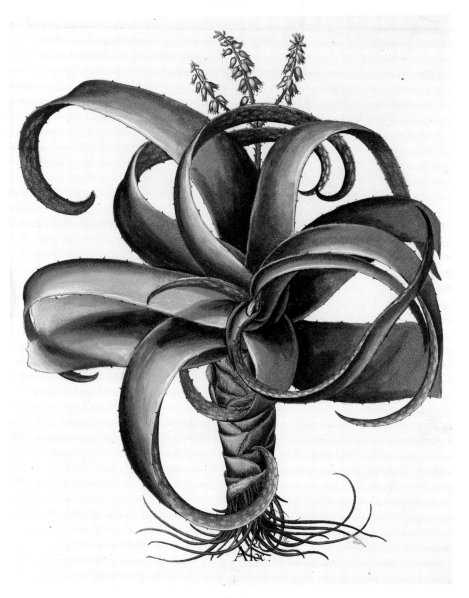

ALOË VERA
Barbados aloe, Curaçao aloe

Plate 355 483

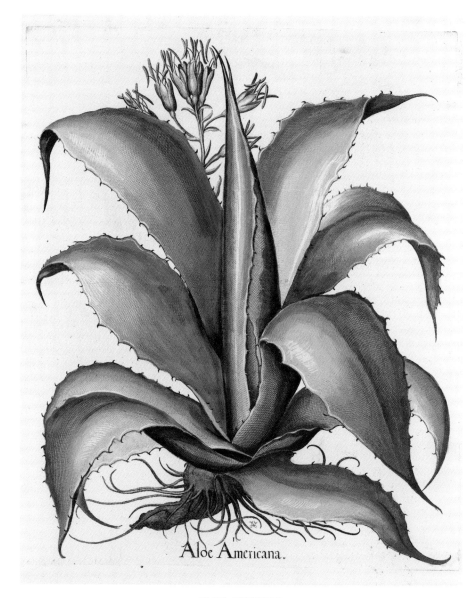

Aloe Americana.

AGAVE AMERICANA
Century plant

Plate 356

Fructus Artiſochi.

CYNARA SCOLYMUS
Globe artichoke

Plate 357 485

Cinara Genuensium. *Cinara maior Boloni,* *Cinara seu Artischochi vul*
II. I *ensis* III *gatin.*

CYNARA SCOLYMUS
Globe artichoke

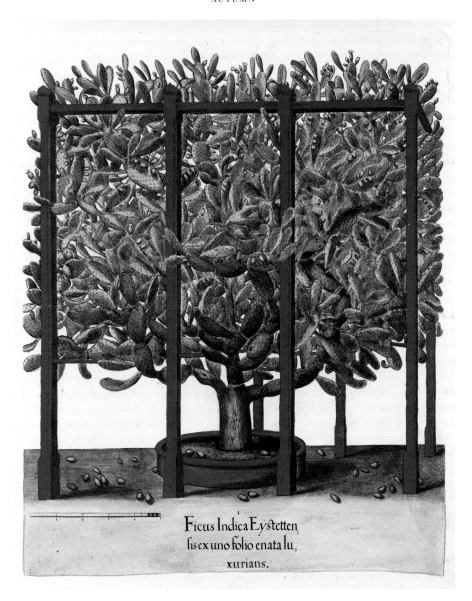

Ficus Indica Eyſtetten,
ſis ex uno folio enata lu,
xurians.

OPUNTIA FICUS-INDICA
Indian fig, Prickly pear

Plate 359 487

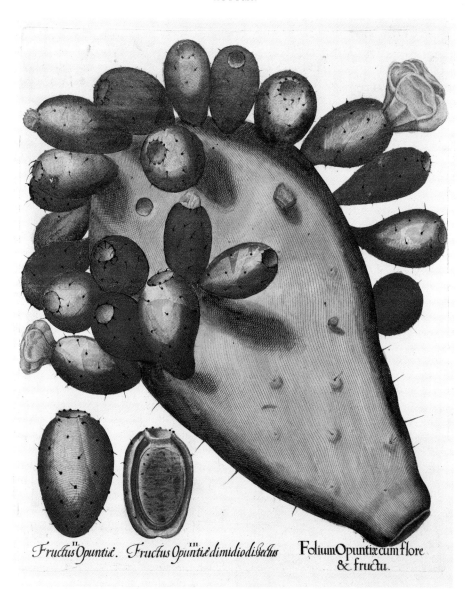

Fructus Opuntiæ. Fructus Opuntiæ dimidio diſſectus Folium Opuntiæ cum flore
& fructu.

OPUNTIA FICUS-INDICA
Indian fig, Prickly pear
(stem segment and fruits)

319

320

1ˢᵀ ORDER OF AUTUMN
PLATES 319, 320

The plates of the first order of autumn illustrate plants that are now more commonly found in vegetable, rather than ornamental gardens. In Besler's day, however, they were still exotic rarities to be marvelled at and proudly displayed not least because of their beautifully coloured fruits.

The tomato (319, I; 320, I) comes from South and Central America. It belongs to the nightshade family and came to Europe early in the 16ᵗʰ century. The Eichstätt garden had two forms with different-coloured fruits. The "love apples", however, are much larger and lumpier than the round fruits grown today, which have been bred only recently. The word "tomato" is derived from the Mexican *tomatl*, meaning swollen berry. In Italy, where some tomatoes came from North Africa, they called the fruit *pomo dei mori*, Moors' apple, which over time became *pomo d'oro* (golden apple) and referred to the yellow-fruited form. In France, on the other hand, *pomo dei mori* became *pomme d'amour*, which

then became *Liebesapfel* in German and love apple in English, particularly as the tomato was said to have aphrodisiac properties. Apart from that, its consumption was restricted to salads, and its distinctive and unpleasant smell led to the belief that it was poisonous when taken in large quantities. At the beginning of the 19ᵗʰ century, the tomato went from Europe to North America.

The melon (319, II), a member of the gourd family closely related to the cucumber, probably originates from Asia or Africa, but became indigenous to the Mediterranean region very early on. Its deliciously sweet flesh is very refreshing and its seeds used to be processed to make medications for kidney and bladder complaints. The Cantaloupe melon is the commonest type sold today, although its surface is not smooth, as shown in the *Hortus Eystettensis*, but covered with rough threads of cork. The water melon (319, III) belongs to a different genus and is very popular for the high water content of its red flesh. As Besler expressly calls it *Falsche Colocynthöpffel*, it cannot be the closely related colocynth or bitter apple

321 322 323 324

which was used in the past as a drastic purgative, and which would therefore have been familiar to the apothecary in his professional capacity.

PLATE 321

India may be the home of the aubergine (321, I), another vegetable-producing member of the nightshade family. This plant, which was unknown in Classical times, was probably introduced to the Mediterranean region by the Arabs. Despite being mentioned as early as the Middle Ages, in Europe it has remained an exotic ornamental plant since the 16th century. Its fruits were originally the size of an egg, hence its other name, eggplant. In German, it is also called *Tollapfel* (mad apple), as it was thought to be poisonous. It is only in the last few decades that the striking purple aubergine, which has been bred to achieve optimum growth,has played any significant role in European cooking.

PLATE 322

At first glance, anyone could be forgiven for thinking this was another tomato, but, according to Aymonin, the text and the German name *Tollapfel aus Mohrenland* (mad apple from the land of the Moors) prove that it is *Solanum macrocarpon* (322, I), a tropical member of the nightshade family.

Marjoram (322, II), has already been illustrated on plate 147, under its then more usual name *Majorana*, whereas here it appears under the name of *Amaracus*, referring back to the myth of how it came into being.

PLATE 323

Weibliche Balsamine (female garden balsam) is the name used in the *Hortus Eystettensis* for the garden balsam (323, I), which has already been discussed on plate 208. The accompanying male plant is shown right next to it, making a decorative arch out of two different-coloured plants in fruit. Although early botanists thought these were two different sexes of the same plant, they are not actually related. What was thought to be the male

325 326 327 328

garden balsam is in fact the edible balsam apple (323, II and III), a member of the gourd family, while the garden balsam belongs to the Balsaminaceae family. The two exotic plants were considered to belong together because of their scent, which is definitely balsamic, and were sub-divided into delicate female and strong male types according to size and their more or less robust habit. The significance of plant sexuality was not fully understood at the beginning of the 17th century.

PLATES 324–331

Today, the chilli pepper (324, I and II; 325, I; 326, I and II; 327, I and II; 328, I and II; 329, I and II; 330, I and II; 331, I and II), another member of the nightshade family, is so familiar that it is very easy to forget its American origin. What was known as the "Indian pepper" actually reached the Old World very quickly and was in cultivation there from as early as the middle of the 16th century, but was thought of almost exclusively only as an ornamental plant. The chilli pepper came via Spain to Greece, the Balkans and Turkey. Hungary, whose cuisine automatically springs to mind in connection with peppers and the paprika made from them, probably discovered it through the Turks. It did not become established as a spice in Germany until the late 19th and early 20th century, and did not become a market vegetable until after the Second World War. Albert Szent-György, the Hungarian biochemist, isolated ascorbic acid from the pepper in such quantities that in 1933 he was able to establish its chemical structure. Its medicinal use is nothing new, however, for it was taken as a diuretic and carminative and to stimulate digestion. It was also used externally in the form of ointments and poultices and was said to help treat skin blemishes. Today, its active ingredient is still used in some ointments for rheumatism. The strikingly attractive fruits with their startlingly hot taste also became religious symbols. Here they were seen as a warning against conspicuous consumption, which inevitably led to the soul being burnt in hell.

329 330 331 332

2ND ORDER OF AUTUMN
PLATES 332, 333

Canna (332; 333), also known as Indian shot and shown here in two different colours, presents another "American". The red-flowered plant (332, I) is illustrated in fruit and already bears the characteristic thorny capsules. For a long time, the starch-rich rhizome of a close relative, *Canna edulis*, was an important food source. Indian shot first reached European gardens in the second half of the 16th century, and its imposing height and bright colours have guaranteed its popularity as a focal point ever since.

PLATES 334, 335

The striking feature of the fringed gentian (334, II), which gives it its unmistakable appearance, is the delicate ciliate margins of its petals. Like the Chiltern gentian (334, III), which has reddish purple flowers instead of blue, it occurs in chalky alpine meadows at altitudes of over 2,000 metres.

The sole representative of the Nyctaginaceae family, almost all of which are native to America, illustrated in the *Hortus Eystettensis* is the marvel of Peru (334, I; 335, I). It was considered to be a marvel because flowers of different colours can be found together on one and the same plant. They do not open until the afternoon, but then stay open throughout the night, not closing again until the morning, which is why, in many languages, it is called the four-o'clock plant.

The plant came to Europe from Mexico and Peru at the end of the 16th century, and its striking flower colours aroused great interest among gardeners. In the 18th century, the name *Schweizerhose* (Swiss hose) became established, as the two-tone striped flowers brought to mind the multi-coloured slit hosiery of the Swiss mercenary, still seen today in the uniform of the Vatican Swiss Guard. An extract used to be obtained from the root of the marvel of Peru and was an ingredient of strong purgatives.

333 334 335 336

Plate 336

The bright yellow flowers of the ele-campane (336, I), a composite plant that grows to an imposing height, make it a popular garden plant. However, it used to be a highly valued medicinal plant as its rhizome has both expectorant and diuretic effects.

With its essential oil and bitter constituents, wild marjoram (336, II and III), which is widespread in Germany, has long been used as a herb. It is closely related to marjoram and is a popular herb, especially in Italian cooking, where it is called oregano.

Plates 337, 338

The tampala (337, I) originates from the tropical regions of Asia and is impressive not for its inconspicuous flowers but for its striking leaf colour, which is why Besler and many others called it *Papageifeder* (parrot's feather). The leaves inspired Hieronymus Bock, who knew the plant from the garden of the Nuremberg apothecary Georg Öllinger, to coin the new name of *Widerschein* (reflection). In contrast, the erect red spikes are a characteristic feature of the prince's feather (338, I). This attractive ornamental plant originates from America and was cultivated from very early on in Germany, whereas the tampala was not known until around the middle of the 16th century at the very earliest. *Amaranthus* means everlasting, although unfortunately this is not absolutely true of this very robust plant.

Aymonin identified the yellow-flowered plant that accompanies the Spanish catchfly (338, III), so-called because of its sticky leaves, and the prince's feather as being the narrow-leaved Hawk's-beard (338, II).

Plate 339

The cockscomb (339, I and II) is a close relative of the prince's feather, even though it is now classified under the genus *Celosia*. It gets its name from the appearance of its red flowers. In German, it is also called *Brandschopf* (fire crest) for the same reason.

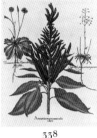
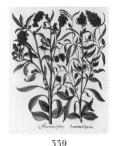
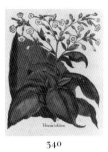

337 338 339 340

PLATES 340, 341

Tobacco (340, I), common tobacco (341, I) and wild tobacco (341, III) introduce three American plants that, as a luxury item, have played and continue to play a major role, despite the associated health risks. On his first contact with the New World, Columbus saw the natives of the island of Guanahani "drinking" tobacco smoke, i.e. smoking tobacco, which could also be taken as snuff or chewed. Tobacco seed reached Europe around 1520, but was evidently not cultivated to any extent worth mentioning. There are no reports of flowering garden examples until the 1560s. Following the example of Jean Nicot, the envoy from the French court, the practice of snuffing tobacco spread extremely rapidly in Europe. In the English court, however, people preferred to smoke the dried leaves, following the example of Walter Raleigh. There is evidence that tobacco was smoked in Germany too from the beginning of the 17th century. Tobacco has been in cultivation in Franconia since about 1630, and began in Thüringen, Baden and Alsace thirty years later. Medicine also

adopted the exotic plant, which came to be called *Heil aller Welt* (cure the world) because of the outstanding effects attributed to it when used internally and externally. However, this name has also been applied to many other plants.

The European cranberry (341, II) is one of four cranberry species belonging to the Ericaceae family that are indigenous to Germany. With its creeping stems, it grows on the moss cushion of boggy areas. In autumn it bears large, round, sour-tasting red fruits, which, like American cranberries, were used in the past to treat diarrhoea.

PLATES 342, 343

The thorn apple (342, I; 343, I) gets its name from the shape of its thorny fruit, although its beautiful trumpet-shaped flowers are rather more striking and gave it its other English common name, horn of plenty, and its German popular name *Engelstrompete* (angel's trumpet). The common thorn apple (343, I) in particular has naturalised to such an extent in Germany that its American origins and the fact that it can be proved to have been

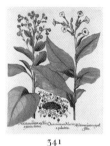
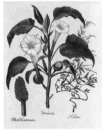
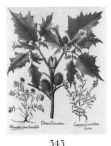

341 342 343 344

a garden plant only since 1584 come as a big surprise.

Like the henbane (cf. 245, I and II), this extremely poisonous nightshade plant attained notoriety as an ingredient in so-called witches' ointments and love potions. In medicine, the leaves were processed to make asthma cigarettes, among other things. Nowadays, only the isolated and standardised constituents are used. The large-flowered species, such as *Datura metel* (342, I) for example, are popular ornamental plants, even though the fact that they are poisonous means they are not without their problems.

The isolated fruit of the cuckoo pint (342, III; cf. plates 33, I and II) suddenly makes an unheralded appearance. The sea purslane (342, II) shown here is equally unexpected, as it is a typical inhabitant of coastal areas.

A germander (343, II) and *Linaria purpurea* (343, III) provide further examples of genera already shown on previous plates.

PLATE 344

Millet, a collective name for a series of tropical species of grain, is still an important food for humans and animals in many regions of the world. Great millet or kafir corn (344, I and II), a sweet grass, is one of the most important representatives worldwide. It originates from the equatorial regions of Africa and, having been described by Pliny as early as the 1st century AD, seems to have been in cultivation in Italy as early as the 13th century, which is why the Germans thought of it as *welsche* (Italian) millet.

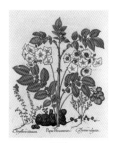

345

3RD ORDER OF AUTUMN
PLATE 345

Perhaps the most significant plant to be imported to Europe from the New World was the potato (345, I), which the Incas had long known as a food. When the Spanish conquered Peru, they too became aware of it. The first tubers reached Spain in the middle of the 16th century, where they even caused a sensation at the court of King Philip II. The rare plants were initially grown in gardens for their attractive violet flowers. Carolus Clusius was the first to make exact scientific illustrations of them, and in 1590 Caspar Bauhin gave them the botanical name *Solanum tuberosum esculentum*, as well as devising the German name *Grüblingsbaum* (pignut tree). Many other common names became established in German, including *Erdapfel* (earth apple), *Erdbirne* (earth pear), *Erdartischocke* (earth artichoke), *Erdmorcheln* (earth morel) and *Grundbirne* (ground pear). Potatoes were often referred to in literature as *Tartuffeln* or *tartufuli*, from truffles, as they are gathered in a similar way.

Although agricultural cultivation was recommended and practised to a small extent as early as the middle of the 17th century, the potato was slow to become a popular food, and only did so gradually when intensively promoted by Frederick the Great around 1770. It became more popular when selective crosses considerably increased the flavour, yield and keeping quality, and the improved three-field rotation system made it possible to have a sufficient tillage. Outside Germany, Ireland was the main place for growing potatoes. Here, in 1845 and 1848, the harvest failed almost completely because of new potato diseases. Faced with the resultant threat of starvation, many Irish were forced to emigrate to America. If people in Europe were initially unsure how to use and prepare the potato, recipes quickly became established for jacket potatoes, chips and potato salad. Potatoes were even mentioned in literature. In his "Potato Song", Matthias Claudius sings the potato's praises, even its looks, and commends its wholesomeness:

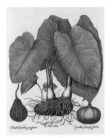

346

Potatoes are so very red
And white and smooth and good.
They're so easily digested –
For any man and wife and kid
They are a real comfort food.

Having already come across the mastic thyme (311, II), we are now presented with the common thyme (345, III) and the broad-leaved thyme (345, II), also known as large thyme. The small subshrub became established in Germany around the 11th century and has been used for its intense fragrance both as a herb and as a medicinal plant ever since. In the kitchen it is used to add flavour to game dishes, for example, whereas chemists made effective cough mixtures from thyme, as well as medicines for stomach and intestinal complaints. The phenol content of its essential oil means that preparations made from thyme also have an antiseptic effect. Many species of thyme grow in the wild and usually have a very similar effect to broad-leaved thyme.

PLATE 346

The taro or cocoyam (346, I) belongs to the arum family. It originates from southeast Asia and was in cultivation in Egypt as early as 2,000 years ago. From there, it seems to have come to Rome and thus to the Mediterranean region. In its countries of origin, the starch-rich rootstocks are eaten, but because of their high oxalic acid content, they must be cooked beforehand so that the pointed crystals are transferred to the cooking water and can thus be thrown away with it. The leaves, stems and spadix are also eaten as vegetables. Flour can be made from the dried tubers. The taro was, and still is, grown as a foliage plant for its large decorative leaves.
The two fruits have been identified as the bottle gourd (346, II) and the pumpkin (346, III), which were grown not least for their size.

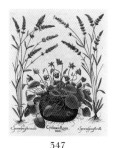 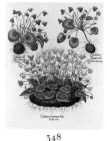 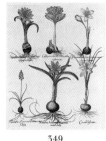 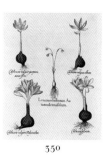

347 348 349 350

PLATES 347, 348

The exotic flowers of the cyclamen have ensured its continuing popularity with florists. *Cyclamen hederifolium* (347, I; 348, I) and *Cyclamen purpurascens* (348, II and III) present two more species (cf. 106, II) that are now very rare in the wild. Its tuber is remarkable, spreading horizontally to form a disk, hence its old German name *Erdscheibe* (earth disk). The other common name for this plant, sowbread, may also relate to this tuber. It looks slightly like a truffle, for which wild boars have a known predilection.

The heat-loving spike lavender (347, II and III) is also an ornamental plant grown for its tall stems and its fragrance. Its flowers are usually violet-blue, but white forms are also known, as shown here in the *Hortus Eystettensis* (plate 310, II).

PLATES 349–353

The meadow saffron (349, IV and V; 350, II–V; 351, I–VI; 352, II and III; 353, II and III) was well known for two reasons. Firstly, because it is poisonous, and secondly, because the late-flowering period of this bulbous plant struck people of ear-

lier times as being unusual. The idea that this plant did not keep to the usual seasons was given further weight by the fact that the striking fruit appears in spring, whereas the flower does not appear until autumn, so that the sequence of these two stages of development appeared confused. This plant, which Besler also illustrates in its double form, can still be found in quite large numbers in meadows in central and southern Germany. Because it is highly poisonous, it could not be used safely for medicinal purposes until the colchicine had been isolated. It is now mainly used to treat severe cases of gout.

The autumn daffodil (349, I and VI), an amaryllis plant indigenous to the Mediterranean region, and the saffron crocus (349, III), previously displayed on plate 191, are included here because they are similar in appearance. It is true that *Scilla autumnalis* (349, II) and the autumn snowflake (350, I) are not similar, but they should be seen here in the context of the other late-flowering plants as the autumnal counterparts of their spring-flowering forms, which are also shown together.

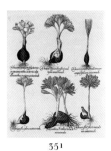 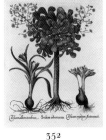 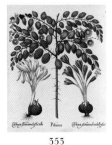 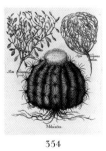

351 352 353 354

The flora of the Canary Islands has a very special place in botany. Many plants are endemic to this area and, because of their historical development, do not occur anywhere else in the wild. One such plant is *Aeonium arboreum* (352, I), a member of the Crassulaceae family, which is now also available in a form with black leaves.

Christ's thorn (353, I) belongs to the buckthorn family and is found from the Mediterranean region to central Asia. As it also occurs in the area around Jerusalem, Jesus' crown of thorns is thought to have been made from its branches, which have secondary leaves transformed into sharp thorns. The woody fruits have broad, rounded wings.

4TH ORDER OF AUTUMN
PLATE 354

The rose of Jericho (354, II and III) belongs to the Cruciferae family and is associated with many stories, all of which relate to its botanical characteristics. Under extremely dry conditions, this plant, which grows in desert areas, becomes woody after it has shed its blossom (354, II), and bends its branches up into a dense ball (354, III). This can then be uprooted relatively easily by strong gusts of wind and rolled over long distances, thus dispersing its seeds. When this unattractive, dried-up ball of twigs is watered, the branches stretch out again and the dead plant seems to return to life. For this reason, it was often brought home from the Holy Land and was seen as a symbol of the Resurrection and of eternal life.

The German common name for *Melocatus intortus* (354, I), a prickly cactus, is hardly charming. *Schwiegermutterstuhl* (mother-in-law's chair) makes it perfectly clear what people think of this maternal relationship by marriage. Turk's cap cactus, the botanical name for this West

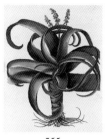
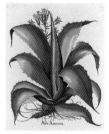

355 356

Indian genus, provides a much less offensive description of this ribbed cactus completely covered with tufts of prickles. A soft, woolly crown, known as a cephalium, can be seen on the top, on which the flowers are borne. When these appear, however, the plant body ceases to develop.

PLATE 355
Besler calls the Barbados aloe (355, I) the unusual German name *Alepatick*, which sounds like the pharmaceutical name *Aloe hepatica* for the dried liver-coloured sap of the plant. This intensely bitter and strongly purgative remedy was common in Germany long before the plant itself was introduced in the 16th century. The fresh sap is used today in the cosmetics industry, but was used in the past to cool burns and wounds and promote healing. With about 300 species, aloes are now widespread succulent ornamental plants found in all tropical and subtropical regions. The fleshy, sometimes speckled leaves, which contain the sap, often have sharp marginal teeth. Many species are branched like a shrub, while others develop stems of varying lengths. They produce panicles of flowers, usually vibrant yellow to red.

PLATE 356
Aloe americana was the old name for this century plant (356, I), which comes from Mexico and Central America. It looks very like the African aloe, even though the plant actually belongs to a different genus and family altogether. It was found in European gardens around the middle of the 16th century. It was first shown in print in 1574, although the flower was not illustrated until 14 years later. The flower's splendour held a particular fascination for plant enthusiasts, as the plant stopped growing when the unusually tall inflorescence appeared. Whether the century plant actually flowered in Eichstätt is a moot point, because the flower hinted at behind the leaves was clearly added by Camerarius for the sake of botanical completeness. Agaves are common ornamental plants, particularly in the Mediterranean region. In America, various species are used to produce the extremely hard-wearing

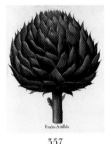
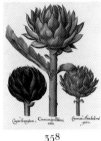

357 358 359

sisal and other fibres. The fermented sap of another species is used in the production of tequila.

PLATES 357, 358

After the cardoon (279, I) comes the artichoke (357, I; 358, I–III), grown both as an ornamental plant and as a vegetable. The cardoon, also called the vegetable artichoke in German, grows wild in the Mediterranean region as an imposing herb. Since Classical times, the leaf stem, which remains white because it is hidden from the light, has been eaten as a salad or vegetable. Crosses were made from this plant to produce the artichoke we know today, which was a popular vegetable in European cuisine as early as the 15th and 16th centuries. Besler differentiates between a Bolognese (358, I) and a Genoese variety (358, II), although the accompanying text obviously confuses the Italian city of Bologna with Poland (Polonia). Even in the latest contemporary edition of the *Hortus Eystettensis* the east European origin of this special type is derived from the similar-sounding name of that country.

In cooking, the preferred parts of the artichoke are the base of the unopened flowerhead and the fleshy bracts. It contains cynarin, a bitter compound, and is therefore a valuable medicinal plant. The extract is successfully used to treat digestive complaints and liver and gall bladder problems, while it is used for its distinctive taste to flavour some aperitifs. In the 17th century and even later, however, it was particularly valued for its aphrodisiac effect, which, in his herbal of 1679, Lonitzer states would apparently "arouse and promote the conjugal act", adding, "This is the most fashionable use for these thistles."

PLATES 359, 360

Like the agave, the Indian fig (359, I; 360, I–III), also known as the prickly pear, comes from Mexico and Central America, and had already reached gardens in the warmer regions of Europe early in the 16th century. Such a splendid example as we find in the *Hortus Eystettensis*, however, would still have been a marvellous rarity at that time. This is why Besler even includes a scale on the plate to give

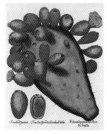

360

an idea of its exceptional size, together
with a note in the caption, proudly stating
that the statuesque plant had been grown
from only a single leaf. Besler devotes
the second plate to just such a detached
leaf with the characteristic edible fruits,
which were called Indian figs. Another
Opuntia species is also of scientific inter-
est because it is home to the cochineal
shield lice, which produce the valuable
deep red dyes used in lipsticks, for exam-
ple, and also as a food colourant.

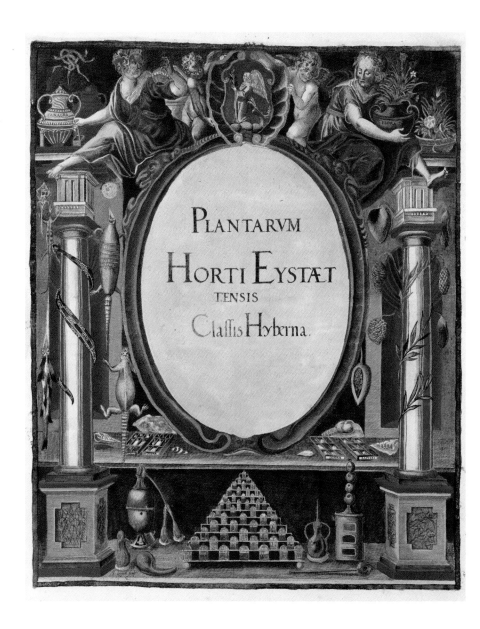

PLANTARVM

HORTI EYSTÆT

TENSIS

Classis Hyberna.

WINTER

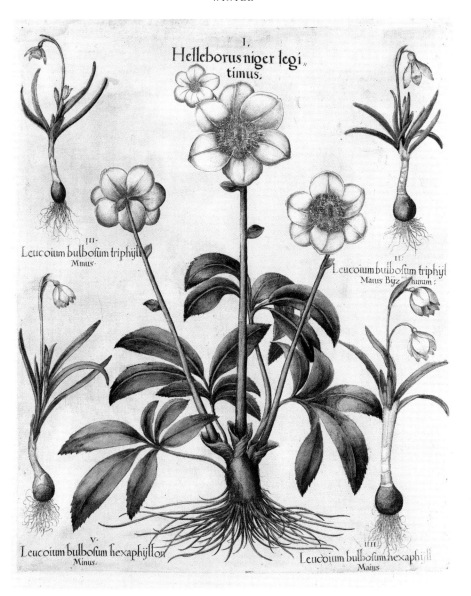

I,
Helleborus niger legi
timus.

III·
Leucoium bulbosum triphÿll
Minus·

II·
Leucoium bulbosum triphyll
Maius Byzantinum :

V·
Leucoium bulbosum hexaphyllon
Minus·

IIII·
Leucoium bulbosum hexaphyll
Maius

GALANTHUS
NIVALIS, II.–III.

Snowdrop

HELLEBORUS
NIGER

Christmas rose

LEUCOJUM
VERNUM, IV.–V.

Spring snowflake

Plate 361 505

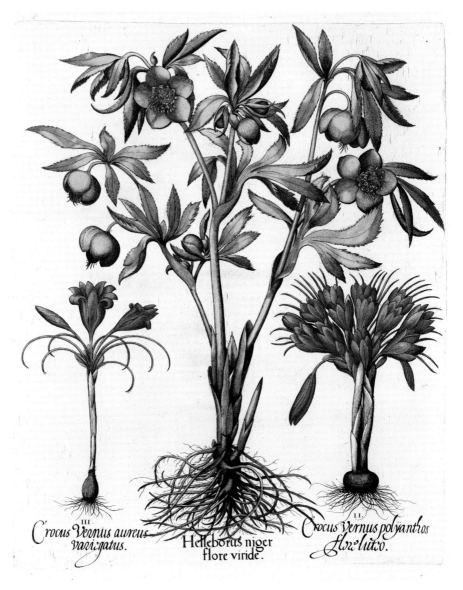

C rocus Vernus aureus variegatus.

Helleborus niger flore viride.

C rocus Vernus polyanthos flore luteo.

CROCUS SPEC.

Golden yellow crocus

HELLEBORUS VIRIDIS

Green hellebore

CROCUS SPEC.

Yellow crocus

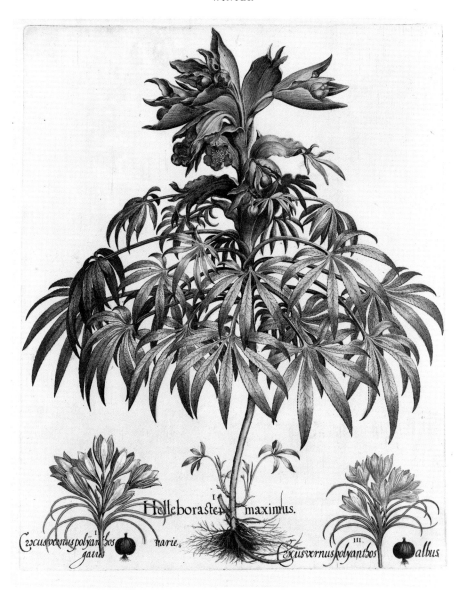

Helleboraster maximus.

Crocus vernus polyanthos variegatus

Crocus vernus polyanthos albus

CROCUS BIFLORUS, II.–III.
Blue crocus

HELLEBORUS FOETIDUS
*Stinking hellebore, Setterwort,
Stinkwort, Bear's foot*

Plate 363 507

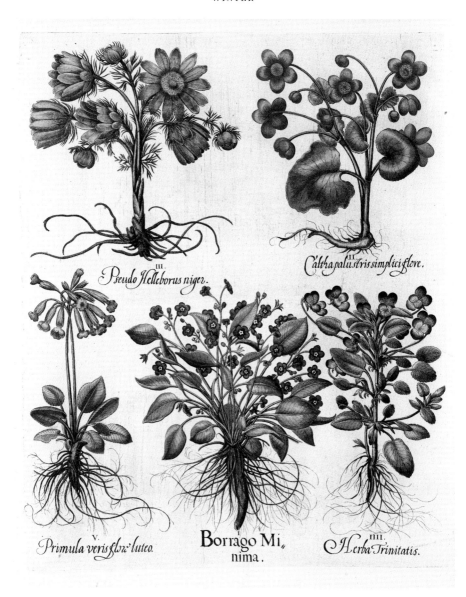

Pseudo Helleborus niger.

Caltha palustris simplici flore.

Primula veris flor luteo.

Borrago Mi„ nima.

Herba Trinitatis.

PRIMULA VERIS	ADONIS VERNALIS	OMPHALODES VERNA	CALTHA PALUSTRIS	VIOLA TRICOLOR
Cowslip	*False hellebore, Yellow pheasant's eye*	*Creeping forget-me-not*	*Kingcup, Marsh marigold, Meadow bright, May-blob*	*Wild pansy, Heart's-ease, Love-in-idleness, Johnny jump up, Pink of my John*

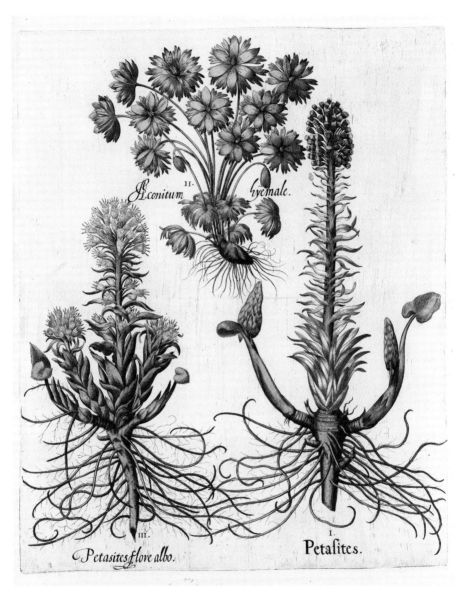

Aconitum II. *hyemale.*

III.
Petasites flore albo.

I.
Petalites.

PETASITES ALBUS

*Butterbur, Sweet
coltsfoot*

ERANTHIS HYEMALIS

Winter aconite

PETASITES HYBRIDUS

*Bog rhubarb,
Common butterbur*

Plate 365

509

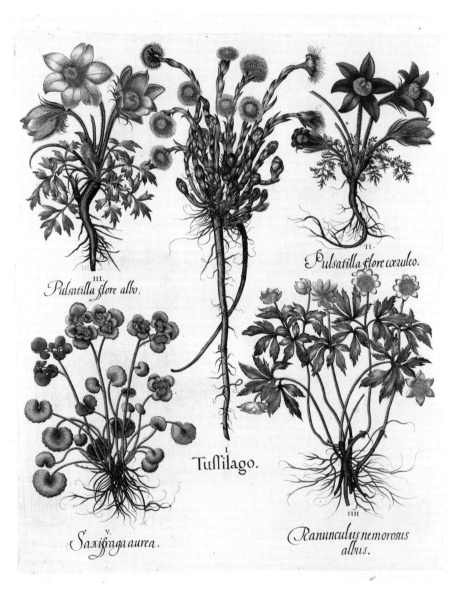

III.
Pulsatilla flore albo.

II.
Pulsatilla flore cœruleo.

I.
Tussilago.

V.
Saxifraga aurea.

IIII.
Ranunculus nemorosus albus.

PULSATILLA VERNALIS	CHRYSOSPLENIUM ALTERNIFOLIUM	TUSSILAGO FARFARA	PULSATILLA VULGARIS	ANEMONE NEMOROSA
Pasque flower	*Golden saxifrage*	*Coltsfoot*	*Pasque flower*	*Windflower, Wood anemone*

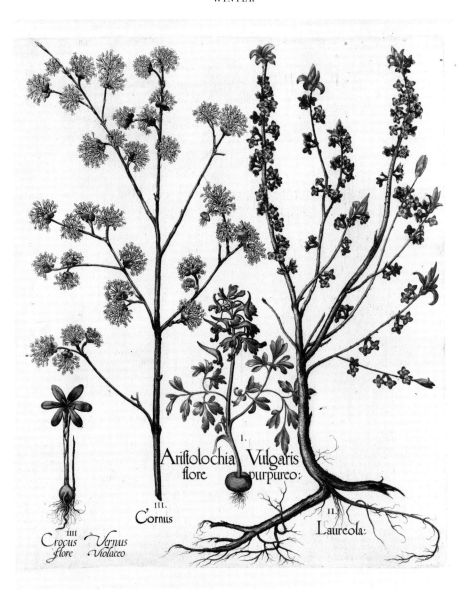

Aristolochia Vulgaris
flore purpureo:

I.

III.
Cornus

II.
Laureola:

IIII.
Crocus Vernus
flore Violaceo

CROCUS VERNUS
Dutch crocus

CORNUS MAS
Cornelian cherry,
Sorbet

CORYDALIS CAVA
Hollow-rooted
corydalis

DAPHNE MEZEREUM
Mezereon, February
daphne

Plate 367

511

WINTER

 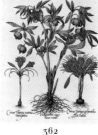 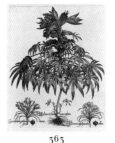 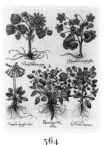

361 362 363 364

1ˢᵀ ORDER OF WINTER
PLATES 361–363

The German name for the represen-
tatives of the genus *Helleborus*, which
belongs to the Ranunculaceae family, is
Nieswurz (sneezewort) (361, I; 362, I;
363, I). They usually flower between
December and April, but have now
become rare in the wild in Germany.
The Christmas rose (361, I) is called the
Schwarze Nieswurz (black sneezewort)
in German and gets its name from the
colour of its rhizome. Its large white or
pink-flushed flowers, which have many
stamens, sometimes appear in the garden
as early as December. The green helle-
bore (362, I) flowers a little later. Its pale
green flowers are borne singly at the end
of the stem, surrounded by leaves. The
stinking hellebore (363, I) produces sev-
eral flowers at a time, which are green
apart from a striking reddish margin.
The leaves, which are split to the base,
are a striking dark green. Despite being
highly poisonous, the hellebore was used
from Classical times as a purgative and a
medicine for many illnesses. It was said
to be a particularly effective treatment
for mental disorders, and legend has it

that it successfully cured the insanity of
both Heracles and the daughters of King
Proitos. The sneeze-producing powder
was also an ingredient in medicinal sneez-
ing powder, which was said to expel
excess mucus from the body.

Even the names of the snowdrop (361, II
and III) and the spring snowflake (361,
IV and V) are an indication of the early
flowering time of these two ornamental
flowers, both of which are indigenous to
Germany, occurring in large numbers in
some places.

The crocuses (362, II and III; 363, II
and III), which occur in various
colours, are cultivated forms, multi-flowered
types being apparently of great significance.

PLATE 364

Like the other species of forget-me-not
already seen, the creeping forget-me-
not (364, I) is a member of the borage
family; it is classified botanically, however,
within the genus *Omphalodes*. This genus
gets its unusual common name, navel-
wort, from the navel-shaped dimples on
its fruits. Plate 113 showed a cultivated
form of the marsh marigold; here is its
wild form (364, II).

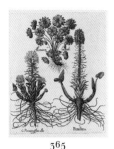 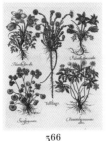

365 366

The contrast between the large yellow petals and the finely divided green leaves makes the false hellebore (364, III) a very attractive plant. Although it is indigenous to Germany, it is now found only very rarely in the wild, but is highly prized in the garden as an early-flowering ornamental plant. It is also used medicinally, particularly in homeopathy.

The wild pansy (364, IV) is also illustrated on plates 48 and 289.

The cowslip (364, V) concludes this spring picture. It is very common in Germany and its bright yellow flowers are extremely eye-catching.

PLATE 365

Two butterbur species are shown together here. Both the widespread bog rhubarb or common butterbur (365, I) and *Petasites albus* (365, III), a rarer, white-flowering butterbur, prefer moist sites, where early in spring their elongated inflorescences shoot up, followed a little later by their striking large leaves. This member of the aster family gets its German name *Pestwurz* (plague root) from the old idea that the plant had a diaphoretic effect and could thus be used to rid the body of the toxins of the plague. In popular medicine, it is used externally to treat skin complaints and internally to relax spasms and as an expectorant. It should, however, be used very sparingly as it contains a substance that can damage the liver.

The yellow-flowered winter aconite (365, II) is native to southern Europe, but has also naturalised from gardens. This very early-flowering crowfoot plant used to be classified as a small species of aconite because of the shape of its leaves.

PLATE 366

The coltsfoot (366, I) is closely related to the butterbur. The small golden-yellow flowerheads appear on the scaly stems even before winter is out. As they ripen, the flowerheads turn into silvery-white seedheads, similar to those of a dandelion. Only then do the leaves appear. These are covered in soft hair underneath and are rather smaller than those of the butterbur. Apart from that, they can easily be confused with those of the butterbur. Coltsfoot is an ancient medicinal plant. It even gets its scientific name, *Tussilago*, from the Latin *tussis*, cough, because the dried leaves used to be burnt

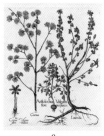

367

to produce smoke as a cure for respiratory diseases. Coltsfoot was often also an ingredient of pectoral teas, but should no longer be used as it has been shown to contain substances that are harmful to the liver.

A typical feature of both the violet-flowered pasque flower (366, II) and the white-flowered *Pulsatilla vernalis* (366, III) is the fact that they are covered in whitish hair. The pasque flower has two German common names, *Kuhschelle* (cowbell) and *Küchenschelle* (kitchen bell). The former is clearly derived from its bell-shaped flower blowing in the wind, but it is still unclear how the name "kitchen bell" came to be applied to this poisonous plant, which has certainly never been used in the kitchen. It is tempting to suggest it is derived from *Kühchen* (little cow), but its traditional names provide no proof to substantiate this.

Having already been shown in its double form (16, V), the wood anemone, which is also called windflower (366, IV), now appears in its species form, as it is known in the wild.

The golden saxifrage shown on this plate is *Chrysosplenium alternifolium* (366, V), a member of the saxifrage family with alternate leaves. The more common species, with opposite leaves, is illustrated on plate 3.

Plate 367

Corydalis cava (367, I) now makes its second appearance (cf. plate 16, IV) and brings a reminder of the early flowering period of this ornamental plant.

The purple-red flowers of the February daphne (367, II) appear in early spring on the bare branches of this shrub, with the leaves appearing only gradually at the end of the flowering period, when the poisonous red berries also ripen. The German name for these fruits is *Kellerhals* (cellar throat), a corruption of the German *quäle den Hals* (torture your throat), because, when chewed, they have an extremely irritant effect on the throat. The German common name for this plant is *Seidelbast*. It is probably derived from the old name *Zeiland*, which is understood to mean "bark [*Bast*] of the gods". In the past, the bark was also used for the substances it contained that were very irritating to the skin. It was therefore tied round warts, which

were then easier to remove, and was also applied as a compress to stimulate weeping inflammations, which were thought to extract toxins from the body.

Its early yellow blossom is not the only reason why the cornelian cherry (367, III), also known as sorbet, is a valuable ornamental shrub. It also produces a sour fruit, used to make jam, although it can also be pressed for its juice, which can then be fermented to make wine.

The Dutch crocus (367, IV) brings not only the end of the winter plates, but also the end of the book. It is March. Spring is just around the corner and with it once again the captivating sequence of brilliantly coloured, fragrant and beautiful plants that the Eichstätt Prince Bishop Johann Konrad von Gemmingen grew at his Willibaldsburg castle and which the Nuremberg apothecary Basilius Besler perpetuated for ever in the *Hortus Eystettensis*.

Hortus Eystettensis

The garden, the book, the plants
Werner Dressendörfer

During the 400 years after it came into being, the *Hortus Eystettensis* – both the actual former garden and the printed catalogue – has never been entirely forgotten. The magnificent garden, situated on the ridge of the Willibaldsburg, high above Eichstätt, fell into decline in the wake of the Thirty Years War, but experienced a partial renaissance in 1998.

Very soon after it was first published, the botanical accuracy of the Latin text came under severe criticism. This in itself would actually seem to underline one of the inherent problems of the *Hortus Eystettensis*: the printed work has to fulfil two clearly different aspects in equal measure. In the first place, it was designed to impress, as is borne out by its unusually large format. Prince Bishop Johann Konrad von Gemmingen (1593/95–1612) wanted to perpetuate the memory of the garden he had created and thus also his own memory in a way that would make people sit up and take notice. He had the means to indulge the great pleasure he took in nature by establishing an exquisitely pleasant garden. He was also wealthy enough to commission the printed documentation, to provide emphatic proof of his open-mindedness with regard to botany, which was only just beginning to be considered on a par with medicine. However, the people who read or owned the book were not by and large botanists; otherwise the work would have been cited in specialist literature more frequently. They were for the most part wealthy nature lovers who took pleasure in the pictures, or influential individuals whom the Bishop considered worthy of benefiting from his generosity. Gemmingen himself, however, did not live to see the work published. Only his successors were able to derive lasting pleasure from his legacy.

Besides being designed to impress, through its section of plants the *Hortus Eystettensis* gives an indication of the inquisitive pleasure taken by nature lovers, thirsty for knowledge, in anything exotic, strange or different from the norm. To this extent, the garden layout and the book also fulfilled a function otherwise met by the art and curiosity collections so popular in Renaissance and Baroque times, which often contained an extremely wide variety of natural curiosities. Everyday things could of course also be a source of pleasure, but only the un-usual could encourage the collecting instinct in any lasting way. Here, Gemmingen's interests coincided with those of the Nuremberg apothecary

Basilius Besler (1561–1629). After the sudden death of the renowned doctor and botanist Joachim Camerarius (1534–1598), whom Gemmingen had originally had in mind to create the garden, Besler was now commissioned to "help establish the garden and propagate the flowers". As the joint project progressed, Gemmingen and Besler discovered that they had other interests in common. Clearly it was Besler, who was familiar with botany through his profession and who had a cabinet containing natural history objects of his own, who suggested to the Bishop, a well-known collector, that the plants he had collected over the past few years at such great expense should be preserved in print. Even if Hainhofer, the most important source, reports that Gemmingen told him that Besler had "begged" him to be allowed to "engrave" the garden "in copper, print it, dedicate it to me and thereby to make his fame and fortune", the high payments that the Bishop subsequently made prove how adept Besler was at making things that were really in line with his own interests palatable to the Prince.

The choice of a paradise scene for the title page is therefore certainly no coincidence, emphasising as it does from the very outset the nature of plants as an important part of God's Creation, as befits a high ecclesiastical dignitary. If the Bishop was proposing to give a book with such an introduction as an honorary gift, the necessary religious reference was sufficiently and strikingly obvious, and despite the botanical subject matter, he would not expose himself to the possible criticism of having given a far too worldly book.

Even Besler emphasises, by the back door, so to speak, his professional breadth of vision, although this does not become apparent in the rest of the text to any extent worth mentioning. If – apart from the mention of his name – the title page itself was denied him, the four interim title pages that were of a similar size did seem to be suitable for this. On these pages, Flora and Salus recall how botany used to be limited to specific purposes and was almost exclusively concerned only with those plants that could be used for medicinal purposes. Fauna's exotic examples on the left-hand pillar, the foreign fruits on the right-hand one and the four boxes on the pedestal labelled "Metalla", "Minera", "Gemma" and "Lapides" represent the three spheres of nature. From these came the substances that the apothecary used with the chemical apparatus shown underneath to produce the medicaments that stand ready to hand in the glass bottles on a pyramid-shaped stand. Above all this – as the deliberate counterpart to the corresponding ecumenical heraldry of the title page – hangs the coat of arms of Basilius Besler, "Artis pharmaceuticae, chymicae amator, singularis rei herbariae studiosus", as he calls himself in the inscription to his portrait.

Thus the cooperation of two energetic men, the Bishop of Eichstätt and the Nuremberg apothecary, assisted by numerous artists and craftsmen, and the text, at least some of which was used, written by Ludwig Jungermann (1572–1653) professor of Botany at Giessen, later at Altdorf, produced a work concerned with botanical knowledge and curiosity in natural history while at the same time enjoying the beauties of nature

and taking pleasure in their full artistic representation.

This also explains, however, why it was practically impossible to sell the remaining copies of the last edition published in 1750. Many of the exotic plants that had been marvelled at as novelties 140 years earlier had long become familiar and commonplace. The potato, in 1613 still a novelty known as *Papas Peruanorum* (345, I), gradually became a common food in the 18th century, and by this time even tobacco (340, I; 341, I and III) no longer represented a peculiarity worth describing in botanical terms. Cultivated forms of previously sought-after garden flowers had long since been put in the shade by even more striking hybrids or had been superseded by other more recently discovered species of plants. The *Hortus Eystettensis* that now lived on only on paper seemed to have been overtaken by the great progress made in horticulture and by intensive botanical research. It therefore did not seem a very attractive purchase as a practical book, and the collection of uncoloured, rather dull-looking illustrations in the unwieldy volumes was obviously not considered as an artistic masterpiece or a bibliophile's collector's item. It is only recently that the beautifully coloured individual plates have become highly sought after for mounting and hanging on walls, belated but justifiable proof of the timeless beauty of the copperplate engravings that were made almost 400 years ago.

The Plants in the Hortus Eystettensis

It is difficult to establish the actual stock of plants kept in the Eichstätt garden with any degree of certainty, because Besler makes a point of stressing in the foreword that he also had illustrated plates made of plants that he had found in the surrounding areas. On the other hand, he also made a point of excluding certain cultivated varieties in favour of other plants that seemed to him to be more important. Even if we can no longer reconstruct the garden with complete authenticity, the *Hortus Eystettensis* undoubtedly provides an accurate overall picture of the appearance of this garden and of the plants treasured by plant enthusiasts at that time.

Using the current system of nomenclature, the plants of the *Hortus Eystettensis* belong to 90 families covering 340 genera, some of which are sometimes represented by several species. Such a list using the modern botanical names makes it easy to forget that at the time the *Hortus Eystettensis* was published, there was no botanical system, nor was there any standardised botanical nomenclature. It was not until the middle of the 18th century that the Swedish botanist Carl Linnaeus (1707–1778) devised such a system, which then went on to become the foundation of scientific botany.

In Besler's time, on the other hand, it was customary, particularly in the case of ornamental plants, to create names that were really a cumbersome description rather than a clear characterisation: *Consolida regalis Arvensis flore variegato* (177, I), *Narcissus Polyanthos Orientalis medio luteus minor odoratus* (64, III), to

mention but two. As the names were devised individually, it could easily happen that one and the same plant could be given several different names by different authors. It is obvious that such a situation was no more beneficial to scientific works at that time than it is to current research into botanical history.

Even though Caspar Bauhin in his *Pinax theatri botanici*, published in 1623, listed about 6,000 plants known at that time and provided important indications as to their identification, it is still extremely difficult to identify plants named in pre-Linnaean literature with any degree of certainty. Even when there are good illustrations, as is definitely the case with the *Hortus Eystettensis*, the final decision often has to be left open, because diagnostic features cannot be seen with sufficient clarity.

Attempts have often been made in the past to catalogue the plants of the *Hortus Eystettensis* using the Linnaean names valid at the time in question. The first person to undertake this task was Franz Seraph Widmann in 1805, who published a *Catalogus systematicus secundum Linnaei Systema vegetabilium adornat arborum, fruticum et plantarum celeberrimi Horti Eystettensis* in Nuremberg (also published in French the following year). Eighty years later, in 1885, the library committee for Augsburg city and district library published a *Catalogue to the Hortus Eystettensis* with two indexes, which provides a table of contents using modern names and an accompanying index. In 1890, in his study *Der botanische Garten der Fürstbischöfe von Eichstätt*, Joseph Schwertschlager published not only a comparative table that listed both the old Latin and German names, but also

a compilation based on the natural system used in botany. He was also the first person to research the history of the garden and its plants in depth. In the colour edition of 1987, Gérard G. Aymonin was the first to describe in detail all the plates of the *Hortus Eystettensis* from a botanical viewpoint and to provide a modern identification for all the plants. His work will remain essential for all those concerned with this subject in the future and forms the basis, in part, of this book's annotated notes, which for the first time deal with the plants primarily from a cultural–historical viewpoint.

The plates are ordered according to the approximate flowering time of the plants they illustrate. Thus they do not follow the established botanical classification principles, but garden practice through the year. The printed *Hortus Eystettensis* thus mirrors the garden of the Bishop of Eichstätt that was so admired by his contemporaries. With a little imagination, we can enter this garden once more by looking at the plates. Even Carl Linnaeus praised it as an "incomparabile opus", a work beyond compare. And who are we to contradict him?

Notes on the Bastion Garden of today

Bernd Ringholz

In June 1998, the Bastion Garden on the Willibaldsburg was opened to the public, following a development project which had lasted almost five years. It was obtaining the plants for the garden which took up most of this relatively long period. Only a time-consuming process involving the listing of all the plants in a data bank made a systematic evaluation possible.

Gérard G. Aymonin laid the foundations for this through his scientific work on the *Hortus Eystettensis*. He classified the plants using the facsimile edition of the coloured catalogue in the Musée National d'Histoire Naturelle in Paris. Only when there was a German edition did the basis exist for the creation of the Bastion Garden. Since the project was based on the facsimile, the idea which developed from this of laying the garden out like an open book can easily be understood.

It is important to realise that the new garden is not a reconstruction of the former Eichstätt garden. This concept was never even discussed, since no precise documentation is available on the original garden's extent or layout. In addition to this, since 1612 the entire area around the Willibaldsburg has been completely altered by fortifications. The military installations on the site at present, which were erected during and after the Thirty Years War, were the reason for the complete disappearance of the original garden. The planting of the Bastion Garden was based on two main criteria, which had to be met as precisely as possible:

1. Only plants which were depicted in the magnificent *Hortus Eystettensis* catalogue could be used.

2. The beds laid out in line were to be planted in an order which followed the seasons – the way the book is set out. The top bed in the north-western corner of the bastion is allocated to the spring blooms in the first section of the book, and the last of the thirty-two beds is reserved for the plants which flower in winter.

Numerous difficulties have arisen in the years after the garden's reopening in connection with the attempt to adhere to these self-imposed guidelines. A planting system which follows the sequence in the book pays little attention to the standard requirements of the plants. Many of the shrubs in the garden need an extraordinarily large amount of space and very soon drive out the adjacent plants. So the conditions in many beds are very

cramped, in stark contrast to the spring beds, in which the parts of the plants above the ground are already dying off by the end of May and leaving gaps.

Many problems also arise in connection with the obtaining of plants. It is particularly difficult, and sometimes impossible, to procure the old types of plant and the many variations shown in the book from nurseries or specialist firms. The only thing that can help here is having close and widespread contacts with botanical gardens and with amateur horticulturalists, who are dedicated to preserving plants in all their abundance.

Many plants cannot be precisely classified in accordance with present-day criteria, and the varying shades of colour in the rare original copies of the book create still more uncertainties.

It can be concluded, from practical experience and from the associated continuous changes to the garden, that the plants shown in the book were never all present in the original garden. These flowers and plants can be shown in all their splendour only in the magnificent *Hortus Eystettensis* catalogue. It is certain that only some of these much sought-after plants were ever on show in the historical garden, and many Mediterranean varieties did not survive the first frost, since suitable over-wintering facilities were not available. A not inconsiderable proportion of the plants probably went straight to the copperplate engraver, without ever having been present in the garden even for a day.

Prince Bishop Konrad of Gemmingen invested a considerable part of his wealth in this rare and valuable book at the time, so that the original garden of Eichstätt is still preserved today through the illustrations in the book. The newly laid out Bastion Garden is intended to reflect the magnificence of this catalogue for its readers. But it is only in the book that the wide range of plants known to the experts of that time can be appreciated all year.

Spring
Summer
Autumn
Winter
Wooded area
Mixed growth

Genera of the Plants
of the *Hortus Eystettensis*

Alphabetical order by family

A

ACANTHACEAE
Acanthus
AGAVACEAE
Agave
AMARANTHACEAE
Amaranthus,
Celosia
AMARYLLIDACEAE
Galanthus,
Leucojum,
Narcissus,
Pancratium,
Sternbergia
ANACARDIACEAE
Cotinus, Pistacia
APIACEAE
Astrantia,
Bupleurum, Cicuta,
Eryngium, Orlaya,
Sanicula, Tordylium
APOCYNACEAE
Nerium, Vinca
ARACEAE
Acorus, Arum,
Calla, Colocasia,
Dracunculus
ARISTOLOCHIACEAE
Aristolochia,
Asarum
ASCLEPIADACEAE
Cynanchum
ASTERACEAE
Achillea, Anacyclus,
Anaphalis,
Antennaria,
Anthemis,
Arnica, Artemisia,
Aster, Bellis, Bidens,
Calendula,
Carduncellus,

Carduus, Carlina,
Carthamus,
Catananche,
Centaurea,
Chamaemelum,
Chrysanthemum,
Cirsium, Cnicus,
Crepis, Cynara,
Doronicum,
Echinops,
Helianthus,
Helichrysum,
Hieracium, Inula,
Leucanthemum,
Petasites,
Pulicaria, Santolina,
Scorzonera, Senecio,
Serratula, Solidago,
Tagetes, Tanacetum,
Tragopogon,
Tussilago

B

BALSAMINACEAE
Impatiens
BERBERIDACEAE
Berberis, Leontice
BORAGINACEAE
Anchusa, Borago,
Cynoglossum,
Myosotis,
Omphalodes,
Pentaglottis,
Pulmonaria,
Symphytum
BOTRYCHIACEAE
Botrychium
BUTOMACEAE
Butomus
BUXACEAE
Buxus

C

CACTACEAE
Melocactus, Opuntia
CAMPANULACEAE
Campanula,
Jasione, Legousia
CANNACEAE
Canna
CAPRIFOLIACEAE
Lonicera, Viburnum
CARYOPHYLLACEAE
Agrostemma,
Dianthus, Lychnis,
Petrorhagia,
Saponaria, Silene
CHENOPODIACEAE
Chenopodium,
Halimione, Salsola
CISTACEAE
Cistus,
Helianthemum
COMPOSITAE
see ASTERACEAE
CONVOLVULACEAE
Calystegia, Ipomoea
CORNACEAE
Cornus
CRASSULACEAE
Aeonium, Sedum,
Sempervivum
CRUCIFERAE
Alyssum, Anastatica,
Cardamine,
Cheiranthus,
Dentaria, Erysimum,
Hesperis, Iberis,
Lunaria, Malcolmia,
Matthiola,
Myagrum, Sinapis
CUCURBITACEAE
Citrullus, Cucumis,

Cucurbita,
Ecballium,
Lagenaria,
Momordica
CUPRESSACEAE
Cupressus, Thuja

D

DIPSACACEAE
Cephalaria, Knautia,
Scabiosa
DROSERACEAE
Drosera

E

EBENACEAE
Diospyros
ERICACEAE
Calluna, Vaccinium
EUPHORBIACEAE
Euphorbia, Ricinus

F

FABACEAE
Aspalthium, Cercis,
Colutea, Cytisus,
Dorycnium,
Galega, Genista,
Hedysarum,
Laburnum,
Lathyrus, Lupinus,
Medicago, Melilotus,
Onobrychis, Ononis,
Pisum, Spartium,
Tetragonolobus,
Trifolium,
Trigonella

G

GENTIANACEAE
Blackstonia,

Centaurium,
Gentiana
GERANIACEAE
Erodium, Geranium
GLOBULARIACEAE
Globularia
GRAMINEAE
see POACEAE
GUTTIFERAE
Hypericum

I
IRIDACEAE
*Crocus, Gladiolus,
Gynandriris,
Hermodactylus, Iris*

L
LABIATAE
see LAMIACEAE
LAMIACEAE
*Ajuga, Ballota,
Calamintha,
Dracocephalum,
Hyssopus, Lavandula,
Marrubium,
Melissa, Melittis,
Mentha, Moluccella,
Nepeta, Ocimum,
Origanum, Prunella,
Rosmarinus, Salvia,
Satureja, Stachys,
Teucrium, Thymus*
LAURACEAE
Laurus
LEGUMINOSAE
see FABACEAE
LILIACEAE
*Allium, Aloë,
Anthericum,
Asparagus,
Asphodelus,
Bellevalia,
Bulbocodium,
Colchicum,
Convallaria,
Dipcadi,
Erythronium,
Fritillaria, Gagea,
Hemerocallis,
Hyacinthoides,
Hyacinthus, Lilium,
Maianthemum,
Muscari,*

*Ornithogalum,
Paradisea,
Paris, Polygonatum,
Ruscus, Scilla,
Tulipa, Urginea,
Veratrum*
LINACEAE
Linum
LYCOPODIACEAE
Lycopodium
LYTHRACEAE
Lythrum

M
MALVACEAE
*Abutilon, Althaea,
Hibiscus, Lavatera,
Malva*
MELIACEAE
Melia
MENYANTHACEAE
Menyanthes
MYRTACEAE
Myrtus

N
NYCTAGINACEAE
Mirabilis
NYMPHAEACEAE
Nuphar, Nymphaea

O
OLEACEAE
*Jasminum,
Ligustrum, Syringa*
ONAGRACEAE
Circaea, Epilobium
OPHIOGLOSSACEAE
Ophioglossum
ORCHIDACEAE
*Cephalanthera,
Corallorhiza,
Cypripedium,
Dactylorhiza,
Epipactis, Goodyera,
Gymnadenia,
Neottia, Nigritella,
Ophrys, Orchis,
Platanthera*
OROBANCHACEAE
Orobanche
OXALIDACEAE
Oxalis

P
PAEONIACEAE
Paeonia
PAPAVERACEAE
*Argemone,
Corydalis, Fumaria,
Glaucium, Papaver*
PINACEAE
Picea
PLANTAGINACEAE
Plantago
PLUMBAGINACEAE
Limonium
POACEAE
Coix, Sorghum
POLEMONIACEAE
Polemonium
POLYGALACEAE
Polygala
POLYGONACEAE
Polygonum, Rumex
PORTULACACEAE
Portulaca
PRIMULACEAE
*Cyclamen,
Lysimachia, Primula*
PUNICACEAE
Punica
PYROLACEAE
Moneses, Pyrola

R
RANUNCULACEAE
*Aconitum, Actaea,
Adonis, Anemone,
Aquilegia, Caltha,
Clematis, Consolida,
Delphinium,
Eranthis,
Helleborus, Hepatica,
Nigella, Pulsatilla,
Ranunculus,
Thalictrum, Trollius*
RESEDACEAE
Reseda
RHAMNACEAE
Paliurus
ROSACEAE
*Aruncus, Filipendula,
Fragaria, Geum,
Malus, Potentilla,
Prunus, Rosa*
RUTACEAE
Citrus, Dictamnus

S
SAPINDACEAE
Cardiospermum
SAXIFRAGACEAE
*Chrysosplenium,
Parnassia,
Philadelphus, Ribes,
Saxifraga*
SCROPHULARIACEAE
*Antirrhinum,
Cymbalaria,
Digitalis, Euphrasia,
Gratiola, Lathraea,
Linaria,
Melampyrum,
Misopates,
Verbascum,
Veronica*
SOLANACEAE
*Capsicum, Datura,
Hyoscyamus,
Lycopersicon,
Mandragora,
Nicotiana, Physalis,
Solanum*
SPARGANIACEAE
Sparganium
STAPHYLEACEAE
Staphylea

T
THYMELAEACEAE
Daphne
TROPAEOLACEAE
Tropaeolum

U
UMBELLIFERAE
see APIACEAE
URTICACEAE
Urtica

V
VALERIANACEAE
*Centranthus,
Valeriana*
VIOLACEAE
Viola

Z
ZYGOPHYLLACEAE
Zygophyllum

Index of Modern Botanical and English Plant Names in the *Hortus Eystettensis*

INDEX

Fritillaria meleagris 56, I;
57, II–III
Fritillaria orientalis 57, I
Fritillaria persica 83, I, IV
Fritillaria persica with
bulb 83, I, IV
Fritillaria pyrenaica 58, II
Fritillaria spec. 58, III;
59, I
Fritillary 56, I; 57, I–III;
58, I–III; 59, I
Fumaria parviflora 25, III
Fumaria spicata 132, III
Fumitory 132, III
Fustuq 6, I

G
Gagea arvensis 39, I
Galanthus nivalis 361, II–III
Galega officinalis 273, II–III
Gand flower 104, II–III; 105, III
Garlic, golden 79, II
Garlic, Levant 202, I
Garlic, serpent's 79, III
Garlic, wild 59, II
Garlic, wood 59, II
Genista tinctoria 91, III
Gentian, Chiltern 334, III
Gentian, crosswort 124, III
Gentian, fringed 334, II
Gentian, marsh 248, II
Gentian, spring 113, III
Gentiana cruciata 124, III
Gentiana germanica 334, III
Gentiana pneumonanthe
248, II
Gentiana verna 113, III
Gentianella ciliata 334, II
Geranium, feather 295, III
Geranium, mint 231, III
Geranium lucidum 24, III
Geranium macrorrhizum
30, II
Geranium palustre 23, II
Geranium phaeum 24, II
Geranium pratense 22, II–III
Geranium rivulare 23, I
Geranium sanguineum 30, I
Geranium tuberosum 30, III
Germander 343, II
Germander, sage-leaved 236, I
Germander, wall 125, III
Germander, water 125, II
Gesneriana hybrid 73, V; 74, V
Geum rivale 19, II

Gillyflower 165, I–III;
166, I–III; 167, I–III; 168, I;
179, I, III
Gladiolus communis
201, III–IV; 203, I–III
Gladiolus palustris 201, II
Gladiolus, common 201, III–IV;
203, I–III
Gladiolus, marsh 201, II
Gladiolus, water 129, IV
Gladwyn 124, I
Gladwyn, stinking 124, I
Glaucium flavum 289, I
Globe-flower, European 26, II
Globularia punctata 193, III
Goat's beard 161, II; 255, II
Golden buttons 208, II–III
Golden chain 7, I
Golden chain, Alpine 7, II
Golden rod 267, II
Goldilocks 162, I
Goodyera repens 196, VI
Gourd, bottle 346, II
Gourd, calabash 346, II
Gourd, white-flowered 346, II
Granny's bonnets 170, I–III;
171, I–III; 172, I–III;173, I–III
Grass of Parnassus 248, III
Gratiola officinalis 108, II
Gratiole 108, II
Groundsel 133, II
Guinea-hen flower 56, I;
57, II–III
Gymnadenia conopsea
90, III–IV
Gynandriris sisyrinchium
190, I

H
Hag taper 266, II
Halimione portulacoides
342, II
Harebell 301, I
Hartwort 292, I
Hawk's-beard 256, I; 338, II
Hawkweed, common 284, II
Hawkweed, orange 150, III
Heart's-ease 289, II–III; 364, IV
Heather 252, I
Hedysarum coronarium 295, I
Helianthemum
apenninum 282, III
Helianthemum nummu-
larium 282, II
Helianthus annuus 204

Helianthus x multiflorus 205
Helichrysum italicum 288, II
Helichrysum orientale 237, I
Hellebore, black 246, II
Hellebore, false 246, I; 364, III
Hellebore, green 362, I
Hellebore, stinking 363, I
Hellebore, white 246, I
Helleborine 196, I
Helleborine, white 130, II
Helleborus foetidus 363, I
Helleborus niger 361, I
Helleborus viridis 362, I
Helmet flower 160, II
Hemerocallis fulva 133, I
Hemerocallis
lilioasphodelus 130, III
Hemp, Virginian 218, I
Henbane, black 245, I
Henbane, white 245, II
Henbane, Russian 245, I
Hepatica nobilis 34, I–II;
35, IV–V
Herb Christopher 264, I
Herb Paris 149, I
Hermodactylus tuberosus
83, II
Heron's bill 22, I; 24, I
Hesperis matronalis 119, II–III
Hibiscus sabdariffa 216, I
Hibiscus syriacus 144, I; 145
Hibiscus trionum 217, I
Hieracium aurantiacum
150, III
Hieracium inuloides 284, II
Hieracium vulgatum 284, II
Hollowroot 25, III
Holly, box 2, I
Holly, sea 281, IV; 282, I;
283, I
Hollyhock 222; 223
Honesty, annual 21, II
Honesty, perennial 21, I
Honeysuckle 129, III; 9, I
Honeysuckle, fly 9, II
Honeysuckle, Italian 129, II
Horehound 224, II
Horehound, common 231, I
Horehound, peregrine 224, III;
231, II
Horehound, white 231, I
Horn of plenty 342, I
Horsemint 228, I–II; 230, III
Hound's tongue 243, II–III
Houseleek 352, I

INDEX

Turk's cap cactus 354, I
Turk's cap lily 88, II; 181, I;
182–184; 186, I–II; 187;
188, II–III; 190, II–III; 191, II
Tussilago farfara 366, I
Tutsan 247, I

U
Urginea maritima 35, I
Urtica pilulifera 230, II

V
Vaccinium ocycoccos 341, II
Valerian 260, I; 261, II
Valerian, Greek 260, I, III
Valerian, red 151, I
Valeriana phu 260, I
Valeriana sambucifolia 261, II
Velvet leaf 225, I
Venus's looking glass 109, I
Veratrum album 246, I
Veratrum nigrum 246, II
Verbascum blattaria 265, I–II
Verbascum lychnitis 266, III
Verbascum nigrum 265, III
Verbascum thapsus 266, II
Veronica longifolia 89, II
Vetch, spring 20, II
Vetch, tuberous 298, V
Viburnum opulus 10, I
Vinca major 129, I
Vinca minor 8, II–V
Vine, balloon 304, I
Vine, canary bird 294, I
Viola canina 113, II
Viola elatior 84, II–III
Viola odorata 18, I–V
Viola spec. 48, II–III
Viola tricolor 289, II–III;
364, IV
Violet 48, II–III; 84, II–III
Violet, Alpine 106, II
Violet, Calathian 248, II
Violet, damask 119, II–III
Violet, dame's 119, II–III
Violet, dog 113, II
Violet, English 18, I–V
Violet, European dog's
tooth 15, II–III
Violet, garden 18, I–V
Violet, heath 113, II
Violet, Persian 106, II
Violet, sweet 18, I–V
Viper's grass, common 255, I
Virginian hemp 218, I

Virgin's-bower 300, I–III; 303,
II–III

W
Wallflower 168, II–III;
169, I–III; 179, II
"Wallflower of Eichstätt"
169, I
Water avens 19, II
Water dragon 49, IV
Water lily, European
white 111, I–II
Water lily, yellow 111, III
Water melon 319, III
Weasel's snout 158, III
White-man's foot 141, II–III
Wickup 156, I
Wig tree 143, III
Willow, French 156, I
Willow bell 156, II–III
Willowherb, great 156, I
Willowherb, rosebay 156, I
Windflower 16, V; 17, II; 31, I–
III; 32, I–IV; 366, IV
Windflower, snowdrop 17, I;
27, III
Wintergreen, lesser 214, I
Wintergreen, one-
flowered 105, II
Wolf bean 297, I–II
Wolfsbane 159, II
Wolfsbane, garden 160, II
Wood nymph 105, II
Woodbine 129, III
Woodbine, Italian 129, II
Wormwood 287, I
Wormwood, blue 287, II
Wormwood, Roman 287, III
Woundwort, marsh 268, III
Woundwort, soldier's
136, II–III

Y
Yarrow 136, II–III
Yellow flag 123, III
Yellow-wort 86, III

Z
Zucchini 346, III
Zygophyllum fabago 262, I

Bibliography

WORKS CITED IN THE
Hortus Eystettensis

BAUHIN, KASPAR (1596)
ΦΥΤΟΠΙΝΑΞ seu enumeratio
plantarum ab herbariis nostro
saeculo descriptarum, cum
earum differentiis, Basle

BOCK [TRAGUS], HIERONYMUS
(1546)
(New) Kreüterbuch, 2nd edn,
Strasbourg

CAMERARIUS THE YOUNGER,
JOACHIM (1588)
Hortus medicus et
philosophicus. Item Sylva
Hercynia a Joanne Thalio,
Frankfurt a. M.

CESALPIN, ANDREAS (1583)
De plantis libri XVI,
Florence

CLUSIUS, CAROLUS (1601)
Rariorum plantarum historia,
Antwerp

CLUSIUS, CAROLUS (1605)
Exoticorum libri decem,
quibus animalium,
plantarum, aromatum
aliorumque peregrinorum
fructuum historiae
describuntur, Leyden

CLUSIUS, CAROLUS (1611)
Curae posteriores, seu
plurimarum non ante
cognitarum, aut descriptarum
stirpium, peregrinorumque
aliquot animalium novae
descriptiones, Leyden

COSTA, CHRISTOPHORUS à (1605)
Aromatum Liber. Presented
to: Carolus Clusius:
Exoticorum Libri decem,
Leyden

DALECHAMPS, JACQUES (1587)
Historia generalis plantarum,
Lyons

DODONAEUS, REMBERTUS (1583)
Stirpium historiae Pemptades
sex, Antwerp

DURANTE, CASTORE (1609)
Hortulus Sanitatis. Das ist ein
heylsam und nützliches
Gärtlin der Gesundtheit,
Frankfurt a. M.

FUCHS, LEONHART (1543)
New Kreüterbuch, Basle

GESNER, KONRAD (1555?)
De raris et admirandis herbis,
quae sive quod noctu luceant,
sive alias ob causas, lunariae
nominantur, commentariolus,
Zurich

HUERTA, GARCIA DEL (1557)
Aromatum et simplicium
aliquot medicamentorum
apud Indos nascentium
historia, Antwerp

L'OBEL, MATTHIAS DE (1576)
Plantarum seu stirpium
historia, Antwerp

L'OBEL, MATTHIAS DE (1581)
Plantarum seu stirpium
Icones, Antwerp

L'OBEL, MATTHIAS DE (1605)
In G. Rondeletii methodicam
pharmaceuticam officinam
animadversiones, London

LA HAYE, JOHANN
ANDREAS DE (1746)
Die in seinem tausendjähri-
gen Alter feyerlichist erneuer-
te Herrlichkeit der Eichstätti-
schen Kirch: Bey jenem
großen Jubel- u. Danck-Fest,
welches wegen ... erreichten
tausend Jahren von Errich-
tung d. Hochstiffts ... höchst-
feyrlichist celebrirt worden
ist, Ingoldstadt

MATTIOLI, PIER ANDREA (1583)
Kreutterbuch, jetzt
wiederumb mit vielen
schönen newen Figuren ...,
ed. by Joachim Camerarius,
3rd edn, Frankfurt

MATTIOLI, PIER ANDREA (1586)
De plantis Epitome utilissima
novis plene ad vivum
expressis iconibus. Improved
and expanded by Joachim
Camerarius, Frankfurt a. M.

MATTIOLI, PIER ANDREA (1598)
Opera quae extant omnia,
ed. by Kaspar Bauhin,
Frankfurt a. M.

PENA, PIERRE AND
L'OBEL, MATTHIAS DE (1576)
Stirpium adversaria nova, in:
Matthias de L'Obel, Plantarum
seu stirpium historia, Antwerp

PLINY, C., THE YOUNGER (1545)
Historiae mundi libri XXXVII,
ed. by Sigismund Gelen and
Desiderius Erasmus, Basle

PLINY, C., THE YOUNGER (1587)
Historiae mundi libri XXXVII,
ed. by J. Dalechamps, Lyons

RAUWOLF, LEONHARD (1583)
Aigentliche Beschreibung der
Raiß, so er vor diser Zeit
gegen Aufgang in die
Morgenländer … volbracht,
Lauingen

RENEAULME, PAUL DE (1611)
Specimen historiae
plantarum, Paris

SCHWENCKFELDT, KASPAR (1600)
Stirpium & fossilium Silesiae
catalogus, Leipzig

TABERNAEMONTANUS, JAKOB
THEODOR (1588–1591)
Neuw Kreuterbuch,
vol. 1, Frankfurt a. M. 1588,
vol. 2, 1591

TABERNAEMONTANUS, JAKOB
THEODOR (1590)
Eicones plantarum seu
stirpium arborum, nempe
fruticum, herbarum,
fructuum, lignorum,
radicum omnis generis,
ed. by Nicolaus Bassaeus,
Frankfurt a. M.

LITERATURE CITED

ALBERT, JOST, LAAR, ALEXANDER AND
EHBERGER, GABRIELE (ED., 1998)
Hortus Eystettensis. Ein
vergessener Garten? Guide to
the Exhibit, first presented
from June 19 to October 11,
1998, in the Willibaldsburg in
Eichstätt at the opening of the
Bastionsgarden, in: Die
Pflanzenwelt des Hortus
Eystettensis, Munich

APPEL, BRUN (1998)
Johann Conrad von
Gemmingen. Ein Bischof
und sein Garten, in: Die
Pflanzenwelt des Hortus
Eystettensis. Ein Buch lebt,
pp. 39–71, Munich et al.

AYMONIN, GÉRARD G. (1987)
Introduction, in: Der Garten
von Eichstätt. Hortus Eystet-
tensis. Das große Herbarium
des Basilius Besler von 1613,
pp. 8–16, Munich

BAIER, HANS (1970)
Die Ausgaben des Hortus
Eystettensis, in: Aus dem
Antiquariat 26, pp. A273–A280

BARKER, NICOLAS (1995)
Hortus Eystettensis. The
Bishop's Garden and Besler's
Magnificent Book. Repr. with
corrections, London

BARKER, NICOLAS (1995)
Who printed the text of the
Hortus Eystettensis? in:
The German Book 1450–1750.
Studies presented to David L.
Paisey, pp. 185–192, London

BELDER, ROBERT DE (1987)
A Magnificent Collection of
Botanical Books being the
finest colour-plate books
from the celebrated library
formed by Robert de Belder,
London

BERND, ULLRICH (1993)
Agaven. Illustrationen
blühender Exemplare bis
1800, Frankfurt a. M. (Der
Palmengarten, special
issue 21)

BERTSCH, KARL AND
BERTSCH, FRANZ (1947)
Geschichte unserer
Kulturpflanzen, Stuttgart

BEUCHERT, MARIANNE (1995)
Symbolik der Pflanzen.
Von Akelei bis Zypresse.
Mit 101 Aquarellen von
Maria-Therese Tietmeyer,
Frankfurt a. M. / Leipzig

BESLER, BASILIUS (1613)
Der Garten von Eichstätt.
Das große Herbarium des
Basilius Besler von 1613.
With a foreword by Dieter
Vogellehner and botanical
annotations by Gérard G.
Aymonin, Munich 1988

BESLER, BASILIUS (1713)
Die schönsten Kupferstiche
aus dem Hortus Eystettensis
1713, Munich 1964 (Die
historischen Taschenbücher, 1)

BESLER, BASILIUS (1713/1750)
Hortus Eystettensis … (Repr.
of the 1713/1750 edition),
Munich 1964

BESLER, BASILIUS (2006)
Hortus Eystettensis Commen-
tarium, ed. by Klaus Walter
Littger, Sansepolcro (Arezzo)

BIRKE, VERONIKA (1998)
Die Kupferplatten des
"Hortus Eystettensis" in
der Albertina, Vienna, in:
Sammelblatt des Historischen
Vereins Eichstätt 91, p. 9

BLUNT, WILFRID (1950)
Tulipomania, Harmondsworth

BLUNT, WILFRID (1994)
The art of botanical illustration, new edition reviewed and enlarged, London

BURGER, DANIEL (1995/96)
Von der Burg zum Schloß. Die Willibaldsburg im 16. Jahrhundert, in: *Sammelblatt des Historischen Vereins Eichstätt* 88/89, pp. 33–57

BURGER, DANIEL (1999)
Der Blick auf den Hortus Eystettensis. Die "Große Altane" auf der Willibaldsburg als Kunstkammer des Eichstätter Bischofs Johann Konrad von Gemmingen, in: *Forschungen zu Burgen und Schlössern*, vol. 5, Munich, Berlin

COATS, ALICE M. (1956)
Flowers and their Histories, London

COWELL, FRANK RICHARD (1979)
Gartenkunst. Von der Antike bis zur Gegenwart, Stuttgart, Zurich

DIERBACH, JOHANN HEINRICH (1833)
Flora mythologica oder Pflanzenkunde in Bezug auf Mythologie und Symbolik der Griechen und Römer, Frankfurt a. M.

DOERING, OSCAR (1894)
Des Augsburger Patriciers Philipp Hainhofer Beziehungen zum Herzog Philipp II. von Pommern-Stettin. Correspondence from the years 1610–1619. Presented in extracts with commentary, Vienna

DOERING, OSCAR (1901)
Des Augsburger Patriciers Philipp Hainhofer Reisen nach Innsbruck und Dresden, Vienna

DOERING, OSCAR (1904)
Hainhofer, in: *Allgemeine Deutsche Biographie*, vol. 49, pp. 719–721, Leipzig

DOPPELBAUER, REGINA, BIRKE, VERONIKA AND KIEHN, MICHAEL (1999)
Die Kupferplatten zum "Hortus Eystettensis", in: *Wiener Geschichtsblätter* 52/53, pp. 22–32

DRESSENDÖRFER, WERNER (1998)
Vom Kräuterbuch zur Gartenlust. Der Hortus Eystettensis zwischen Medizin, Botanik und Hortikultur, in: *Die Pflanzenwelt des Hortus Eystettensis*, pp. 73–90, Munich et al.

DRESSENDÖRFER, WERNER (2006)
Die Pflanzen des Hortus Eystettensis. Ein botanischer und kulturhistorischer Spaziergang durch das Gartenjahr, in: *Basilius Besler: Hortus Eystettensis Commentarium*, hg. v. Klaus Walter Littger, Sansepolcro (Arezzo), pp. 58–274

PFLANZEN-ENZYKLOPÄDIE (1998)
DuMont's große Pflanzen-Enzyklopädie A–Z, Cologne, 2 vols

EISZEPH, LAURENTIUS (1590)
Leychpredig / Bey der Christlichen Begräbnuß / weyland deß hochwirdigen Fürsten und Herren / Herrn Martin von Schaumberg / Bischoffen zu Eystett [...], Ingolstadt

ENCKE, FRITZ (ED., 1958)
Pareys Blumengärtnerei. Beschreibung, Kultur und Verwendung der gesamten gärtnerischen Schmuckpflanzen, 3 vols, Berlin, Hamburg

ENGEL, FRITZ-MARTIN (1978)
Zauberpflanzen – Pflanzenzauber, Hanover

ENGEL, FRITZ-MARTIN (1984)
Giftpflanzen – Pflanzengifte, Zurich

FISHER, JOHN (1989)
The Origin of Garden Plants, London

FRANKE, WOLFGANG (1989)
Nutzpflanzenkunde. Nutzbare Gewächse der gemäßigten Breiten, Subtropen und Tropen, Stuttgart, New York

FÜSSEL, STEPHAN (1994)
Die Weltchronik – eine Nürnberger Gemeinschaftsleistung, in: *Pirckheimer-Jahrbuch* 9, pp. 7–30

GENAUST, HELMUT (1996)
Etymologisches Wörterbuch der botanischen Planzennamen, Basle et al.

GERHARDT, CLAUS W. (1975)
Der Buchdruck, in: *Geschichte der Druckverfahren*, vol. 2, Stuttgart

GIBBONS, BOB AND BROUGH, PETER (1993)
The Hamlyn Photographic Guide to the Wild Flowers of Britain and Northern Europe, London

GODET, JEAN-DENIS (1991)
Pflanzen Europas. Kräuter und Stauden, Munich

GOTHEIN, MARIE LUISE (1926)
Geschichte der Gartenkunst, 2 vols, Jena

GRANT, MICHAEL AND HAZEL, JOHN (1987)
Lexikon der antiken Mythen und Gestalten, Munich

GRETSER, JACOBUS (1617)
Philippi ecclesiae Eystettensis
XXXIX episcopi, de eiusdem
ecclesiae divis tutelaribus [...]
commentarius, Ingolstadt

HÄUSERBUCH DER STADT
MÜNCHEN (1958–1977)
Published by the Munich city
archive after preparatory
work by Andreas Burgmaier,
5 vols, Munich

HAINHOFER, PHILIPP (1881)
Die Reisen des Augsburgers
Philipp Hainhofer nach Eich-
städt, München und Regens-
burg in den Jahren 1611, 1612
und 1613, ed. by Christian
Häutle, in: Zeitschrift des His-
torischen Vereins für Schwaben
und Neuburg 8, pp. 1– 204

HAINHOFER, PHILIPP (1984)
Der Briefwechsel zwischen
Philipp Hainhofer und Herzog
August d. J. von Braunschweig-
Lüneburg. Ed. by Ronald
Gobiet, Munich

HAMBERGER, GEORG CHRISTOPH
AND MEUSEL, JOHANN GEORG
(1965–66)
Das Gelehrte Teutschland
oder Lexikon der jetzt
lebenden teutschen Schrift-
steller, 5th edn, 24 vols, repr.
of the Lemgo edn 1796–1834,
Hildesheim

HARMS, WOLFGANG AND
KUECHEN, ULLA-BRITTA (1988)
Introduction, in: Joachim
Camerarius: Symbola et
emblemata (Nürnberg 1590–
1604), 2 vols, Graz

HEGI, GUSTAV (1906–)
Illustrierte Flora von
Mitteleuropa, 1st–3rd edns

HENNEBO, DIETER AND
HOFFMANN, ALFRED (1965)
Geschichte der deutschen
Gartenkunst. Vol. 2: Der
architektonische Garten.
Renaissance und Barock,
Hamburg

HESSE, HEINRICH (1690)
Neue Garten-Lust. [...],
Leipzig

HOFMANN, MARA AND
ZÖHL, CAROLINE (2003)
Hortus Eystettensis. Studien
zur Entstehung des Kupfer-
stichwerks und zum Exemplar
des Andrea Vendramin, Art-
Dok", Publikationsplattform
Kunstgeschichte der Univer-
sitätsbibliothek Heidelberg
(URL: http://archiv.ub.uni-
heidelberg.de/artdok/volltex-
te/2010/963/)

HORTUS EYSTETTENSIS (1989)
Zur Geschichte eines Gartens
und eines Buches, Munich
(Schriften der Universitätsbi-
bliothek Erlangen-Nürnberg, 20)

JEDLITSCHKA, ARMIN (1990)
Neues zum Hortus
Eystettensis? in: Aus dem
Antiquariat 46, pp. A1–A8

KAISER, WOLF-DIETER AND
VETTER, RAINER R. (1988)
Blüten aus Zwiebeln
und Knollen, Leipzig,
Radebeul

KELLENBENZ, HERMANN (1971)
Wirtschaftsleben zwischen
dem Augsburger
Religionsfrieden und dem
Westfälischen Frieden, in:
Nürnberg. Geschichte einer
europäischen Stadt, ed. by
Gerhard Pfeiffer, pp. 295–302,
Munich

KEUNECKE, HANS-OTTO (1989)
Der Hortus Eystettensis. Zur
Geschichte eines Buches, in:
Hortus Eystettensis. Zur
Geschichte eines Gartens und
eines Buches, pp. 91–118,
Munich (repr. in: Die
Pflanzenwelt des Hortus
Eystettensis. Ein Buch lebt,
Munich 1998, pp. 91–115)

KEUNECKE, HANS-OTTO
(ED., 1998)
Die Pflanzenwelt des Hortus
Eystettensis. Ein Buch lebt.
Munich

KÖRBER-GROHNE, UDELGARD
(1987)
Nutzpflanzen in Deutschland.
Kulturgeschichte und Bio-
logie, Stuttgart

KRAUSCH, HEINZ-DIETER (1992)
Alte Nutz- und Zierpflanzen
in der Niederlausitz.
Verhandlungen des
Botanischen Vereins von
Berlin und Brandenburg,
Supplement 2, Berlin

LEHNER, ERNST AND
LEHNER, JOHANNA (1960)
Folklore and Symbolism of
Flowers, Plants and Trees,
New York

LEHNER, ERNST AND
LEHNER, JOHANNA (1973)
Folklore and Odysseys of
Food and Medicinal Plants,
London

LEVI D'ANCONA, MIRELLA (1977)
The Garden of the
Renaissance. Botanical
symbolism in Italian painting,
Florence

LEVI D'ANCONA, MIRELLA (1983)
Botticelli's Primavera. A
botanical interpretation,
Florence

LILIEN, OTTO M. (1978)
Der Tiefdruck, in: Geschichte
der Druckverfahren, vol. 3,
pp. 1–133

LITTGER, KLAUS WALTER (1997)
Eichstätt 1, in: Handbuch der
historischen Buchbestände in

Deutschland, vol. 11, pp. 216–239, Hildesheim et al.

LITTGER, KLAUS WALTER, (2001) Die Titelblätter des „Hortus Eystettensis" in der Tradition der Pflanzenbücher des 16. und frühen 17. Jahrhunderts, in: *Wiener Geschichtsblätter* 56, pp. 53–70

LITTGER, KLAUS WALTER, (2008) Der „Hortus Eystettensis" als Wunderkammer, in: *Hortus Wander Wunder Kammer*, Eichstätt, pp. 10–13

LOCHNER VON HÜTTENBACH, OSKAR (1912) Die Willibaldsburg bei Eichstätt, in: *Sammelblatt des Historischen Vereins Eichstätt* 27, pp. 1–40

MADER, FELIX (1924) Die Kunstdenkmäler von Bayern (KDB). Mittelfranken, vol. 1: Eichstätt, Munich

MARZELL, HEINRICH (1943–1958) Wörterbuch der deutschen Pflanzennamen, 5 vols, Leipzig

MEYER, CHRISTIAN (ED., 1910) Die Hauschronik der Familie Holl (1487–1646), insbesondere die Lebensaufzeichnungen des Elias Holl, Baumeisters der Stadt Augsburg, Munich

MEYER, KARL HEINRICH (1960) Gefährten des Gartenjahres. Ein Buch für Freunde des Gartens über winterharte Blumenzwiebeln und Knollenpflanzen, Hamburg, Berlin

MIELKE, FRIEDRICH (1989) Treppen in Eichstätt, Eichstätt (*Scalalogia. Schriften zur internationalen Treppenforschung* vol. 3)

MÜLLER-JAHNKE, WOLF-DIETER (2009) Artis Pharmaceuticae Chymicae Amator. Apotheker Basilius Besler und der Paracelsismus in Nürnberg, in: *Geschichte der Pharmazie. Beilage der Deutschen Apotheker Zeitung (DAZ)* 61, pp. 35–44

MUMMENHOFF, ERNST (1927) Entwicklung und Blüte des Nürnberger Handwerks, in: *Nürnberg*, pp. 207–213, ed. by City Council, Berlin (*Monographien deutscher Städte* vol. 23)

NISSEN, CLAUS (1966) Die botanische Buchillustration. Ihre Geschichte und Bibliographie, 2nd edn, Stuttgart

OSMANISCHE BLUMEN (1985) Osmanische Blumen. Ein Beitrag zur Kulturgeschichte von Pflanzen aus Vorderasien, Frankfurt a. M. (*Der Palmengarten*, special issue 1/85)

OVID (1955) Metamorphoses. Translated by Rolfe Humphries, Harmondsworth

PAPEBROCH, DANIEL (1975) Daniel Papebrochs Reisebericht über Nürnberg, Ellingen, Weißenburg und Eichstätt aus dem Jahre 1660. I. Edition and translation by Udo Kindermann, II. Historical annotations to Papebroch's travelogue by Ernst Schubert, in: *Zeitschrift für bayerische Kirchengeschichte* 44, pp. 60–97

PERGER, ANTON VON (1864) Deutsche Pflanzensagen, Stuttgart

PERRY, FRANCIS (N.D.) Blumen der Welt, Cologne

PFLANZENLEXIKON (1969) rororo Pflanzenlexikon, 5 vols, Reinbek

PLESSEN, MARIE-LOUISE (ED., 1985) Berlin durch die Blume oder Kraut und Rüben. Gartenkunst in Berlin-Brandenburg, Berlin

RICKERT, FRANZ (1994) Biene, in: *Lexikon für Theologie und Kirche*, 3rd edn, vol. 2, col. 438, Freiburg et al.

RINGHOLZ, BERND (1998) Die Pflanzenwelt des Hortus Eystettensis im Bastionsgarten auf der Willibaldsburg, in: *Die Pflanzenwelt des Hortus Eystettensis. Ein Buch lebt*, pp. 19–24, Munich

ROBERT, NICOLAS (1981) Tulpen. Nach den Miniaturen in der Österreichischen Nationalbibliothek. Ed. by Armin Geus, Dortmund

ROECK, BERND (1985) Elias Holl. Architekt einer europäischen Stadt, Regensburg

RÖHRICH, HEINZ (1974) Jungermann, in: *Neue Deutsche Biographie*, vol. 10, pp. 683f., Berlin

RÖHRICH, LUTZ (1994) Lexikon der sprichwörtlichen Redensarten, 5 vols, Freiburg, Basle, Vienna

ROTHMALER, WERNER (ED., 1976) Exkursionsflora für die Gebiete der DDR und der BRD, vol. 4: Kritischer Band, Berlin

RUPPRECHT, HELMUT AND
MIESSNER, ECKART (1989)
Zierpflanzenbau.
Zierpflanzen von A bis Z,
Berlin

SCHAUER, GEORG KURT (1943)
Rosen und Tulipan, Lilien und
Safran. Gartenlust von
Gestern und Heute, Brünn,
Munich, Vienna

SCHIRAREND, CARSTEN AND
HEILMEYER, MARINA (1996)
Die Goldenen Äpfel.
Wissenswertes rund um die
Zitrusfrüchte, Berlin

SCHMEIL-FITSCHEN
Flora von Deutschland und
seinen angrenzenden
Gebieten, Heidelberg

SCHMID, ALOIS (1996)
Gemmingen, Johann Konrad,
in: Die Bischöfe des Heiligen
Römischen Reiches 1448–1648,
ed. by Erwin Gatz, pp. 215f.,
Berlin

SCHMIDT-HERRLING,
ELEONORE (1951)
Hortus Eystettensis. Vom
bischöflichen Garten zu
Eichstätt, in: Frankenspiegel
2, 5, pp. 9f.

SCHNEIDER, WOLFGANG
(1968–1975)
Lexikon zur Arzneimittelge-
schichte, 7 vols, Frankfurt a. M.

SCHNIZLEIN, A. (1913)
Der "Hortus Eystettensis" von
1613, in: Der Sammler 156,
pp. 3f.

SCHÖNFELDER, INGRID AND
SCHÖNFELDER, PETER (1990)
Die Kosmos-Mittelmeerflora,
Stuttgart

SCHUBERT, RUDOLF (ED., 1991)
Exkursionsflora von
Deutschland, vol. 3: Atlas der
Gefäßpflanzen, Berlin

SCHÜTTE, ULRICH (1994)
Das Schloß als Wehranlage.
Befestigte Schloßbauten der
frühen Neuzeit im alten
Reich, Darmstadt

SCHÜTZE, SEBASTIAN (1994)
"Urbano inalza Pietro, e Pietro
Urbano". Beobachtungen zu
Idee und Gestalt der
Ausstattung von Neu-St.-Peter
unter Urban VIII., in:
Römisches Jahrbuch der
Bibliotheca Hertziana 29,
pp. 213–287

SCHWERTSCHLAGER,
JOSEPH (1890)
Der botanische Garten der
Fürstbischöfe von Eichstätt.
Eine Studie, Eichstätt

SCHWERTSCHLAGER,
JOSEPH (1907)
Eine historisch bedeutsame
Treppe auf der Willibalds-
burg, in: Sammelblatt des
Historischen Vereins Eichstätt
22, pp. 86–89

STEARN, WILLIAM T. (1965)
The origin and later
development of cultivated
plants, in: Journal of the Royal
Horticultural Society 90,
pp. 279–291, 322–340

TERGIT, GABRIELE (1963)
Kaiserkron und Päonien rot.
Kleine Kulturgeschichte der
Blumen, Cologne, Berlin

THIEME-BECKER (1907–1950)
Allgemeines Lexikon der
bildenden Künstler von der
Antike bis zur Gegenwart.
Presented by Ulrich Thieme
and Felix Becker. Rev. and
ed. by Hans Vollmer, 37 vols,
Leipzig

TURNER, ROBERT (1580)
Oratio & epistola de vita &
morte reverendissimi et
illustrissimi Dn. Martini a
Schaumberg, principis &
episcopi Eystadiani, illa in
funere 3. Non. Iul. An. 1590
Eystadii habita […].
Subnexum est […] Philippi
Menzelii carmen de eadem re
elegantissimum, Ingolstadt

URANIA PFLANZENREICH (1995)
Urania Pflanzenreich, 5 vols,
Leipzig et al.

WEISS, HILDEGARD (1986)
Lebenshaltung und
Vermögensbildung des
"mittleren" Bürgertums.
Studien zur Sozial- und
Wirtschaftsgeschichte der
Reichsstadt Nürnberg 1400–
1600, Munich (Zeitschrift für
Bayerische Landesgeschichte,
Supplement 14, Series B)

WICKERT, KONRAD (1989)
Die Erlanger Exemplare des
"Hortus Eystettensis". Ihre
Herkunft und ihr Schicksal,
in: Hortus Eystettensis. Zur
Geschichte eines Gartens und
eines Buches, pp. 119–145,
Munich

WICKERT, KONRAD (1993)
Das Camerarius-Florilegium,
Erlangen (Kulturstiftung der
Länder – Patrimonia 61)

WIDNMANN, FRANZ SERAPH
(1805)
Catalogus systematicus
secundum Linnaei Systema
vegetabilium adornat
arborum, fruticum et
plantarum celeberrimi Horti
Eystettensis, Nuremberg

ZANDER (1993)
Zander. Handwörterbuch der
Pflanzennamen, Stuttgart

What Great
Paintings Say

Michelangelo.
Complete Paintings

Michelangelo.
The Graphic Work

Leonardo da Vinci.
Complete Paintings

Leonardo da Vinci.
The Graphic Work

Monet

Van Gogh

Dalí. The Paintings

Impressionism

Bauhaus

Modern Art

Bookworm's delight:
never bore, always excite!

TASCHEN
Bibliotheca Universalis

The Stanley Kubrick
Archives

Prisse d'Avennes.
Egyptian Art

Braun/Hogenberg.
Cities of the World

Bourgery. Atlas of
Anatomy & Surgery

Alchemy & Mysticism

Byrne. Six Books
of Euclid

Basilius Besler's
Florilegium

The World
of Ornament

Racinet.
The Costume History

Fashion History

20th Century Fashion

Curtis. The North
American Indian

Stieglitz.
Camera Work

20th Century
Photography

New Deal
Photography

A History of
Photography

Photographers A–Z

Lewis W. Hine

Photo Icons

Karl Blossfeldt

Eugène Atget. Paris

Burton Holmes.
Travelogues

The Grand Tour

Modern
Architecture A-Z

Small Architecture

Green Architecture

100 Contemporary
Wood Buildings

Contemporary
Concrete Buildings

Tree Houses

Cabins

Industrial Design A–Z

Design of the
20th Century

Scandinavian Design

Living in Asia

Living in Provence

Living in Tuscany

EACH AND EVERY TASCHEN BOOK PLANTS A SEED!
TASCHEN is a carbon-neutral publisher. Each year, we offset our annual carbon emissions with carbon credits at the Instituto Terra, a reforestation programme in Minas Gerais, Brazil, founded by Lélia and Sebastião Salgado. To find out more about this ecological partnership, please check: www.taschen.com/zerocarbon
Inspiration: unlimited.
Carbon footprint: zero.

To stay informed about TASCHEN and our upcoming titles, please subscribe to our free magazine at www.taschen.com/magazine, follow us on Instagram and Facebook, or e-mail your questions to contact@taschen.com.

© 2022 TASCHEN GmbH
Hohenzollernring 53
D–50672 Köln
www.taschen.com

Original edition
© 2000 TASCHEN GmbH

Editor: Petra Lamers-Schütze, Cologne
English translation: Harriet Horsfield
in association with First Edition
Translations Ltd, Cambridge, UK
Many thanks to Sarah Jennings of the
Royal Botanical Gardens Kew, and to
Iain Soden and Wendy Carruthers,
who offered valuable help.

Printed in Bosnia–Herzegovina
ISBN 978–3–8365–5787–0

This reprint of the colour plates is taken from the hand-coloured copy of the first edition of the *Hortus Eystettensis* in the Eichstätt-Ingolstadt university library / property of the Seminarbibliothek, shelf mark: 183/1 SJ II 2894-1-3. We would like to thank Constance Dittrich and Maria Löffler for their kind support.

The digital reproduction of the original was carried out by the Center for Retrospective Digitization (GDZ) at the Göttingen State and University Library, Germany. We wish to thank Martin Liebetruth of GDZ for his kind support.

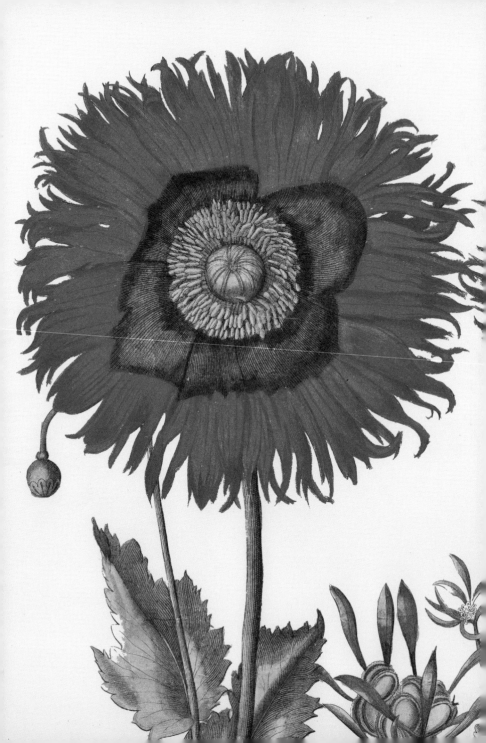